D0885930

RAIDING THE ICEBOX

RAIDING THE ICEBOX

Reflections on Twentieth-Century Culture

◆

PETER WOLLEN

INDIANA UNIVERSITY PRESS

Bloomington and Indianapolis

Published by Indiana University Press
601 North Morton Street, Bloomington, Indiana 47404

© 1993 by Peter Wollen
All rights reserved

The paper used in this publication meets the minimum requirements of
American National Standard for Information Sciences—Permanence of
Paper for Printed Library Materials, ANSI Z39.48-1984.

Library of Congress Cataloging-in-Publication Data
Wollen, Peter.
Raiding the icebox: reflections on twentieth-century culture / by
Peter Wollen.
p. cm.
Includes bibliographical references and index.
ISBN 0-253-36587-2 (hard : alk. paper).—ISBN 0-253-20770-3
(pbk. : alk. paper)
1. Arts, Modern—20th century. 2. Arts and society—History—20th
century. 3. Culture. I. Title.
NX456.W66 1993
700′.9′04—dc20 92–44592

Manufactured in Great Britain by Biddles Ltd

CONTENTS

ACKNOWLEDGEMENTS

Early and experimental versions of many chapters of this book were originally given as conference papers or lectures, and I am especially grateful to the organizers of these events and to the many participants who made valuable comments. Parts of it have also been published, in earlier, often variant, versions, in *New Formations* 1, Spring 1987 ('Fashion/Orientalism/The Body'); *Communications* (Paris) 48, 1988 ('Le cinéma, l'américanisme et le robot'); *New Formations* 8, Summer 1989 ('Cinema/Americanism/The Robot'); *Modernity and Mass Culture*, James Naremore (ed.), University of Indiana, Bloomington, 1989 ('Cinema/Americanism/The Robot'); *Andy Warhol/Film Factory*, Michael O'Pray (ed.), BFI Publishing, London 1989 ('Raiding the Icebox: Andy Warhol'); *New Left Review* 174, March/April 1989 ('The Situationist International'); *An endless adventure. . . an endless passion. . .an endless banquet*, Iwona Blazwick (ed.), Institute of Contemporary Arts, London, with Verso, London 1989 ('Bitter Victory: the Situationist International'); *On the passage of a few people through a rather brief moment in time: The Situationist International, 1957–1972*, Institute of Contemporary Art, Boston, with MIT Press, Cambridge, 1989 ('Bitter Victory: The Art and Politics of the Situationist International'); *Between Spring and Summer*, Tacoma Art Museum, Tacoma, Washington ('Scenes from the Future: Komar & Melamid'); *New Formations* 12, Winter 1990 ('Tourism, Language and Art'). I would like to thank the editors of these collections, journals and exhibition catalogues for their support.

I am especially grateful to Mark Francis, with whom I worked as curator on exhibitions of the work of *Frida Kahlo and Tina Modotti* in 1982, *V. Komar & A. Melamid* in 1985, and *Sur le passage de quelques personnes à travers une assez courte unité de temps: l'Internationale Situationniste, 1957–1972*, at the Musée Nationale d'Art Moderne, Centre Pompidou, Paris, in 1989, subsequently travelling to the Institutes of Contemporary Art in London and Boston. I

would also like to thank the many other people involved in the situationist show, especially Jørgen Nash, Jamie Reid, Jens Jørgen Thorsen, Troels Andersen, Paul-Hervé Parsy and Elizabeth Sussmann, as well as Jean-Hubert Martin for his vision in organizing the exhibition, *Magiciens de la Terre*, also for the Centre Pompidou in 1989.

I am grateful to my research assistant, Andrea Pyrou, at Vassar College, Poughkeepsie, whose efficiency was vital at crucial moments. I discussed the ideas that motivated me to write with countless people in a wide variety of circumstances and I would like to thank them all for their forbearance and interest. I would especially like to thank my colleagues and students at UCLA. Above all, I am indebted to Leslie Dick, who, over the years, has assessed every idea and every comma in this book.

OUT OF THE PAST: FASHION/ ORIENTALISM/THE BODY

1. *The Thousand and One Nights*

On 24 June 1911, the renowned fashion designer Paul Poiret gave a Thousand and Second Night party, to celebrate his new 'Oriental' look. Orientalism had been a staple of French visual culture throughout the nineteenth century, but it was given a new twist and a new lease of life by the publication in 1899 of a fresh translation by Dr J.-C. Mardrus of *The Thousand and One Nights*, published by the leading journal of the avant-garde, the symbolist *Revue Blanche*, and appearing serially volume by volume over the next five years.[1] The entire translation was dedicated to the memory of Mallarmé and individual volumes bore inscriptions to Valéry, Gide, and a number of other symbolist and Decadent writers. Poiret was a close friend of Mardrus (who himself came from the Middle East) and the theme and fantastic scenography of both the party and the fashion derived from Mardrus's translation.

At the Thousand and Second Night fête Poiret himself was dressed as a sultan, lounging on cushions under a canopy, wearing a fur-edged caftan, a white silk turban, a green sash and jewelled velvet slippers. In one hand he held an ivory-handled whip and in the other a scimitar. Nearby was a huge golden cage in which his wife, Denise Poiret, his 'favourite', was confined with her women attendants. When all the guests were assembled, dressed in costumes from tales of the Orient (*absolument de rigueur*), Poiret released the women. Denise Poiret was wearing the 'lampshade tunic' (mini-crinoline over loose trousers) that later formed the basis of Poiret's 'Minaret look'. The whole party revolved around this pantomime of slavery and liberation set in a phantasmagoric fabled East.

The remainder of the fête continued the Oriental theme. Claude Lepape described the scene:

> The guests came in to find themselves beneath a vast awning. There they were
> greeted by six ebony-black negroes, stripped to the waist and wearing baggy

trousers of muslin silk in Veronese green, lemon, orange and vermilion. They bowed low before us: 'Come!' And so you passed on through the salons, which were strewn with cushions of all colours, and arrived in the gardens spread with Persian rugs. There were parrots in the trees and little bands of Eastern musicians and flute-players hidden among the bushes. Your way was discreetly lit by little twinkling lights. As you advanced you came across booths of the sort found in Arab souks, craftsmen at work and acrobats of all kinds. Your footsteps were muffled by the rugs, but you could hear the rustle of the silk and satin costumes. . . . Suddenly a miniature firework flared from behind a bush, then another and another. It was like fairyland.[2]

Elsewhere there were *almays*, black slaves, Circassians. The immense awning, over one hundred square metres in area, was painted by Raoul Dufy. During the party, the famous actor Edouard De Max (Cocteau's first patron) recited passages from *The Thousand and One Nights*. There were bands of musicians playing Eastern music, illuminated fountains, incense-burning braziers, an almost incredible excess and extravagance. The party firmly established Poiret's reputation as *Le Magnifique*, after Suleiman the Magnificent. From then on, alongside the all-pervasive influence of Sergei Diaghilev's Russian Ballet, the Oriental look dominated the fashion world and the decorative arts.

During the previous few years Poiret had transformed French fashion. It was primarily Poiret who sealed the fate of the corset and ended an epoch in which the female body had been divided into two bulks by an emphatically narrow waist. 'It was still the age of the corset. I waged war upon it. . . . It was in the name of Liberty that I brought about my first Revolution, by deliberately laying siege to the corset.' (Poiret's putting together of the images of Revolution, Liberty and siege served to equate the banishment of the corset with the fall of the Bastille.) Poiret's new look stressed bright colours, physical movement, a reduced and unified body image, with clothes that hung from the shoulders. The waist was moved up to just below the breasts and dresses were designed to follow the line of the body, giving a revived Directoire look. This neoclassical trend was influenced by the dance and costume innovations of Isadora Duncan and, in turn, Duncan went to Poiret for her own clothes and for the decoration of her Paris apartment.[3]

In 1911 Poiret followed the Directoire with his first Oriental look. Poiret had summed up his work of the previous three years in the illustrated album *Les Choses de Paul Poiret*, the work of Georges Lepape. The last section of this lavish booklet, dedicated to the fashions 'of tomorrow', showed four images of

women in trousers, with gardening and sporting motifs. The 'harem panta-loons' that followed allowed Poiret to launch a bifurcated look in the sphere of high fashion. Poiret took the crucial further step implied by the abolition of the petticoat and the wide skirt by devising 'quatre manières de culotter une femme', based on the notion of Oriental dress. Thus he recapitulated, in a completely different context, both Amelia Bloomer's 'Turkish trousers' and Lady Harberton's 'Eastern' divided skirt, designed in the 1880s, for the Rational Dress Society.[4]

Yet Poiret always denied that he had been influenced by the Russian Ballet. He himself had studied at the School of Modern Oriental Languages in Paris. On a visit to England in 1908, where he had been invited by the prime minister's wife, Margot Asquith, he was impressed by the collection of Eastern miniatures in the Victoria and Albert Museum, as well as by the Indian turbans. He even sent an assistant from Paris to make copies of the turbans (originally they were used *à la Madame Tallien* to contribute to the Directoire look). Poiret also toured North Africa in 1910. But the huge success of Diaghilev's *Schéhérazade* in Paris that same year was a precondition for the effect of Poiret's Oriental fashion. It is hard to believe he knew nothing of it – Lepape, for instance, did a gouache of Nijinsky in *Schéhérazade* while working for Poiret. The Russian Ballet launched the new Orientalism, Poiret popularized it, Matisse channelled it into painting and fine art.

Schéhérazade was designed by Diaghilev to follow up the success he had enjoyed with *Cleopatra* and the (Tartar) Polovtsian dances in *Prince Igor* the previous year, his debut in Paris. The spectacle of *Schéhérazade* was freely devised to fit Rimsky-Korsakov's symphonic poem. It displayed the fantastic scenography of 'Oriental despotism' in concentrated form. In Act 1, the Shah, refusing the entreaties of his favourite, Zobeida, and the attractions of three odalisques, leaves on a hunting expedition. In Act 2 the women of the harem adorn themselves with jewels and bribe the eunuchs to admit black slaves (wearing rose and green costumes and covered with body paint). Finally Zobeida bids the Chief Eunuch open a third door to release the Golden Slave (played in Paris by Nijinsky). Dancing girls inspire passion and the scene turns into an orgy, all whirling and springing in a frenzied dance. In Act 3 the Shah returns and janissaries with flashing scimitars massacre the women and the slaves. The Golden Slave is the last to die, spinning on his head like a break-dancer. Finally, as the Shah hesitates to kill his favourite, she commits suicide. The Shah buries his face in his hands.[5]

This ballet, with which Diaghilev conquered Paris, was in fact the fourth of his ventures. He had already brought Russian painting, orchestral music and opera to France, with success though not with overwhelming triumph. This turn to the West began after the 1905 revolution. In 1899 the ruin of the railway tycoon Mamontov put Diaghilev's magazine *The World of Art* into crisis, from which it was rescued by friends and by a subsidy from the Tsar (whose portrait was painted by a contributor, Somov). In 1901 Diaghilev was dismissed from his post in the administration of the imperial theatres after losing out in a struggle for power. He was disgraced and forbidden any further employment in the imperial arts bureaucracy. In 1904, as a result of the Russo-Japanese War, the tsar withdrew the subsidy from *The World of Art*, which collapsed. The revolution the next year deepened the political, ideological and personal splits in Diaghilev's entourage. The turn to the West provided a way out.

The success of *Schéhérazade* depended on design, dance and story: first, the audience was struck by Leon Bakst's décor and costume. Bakst had trained as a painter and met Diaghilev in St Petersburg, where they were both members of the circle round Alexandre Benois, the so-called 'Nevsky Pickwickians'. Diaghilev came to dominate the group and carried it with him, first to *The World of Art*, for which Bakst worked, then (after some falling off) to the Russian Ballet. Bakst's roots were in the symbolism of the *World of Art* group, whose left wing was tinctured with the Decadence.[6] (A volume of de Sade was usually to be seen peeping out of the pocket of Bakst's friend, Nourok.) His first stage designs for Diaghilev were for *Cleopatra* in 1909, itself an Oriental spectacle, and *Schéhérazade* the next year. The impact of *Schéhérazade* was due, above all, to brilliant and unexpected combinations of massed colour: emerald green, deep blue, orange-red. (After its success Cartier set emeralds and turquoises together for the first time.) The costumes of the dancers were equally brilliantly coloured, with gaps showing the body beneath and folds tied in by cords and ropes of jewels.

Within this setting, Michel Fokine developed a choreography that depended on three innovative elements. First, there was the centrality of the male dancer, Nijinsky, both athletic and 'effeminate' – in Benois's words 'half-cat, half-snake, fiendishly agile, feminine and yet wholly terrifying'.[7] Second, the choreography of the group scenes, the orgy and the bloodbath, brought the whole company into the action of the dance, in vivid geometric movements, rather than treating them simply as background. The third

element was Fokine's reform of mime, especially in Ida Rubinstein's perform-
ance as Zobeida, using expressive, rather than conventional, gesture, and
staying completely immobile, frozen, during the massacre until her own
suicide. (In this Fokine was helped immensely by the stage presence of
Rubinstein, who incarnated the decadent vision of the *femme fatale*.) Fokine,
who had felt increasingly hampered in St Petersburg, frustrated in his
attempts to reform the Imperial Ballet (under the influence, like Poiret, of
Isadora Duncan), was to find his opportunity with Diaghilev.

Finally, the fascination of *Schéhérazade* derived from its story and scenogra-
phy. Since the time of Montesquieu, in the seventeenth century, the myth of
'Oriental despotism' had served as a projection of domestic fears on to the
screen of the Other. The West described the East to itself in terms that simply
reflected its own political anxieties and nightmares: an exaggerated absolu-
tism dispensing with the established rule of law. For Montesquieu the fear was
that the regime of Louis XIV would degenerate towards the twin dangers of an
over-powerful monarch ruling without check or balance, or a weak monarch
allowing power to slip into the hands of a corrupt court. Later, for Voltaire,
who was a critic of Montesquieu and an admirer of Louis XIV and 'en-
lightened' absolutism, it was the papacy that was translated into a fear-
inspiring fantasy of the Islamic East.

Next came Hegel. Now it was the turn of Robespierre and the Terror to
inspire fear: '*La religion et la terreur* was the principle in this case, as with
Robespierre, *la liberté et la terreur*.' Islam had now become, by another
inversion, the reflected image of the French Enlightenment, 'an abstract
thought which sustains a negative position towards the established order of
things'.[8] Finally, in the twentieth century, there was another wave of
revolution and Wittfogel wrote his post-Marxist polemic, *Oriental Despotism*,
against Stalin. Hitler too had his moment. 'Incarnated in the person of the
leader (in Germany the properly religious term, prophet, has sometimes been
used) the nation thus plays the same role that Allah, incarnated in the person
of Mahomet or the Caliph, plays for Islam.' Thus wrote Georges Bataille, in
his 1933 essay entitled 'The Psychological Structure of Fascism'.[9]

As, in their different ways, Edward Said (in *Orientalism*) and Perry Anderson
(in *Lineages of the Absolutist State*) have both shown, the Orient is the site of
scientific and political fantasy, displaced from the body politic of the West, a
field of free play for shamelessly paranoid constructions, dreamlike elabo-
rations of a succession of Western traumas.[10] In the nineteenth century, the

Orient became more and more the site for erotic as well as political projection. Not pure fear, but fearful desire was now projected onto the screen. (Presumably this was due to the steady political subjugation of North Africa and the Middle East during this period, from the Napoleonic campaign in Egypt onwards.) It was at this time that *The Thousand and One Nights* began to exercise its peculiar sway over the Western imagination, a secular, licentious narrative, with almost no trace of moralism (or even Islam), but full of tales of deviant, transgressive and bizarre sexuality.

Key figures in this transition were Flaubert and Gérome, a writer and a painter, building on the earlier example of Byron and Delacroix. Linda Nochlin describes the 'insistent, sexually charged' atmosphere that pervades Orientalist painting, in her article, 'The Imaginary Orient'.[11] She brings out the ways in which erotic fantasy combined with the scenography of despotism to produce a perverse and sadistic visual theatre, which can suggest 'the connection between sexual possession and murder as an assertion of absolute enjoyment.' We should remember how Flaubert, after possessing the *almay* Kuchuk Khanem, during his travels in Egypt, cast himself as the despot in a scenario of the East's revenge:

> I gave myself over to intense reverie, full of reminiscences. Feeling of her stomach against my buttocks. Her mound, warmer than her stomach, heated me like a hot iron. Another time I dozed off with my fingers passed through her necklace, as though to hold her should she awake. I thought of Judith and Holofernes sleeping together.[12]

2. Schéhérazade

The scenography of *Schéhérazade* derived directly from the eroticized and sado-masochistic vision of the imaginary Orient. But the scenario was both more complex and more vivid. Only two years later, in 1912–13, Freud was to write *Totem and Taboo*, the definitive version of the fantasy of the all-powerful male with monopolistic control of all the women. Freud's fantasy, presented as a myth of origins, was structured round the twin poles of terror (castration, absence of Law, slavery) and desire (immediate gratification contrasted with utter frustration for the males, total availability and subjugation for the females). In *Schéhérazade*, the Shah (the phallus) stands at the apex. To one side are the janissaries (castrators) and to the other the eunuchs (castrated). Beneath are the women (desiring) and finally the slaves (desired, but

forbidden to acknowledge desire, under threat of castration, because the phallus must appear to be the monopoly of the Shah).

The dominant fantasy (in both *Totem and Taboo* and *Schéhérazade*) is of a 'family' (whether presented as a household, a horde of kin, or a seraglio) outside or prior to the Oedipal Law (the Symbolic order). This fantasy is then projected onto the state, *le grand sérail*, combining the myth of Oriental despotism with that of an untrammelled primal patriarchy, combining a political with a sexual monopoly of power. The main difference between Freud's fantasy and Diaghilev's lies in the role allotted to the women's desire. In the ballet, it is the woman who is desiring, the slave who is desired. This is in line both with the introduction to *The Thousand and One Nights*, the main source of the story, and the decadent image of the *femme fatale*, both of which stress the libidinal power of woman, once her desire is released. In *Totem and Taboo* it is the polygamous patriarch who is killed, thus instituting Law, social organization and the monogamous family, while in *Schéhérazade* it is the women and the slaves, subjects and objects of desire, who die, thus upholding the regal phallus at the cost of eliminating desire and reducing society itself to an all-male dialectic of castrators and castrated.

As Alain Grosrichard has shown in his brilliant study *Structure du Sérail*, the concept of despotism originates in the idea of a confusion of domestic patriarchal authority with state political power.[13] In a despotism the citizens have no more rights than the women and slaves in a patriarchal household. Thus, the image of the seraglio is crucial to the scenography of the Orient precisely because it conflates state and household. The patriarch and the Shah merge into one, the despot. (Since there is no Law, and hence no legitimacy, the structure of the family allows no significance to any of the children.) At the same time, the despot (male) is singular and the women (the harem, the multitude of wives) are plural.[14]

There is a strangely similar fantasy of the male as the singular and the female as plural in Poiret's work. For the 1925 Exhibition of Decorative Arts he placed three elaborate show barges on the Seine, one for fashions, one for interior design and perfume, whilst the third was a floating restaurant. They were named *Amours, Délices* and *Orgues*, the three words in the French language that are of masculine gender in the singular, but feminine in the plural. Thus Poiret translated the economy of fashion into that of the singular masculine phallus and Leporello's endless list of women's names, in the story of Don Juan. In *Schéhérazade* the plural desire of the women proves intolerable to the

patriarchy: hence the Shah's departure on a hunting trip, his impotence and cruelty, his pitiless revenge and, then, his final solitude, lost in mourning and melancholia.

There are many ways in which *Schéhérazade* can be read allegorically. On one level, it is a contemporary drama: the husband absent at work, the desire of the wife, the eroticized servant (a premonition of *Lady Chatterley's Lover*). On another level, it could be seen as an orgiastic festival of the oppressed, the women and the slaves, followed by a bloody counter-revolution. In this reading, it recalls 1905 and anticipates 1917 in fantasy. On a third level, it could be seen in terms of the Russian Ballet itself, recalling the traditional role of the Imperial Ballet in St Petersburg as virtually a harem for the tsar and his family, as well as Diaghilev's own relationship with Nijinsky, as both patron and lover. As his friend and musical adviser Nouvel asked him: 'Why do you always make him play the slave? I hope you emancipate him one day.' All these levels are present in a complex imbrication of the sexual and the political, reflecting both a crisis in the state and a crisis in the family (the threat both of female desire and of homosexuality).

The whole action of *Schéhérazade* revolved around the decisive role of Zobeida, the queen. Ida Rubinstein was not a professional dancer, but an heiress determined to use her large personal fortune to become a star in her own right. She left Diaghilev's company after the success of *Schéhérazade* in order to finance and star in a series of 'mime dramas' in which she played St Sebastian, Salomé and La Pisanelle (smothered to death by flowers). Her new associates were the high priests of the Decadence, de Montesquieu and d'Annunzio. She was also an intimate of Romaine Brooks and a dominant figure in the lesbian milieu that ran from Brooks and Natalie Barney (the lover of Dr Mardrus's wife, Lucie Delarue) through to Gertrude Stein, the female counterpart to the male homosexual world that Diaghilev dominated.

Rubinstein had begun her career in St Petersburg, where she was first introduced to Fokine (by Bakst) because she wanted to have dance lessons in order that she could play the part of Salomé in her own production of Oscar Wilde's play. She was particularly anxious, Fokine recalled, to appear in the Dance of the Seven Veils. Fokine 'felt that it would be possible to do something unusual with her in the style of Botticelli', i.e. the graceful Botticelli who influenced Isadora Duncan as well as the 'satanic, irresistible, terrifying' Botticelli of the *fin de siècle* who inspired Beardsley's *Hermaphroditus*.[15] In the end, the production was banned because of rumours that

Rubinstein would appear naked after the last veil was removed, 'an unusual situation for a young girl belonging to a conventional and well-to-do family', as Benois noted.

The next year, 1909, Bakst and Fokine persuaded Diaghilev, after some opposition, to risk casting Rubinstein in the name part of *Cleopatra* (based on Pushkin's *Egyptian Nights*) to feature in his first Paris season. Bakst and Fokine then transposed the Dance of the Seven Veils to the new ballet, making the number of veils up to twelve. Rubinstein was carried in on the shoulders of six slaves, in a sarcophagus which, when opened, revealed her swathed from head to foot like a mummy. Cocteau described the scene: 'Each of the veils unwound itself in a fashion of its own; one demanded a host of subtle touches, another the deliberation required in peeling a walnut, the third the airy detachment of the petals of a rose, and the eleventh, most difficult of all, came away in one piece like the bark of the eucalyptus tree.' Rubinstein removed the last veil herself and stood 'bent forward with something of the movement of an ibis's wings'.[16] Cecil Beaton described her memorable appearance:

> An incredibly tall, thin woman, the proverbial 'bag of bones', Ida Rubinstein's slender height allowed her to wear the most outlandishly remarkable dresses, often with three-tiered skirts that would cut up almost any other figure. In private life she was as spectacular as on the stage, stopping the traffic in Piccadilly or the Place Vendôme when she appeared like an amazon, wearing long, pointed shoes, a train, and very high feathers on her head, feathers that could only augment an already giant frame.[17]

She was dressed by both Bakst and Poiret (the three-tiered skirt, a headdress shaped like a lyre). Rubinstein made herself an object of fascination, a trap for the gaze, both on and off the stage. With kohl round her eyes, her hair 'like a nest of black serpents', she reminded Beaton of Medusa. Fokine commented on the importance of Nijinsky's 'lack of masculinity' for the success of *Schéhérazade*, in contrast to the 'majesty' and 'beautifully elongated lines' of Rubinstein. 'Next to the very tall Rubinstein, I felt that he would have looked ridiculous had he acted in a masculine manner.' This sexual inversion was crucial to the overwhelming effect of the ballet. At the same time, Fokine felt the most dramatic scene was that of Zobeida's 'utter stillness' during the massacre. 'She majestically awaits her fate – in a pose without motion.' Here, 'majestically' qualifies the same 'dandyish coolness in the face of extreme sensual provocation' that Sardanapalus showed in the great painting by Delacroix that Fokine much admired. Both petrifying and petrified,

castrating and castrated, Rubinstein incarnated the phallic woman of the Decadence, surrounded by energy, colour and 'barbarism'.

The origins of the Russian Ballet were both in Russian culture (the native Orientalist tradition of Pushkin and Rimsky-Korsakov) and in French, especially in French symbolism. Already in St Petersburg those who belonged to the *World of Art* group around Diaghilev were reading the *Revue Blanche*, steeping themselves in Baudelaire, Huysmans and Verlaine. (These were forbidden pleasures: both *Les Fleurs du mal* and *À rebours* were banned in Russia.) 'Civilized' and 'Western' Petersburg was the centre for the clandestine import of the most up-to-date French culture. Benois always contrasted Petersburg with Moscow, the hated 'Eastern' rival, which stood for 'the dark elements' against the enlightenment and cosmopolitanism of St Petersburg. 'By nature we all belonged to Europe rather than to Russia.' Yet, by a strange reversal, the trend was turned around and, in the form of the Russian Ballet, Paris (cultural capital of Europe, the 'West') began to import Russia and the 'East', in a deluge of exaggerated Orientalism.

The East conquered. Beaton described how 'a fashion world that had been dominated by corsets, lace, feathers and pastel shades soon found itself in a city that overnight had become a seraglio of vivid colours, harem skirts, beads, fringes and voluptuousness'. Benois, as we might expect, reacted with mixed feelings to this triumph:

> The reader knows that I am a Westerner. . . . Yet, stifling deep in my heart my feeling of resentment at the forthcoming victory of the 'barbarians', I felt from the very first days of our work in Paris, that the Russian Savages, the Scythians, had brought to the 'World Capital', for judgement, the best of art that existed in the world.

The 'barbarians', of course, the 'Scythians', were forebodings of the revolutionaries who had risen up in 1905 and were eventually to triumph in October 1917, less than a decade later.

Diaghilev was able to bring to the Parisians a version of France's own absolutist past, combined with the memory of France's own revolutions. He came to France through a time lock, from a country in which absolutism was still the present and in which the forthcoming triumph of the Scythians could be anticipated in real terms. The scenography was not one simply of fear and desire, but also of displaced political nostalgia and political presentiment, displaced not only from France onto Russia, the 'pre-Orient', but also onto the

'Orient' itself, a doubly phantasmagoric East. Diaghilev's own politics were complex. He wanted to 'modernize' but, still in St Petersburg, was dependent on the imperial court for patronage. His stepmother, a Filosofov, came from a family with a radical political past, by whom Diaghilev was greatly influenced. His homosexuality, too, impelled him outward to the margins and across the limits of the official culture.

At the time of the 1905 revolution, a comprehensive exhibition of historical Russian portraits, organized by Diaghilev, was hanging in the Tauride Palace. Over 3,000 portraits were on display, dominated by those of the tsars and the great aristocracy. A banquet was given in Diaghilev's honour and he took the opportunity to make a speech which began as follows: 'There is no doubt that every tribute is a summing-up and every summing-up is an ending. . . . I think you will agree with me that thoughts of summing-up and ending come to one's mind more and more these days.' Diaghilev described the era of absolutism that was ending in terms of aesthetic regret, of nostalgia for its theatrical brilliance, for an enchantment like that of Oriental legends, now diminished to old wives' tales in which 'we could no longer believe'. 'The end of a period is revealed here, in those gloomy dark palaces, frightening in their dead splendour, and inhabited today by charming mediocre people who could no longer stand the strain of bygone parades. Here are ending their lives not only people, but pages of history.' He concluded as follows:

> We are witnesses of the greatest moment of summing-up in history, in the name of a new and unknown culture, which will be created by us, and which will also sweep us away. That is why, without fear or misgiving, I raise my glass to the ruined walls of the beautiful palaces, as well as to the new commandments of a new aesthetic. The only wish that I, as an incorrigible sensualist, can express, is that the forthcoming struggle should not damage the amenities of life, and that the death should be as beautiful and illuminating as the resurrection.[18]

Thus with dandyish disdain, decadent fervour and committed hedonism, Diaghilev summed up his position in the revolutionary crisis to grip Russia. The politics of the Decadence, like those of modernism in general, were often ambivalent and undecided between a left and a right wing. Diaghilev, by seeing himself positioned at a pivotal moment in history, was able to look both ways and to accommodate both trends.

3. 'My Revelation Came From the Orient.'

The true political significance of the Decadence lies, of course, in its sexual politics, in its refusal of the 'natural', in its re-textualization of the body in terms that had previously been considered perverse. It runs parallel to the work of Freud, whose discourse was that of science rather than art.[19] In this respect, the Russian Ballet goes much further than Matisse, even though we can find points of comparison in their Orientalism. No doubt Matisse owed a debt to the Decadence (he was, after all, a pupil of Gustave Moreau) but, although he broke away from descriptive painting and employed a personal vocabulary of pictorial signs, he took care to retain a traditional respect for beauty, harmony and composition. It is in his enthusiasm for bold colour that he was closest to Bakst.

Matisse had mixed feelings about *Schéhérazade*.

> The Russian Ballet, especially Bakst's *Schéhérazade*, overflowed with colour. Profusion without moderation. You could say it was slung on by the tubful. . . . It's not quantity that counts, but choice and organization. The only advantage that came out of it was that from then on colour had universal freedom, even in the department stores.

For Matisse, who also said, 'My revelation came from the Orient', Bakst was both an ultra and a vulgarizer. The lessons Matisse learnt from the Orient came in the use of flat areas of bright and saturated hues to produce forms of decorative pattern and spatial organization with little precedent in the West, and in the use of an ornamental, arabesque line in drawing. This involved a reversal of the traditional relationship of precedence between colour and design, so that Matisse could speak about drawing as 'painting made with reduced means' (Matisse believed strongly that 'black is a colour').[20]

His first significant encounter with Oriental art was at an exhibition at the Pavillon de Marsan in Paris in 1906, but the turning-point came with his visit to Munich to see the great exhibition of Islamic art held there in 1910, a trip also made by Roger Fry. Matisse visited Morocco in 1906, but after the Munich show he went south year after year, first to Andalusia and then twice more to Morocco.

> I found the landscapes of Morocco just as they had been described in the paintings of Delacroix and in Pierre Loti's novels. One morning in Tangiers I was riding in a meadow; the flowers came up to the horse's muzzle. I wondered

where I had already had a similar experience – it was reading one of Pierre Loti's descriptions in his book *Au Maroc*.

It was a contact with nature both *déjà vu* and *déjà lu*.

These crucial Orientalizing years fixed Matisse as an artist. In 1950 he could still produce a cutout piece entitled *The Thousand and One Nights*, with Schéhérazade's words, 'At this point I saw the approach of morning and discreetly fell silent.' In between came, of course, an endless series of odalisques. After the great early works – *The Blue Nude (Memories of Biskra)*, *The Red Studio*, *The Moroccans* – he had little more to do than exploit the lessons he had learnt. In contrast to nineteenth-century Orientalists like Tissot or Gérome, he painted Oriental signifieds with Oriental signifiers, in a style adapted from Islamic art as seen through Western eyes; this pushed him beyond Gauguin or Cézanne. Matisse distrusted the excess, the prodigality, the 'profusion without moderation' of Bakst and the Russian Ballet. He wanted to reduce the figure of the capricious and fanatical sultan (which Poiret and Diaghilev played in their private lives as well as in their scenography of the Orient) to that of the bourgeois patriarch in his armchair. The importance of Matisse lies in the way that he found an expression in easel painting of the same excitement and shock that galvanized the decorative arts.

In 1927 the *New Yorker* magazine profiled Paul Poiret, now a legendary figure, looking back over his career as it approached its end:

> Poiret was one of the Continentals who has helped to change the modern retina. Working closer to the hearth than Bakst or Matisse, the other two great colourists, he reintroduced the full spectrum into the life of the twentieth century. . . . More than Bakst or Matisse, restricted to canvas and coulisse, Poiret, as dominant decorator and dressmaker, has been able to make his ideas popularly felt.

These three – Paul Poiret, Leon Bakst, Henri Matisse – had more in common, and more significant things, than colour, important though that was. In the pivotal years just before the First World War, each of them created a scenography of the Orient that enabled him to redefine the image of the body, especially, but not exclusively, the female body.

All three of them were decorative artists. 'Decoration', Clement Greenberg said, 'is the spectre that haunts modernist painting.'[21] The first wave of historic modernism developed an aesthetic of the engineer, obsessed by machine forms and directed against the lure of the ornamental and the

superfluous. To use Veblen's terms, an art of the leisure class, dedicated to conspicuous waste and display, gave way to an art of the engineer, precise, workmanlike and production-oriented. This trend, which grew alongside and out of an interpretation of cubism, culminated in a wave that swept across Europe: Soviet constructivism, the Bauhaus, De Stijl, purism, Esprit Nouveau. All of these were variants of an underlying functionalism which saw artistic form as analogous to (or even identical with) machine form, governed by the same functional rationality.

'The evolution of culture is synonymous with the removal of ornament from utilitarian objects.' Adolf Loos's battle cry, first heard in Vienna in 1908, rang down the decades.[22] For Loos ornament was a sign of degeneracy and atavism, even criminality. It was like tattooing or sexual graffiti. It had no place in the new twentieth century. In fact, Loos's famous broadside echoed and repeated a series of articles he had written for the *Neue Freie Press* ten years earlier. One of these especially, on 'Ladies' Fashion', reads like the first draft of his later 'Ornament and Crime.'[23]

According to Loos, women dressed to be sexually attractive, not naturally but perversely. The fashion leader was the coquette, most successful in arousing desire. Men, on the other hand, had renounced gold, velvet and silk. The best-dressed wore unostentatious English suits, made from the best materials and with the finest cut. Their bodies moved freely whereas women's dress impeded physical activity. Loos welcomed cycling clothes for women and looked forward to the day when 'velvet and silk, flowers and ribbons, feathers and paint will fail to have their effect. They will disappear.' Writing a year later, Thorstein Veblen, in his *The Theory of the Leisure Class*, made much the same points.[24] Women's dress demonstrated 'the wearer's abstinence from productive employment.' High heels, long skirts, drapery and, above all, corsets 'hamper the wearer at every turn and incapacitate her for all useful exertion'.

Both Loos and Veblen applauded what fashion historians call the Great Masculine Renunciation, the abandonment of sartorial display in men's clothing around the beginning of the nineteenth century.[25] In effect, Loos's career was devoted to generalizing the Great Masculine Renunciation by driving ornament not only out of clothing but out of all the applied arts, architecture and, by extension, painting itself. Indeed, many of his first architectural projects were for Viennese menswear stores. He had his tailor design him a special uniform when he was called up during the First World

War, with a loose rather than a stiff collar and calf leggings rather than heavy boots. (He was nearly court-martialled.) The project of modernism was linked inextricably in his mind with that of dress reform.

Nor was Loos alone. In the Soviet Union, the great constructivist Vladimir Tatlin turned to designing functional clothes for men. Walter Gropius, the director of the Bauhaus, argued that the modern home should follow the same principles as modern tailoring. The De Stijl architect Oud explained that menswear and sports clothes possessed within themselves, 'as the purest expressions of their time, the elements of a new language of aesthetic form'. Modernists applauded the uniformity, the simplification of men's clothing, its lack of ornament and decoration, its adaptation to productive labour. The Great Masculine Renunciation was seen as exemplary.

The second wave of modernism, in the United States after the Second World War, abandoned the machine aesthetic. The hard-edged geometric abstraction of the American abstract artists, heirs of De Stijl, was pushed aside. But the art that succeeded it and triumphed internationally, after Jackson Pollock's startling breakthrough, soon settled down into an equally simplified and reductive aesthetic. Indeed, Mies van der Rohe's motto, 'Less is more', could perfectly well serve for the American 'colour field' painters who came to prominence in the 1950s. Clement Greenberg, who emerged as their principal publicist and theorist, was resolutely reductive in his own approach. He demanded not only a renunciation of representational images (and even of the suggestion of images) but also an end to depth, framing, drawing and value contrast. Every feature of painting was to be tested for indispensability in the interest of a radical simplification, excluding and divesting until only the optically irreducible was left.

Despite his 'art for art's sake' stance, Clement Greenberg remained a functionalist, but one who saw the function of painting as intrinsic rather than extrinsic. Painting should serve the immanent laws of painting itself. It had its own quasi-scientific laws and provided its own purpose. The Kantian idea of 'purposiveness without purpose' was adapted into a programmatic 'functionalism without function'. The sole function of a picture was to be quintessentially 'pictorial', to be nothing other than itself. This led to an even more compulsive stripping-down and renunciation than the machine aesthetic it replaced. More and more was judged to be superfluous and unnecessary, non-functional for painting as such.

At first, Greenberg leaned on Cézanne and Picasso to validate Jackson

Pollock's breakthrough, but later, when colour field painting appeared, he began to turn to Monet and Matisse to provide a subsidiary alternative tradition. As a result he was forced to face the problem of the 'decorative' head on. He concluded that decoration could be avoided only by merging the optical image into the material support of a painting. Thus, in an article on 'Picasso at Seventy-five', Greenberg took Picasso to task for applying cubism as a style to canvases which remained 'mere' objects. 'Applied cubism, cubism as finish, acts to convert the picture into a decorated object.'[26] This 'cubist' canvas is Loos's ornamented object in a new guise – the guise of an apparently non-utilitarian object whose true function is to transcend itself and become a picture by sealing its decoration into itself. No longer should 'mere' decoration be applied to 'mere' canvas, but a painting should be the fused and transcendent unity of the two. Thus decorativeness could be justified in the name of higher values, to demonstrate – as he wrote of Matisse – 'how the flesh too is capable of virtue and purity'.

Matisse himself, however, was completely unashamed of being thought decorative. He saw nothing to justify or transcend. 'The decorative for a work of art is an extremely precious thing. It is an essential quality. It does not detract to say that the paintings of an artist are decorative.' In fact, it almost always is taken to detract, certainly from the viewpoint of modernism. At best, the decorative is seen as a means in the service of higher values. Greenberg's antinomy between the 'pictorial' and the 'decorative', like that between the 'functional' and the 'ornamental', is basic to the dominant modernist aesthetic. It is one of a series of similar antinomies which can be mapped onto each other in a series of analogies: engineer/leisure class, reality principle/pleasure principle, production/consumption, active/passive, masculine/feminine, machine/body, west/east . . . Of course, these pairs are not exactly homologous, but they form a cascade of oppositions, each of which suggests another, step by step.

4. The Male Ascetic versus the Grande Cocotte

Endings rewrite beginnings. Every new turning point in the history of art brings with it a retrospective process of reappraisal and redramatization, with new protagonists, new sequences, new portents. We discover possible pasts at the same time as we feel the opening up of possible futures. Now that we are coming to the end of the modernist period – in the visual arts, at least – we

need to go back to those heroic years at the beginning of the twentieth century when the story first began to take shape.

Modernism wrote its own art history and its own art theory, from its own point of view. It identified its own mythic moment of origin principally with cubism and Picasso (thus sidelining fauvism and Matisse). Along with this, Picasso's own career was given a particular interpretation, highlighting some aspects of his work and relegating others. This process of purification began very early. Cocteau has recalled how, when he asked Picasso to work with Diaghilev in 1917:

> Montparnasse and Montmartre were under a dictatorship. We were going through the puritanical phase of cubism. . . . It was treason to paint a stage setting, especially for the Russian Ballet. Even Renan's heckling off-stage could not have scandalized the Sorbonne more than Picasso upset the Rotonde by accepting my invitation.[27]

Modernism saw a teleology in the convergence of cubism with industrial techniques and materials and its development towards abstract art. The true situation, as we have seen, was much more complex. In the years immediately after 1910, Poiret, Bakst and Matisse were much more widely known than Picasso or the cubists. Their impact was much greater. Poiret was the most successful designer of the time, the unchallenged leader of innovative fashion. The Russian Ballet swept all before it in Paris and wherever it appeared. Matisse built steadily on the scandal of the Fauves, consolidating his own reputation with a series of startling new works. They represent a pivotal moment in the emergence of modernism, later to be disavowed. Only now, perhaps, as modernism declines, can we see their significance again. They were pivotal and Janus-faced, looking back towards the nineteenth century in which they were formed, while subverting and eventually destroying its underlying presumptions. Matisse had an academic training: he was taught by Bougereau, drawing from plaster casts, then at the Académie Julien, drawing from live models, then by Gustave Moreau, copying for years in the Louvre: Raphael, Caracci, Poussin, Ruysdael, Chardin. The roots of the Russian Ballet were in imperial St Petersburg, where ballet was an official art, directly administered by the court, under the patronage of the tsar. Poiret learned his art in the Belle Epoque and his clientele was always drawn from the aristocracy and high society. Poiret and Matisse were the last Orientalists (in art) and the first modernists. They broke with the official art by which they

were formed, but without embracing functionalism or rejecting the body and the decorative.

As Perry Anderson has argued, modernism emerged 'as a cultural field of force triangulated by three decisive co-ordinates': first, the official art of regimes still massively pervaded, and often frankly dominated, by dynastic courts and the old aristocratic or landowning classes (even west of the Elbe); second, the incipient impact of the new technologies of the second industrial revolution; and, third, the 'hope or apprehension' of social revolution.[28] Anderson's schema is indebted to Arno Mayer's *The Persistence of the Old Regime*, where the same case is argued more fiercely and with a mass of documentary detail. In effect, Mayer claims that the completion of the 'bourgeois revolution' was delayed until after the Second World War. Modernism developed alongside this long-postponed transfer of power. Its first stirrings took place at a time when the outlook was still far from clear and the lines of fissure were often tantalizingly displaced.

It seemed certain that the *anciens régimes* must give way, their dynastic rearguard action must end, but it was not clear what was going to replace them. Peering into the future, Adolf Loos and Thorstein Veblen gave one exemplary prognosis for modernism: utility will supplant ornament, the engineer will supplant the leisure class, production will supplant consumption. Decoded, this meant the bourgeoisie will finally supplant the aristocracy, both culturally and politically as well as economically. But the exact role of the bourgeoisie and the cultural implication of the new technologies were still an open question. During the period immediately before the First World War there was a vigorous debate about the likely effects of the new phase of capitalism on the cultural and political superstructure, exemplified most strikingly in the conflicting theories put forward by Max Weber and Werner Sombart.[29]

Weber's views are now well known. He argued in *The Protestant Ethic and the Spirit of Capitalism* that this spirit derived from the asceticism of the Puritans: originally a calling, now a compulsion. This asceticism 'acted powerfully against the spontaneous enjoyment of possessions; it restricted consumption, especially of luxuries'. Puritanism repudiated luxury and eroticism as 'temptations of the flesh', it esteemed thrift and labour discipline, it encouraged a rationalist and utilitarian outlook. A 'sober simplicity' was preferred to 'glitter and ostentation'. In the end, for Weber, the spirit of

capitalism had developed out of an ascetic Protestantism into its current mode of 'pure utilitarianism'.

Sombart's view was diametrically opposed to Weber's. In his 'loose and extravagant' *Luxury and Capitalism*, published in 1913, he took Weber to task without ever mentioning him by name. He argued that expenditure and luxury were the real mainsprings of capitalist development. The great centres of luxury were the court and the city, which pulled the whole economy into their orbits. Above all, luxury was the province of women. For Sombart, sex was the motor of capitalism, in so far as all pleasurable consumption is a form of eroticism. He argued:

> All personal luxury springs from purely sensuous pleasure. Anything that charms the eye, the ear, the nose, the palate, or the touch, tends to find an ever more perfect expression in objects of daily use. And it is precisely the outlay for such objects that constitutes luxury. In the last analysis, it is our sexual life that lies at the root of the desire to refine and multiply the means of stimulating our senses, for sensuous pleasure and erotic pleasure are essentially the same. Indubitably the primary cause of the development of any kind of luxury is most often to be sought in consciously or unconsciously operative sex impulses. For this reason we find luxury in the ascendant wherever wealth begins to accumulate and the sexuality of a nation is freely expressed. On the other hand, wherever sex is denied expression, wealth begins to be hoarded instead of spent.

Perhaps on one level Weber and Sombart had much in common. They were both romantic anti-capitalists who came from the same intellectual circle in Heidelberg. Both saw capitalism as materialist, a falling-away from the romantic, male ideal. Weber saw this in terms of mechanization, the Puritan metamorphosed into the machine, and Sombart in terms of feminization, sensual gratification, leading in the end to debauchery and perversion. But their visions of the essential capitalist spirit were totally at odds, the male ascetic versus the *grande cocotte*. Sombart depicted the court mistress, the courtesan and the actress as the key figures in the development of luxury, who set the pace for other women, until luxury was domesticated in the home: 'rich dresses, comfortable houses, precious jewels'. Again we find the contrast between a production and a consumption model of capitalism mapped onto the gender distinction between masculine and feminine. Each reflects a different theory of the economic dynamic underlying modernism, these two theories corresponding to the two rival aesthetic models we have been surveying.

Sombart both praised and criticized Veblen. 'If luxury is to become personal, materialistic luxury, it must be predicated on an awakened sensuousness and, above all, on a mode of life which has been influenced decisively by eroticism.' Veblen denied both the eroticism involved and the contribution of demand to economic growth. But Sombart, like Veblen, stresses the importance of fashion as a social phenomenon. Though he does not deal directly with the Great Masculine Renunciation we can imagine that he would have seen it as part of the 'counter-tendency' of 'middle-class respectability' derived from the sermons of the Puritans, whose ascendant influence he felt, but which he dismissed as a temporary diversion. Perhaps, but it had not yet reached its zenith.

The female body of 1900 was encased and upholstered. As Veblen said, it had been made into a fetish, into an object of display for the male: his 'chief ornament' as Veblen put it. The female body was the object of masculine 'parade', in Lacan's language of sexual display, rather than the subject of feminine masquerade. Flugel explained this as a reaction formation against the repression of exhibitionism implied by the Great Masculine Renunciation. Male exhibitionism was displaced and projected onto the body of the woman, in what Flugel saw as a kind of vicarious transvestism. (The other reaction formations at work, according to Flugel, were the sublimation of male exhibitionism into performance and work, and its reversal into scopophilia.) To fulfil this function of parade, vicarious male display, the female body itself had to be suppressed. It had to be both concealed and constricted. Jean Cocteau described fashionable women of the Belle Epoque as *'raide'*: taut, stiff, tight. The dominant image of woman was disciplined, phallic, retentive.[30]

This body eventually gave way to the 'modernist body': as Lazenby Liberty put it, in the clothes reform journal *Aglaia*, a body that was 'healthy, intelligible and progressive'.[31] The female form was unconfined, regulated and stripped down. Once the Belle Epoque look had been overthrown and women had been liberated from the corset, by Poiret and others, it soon gave way to the new look we associate with Coco Chanel and Patou, a transformation completed by the mid-1920s. Ornament and artifice were discarded in order to produce a more natural and functional figure, a more 'managed' and 'nuanced' image of sexual difference and focus of sexual display and desire. This involved adopting a set of new disciplines, internal rather than external: exercise, sports and diet, rather than the corset and the stays. In reality, the

'modern' body, however healthy and hygienic, however 'natural', simply brought with it new forms of body sculpture. Fitness and slimming mania replaced tight-lacing as forms of extreme artifice.

Colette, in 1925, described the new image as 'short, flat, geometrical and quadrangular . . . the outline of the parallelogram'. The same year Patou contextualized his own designs in explicitly functionalist terms: 'Each element contributes to the formation of a very homogeneous whole. We are not really at ease and we do not feel completely at home except in the midst of modern machinery. This latter has been perfected to the point of attaining real beauty in which the style of the epoch asserts itself.' Or, echoing the Bauhaus, 'May our furniture, our clothing, the machinery we use, be quite of the same family.'[32] Patou used cubist motifs and, though he never went as far as the Russian constructivists, the impulse is the same. As we might expect, alongside the cults of the sun and sports, the body functioning like an efficient, smoothly running machine, we find the cult of the machine itself as an object of beauty as well as and, indeed, because of its utility and fitness for purpose.[33]

Angles and lines, as Cocteau put it, were hidden away beneath the ample skirts of the nineteenth century, until one day 'Negro art, sport, Picasso and Chanel swept away the mists of muslin and compelled the once-triumphant Parisienne either to find her place back at the hearth or to dress to the rhythm of the stronger sex.' Cocteau saw the 1920s as a period of masculinization after the 'feminine' epoch that preceded it. It would be more accurate to say that the Great Masculine Renunciation spread from male to female costume, as well as across the whole range of the arts: architecture, painting, design. Utility, function, fitness and the machine superseded ornament, luxury and erotic display.

5. 'Burn It, I Say, Burn All of It!'

Cocteau's strategy for the epoch after the Great War of 1914–18 was to yoke modernism to neoclassicism. The roots of his policy lay in the war period, when France, land of Descartes and the Enlightenment, attributed to itself the virtues of classical reason, as opposed to the wave of supposed unreason and irrationalist *Kultur* represented by Germany. Reason, too, rather than standing simply for French and Latin civilization, could be presented as the supreme value of Europe itself. France could then be positioned as the

standard-bearer of the West, mortally threatened by a barbaric Germany to the east. Under the stress of war, it followed, France must give up its decadence and frivolity and return to the manly and classical values of order, discipline and reason. Reason, in fact, became the watchword of a chauvinistic reaction, feeding on the war, but determined to roll back the avant-garde advances of the pre-war years. Already in November 1914, Cocteau was calling prudently for accommodation and for restraint ('The tact of understanding how far to go too far')[34] and gradually a tactic evolved of reinterpreting cubism, not as an iconoclastic assault on age-old values, but as a return to reason, an imposition of a new geometrical order, rooted in the spirit of ancient Greece.

In August 1915, a year after the beginning of the war, the political and cultural journal *La Renaissance* carried an *ad hominem* attack on Paul Poiret, based on its reading of a cartoon in the German comic paper *Simplicissimus*, which featured a German housewife being assured by her soldier husband that she would soon get a new Poiret dress. Poiret dresses, *ergo*, were desirable to Germans; they suited German women. 'What does M. Poiret think of that? Is it perhaps that, despite himself, he had *boche* taste so that the Germans recognized him then as one of theirs? After the war, M. Poiret will have to be pardoned by the French; he will most certainly need it.' In October, the same magazine returned to the attack, denouncing the Maison Martine, Poiret's design workshop, in particular, and calling for its disgusting designs, its 'German garbage' to be thrown on the fire: 'Burn it, I say, burn all of it!' The disgusting colours – 'blacks, greens, reds, yellows' – were singled out for abuse.[35]

Essentially, as Kenneth Silver has pointed out, the attacks on Poiret conflated the overt accusation of Germanism, of 'Munich taste', with the covert, but well-understood, charge of Orientalism. The two were simply lumped together in the public mind. For instance, a friend wrote to the painter and *art déco* designer André Mare in 1917 that 'Morocco is beautiful despite the orientalists, beautiful in itself, beautiful for the Moroccans, beautiful for Moroccan decoration. I am well aware that people would find the interiors here *munichois* in the sense you know.'[36] The right-wing writer Léon Daudet similarly denounced German Orientalism as a 'screeching modernism' which produced 'discordant monsters'. He went on to link it with 'the aspirations of German imperialism, her sights trained toward Baghdad and elsewhere. The stamp that was put on these theatrical *turqueries* held a political

meaning.' Diaghilev too was tarred with the same brush – *Schéhérazade*, after all, was the prime example of the Oriental, the exotic, the fantastic – and even Matisse, according to Silver, prudently toned down the Orientalism of his palette and his design.[37]

Poiret took out an action against his traducers and the case was finally settled out of court. Poiret's career, however, never fully recovered. Many concerned artists rallied to his defence, attesting to his patriotism and the 'Parisian' quality of his fantasy. Jacques-Emile Blanche, the friend of Misia Sert, distinguished carefully in his defence of Poiret between the 'Germanic' and the 'Oriental', attributing both Poiret's and Diaghilev's 'beneficial influence' to the 'Russian genius' of the ballets. Russia, of course, was an ally of France. Yet conspicuously absent from the ranks of Poiret's staunch defenders was Jean Cocteau. His comments referred simply to an 'age of misunderstanding' and concluded, 'There's nothing to do, alas! we must wait.' He was himself vulnerable and soon to be badly burned by the scandal over *Parade*, the ballet he masterminded with Picasso and Satie for Diaghilev, and which was hooted off the stage with shouts of '*boche*', '*munichois*', etc., as an example of the very decadence Cocteau was seeking to avoid.

Even though he acted with what he imagined would be the requisite degree of tact, Cocteau miscalculated badly. He had aimed to bring Picasso and the cubist avant-garde together with Diaghilev and the Russian Ballet in an attempt to create a united front, whereby Picasso's Left Bank bohemianism would be elevated by Diaghilev's Right Bank social success and Diaghilev's exoticism would be disciplined by cubist geometry and rigour. In fact, *Parade* proved much too extreme for its wartime audience. Instead of being the light-hearted entertainment Cocteau had intended, with its carefully chosen references to the profoundly Latin *commedia dell'arte*, it struck its audience as a frivolous vaudeville. The Americanism that Cocteau already fostered was not yet admissible as a suitable alternative to Orientalism. Cocteau learned his lesson well. After the war, he shifted further towards an explicit neoclassicism, in which avant-garde and Americanist elements were presented in the less intimidating register of what Lynn Garafola has called 'life-style modernism'.[38] In terms of fashion and décor, Coco Chanel replaced Pablo Picasso (let alone Léon Bakst) as Cocteau's designer of choice.

In 1929 Diaghilev died in Venice and Poiret closed his fashion house. In the same year Elsa Schiaparelli showed her first major collection and ended the ascendancy that Chanel had enjoyed for a decade. Schiaparelli had been first

inspired by Poiret and, in 1934, at the height of her success, was described by *Harper's Bazaar* as 'the feminine Paul Poiret'. But although there was a clear Orientalist influence at times, Schiaparelli's most striking inspiration was drawn from surrealism. In the twenties, she was a protégée of Gaby Picabia, through whom she met not only Francis Picabia and Paul Poiret, but also Marcel Duchamp, Tristan Tzara and Man Ray, all former dadaists. Her early connections with dadaism prepared her, in the thirties, for surrealism as a movement of painters as well as writers. She was especially indebted to Salvador Dali, who painted a scarlet lobster onto a white satin dress for her and inspired her famous hat in the shape of a shoe. In 1936 she designed a 'Desk Suit', with tiers of pockets embroidered to look like drawers, with buttons as knobs, based on Dali's drawings. Schiaparelli brought back fantasy and rich colours to fashion, summarized by her trademark 'shocking pink', which Dali used for the upholstery of his 'Mae West's lips' sofa. Schiaparelli reintroduced outrageous ornament and a concentration on witty and disproportionately prominent accessories, throwing restraint and good taste to the winds. Chanel's neoclassical simplicity and elegant functionalism were superseded in novelty by Schiaparelli's profuse and extravagant dream world.[39]

6. The Raw, the Cooked and the Rotten

Surrealism was the principal successor to Orientalism as the vehicle for a rejection of instrumental reason from within the avant-garde. Indeed, in its early years, there was a strong transitional Orientalist current at play within the Surrealist movement itself. In *La Révolution Surréaliste* (1925) Antonin Artaud appealed to the Orient for aid against the binarism of 'logical Europe' and Robert Desnos called on barbarians from the East to join him in revolt against the oppressive West. In April 1925, Louis Aragon summoned up the Orient again in his *Fragments of a Lecture given at Madrid at the Residencia des Estudiantes*:

> Western world, you are condemned to death. We are Europe's defeatists. . . .
> Let the Orient, your terror, answer our voice at last! We shall awaken
> everywhere the seeds of confusion and discomfort. We are the mind's agitators.
> All barricades are valid, all shackles to your happiness damned. Jews, leave your
> ghettos! Starve the people, so that they will at last know the taste of the bread of
> wrath! Rise, thousand-armed India, great legendary Brahma! It is your turn,

Egypt! And let the drug merchants fling themselves upon our terrified nations!
Let distant America's white buildings crumble among her ridiculous prohibi-
tions. Rise, O world!

Then, in June, the future anthropologist Michel Leiris provoked a riot by
bellowing out of a window into the street, 'Long live Germany! Bravo China!
Up the Riffs!'[40]

Not surprisingly, there was a brisk response to these excesses of Orienta-
lism, not only from the right but also from the left. In early 1926 the Marxist
writer Pierre Naville, with whose Clarté group the Surrealists had formed a
tactical alliance, launched a critique of their 'abusive use of the Orient myth',
arguing that the Surrealists must choose between an anarchic and individua-
list commitment to 'liberation of the mind' and a collective commitment to
revolutionary struggle in 'the world of facts' against the power of capital.
There was no real difference between East and West, Naville argued: 'Wages
are a material necessity by which three-quarters of the world's population are
bound, independent of the philosophical or moral preoccupations of the so-
called Orientals or Westerners. Under the lash of capital both are exploited.'
In September Breton replied, in one of his most powerful tracts, *Légitime
défense*.

Breton argued, as always, that it was necessary to struggle against both
material and moral oppression. Neither should be privileged. He warned
against reliance on Western technology: 'It is not by "mechanization" that the
Western peoples can be saved – the watchword "electrification" may be the
order of the day, but it is not thereby that they will escape the moral disease
from which they are dying.' To counter this 'disease' it was still quite
admissible to use certain 'shock terms', with both negative and positive
values, such as the battle cry of 'Orient', which 'must correspond to some
special anxiety of this period, to its most secret longing, to an unconscious
foreboding; it cannot recur with such insistence for no reason. Of itself it
constitutes an argument which is quite as good as any other, and today's
reactionaries know this very well, never missing an opportunity to make an
issue out of the Orient.' Breton went on to cite a series of examples of the anti-
Oriental rhetoric of the day, which linked the spell of the East, as we have
seen, to 'Germanism', and, more generally, to monstrosity, madness and
hysteria. 'Why, in these conditions, should we not continue to claim our
inspiration from the Orient, even from the "pseudo-Orient" to which

Surrealism grants no more than a moment of homage, as the eye hovers over the pearl?'[41]

In the end, of course, the moment passed and the idea of the Orient lost its subversive force. For the surrealists, it had served as a metaphor for a greater, stranger Elsewhere, rooted in the Freudian concept of the unconscious and the political possibility of an alternative to a technology-driven productivism. Breton's late Orientalism did not imply the mastery of an inchoate Other through the means of instrumental reason (let alone, political power) or even the projection onto the other of an idealized fantasy, diminishing its object. For Breton, the fact that reactionaries consistently warned against the danger of Oriental influence, as they warned against any threat to the stability of their own Western culture, simply meant that those who themselves wished to destabilize the dominant culture could and should make use of the myth of the Orient as they might any other potentially subversive force. This concept of the Orient was the rallying cry for those who wanted to create an alternative aesthetic, which stood apart from the binary opposition of Western modernism and social change versus Western academicism and the *ancien régime*. For Breton, it was one of a number of such terms, part of a subterranean lexicon, alongside the Gothic novel, philosophy in the bedroom, and the legacy of symbolist poetry, as well as the art of the self-taught and the insane.

The Orient shifted to the forefront precisely because it was the negative that threatened to cast doubt on modernism's evolving myth of its own origins, most obviously in the need to suppress the crucial role played by the Russian Ballet. Over and over, the adjectives used to describe the Russian Ballet are 'barbaric', 'frenzied', 'voluptuous'. What the critics really meant was that the ballet eroticized the body and flooded the stage with colour and movement. In the same way, the Fauves were called wild beasts and Poiret spoke of his innovations in colour as 'wolves thrown into the sheepfold': reds, oranges, violets, envisaged as savage beasts of prey, attacking the sheeplike lilacs, hortensias and mauves. Diaghilev, Poiret and Matisse were shamelessly eroticizing the female body at the same time that the arts were preparing to enter the de-eroticized world of the machine and non-figurative art. Diaghilev, of course, also eroticized the male body and struck back against the Great Masculine Renunciation in its heartland; witness Nijinsky in his brilliant colours, his brassiere, his body make-up and his jewels.

The Russian Ballet was both 'ultra-natural' (wild, untamed, passionate, chaotic, animal) and 'ultra-artificial' (fantastic, androgynous, bejewelled,

decorative, decadent). It was represented as both barbaric and civilized, both wild and refined, both loose and disciplined. Thus *Vogue* in 1913:

> The barbarism of these Russian dancers is young with the youth of the world . . . but the technique of their art is trained and civilized. Here, as in the case of Russian music, we observe a huge and lawless impulse reined and harnessed by a sense of law. The message of this art may be semi-Asiatic; the method is more than semi-European. The material may be barbaric; the craftsmanship, if anything, is super-civilized.[42]

For the *ancien régime* the spectacle was too disordered, too lawless, too sensuous, it released too many of the longings concealed within the fetish. It was too natural, in the sense of 'animal passions', or of undisguised libidinal drives. For modernism, on the other hand, it was too artificial, too decorative, too mannered (i.e. too textualized), too extravagant.[43]

Extravagance, waste, excess: this is the politico-erotic domain that Georges Bataille made his own.[44] Bataille posited that every 'restricted economy' based on production, utility and exchange is shadowed by a 'general economy', in which an excess or surplus is freely spent or wasted, with no presumption of return. This is the domain of the sacred and erotic, in whose economy 'human sacrifice, the construction of a church, or the gift of a jewel, bear no less significance than the sale of wheat'. Bataille drew on the Northwest Coast Native American custom of potlatch, the wilful expenditure of the surplus by a chief rather than its use for exchange or productive investment, to construct a model of a 'general economy' that could be contrasted with the 'restricted economy' of contemporary capitalism.

'The hatred of expenditure is the *raison d'être* of and the justification for the bourgeoisie; it is at the same time the principle of its horrifying hypocrisy.' Thus Bataille turned Veblen on his head. As Allan Stoekl points out, '"Conspicuous consumption", for Bataille, is not a pernicious remnant of feudalism that must be replaced by total utility.' Instead, it is a perversion of the impulse to spend, to waste and ultimately to destroy.[45] It is this transgressive negativity that Bataille celebrated, rather than the dialectical negativity of Hegel and Marx. Revolution, for Bataille, was a form of expenditure from below, a release of the masses from the restrictions of the exchange economy in an orgy of *dépense*.

Bataille mapped a passionate political economy onto the theory of anal eroticism. Shit is the physical form of expenditure and loss. Pleasure in

prodigality derives from 'joy in evacuation', to use Borneman's phrase, a pleasure that must be repressed if the obsessive traits required to foster thrift, labour discipline and accumulation are to be inscribed in the psyche.[46] Weber's ascetic bourgeois is just such a personality, withholding rather than expelling, regular rather than irregular, hygienic and precise rather than delinquent and profuse. In this perspective, the renunciation of ornament is not only a denial of exhibitionism, but also a trait of anal eroticism, an orderly cleaning-out of the superfluous and a parsimonious dislike of the excessive and unnecessary. For Bataille, in contrast, waste is a pleasure, escape from the discipline and regulation of the exchange economy. He defends jewels: 'Jewels, like excrement, are cursed matter than flows from a wound.' Jewels are both base matter, always to be preferred to high ideals, and brilliant waste.

Bataille combined a nostalgia for feudal excess and lavishness with an optimism about the revolutionary crowd.[47] As Michèle Richman remarks, in her book *Reading Georges Bataille*, 'In our own culture, adolescence manifests a *dépense* susceptible to psychoanalytic interpretation. Its "juvenile" prodigality, however, barely intuits the implications of the ecstasy of giving in "a certain orgiastic state".'[48] Yet through Bataille we can perhaps see a link between even the Russian Ballet and punk, the radical excess of the last years of the *ancien régime* and that of postmodern street culture, complete with its own scenography of bondage, aggressive display and decorative redistribution of bodily exposure.

Indeed, when the Russian Ballet came to London just before the First World War, the 'warlike group' of Slade students who startled London with 'a witches' sabbath of fauvism', the 'terrors of Soho', were enthusiasts for Bakst and Fokine, at least according to Ezra Pound, who wrote in his poem 'Les Millwin' how:

> The turbulent and undisciplined host of art students –
> The rigorous deputation from 'Slade' –
> Was before them.
>
> With arms exalted, with fore-arms
> Crossed in great futuristic Xs, the art students
> Exulted, they beheld the splendours of *Cleopatra*.[49]

The extravagance of the Russian Ballet was also, of course, a premonition of 'camp'. (Erté, it is worth recalling, worked as an assistant to Poiret during 1912–14, and was responsible for much of the 'Minaret look', including, for

instance, one of Poiret's most successful designs, 'Sorbet'. He saw many of the Diaghilev ballets, including the Paris *Schéhérazade*, and was fascinated by Rubinstein.[50]) In the 1960s there was a second revolt against the Great Masculine Renunciation, at the dusk rather than the dawn of modernism. There was another revival of the Orientalist vogue, with many of the same ambiguities. Warhol appeared as an appropriately low-key Diaghilev; Jagger played the same sort of role as a pastiche Nijinsky. In a new upsurge of hedonistic consumerism, as the old manufacturing, smokestack industries decayed, once more there appeared the fascination of androgyny, the return of the decorative and ornamental, and the insistence of female desire, celebrated or problematized.

I want neither to play the part of a new, disenchanted Veblen (like early Baudrillard, with his endless, sour yet complicit denunciations of commodity fetishism and spectacle[51]) nor to adopt the stance of a starry-eyed advocate of postmodernism, retracing the dissident surrealist gestures of Bataille. The revival of the decorative and the extravagant is symptomatic of the decline of modernism, but it is not an exemplary alternative or antidote. It was modernism's symptomatic shadow from the very beginning. The problem in the end, however, is how to find ways to disentangle and deconstruct the cascade of antinomies that constituted the identity of modernism and whose threads I have been following: functional/decorative, useful/wasteful, natural/artificial, machine/body, masculine/feminine, West/East. But deconstruction has always to begin from the side of the negative, the Other, the supplementary – the decorative, the wasteful, the hedonistic . . . the feminine, the Orient. (One might say, from the projection rather than the disavowal of desire.) The hybrid and contradictory nature of this 'other' art of our century both reflects the antinomies of modernism and, on occasion, fissures and splinters them. As well as the cooked and the raw, there is also the rotten.

In 1913 Paul Poiret went on a lecture tour of the United States. He appeared as a despot, he claimed, only because he could read the secret wishes of women who to themselves seemed slaves. He had antennae that allowed him to anticipate and read the 'secret intentions' of fashion itself. 'I do not speak to you as a master, but as a slave desirous of divining your secret thoughts.' Fashion, like the unconscious, 'does what it wants and no matter what. It has even, at every moment, a right of self-contradiction and of taking the opposite side to the decisions it has made the day before'.[52] In this dialectic of master and slave (not unlike that of analyst and analysand, as Lacan

has reminded us) the master is slave to the slave's desire, because he can read that desire through its symptomatic indications and is himself compelled by its 'astral influence'. At face value, Poiret's observation is simply a self-justifying way of assigning power to the consumer, rather than the producer, in a market economy. But, at a deeper level, it reminds us how a producer's perverse fascination with scenarios of the Orient can correspond, to a significant degree, to the desire of women to re-shape, or re-signify, their own bodies. In the last analysis, Poiret's scenography of the Hegelian dialectic can only be overcome when the slave is able both to read and to write the signs of her own desire.

Notes

1. Mardrus's translation is mentioned by Marcel Proust; the narrator's mother regrets giving it to her son. Cocteau was also influenced. In 1906 he brought out a short-lived poetry magazine called *Schéhérazade*, with a cover by Poiret's illustrator, Iribe, showing a naked sultana.
2. Claude Lepape and Thierry Defert, *The Art of Georges Lepape – From the Ballets Russes to Vogue* (London: Thames & Hudson, 1984).
3. See Poiret's autobiography, *My First Fifty Years* (London: Gollancz, 1931). Between the Directoire and Oriental looks, Poiret launched the hobble skirt. Later he organized a group of models in harem pantaloons to taunt those in hobbles at the race track and then run away unencumbered. It is important to stress that as well as designing clothes Poiret dominated interior decoration through his school of decorative arts, Martine. Sara Bowman's book *A Fashion for Extravagance* (London: Bell & Hyman, 1985), contains fascinating material on Martine. See also Palmer White's *Poiret* (London: Studio Vista, 1973).
4. On dress reform, see Stella Mary Newton's *Health, Art and Reason* (London: Murray, 1974). David Kunzle's *Fashion and Fetishism* (Totowa, NJ: Rowan & Littlefield, 1982) and Valerie Steele's *Fashion and Eroticism* (Oxford: Oxford University Press, 1985) provide enough detailed information about nineteenth-century fashion, especially the role of the corset and tight-lacing, for readers to make up their own minds on all the historical, aesthetic, ethical and psycho-pathological questions that have become matters of impassioned scholarly controversy.
5. Although the ballet was called after her, Schéhérazade does not herself appear in it as a character. Instead the ballet is adapted from the framing story, that of King Shahryar, in which his discovery of his wife's infidelity leads to her execution. From then on, every morning Shahryar executes the woman he has slept with the night before, in order to prevent any possibility of further betrayal. Schéhérazade finds a way to ward off this drastic fate by distracting Shahryar through her story-telling for a thousand and one nights, after which she is spared.
6. The influence of Mikhail Vrubel on Bakst was particularly important. Vrubel did a series of paintings of Queen Tamara who, like Cleopatra according to legend, killed every man she slept with (an inversion of the *Thousand and One Nights*). Bakst designed a later Diaghilev ballet on this theme, one apparently close to his heart.
7. Alexandre Benois, *Reminiscences of the Russian Ballet* (London: Putnam, 1942). See also, for other reactions to Nijinsky, Richard Buckle's biography *Nijinsky* (London: Weidenfeld & Nicolson, 1972).
8. G.W.F. Hegel, *Lectures on the Philosophy of History* (London: Bell, 1900).
9. Georges Bataille, *Visions of Excess* (Manchester: Manchester University Press, 1985).
10. Edward Said, *Orientalism* (New York: Pantheon, 1978). Perry Anderson, *Lineages of the Absolutist State*

(London: Verso, 1974). Anderson concludes his chapter on the 'Asiatic mode of production', 'It is merely in the night of our ignorance that all alien shapes take on the same hue.' Said demonstrates how wilful, self-interested and relentless that 'ignorance' was – and still is.

11. Linda Nochlin, 'The Imaginary Orient', *Art in America*, no. 71 (May 1983).

12. *Flaubert in Egypt*, translated and edited by Francis Steegmuller (London: Michael Haag, 1983).

13. I am grateful to Olivier Richon for introducing me to Grosrichard's *Structure du Sérail* (Paris: Seuil, 1979). See also Richon, 'Representation, the Despot and the Harem', in Francis Barker, Peter Hulme and Margaret Iversen (eds.), *Europe and its Others* (Colchester: University of Essex, 1985).

14. Jon Halliday tells me that in 1968 Jacques Lacan spelled out to him, over the telephone, the address at which he could be found in Rome, using women's names for all the letters (A as in Antoinette, N as in Nanette, etcetera) until he got to L: 'Comme dans Lacan, n'est-ce-pas?' – with a distinct shift in his voice.

15. Michael Fokine, *Memoirs of a Ballet Master* (Boston: Little, 1961). For the *fin-de-siècle* Botticelli, see Francis Haskell, *Rediscoveries in Art* (Oxford: Phaidon, 1976). All comment on the Decadence is, of course, indebted to Mario Praz's classic *The Romantic Agony* (London: Oxford University Press, 1933). See also Ian Fletcher (ed.), *Decadence and the 1890s* (London: Arnold, 1979).

16. Quoted in Charles Spencer's *Leon Bakst* (London: Academy, 1973), which has a chapter on Ida Rubinstein.

17. Cecil Beaton, *The Glass of Fashion* (London: Weidenfeld & Nicolson, 1954). Beaton's description is corroborated by the nude photographs of Ida Rubinstein from Romaine Brooks's collection, one of which is reproduced in Meryle Secrest, *Between Me and Life* (London: MacDonald, 1976).

18. Quoted in different versions in Richard Buckle's *Diaghilev* (London: Weidenfeld & Nicolson, 1979) and Charles Spencer's and Philip Dyer's *The World of Diaghilev* (Chicago: Regneru, 1974). I have used both versions. Diaghilev welcomed the February Revolution in Russia. He was opening a new season in Paris in May 1917, with *The Firebird* in the programme, and 'decided to make an alteration in the final tableau of that ballet to accord with the spirit of the times. Instead of being presented with a crown and sceptre, as he had been hitherto, the Tsarevich would in future receive a cap of Liberty and a red flag. . . . His idea was that the red flag would symbolize a victory of the forces of light over those of darkness, represented by Kashchey. We all thought this gesture of Diaghilev's decidedly out of place; but he was obstinate and would not heed us': S. L. Grigoriev, in his memoirs of *The Diaghilev Ballet* (London: Constable, 1953). After Diaghilev had received a number of protests he defended his innovation publicly, but later deferred to his critics and withdrew the offending flag. He made no such comment on the subsequent October Revolution, but in 1922 he met Mayakovsky in Berlin and helped to secure him a visa to visit Paris. Mayakovsky in turn encouraged Diaghilev to return to the Soviet Union, and on a second visit to Paris wrote to Lunacharsky asking him to help expedite Diaghilev's visa. Diaghilev intended to go back to Russia and withdrew only when the Soviet authorities refused to give a two-way visa to his assistant, Kochno. In 1927 Diaghilev produced Prokoviev's *Le Pas d'Acier*, which outraged Benois: 'an apotheosis of the Soviet regime. *Le Pas d'Acier* could easily be taken for one of those official glorifications of Industrialism and of the Proletariat in which the USSR excels. The cynical zeal of the authors and producer had actually gone so far as to offset the triumph of the workers by sneers at the defeat of the bourgeoisie.' The next year, just months before his death, Diaghilev met Meyerhold and suggested a joint season with him. Nouvel and others protested at collaboration with Bolsheviks, but Diaghilev wrote to Lifar that 'if one took their advice, one might as well go straight to the cemetery'.

19. We can see from Perry Meisel and Walter Kendrick (eds.), *Bloomsbury/Freud: The letters of James and Alix Strachey* (London: Chatto & Windus, 1986), how psychoanalysis and the Russian Ballet could both be fascinating to the same people. Bloomsbury was heavily influenced by Poiret (via Omega) and Matisse as well as by Diaghilev. Keynes went so far as to marry a dancer from Diaghilev's company, Lydia Lopokova. In the context of this study, it is tempting to link this marriage to his theories on the role of consumption, expenditure and waste in the economy.

20. All Matisse's pronouncements on art and on his own work have been gathered together by Jack D. Flam in *Matisse on Art* (New York: 1978).

21. 'If decoration can be said to be the spectre that haunts modernist painting, then part of the latter's formal mission is to find ways of using the decorative against itself': Clement Greenberg on 'Milton Avery', reprinted in his *Art and Culture* (Boston, Mass.: Beacon, 1961).

22. 'Ornament and Crime' was first published in Vienna in 1908. Herwarth Walden republished it in *Der Sturm*, in Berlin in 1912, and it was translated into French, heavily cut, in *Les Cahiers d'aujourd'hui* (Bruges: Imprimerie Saint-Cathérine, 1913), and again, in Paris, in Le Corbusier's *L'Esprit nouveau* in 1920, 'perhaps its most influential reprinting', according to Reyner Banham. It is available in English in Ulrich Conrads (ed.), *Programmes and Manifestos on 20th-century Architecture* (London: Lund Humphries, 1970). As well as influencing other artists, Loos's ideas helped to form those of his friend Ludwig Wittgenstein, as Allan Janik and Stephen Toulmin recount in their *Wittgenstein's Vienna* (New York: Simon & Schuster, 1973).

23. 'Ladies' Fashion' (1898) reprinted and translated in *Spoken into the Void* (Cambridge, Mass.: MIT, 1982).

24. *The Theory of the Leisure Class* was first published in 1899. It was Veblen's first book, followed among others by *The Instinct of Workmanship* (New York: Macmillan, 1914) and *The Engineers and the Price System* (New York: B.W. Huebsch, 1921). David Riesman, in his *Thorstein Veblen* (New York: Scribner, 1953) tells how he became a 'young functionalist' in the 1920s under Veblen's influence. Theodor Adorno's *Prisms* (London: Spearman, 1967) contains a brilliant essay on Veblen, dealing with his attitudes to women and luxury, and his roots in radical Protestantism.

25. The concept of the 'Great Masculine Renunciation' comes from J.C. Flugel's *The Psychology of Clothes* (London: AMS, 1930) whose contents were originally written as a series of talks for the BBC in 1928. Flugel's pioneering psychoanalytic study is still one of the best theoretical books on clothes and fashion.

26. Reprinted in Greenberg's *Art and Culture*. Greenberg's criticisms of Picasso's late work are part of a general denunciation of French painting as 'tailored' and 'packaged'. The colour field painters he wrote about include Still, Rothko and Newman. Greenberg's then disciple, Michael Fried, praised Morris Louis, in his 'Three American Painters' catalogue (Boston, 1965), for 'identifying the image with its woven canvas ground, almost as if the image were thrown onto the latter from a slide projector'. See also Donald B. Kuspit, *Clement Greenberg: art critic* (Madison: University of Wisconsin, 1979), especially chapter 4, 'The Decorative'.

27. Quoted by Tim Hilton in his *Picasso* (London: Thames & Hudson, 1975). The ballet in question was *Parade*. Hilton goes on to comment that Picasso 'was damaged by the contact he had with the ballet. It is always pointed out how natural it was for Picasso, with his delight in the performing arts (of the more popular type to be sure) to collaborate with a theatrical spectacle. This is a major misreading of the nature of modern art.'

28. Perry Anderson, 'Modernity and revolution', *New Left Review*, no. 144 (March–April 1984). This article is marred by Anderson's sweeping pessimism, so sweeping that he cannot imagine any significant art being produced at all in our 'routinized, bureaucratized economy of universal commodity production' and 'permissive consumerism'. At times, he contrives to out-jaundice the grimmest culture critic as he contemplates the morbidity of our epoch and the indefinite postponement of revolutionary hope. Arno Mayer's *The Persistence of the Old Regime* (London: Croom Helm, 1981) is positively bracing in contrast. It challenges us to reassess all our conventional views about the bourgeois revolution and twentieth-century history.

29. Max Weber, *The Protestant Ethic and the Spirit of Capitalism* (1904–5) (London: Allen & Unwin, 1930) and Werner Sombart, *Luxury and Capitalism* (1913) (Michigan: University of Michigan Press, 1967). See also Michael Lowy's *Georg Lukacs – From Romanticism to Bolshevism* (London: Verso, 1979) for an evocation of the Heidelberg milieu from which they all emerged. Lukács, of course, ended up attempting to popularize a social-hygienist view of art.

30. See Kaja Silverman, 'Fragments of a Fashionable Discourse', in Tania Modleski (ed.), *Studies in Entertainment* (Bloomington: University of Indiana Press, 1986) for a feminist discussion of Flugel's argument and its implications.

31. Lazenby Liberty founded Liberty's store in Regent Street, London.

32. See Meredith Etherington-Smith, *Patou* (London: Hutchinson, 1983).

33. The ultimate cult of the body-machine was that of biomechanics, favoured by Meyerhold – who had travelled a long way since he directed Ida Rubinstein's production of *La Pisanelle* in Paris, 1913. Meyerhold borrowed from the work of Taylor on body movements in the labour process, work which attempted to find a scientific basis by which to harness the body of the worker to the machine in the interests of greater labour discipline and productivity (that is, greater exploitation).

34. Cocteau, *Le Rappel à l'ordre* (Paris: Stock, 1926). My translation.

35. For further information on Cocteau, Poiret and the onslaught on Orientalism, see especially Kenneth Silver, *Esprit de Corps: The Art of the Parisian Avant-Garde and the First World War, 1914–1925* (Princeton: Princeton University Press, 1989) from which these quotations are taken. This is an outstanding revisionist account of the ways in which the cubists and their supporters (and the pre-war avant-gare in general) adapted to the chauvinist and reactionary currents that came to the fore during the Great War. Citations are from Silver, unless otherwise noted.

36. Cited in Silver. Mare, like Poiret, was a major decorator exhibited at the 1925 Paris exhibition.

37. Silver compares Matisse's *The Piano Lesson* of 1916, in which arabesque plays a key role, although already less than work done before the outbreak of war, with the 'delicacy of manners and good taste' that characterize *The Music Lesson*, painted the following year.

38. For 'life-style modernism' see Lynn Garafola, *Diaghilev's Ballets Russes* (Oxford: Oxford University Press, 1989). This is an outstanding book, which deals not only with the artistic but also with the social and economic dimensions of the Ballets Russes. It is particularly informative about patrons and audiences.

39. See Palmer White, *Schiaparelli* (New York: Rizzoli, 1986).

40. Quotation from Maurice Nadeau, *The History of Surrealism* (London: Jonathan Cape, 1968). This remains the standard account of the movement.

41. André Breton, *Legitimate Defence* (September 1926), reprinted in Nadeau.

42. Bryan Holme et al. (eds.), *The World in Vogue* (London: Secker & Warburg, 1963).

43. Diaghilev himself took a turn towards modernism, on Cocteau's prompting, which became irreversible after *Parade* in 1917 and culminated with the constructivist *La Chatte* in 1927. He worked consistently not only with Stravinsky and Picasso but also with many other leading modernists. Almost his last public act was a visit to Baden-Baden to hear the Hindemith–Brecht *Lehrstuck*.

44. See especially 'The Notion of Expenditure', reprinted in Bataille.

45. Allan Stoekl's Introduction to Bataille's *Visions of Excess*.

46. Ernest Borneman, *The Psychoanalysis of Money* (New York: Urizen Books, 1976). Borneman gathers together many of the key psychoanalytic texts on money and capitalism. His introduction needs to be supplemented by Russell Jacoby's *The Repression of Psychoanalysis* (New York: Basic Books, 1983) if the history and scope of anti-capitalism in the psychoanalytic movement is to be more fully understood.

47. On flamboyant display from beneath as a signifier of insurrection, see, for instance, the section 'Dressed to Kill: the fashionable hooligan' in Geoffrey Pearson, *Hooligan* (London: Macmillan, 1983), and Stuart Cosgrove, 'The Zoot Suit and Style Warfare', *History Workshop Journal*, no. 18 (autumn 1984).

48. Michèle H. Richman, *Reading Georges Bataille* (Baltimore: Johns Hopkins, 1982).

49. Ezra Pound, 'Les Millwin', first published as part of the 'Lustra' series in *Poetry*, no. 2, Chicago, November 1913. See also the chapter on 'Student Unrest at the Slade' in Richard Cork, *Vorticism and Abstract Art in the First Machine Age*, vol. 1, *Origins and Development* (London: Fraser, 1976). Pound saw the Russian Ballet in London in 1911.

50. See Erté, *Things I Remember* (London: Owen, 1975).

51. See, for instance, the section, 'La Mode ou la Féerie du code', in Jean Baudrillard, *L'Échange symbolique et la mort* (Paris: Gallimard, 1976).

52. Poiret, *En habillant l'époque* (Paris: Grasset, 1930).

MODERN TIMES: CINEMA/ AMERICANISM/THE ROBOT

1. 'Yesterday, European Culture! Today, American Technology!'

If, in the early years of the century, Orientalism was crucial to the emergence of modern art (fashion, ballet, decorative art), the period of consolidation was marked by Americanism (cinema, architecture, applied art). Film-makers and theorists of culture looked to the work of Griffith and Chaplin. Architects sang the praises of the silo and the skyscraper. The cult of jazz swept across Europe.[1] Oskar Schlemmer observed that, at the Bauhaus: 'The artistic climate here cannot support anything that is not the latest, the most modern, up-to-the-minute, Dadaism, circus, variety, jazz, hectic pace, movies, America, airplanes, the automobile. Those are the terms in which people here think.'[2]

In 1929 Pirandello wrote, 'Americanism is swamping us. I think that a new beacon of civilization has been lit over there.' He thought that in Berlin 'the structure of the city itself offered no resistance', whereas in Paris, 'Americanism is as strident and jarring as the make-up on the face of an ageing *femme du monde*'.[3] The further east you looked in Europe, the more intense was the cult of Americanism (Germany, the USSR) while in the West (Britain, France) the cult was much weaker. Gramsci explained the discrepancy succinctly: the further east you went in Europe, the more completely the traditional ruling class had been swept away.

In the Soviet Union, Americanism had a pronounced utopian ring. The avant-garde stage company Feks (Factory of the Eccentric Actor), issued a typical proclamation: 'Yesterday, European culture. Today, American technology. Production and industry under the star-spangled banner. Either Americanization or arranging the funeral ceremonies.'[4] Under the influence of Frederick Taylor's work study experiments, Gastev set up the Institute for the Scientific Organization of Work and the Mechanization of Man.[5] Mayakovsky

hymned the Brooklyn Bridge and Douglas Fairbanks and Mary Pickford were mobbed throughout a triumphant tour of the Soviet Union.[6] There, as elsewhere, Americanization stood for true modernity, the liquidation of stifling traditions and shackling lifestyles and work habits.

On a simple level, there was a fascination with movies, soaring towers, powerful machines and speeding automobiles. But behind this was a growing recognition that the USA was providing the world with a new model of industrialism. Taylor was the pioneer of what we now know as ergonomics. By observation, photographic recording, and experiment, he broke down the physical gestures of workers to find out which were the most efficient, in time and expenditure of labour power, for any particular job. These model gestures then became a standard for all workers, to be instilled by coercion or by habit. All would perform the same maximally efficient, radically simplified movements. Taylor's *Principles of Scientific Management*, published in 1911, heralded a new epoch in which the worker would become as predictable, regulated, and effective as the machine itself.[7]

By the time of Taylor's death in 1915 the assembly line at Henry Ford's factory in Highland Park, Detroit, was fully in operation after two years of experiment. Fordism meant more than the mass production of standardized objects. It meant a new form of organization of production. This involved bringing together three principal elements: first, a hierarchy of standardized segmented and subsegmented parts, all interchangeable, plus a parallel hierarchy of machine tools (themselves made up from standardized parts) which both formed and assembled the parts into the finished product; second, a fully Taylorized workforce, themselves performing segmented and standardized repeated actions (a de-skilled labour force, controlled by an elite of engineers, supervisors and designers); third, a continuous, sequential assembly line, with a tempo determined by time and work studies, which transferred the parts through the whole process, designed so that the worker never had to move, even to stoop to pick something up. In effect, Fordism turned the factory into a kind of super-machine in its own right, with both human and mechanical parts.[8]

In the 1920s Fordism became a world-view, whether extolled, feared, or satirized. Matthew Josephson, editor of the avant-garde magazine *Broom*, wrote there in 1923:

Mr Ford, ladies and gentlemen, is not a human creature. He is a principle, or

better, a relentless process. Away with waste and competitive capitalism. Our
bread, butter, tables, chairs, beds, houses, and also our homebrew shall be
made in Ford factories. There shall be one great Powerhouse for the entire land,
and ultimately a greater one for the whole world. Mr Ford, ladies and
gentlemen, is not a man. . . . Let him *assemble* us all into his machine. Let us be
properly assembled. Let us all function unanimously. Let the wheels turn more
swiftly.[9]

Fordism became a vision not only of greater productivity, necessary for the
development of capitalism, but also of a new model of social organization,
with universal implications.

Thus, one of the most favourable accounts of Fordism was that given by
Gramsci in his prison notebooks.[10] In his classic essay 'Americanism and
Fordism', Gramsci unreservedly welcomed the advent of Fordism. He saw it
as a necessary and desirable restructuring not only of the capitalist system but
of the working class itself. At one point Gramsci asked himself, in view of the
high labour turnover at the Ford plant, despite high wages, whether this did
not indicate that Fordism was a 'malignant phenomenon which must be
fought against through trade union action and through legislation'. But
Gramsci decided in favour of Fordism. 'It seems possible to reply that the Ford
method is rational, that is, that it should be generalized; but that a long
process is needed for this, during which a change must take place in social
conditions and in the way of life and habits of individuals.' The key word here,
of course, is 'rational'.

Gramsci came to a positive conclusion about Fordism despite his recog-
nition that the old 'psycho-physical nexus' of work involved 'a certain active
participation of intelligence, imagination and initiative on the part of the
worker', whereas the de-skilled Taylorized and Fordized worker finds labour
reduced 'exclusively to the mechanical, physical aspect'. Indeed, Gramsci
went much further in his approval of Fordism. 'A forced selection will
inevitably take place; a part of the old working class will be pitilessly
eliminated from the world of labour, and perhaps from the world *tout court*'(!)
The transformation of Italian society demanded, through a 'passive revolu-
tion', the march of reason through the working class.

Perhaps the most memorable image of the 'elimination' of the irrational is
the forced removal of Charlie Chaplin from the factory to the lunatic asylum in
Modern Times.[11] Chaplin proves unable to acquire the new psycho-physical
habits required under Fordism. He runs amok, unable to stop performing his

segmented mechanical action even when away from the assembly line. Demented by the speed-up of the line and relentless video-surveillance, he throws himself into the machine itself, being swallowed up in it, and then after his release continues compulsively tightening bolts everywhere inside and outside the factory, including boltlike objects such as noses and buttons on women's clothing. The image of incorporation into the machine is inverted when Chaplin is clamped into an automatic feeding machine that crams bolts into his mouth instead of lunch. The machine too runs amok, defying its designer.

In *Journey to the End of the Night*, Céline describes the experience of his hero as a worker on the Ford assembly line in Detroit: 'One lived in a sort of suspense between stupefaction and frenzy.'[12] It is exactly this world that Chaplin captures in his mime. Céline's hero too is thrown back into the *lumpen* world, a reject, incapable of assimilating. 'I even felt shamed into making an effort to go back to work. Nothing, however, came of my heroic little gesture. I went as far as the factory gates, but on this boundary line I stood rooted and the thought of all those machines whirring away in wait for me irrevocably quashed my wish for work.' In any case, it turns out that he has already been replaced by a machine, within three weeks of leaving.

From Gramsci's point of view both Chaplin's and Céline's heroes lacked the self-discipline necessary to transfer from the old to the new working class. Gramsci argued for a new puritanism, a kind of communist phase two of Weber's Protestant ethic, extended from the bourgeoisie to the workers.

> 'Puritanical' initiatives simply have the purpose of preserving, outside of work, a certain psycho-physical equilibrium which prevents the physiological collapse of the worker, exhausted by the new method of production. This equilibrium can only be something purely external and mechanical, but it can become internalized if it is proposed by the worker himself, and not imposed from the outside, if it is proposed by a new form of society.

Gramsci identified with Henry Ford's support of Prohibition and even approved his monitoring of the private lives of his workers. For Gramsci, as for Ford, the question of sexuality was intimately involved with that of labour. Gramsci saw the new labour discipline as a blow against sexual promiscuity. The new (assumed-to-be-male) worker would want (in the words of Horace) '*venerem facilem parabilemque*', easy and accessible sex, a woman to return home to, 'sure and unfailing.

It might seem that in this way the sexual function has been mechanized, but in reality we are dealing with the growth of a new form of sexual union, shorn of the bright and dazzling colour of the romantic tinsel typical of the petit bourgeois and the Bohemian layabout. The exaltation of passion cannot be reconciled with the timed movements of productive motions connected with a fully perfected automatism.

Gramsci saw the 1920s as a period of sexual crisis. On the one hand, 'the institutions connected with sexual life' had been profoundly shaken by the war and the demand for an end to sexual repression when peace returned. On the other hand, the demand for sexual liberation 'came into conflict with the necessities of the new methods of work' imposed by 'Taylorism and rationalization in general'. In this conflict, Gramsci felt constrained to come down on the side of reason 'against the element of "animality" in man'. Gramsci's vision of a new monogamy was really one which extended the 'order, exactitude and precision' of the machine and the assembly line to the sphere of private life. Just as the industrial economy needed a stable labour force, 'a permanently well-adjusted complex', so too domestic life had to be stable and well adjusted. The workforce of a factory, Gramsci argued, is itself like 'a machine which cannot, without considerable loss, be taken to pieces too often and renewed with single parts.' The wife waiting at home became another such permanent machine part.

Sexual passion was seen as an excess which must be expelled from the rational system of advanced industrial civilization, inconsistent with 'order, exactitude and precision'. In 1932, contemporaneously with Gramsci's writings on Fordism, Rudolf Carnap published a notorious article on 'the elimination of metaphysics through logical analysis of language' in the journal of the Vienna Circle, *Erkenntnis*.[13] Metaphysics was the philosophical waste to be expelled from the realm of reason, the realm of emotion rather than cognition, nonsense rather than meaning. Carnap's philosophical project, as R.S. Cohen has pointed out, was 'conceptualized parallel with the technological demands of modern industry'.[14] Its criteria were indeed order, exactitude, and precision, particularly in segmentation and subsegmentation. In his reply to Strawson's 'natural language' critique, Carnap noted: 'A natural language is like a crude primitive pocketknife, very useful for a hundred different purposes. But for certain specific purposes, special tools are more efficient, e.g., chisels, cutting-machines, and finally the microtome.'[15] Standardized

artificial symbols, terms, and protocols function like philosophical machine tools, shaping the useful and excising the waste.

A parallel project of standardization can be seen in the contemporaneous development of the 'Isotype' by Otto Neurath, one of the leaders of the Vienna Circle and a colleague of Carnap.[16] In the late 1920s Neurath began work on designing an international picture language for graphic communication. This consisted of a basic vocabulary of graphic signs and a number of rules for combining them. The signs showed simplified silhouetted figures of people and objects, designed by Gert Arntz[17] and somewhat similar to Léger's standardized figures of the 1920s, developed during his Esprit nouveau period. Indeed, both Léger and Neurath were influenced by Egyptian art.[18]

The standard Isotype signs were combined into complex charts and diagrams in order to convey information visually with immediacy and clarity. Thus a chart showing automobile production in 1929 contrasts five identical silhouette workmen and fifty-five identical silhouette automobiles for the USA with eight workmen and only seven cars for Europe. The rows of standardized human figures are immediately reminiscent of the factory discipline under which the real workers worked on the assembly line, as well as Carnap's contemporary arithmetization of syntax. (The whole chart also graphically illustrates the impact of Fordism and the enormous European productivity lag that gave rise to the voluntaristic upsurge of Americanism.)

The members of the Vienna Circle saw their work as part of an overriding project of 'rational socialism' and 'scientific humanism'. They saw market forces as irrational and wasteful and favoured conscious, scientific planning. Neurath was militantly within the Austro-Marxist tradition and Carnap too was on the left. In the Soviet Union socialism itself became increasingly identified with planning and industrialization using a Fordist model. As Asya Lacis put it in conversation with Walter Benjamin: 'Gradually she had realized what was going on here [in the Soviet Union]: the conversion of revolutionary effort into technological effort.'[19] In the Soviet Union, the lag behind the United States was also an incentive towards Americanization in a revised Fordist form, however parodic this may now appear.

The Fordist vision expounded in different ways by Gramsci, the Vienna Circle and Stalinist productivism contrasts starkly with Aldous Huxley's critique, in his 1932 science fiction novel Brave New World.[20] Huxley imagined a future in which Fordism has become a world system, having absorbed both American capitalism and Soviet communism. Ford is invoked

in place of God as the founder of a new secular religion and his book *My Life and Work* (bound in surrogate leather) has become a new Bible. The whole of society, on a global scale, is now organized on Fordist principles, though Huxley envisaged these as supplemented by developments in genetic engineering, pharmacological regulation of the psyche and new forms of state-controlled mass media. The imperatives of a 'rationalized' technology rule throughout the system.

However, in Huxley's dystopia the workers do not return to stable monogamous families as they do in Gramsci's matching Fordist utopia. Instead monogamy and the family unit have been eliminated and replaced, for the purpose of human reproduction, by genetic technology. For sex there is a compulsory pattern of short-term relationships with a series of different partners. It is frowned on to spend too long with any one partner. The need for *venerem facilem parabilemque* is organized on lines that demand interchangeability of parts. Huxley associates this pattern of sexual behaviour with Freud. 'Our Ford – or Our Freud, as for some inscrutable reason, he chose to call himself whenever he spoke of psychological matters – our Freud had been the first to reveal the appalling dangers of family life.'

For Huxley, it was the family that was counterposed to the machine – especially the family's 'natural' basis, the mother. Mothers, he noted, gave rise to 'every kind of perversion from sadism to chastity'. His anti-hero, the Savage, is born anomalously to a mother and brought up by her (though he lacks a father). As a result, he is characterized precisely by sadistic impulses and a flight into chastity in his relations with women.[21] Like Gramsci, Huxley saw the passions as a threat to the well-regulated social mechanism. Where they differ is that Gramsci viewed the family, albeit transformed and rationalized, as a necessary complement to the machine, whereas Huxley saw it as radically other, necessarily beyond the control of the system. For Huxley the 'savage' threat of sexuality-out-of-control was family-generated (especially mother-generated) whereas for Gramsci it came from the 'animality' of the drives, to be regulated socially through the agency of the family.

2. 'Robots of the World, Unite!'

The problem of the machine and sexuality was vividly expressed in the imagery and literature about robots that springs up during the 1920s. The robot was, of course, a metaphorical extension of the position of the worker in

a Taylorist and Fordist system, like that of the clone in *Brave New World*. The term was first coined by the Czech writer Karel Capek in 1917, from the Czech word for 'serf', implying forced labour. In 1920 Capek wrote his robot play, *R.U.R.*[22] The R.U.R. company (Rossum's Universal Robots) mass-produces artificial humanoids and sells them all over the world as cheap labour. The orderly running of the factory is disturbed by the arrival of a visitor from the Humanity League, Henrietta Glory. She wants to improve the oppressive conditions of robot 'life'. The factory managers and engineers resist this, putting forward a series of different ideas on the role played and benefits provided by robots, but in the end she seductively persuades one of them to alter the design (they are all of them in love with her!). As a result of the alteration the robots reach a new level of self-consciousness and begin to revolt. They take over the factory and, eventually, the whole world, destroying humanity.

The robots are simplified and ergonomically improved models of humans. 'A working machine must not want to play the fiddle, must not feel happy, must not do a whole lot of other things. A petrol motor must not have tassels or ornaments, Miss Glory. And to manufacture artificial workers is the same thing as to manufacture motors.' Thus emotions are rejected as unnecessary and consequently equated with ornaments. The robots feel neither pleasure nor pain: they have neither libido nor affect. They have no fear of death but when ordered go immediately to the stamping-mill to be destroyed. They have no enjoyments and feel no sorrow. They have no childhood: 'From a technical point of view, the whole of childhood is sheer stupidity.'

On the other hand, they are superior to humans in many ways: 'Nature hasn't the least notion of modern engineering. The human machine was terribly imperfect. It had to be replaced sooner or later.' After all, 'the product of an engineer is technically at a higher pitch than a product of nature'. The robots have astonishing memories and can repeat whole encyclopaedias word for word with complete accuracy, but 'they never think of anything new.' They are stronger than humans, more intelligent (in task-oriented ways), more reliable, more punctual, and so on. In short, they have been designed as ideal mechanical slaves, inexpensive, capable and obedient.

Occasionally robots do go wrong. 'Something like epilepsy, you know. We call it robot's cramp. They'll suddenly sling down everything they're holding, stand still, gnash their teeth – and then they have to go to the stamping-mill.' When the extra quality of 'sensitivity' is added, it joins with this tendency to

malfunction to produce organized revolt. Led by the librarian robot Radius, who has a larger brain than the others, the robots begin to demand power for themselves. The first signs of 'humanity' are hatred and the will to power. As they mutate they claim sovereignty and wreak destruction. 'I don't want any master. I know everything for myself. I want to be master over people.' Eventually robots trained as soldiers turn on their human overlords and declare war.

Revolutionary committees of robots set up soviets and issue manifestos:

> Robots of the world. We, the first national organization of Rossum's Universal Robots, proclaim man as an enemy and an outlaw in the Universe. Robots of the world, we enjoin you to murder mankind. Spare no men. Spare no women. Save factories, railways, machines, mines and raw materials. Destroy the rest. Then return to work. Work must not be stopped.

The underlying fantasy is of the Terror and the Bolshevik Revolution, of class warfare carried through to the extreme without pity or restraint. Only one man is spared, Alquist, a Tolstoyan, who has argued for the dignity and virtue of toil. Victorious, the robots continue to work ever harder in an orgy of senseless productivity.

It is as though the robots, in the main part of the play, are projections of human sadism and aggression which have become, so to speak, sedimented in machines. The whole of Fordist civilization, seen together with the industrialization of war, is oriented towards death. The aggression that is turned on humanity by the robots originates in humanity itself, in the splitting-off and overvaluation of a will to power in the whole enterprise of Fordism and modern capitalism. Thus the phenomenon of technology-out-of-control, which is the central fear of *R.U.R.*, is simply another aspect of a perverse turn from love to hate, from natural reproduction to mechanical sterility. It is as if the technology itself is an externalization of the sadism and chastity of Huxley's Savage.

For Capek there were two deep structures underlying the metaphor of the robot, presented symbolically in the two contrasting world-views of Old and Young Rossum, the father and son inventors of the robots. For Capek, Old Rossum 'is no more or less than a typical representative of the scientific materialism of the last century.'[23] He wishes to create an artificial man in order to prove God unnecessary. Thus, paradoxically, he is both a scientist and a magus, a creator of golems. In contrast, Young Rossum is a modern

scientist, untroubled by metaphysical ideas; scientific experiment is for him the road to industrial production, he is not concerned to prove but to manufacture. Young Rossum, then, is a pragmatic engineer. His invention of the industrial robot takes place on the anniversary of the discovery of the United States. He is the exponent of Americanism.

As we have seen, the central idea of 'Americanism' was provided by Fordism. Ford stood for the mass rather than the individual. He provided one standard and constant manufactured object: the Model T. 'I thought that it was up to me as the designer to make the car so completely simple that no one could fail to understand it.'[24] It was to be a basic, 'generic' car, reduced to functional essentials. 'We made no provision for the purely "pleasure car"', Ford wrote. If the Model T gave any pleasure, this was to be purely a by-product. The car was to have no unnecessary decoration or ornament. 'Start with an article that suits and then study to find ways of eliminating the entirely useless parts': like the cockade on a coachman's hat. And it was to be black, according to the famous dictum 'Any customer can have a car painted any colour that he wants as long as it is black.'(When Chanel launched her 'little black dress' in 1926, *Vogue* wrote: 'Here is a Ford signed "Chanel".')[25]

Capek's robots followed the same pattern as the Model T. They were all identical in appearance, like women wearing their Chanel 'uniform' or like the cars rolling off the assembly line. Young Rossum's motto might have been, as was said of Chanel, 'Lop it off!': reduce, be functional. The difference between Old and Young Rossum reflected the distinction between two epochs of technology and of the economy. The difference between the fantastic automaton and the industrial robot was like that between the magic horse of folklore and the Ford car. When Vaucanson made his famous automaton of a duck in 1738 he tried to imitate a real duck exactly. A single wing contained more than 400 articulated parts and the duck could walk, quack, splash about and even eat, digest and excrete food.[26] It was intended as a marvel rather than an object of use.

Earlier versions of robots were, as Capek points out, semi-magical beings. 'To create a Homunculus is a medieval idea: to bring it in line with the present century this creation must be undertaken on the principle of mass-production.' Beyond that, the robots themselves become the masses, standing in for the human masses of the great industrial cities. The ideal robots of the nineteenth century were still conceptualized as individuals, unique artefacts with a personal relationship to their maker: Frankenstein's monster,

Spallanzani's Olympia, Edison's Future Eve.[27] They were essentially craft products: experimental prototypes or customized luxury goods.

In these instances, the dialectic between human and machine is mapped onto that between parent and child and also – explicitly in the case of Olympia and Hadaly (the Future Eve) – that between male lover and female love-object. Caught up in the circulation of desire, the automaton becomes both philosophical toy and sexual fetish or surrogate. Thus Edison in Villiers de L'Isle Adam's *L'Ève future* is both magus (though American) and marriage-broker (even 'idealized' procurer and pimp). His project is the technical realization of the ideal object of masculine desire. The real task of creation is not simply to create a human being, but to create woman *for man*. In the twentieth century, this project reached a point of delirium with two modern artists, Kokoschka and Bellmer, both of whom had dolls manufactured for their personal gratification. Kokoschka took his (a life-sized replica of his ex-lover, made by her dressmaker, Hermine Moos) for excursions in his carriage, for meals in restaurants, where he insisted a place be laid for her, and to the theatre where she sat in the seat next to his. Bellmer, who knew of Kokoschka's doll, crafted a whole series of dolls, which he arranged in provocative postures and photographed. They became famous after they were publicized as 'surrealist objects' in the magazine *Minotaure*, and were later categorized as 'bachelor machines'.[28]

Unlike other puppets and robots, Hadaly is not entirely a 'bachelor machine' because she is given a surrogate 'mother' who is co-creator of the machine's 'soul' through her occult influence on the recorded voice given to Hadaly. Thus the ideal receives the necessary 'maternal' input, the robot is intrinsically as well as contingently feminized. It is important to note this because, as both Raymond Bellour and Annette Michelson point out,[29] the Ideal that Edison produces, the perfect facsimile of image and sound, is a prefiguration of the cinema – still to be invented at the time the book was written – 'the artificial living through illusion'. 'There's no doubt that within a few years, models like this one will be fabricated by the thousands: the first manufacturer who picks up this idea will be able to start the first factory for the production of Ideals.' In a word, Hollywood.

In fact, not only does the gynoid prefigure the cinema, she comes to figure in it. Hadaly prefigures the False Maria, the robot vamp of Fritz Lang's *Metropolis*,[30] which combines the thematic of *L'Ève future* with that of *R.U.R.* (as well as Kaiser's *Gas*). The robot-maker, Rotwang, is a magus of the same

type as Old Rossum and Edison. Like them, he is a scientist magician, whose roots are in medieval times but whose technical resources are ultra-modern. *Metropolis* sets the primordial drama of the creation of a female robot in a setting of industrial production and enslaved masses. At the same time, the robot is part of the personal project of Rotwang, the instrument of his desire. Through her seductive powers she will bring his sexual rival, Fredersen, to destruction, along with his industrial empire of Metropolis.

As Andreas Huyssen has shown, the film revolves around the displacement of the fear of technology-out-of-control on to that of (female) sexuality-out-of-control.[31] When the anarcho-hysteric flood of female sexuality is tamed and the (robot) witch who provoked it is burned at the stake, then owners and minders of the machines can be reconciled, and progress through technology can be assured. The heart brings the hands and the head (body and mind, labour and capital) together, once the force of female sexuality has been eliminated. The robot vamp, unlike Hadaly, has not transcended her sterility through the maternal gift of a 'soul'. She is completely outside the sphere of the good mother, the True Maria, and utterly opposed to it. She is the incarnation of destructive sexuality, seductive and spellbinding.

Technology and sexuality are condensed in the figure of the robot Maria. Libido and the drives are represented in the first part of the film by the industrial machinery of the underground city which swallows up and destroys the human workers who are presented as its slaves. The destructive power of the technology is represented by the terrifying image of Moloch, the cannibal who devours his own children.[32] These sadistic and aggressive paternal drives must be counteracted by a nurturing maternal libido if catastrophe is to be averted. This is achieved through the agency of the True Maria, who is a spiritualized and desexualized mother figure. Her victory over the False Maria, who urges the workers to destroy the machines in a frenzy of auto-castration and infanticide, allows the paternal aggression projected into the industrial apparatus to be sublimated and controlled. The family is reconstituted symbolically and thus both productivity and social harmony are assured without further danger. For this to happen the aggression and destructiveness of the False Maria's phallic female sexuality must first have been vanquished.

The False Maria, like Hadaly, is a creature whose physiognomy is itself a masquerade, a facsimile transferred from a model, the True Maria. These robot women, as Patricia Mellencamp has pointed out, are literally 'special effects',[33] natural on the outside, but mechanical within. The False Maria is

herself 'false' and holds sway, as a witch, over the 'false' realms of superstition and rhetoric, emotive suasion.

In the figure of her creator, Rotwang, we see an unusually clear case of the way in which 'scientific materialism' and 'medieval magic' are linked on the terrain of sex. On the one hand, sex subsumes the realm of sensation and the body (hence, as the opposite of the spiritual, it is materialistic) and yet, on the other hand, it is irrational, disordered, and compulsive (hence, as the opposite of the rational, it is occult and magical, a seduction from the truth). Sex is associated with matter, the carnal and the sensual, but also with enchantment, mesmerism and weird powers. Thus eros falls outside the sphere of logos in two conflicting ways. Again, we might be reminded of Carnap. First, the scientific – the meaningful – must be separated from the meaningless and, worse, from the pseudo-meaningful or metaphysical. The master image used by Carnap was that of music ('Metaphysicians are musicians without musical talent'[34]) but we can easily make the parallel between music and sex.

The linking category between 'music' and 'metaphysics', sex and witchcraft, is that of 'passion'. The False Maria exists in the realm of the mechanical and the spectacular. She falls outside the sphere of the natural and the spiritual, the sphere of motherhood. At the same time, her role as enchantress and spellbinder puts her outside the reach of patriarchal order and reason. She distracts and diverts the mesmerized masses and thus endangers the mastery of the father. Not until she is destroyed, therefore, can a naturalized and spiritualized technology be secured, can the danger of mass hysteria be finally averted. The connection with Gramsci's fear of sexual excess is clear: sexuality-out-of-control is the main threat to the rationality of technology. For Gramsci, too, feminism was identified with the True Maria rather than the False ('unhealthy "feministic" deviations in the worst sense of the word'). The True Maria contains pleasure within the private sphere, whereas the False Maria carries it into the public sphere: into the pleasure zone of Yoshiwara, the site of spectacle (music and sexual display).

3. The Work of Art in the Age of Mechanical Reproduction

Cinema has always been open to the same double charge: on the one hand, of being a mechanical copy and, on the other, a diverting spectacle, like Hadaly or the False Maria, an 'electrical-mechanical spectacle', as El Lissitsky put it.[35] Cinema too can be condemned as a simulacrum, a masquerade, a display

which bewitches the passions and the mind. In 1935 Walter Benjamin completed his famous essay, 'The Work of Art in the Age of Mechanical Reproduction'.[36] Here Benjamin defended film against both lines of attack, tackling the question of the 'copy' and of 'diversion' head on, while at the same time trying to enlist cinema on the side of technological reason, to the exclusion of enchantment and sensual pleasure (unless 'fused' with instruction). His essay was the high point of the modernist theory of cinema, resolute in its insistence that art must be industrialized if it is to be truly modern: that is, to reach and respond to the needs of the masses.

It is important to realize that for Benjamin 'copy' and 'distraction' are subsidiary concepts to that of the 'masses'. It is mass production that produces the copy, the standardized product, and mass consumption that produces 'diversion' or 'distraction'. His modernist transformation of aesthetics is founded on the postulate of Fordism, capitalist production in its most contemporary form. Just as the Model T replaces the customized coach or car, so the copy replaces the original. The scandal of Benjamin's approach is that this involves reversing the traditional terms of discussion. For Benjamin, the copy becomes associated with the true, and the original with the false. Exhibition value, brought to dominance by the copy, brings the masses close to reality, whereas cult value, the province of the original, required contemplation at a distance, to be rewarded by a spiritual, rather than a secular, and real, experience. The decay of the 'aura', the special quality of cult value, is part of the general decay of magic, theology, and metaphysics.

Benjamin associates the film-maker, the artist working with modern optical technology, with the surgeon (a technician using an 'endonasal perspective procedure' or a laryngoscope), whereas the painter, the traditional artist, is associated with the magician, the shamanistic healer with his spells and mystical laying-on of hands. The modern is the impersonal and the standardized. Thus Benjamin notes the 'increasing importance of statistics' in the sphere of theory, the translation of human behaviour into abstract numerical values. He explains at some length how the artificial means of film production can paradoxically bring us closer to reality. 'The equipment-free aspect of reality here has become the height of artifice; the sight of immediate reality has become an orchid [in the original, a "fairy-tale blue flower"] in the land of technology.' We are reminded, perhaps, of Carnap's insistence that an artificial language is necessary to the scientific representation of the world.

For Benjamin this whole approach meant a rejection of the 'poetic politics'

associated with the surrealists, who had long been a major influence on his work. In his 1929 essay on surrealism he endorsed the Surrealist project: 'To win the energies of intoxication for the revolution', that is, the energies of the marvellous, the passionate, the ecstatic.[37] But he insisted that to serve the revolution these intoxicating energies must be welded to the life of the masses, a life dominated by the norms of modern industry and urban life. This meant taking the surrealist moments of 'illumination' (dreams, drugs, telepathy, etc.) outside the realm of private experience and rendering them public and 'profane'. For Benjamin, this could be envisaged as a kind of dream-sociology, a recapturing of lost configurations of fragmentary images of urban life, webs of affinity and correspondence, which, by restoring to memory what was lost to everyday experience, could also suggest the lineaments of a hoped-for future, the goal of a 'poetic politics'.

However, as time went on, and Benjamin felt himself constrained to identify more closely with communism as the only hope of defeating fascism, so he began to shift still further away from a surrealist conception of politics. He became much more critical of the romantic idealism that characterized the Surrealist project and began to doubt that surrealist ideas of magic and the mysterious could ever take a profane rather than a spiritual form. He concluded his lecture on 'The Author as Producer' with the following words, addressed to Aragon (whose *Paris paysan* had once deeply influenced him):

The more exactly he is thus informed on his position in the process of production, the less it will occur to him to lay claim to 'spiritual' qualities. The spirit that holds forth in the name of fascism *must* disappear. The spirit that, in opposing it, trusts in its own miraculous powers *will* disappear. For the revolutionary struggle is not between capitalism and spirit, but between capitalism and proletariat.[38]

As Benjamin turned away from surrealism, so he moved closer to the unremittingly materialist Bertolt Brecht, whom he had come to know. Behind Brecht stood the tradition of Soviet constructivism and avant-gardism which had, in turn, influenced Brecht and in which Benjamin had long shown an enthusiastic interest. Brecht, of course, was much closer to mechanical materialism than Benjamin – he argued in favour of behaviourism and logical positivism – and it seems clear that he pulled Benjamin some way in that direction. Brecht's whole mode of thought revolved around the antinomies between feeling and reason, individual and collective, psychology and action,

each of which can be mapped onto the other. In his famous afterword to *Mahagonny* two sets of antinomies are listed side by side, culminating in 'feeling' versus 'reason'.[39] In the very next paragraph there is an onslaught against witchcraft, hypnosis, intoxication and fog (whose unstated opposites are science, reason, sobriety, and clarity). A little further on, we find magicians who are seeking to keep their (bourgeois) audience spellbound. All these pairs of contraries can also be detected in the structure of the 'Work of Art' essay.

The link between the concept of the 'copy' and that of 'distraction' was effected by Benjamin in a curious way, through another couplet, drawn from nineteenth-century psychology and aesthetics, that of the 'optical' and the 'tactile'. Benjamin reserved the realm of the 'optical' for the original image (*Bild*), while the copy (*Abbild*) is assigned to the realm of the 'tactile'. The image demands contemplation, absorbed attention, a fixed gaze. It is always at a distance, to be looked at. The copy, on the other hand, is always close, it can be handled, touched, and manipulated. Moreover, the whole mode of apperception of modern life is 'tactile'. Here Benjamin turned to a concept which becomes ever more important to him, that of 'shock'. He conceived of life in the city as an unending series of shocks, which act on us like physical blows: to use a favourite image, like being jostled in a crowd. The copy, because it is both ubiquitous and transient (unlike the image, unique and permanent), jostles us in a crowd of other copies.

In a later essay, finished in 1939, 'On Some Motifs in Baudelaire',[40] Benjamin described how 'the shock experience which the passer-by has in the crowd corresponds to what the worker "experiences" at his machine'. He quoted Marx on the division and de-skilling of labour under conditions of capitalist production, the way in which workers learn to coordinate 'their own movements with the uniformly constant movements of an automaton' and subject their own volition to the objectified will of the machine. It is clear, I think, that this reading of Marx was performed retroactively, a method of reading fundamental to Benjamin, tracing at the beginning of modernism the ulterior lineaments of Fordism. Benjamin associated the cinema particularly closely with the experience of the urban masses. Film provides a series of shocks, sudden shifts in camera position, discontinuities in time and space, close-ups and bird's-eye views, changes in the tempo of editing and the scale of objects. 'There came a day when a new and urgent need for stimuli was met by the film. In a film, perception in the form of shocks was established as a

formal principle. That which determines the rhythm of production on a conveyor belt is the basis of the rhythm of reception in film.'

Benjamin turned the concept of 'distraction' upside down. Instead of seeing it as antagonistic to thought and reason, he argued that it was supportive of reason. He did this in two ways. First, he argued that film, through its technique of shocks, instilled new habits in the masses, new modes of apperception. These, in turn, were necessary to the masses at the present turning point in history, when the human apparatus of perception was confronted with a multitude of new demands and new tasks. Thus cinema, in a sense, was fulfilling the role of fitting the masses for the new and progressive forms of production that were being introduced. Here, Benjamin was on the same ground as Gramsci in looking for a new kind of psycho-physical complex in the worker. Shock (instead of being a shock of juxtaposition, suggesting new and hitherto secret affinities, as with surrealist montage) had become a form of training and film a form of training manual.[41]

Gramsci went even further than Benjamin and argued that Taylorized work could itself be potentially liberating.

> Once the process of adaptation has been completed, what really happens is that the brain of the worker, far from being mummified, reaches a state of complete freedom. The only thing that is completely mechanized is the physical gesture: the memory, reduced to simple gestures repeated at an intense rhythm, 'nestles' in the muscular and nervous centres and leaves the brain free and unencumbered for other occupations.

Just as, when we walk, we can synchronize our physical movements automatically and still 'think whatever we choose', so the new worker, instead of being a 'trained gorilla' (Taylor's unfortunate phrase), can become a free intellectual.[42]

Gramsci reached this counter-intuitive conclusion after considering the case of the skilled compositor (he viewed typesetting as a prototype of mechanized work processes). The compositor, he argued, has to learn to isolate the symbols of a text from its 'often fascinating intellectual content'. In the same way, the worker on the assembly line performs a series of symbolic operations without any regard for their meaning. As Ilya Ehrenburg put it in his brilliant novel *The Life of the Automobile*, 'The worker doesn't know what an automobile is. He doesn't know what an engine is. He takes a bolt and tightens a nut. . . . Upwards to the right, half a turn and then down. He does

this eight hours in a row. He does it all his life. And that's all he ever does.'[43] Benjamin similarly compared the drudgery of the assemblyline worker to that of a gambler: the endless repetition of futile, empty gestures, none of which has any meaning. 'They live their lives as automatons and resemble Bergson's fictitious characters who have completely liquidated their memories.'[44]

Fordism introduced an industrial regime – for the worker – of pure signifiers, stripped of meaning. Medieval copyists, Gramsci observed, became interested in the texts they were copying and consequently made mistakes, interpolating glosses and comments, distracted by the signifieds, the meaning of the text. 'He was a bad scribe because in reality he was "re-making" the text.' The mechanization of copying through printing led to a mechanization of the labour process, a suppression of the signified, an end to the creative re-writing of the copyist. Now the Ford worker carries out a single symbolic operation. The assembly line proceeds like an algorithm, carrying out a predetermined sequence of formalized instructions. Meaning is suspended until the process is completed and there is an output that can be interpreted: in the case of the Ford factory, a fully assembled automobile with a meaning, not for its producer, but for its purchaser. Gramsci's argument was that this very formalization, this reduction of work to a series of empty signifiers, made it possible to think about something else, left a space for other signifieds.

Benjamin attempted a similar paradoxical reconciliation of 'distraction' with 'reason' in his concluding observation that 'film makes cult-value recede into the background not only by putting the public in this position of critic, but also by the fact that at the movies the position requires no attention. The public is an examiner, but an absent-minded one.' Benjamin, in fact, deployed two different concepts of 'criticism'. The first was drawn largely from Brecht. The example that Benjamin gave is that of 'a group of newspaper boys leaning on their bicycles and discussing a bicycle race'. In the cinema it is 'inherent in the technology', as it is with sport, that 'everybody who witnesses its accomplishments is something of an expert'. As early as 1922 Brecht had been arguing for a 'smoker's theatre' whose audience would be like that at a boxing match. In his notes to *The Threepenny Opera*, he called for 'a theatre full of experts, just as one has sporting arenas full of experts'.[45] Benjamin's contribution to this dubious view was to link the notion of expertise to the possibility of interchanging spectators with performers, in line with the theories of Vertov and Tretyakov about proletarian art.

But Benjamin had a second concept of expertise, also taken from Brecht,

but very different in its implications. This was the idea that a segment of film is like a vocational aptitude test or a scientific investigation of human behaviour. 'The act of reaching for a lighter or a spoon is a familiar routine, yet we hardly know what really goes on between hand and metal, not to mention how this fluctuates with our moods'; but these ordinary actions can be brought into our cognitive scope by the film camera (shades of Taylor and his chrono-photography of work gestures!). Brecht was interested in the possibility of building up an archive of gestures on film and used film to record gestures during rehearsals for stage performances. Benjamin seems to have assimilated this both to the screen test and to the related vocational aptitude test, as if unaware of the fatal concession he was making to 'scientific management' in the Taylorist sense.

As Benjamin moved away from a fascination with the 'fragment', the detail of dream-kitsch, the waste product of the economy that reveals more than it seems to tell, towards an obsession with the 'segment', the detail isolated for scientific analysis, we can sense very clearly the affinity between his thought and that of Gramsci. It was not only the surviving residues of surrealism or 'mysticism' that distanced Benjamin from Brecht (indeed both share, at this point, a number of 'mystical' beliefs: in sports, physicalist psychology, and so on) but the absence of concrete politics. In the 'Work of Art' essay, as in Gramsci's 'Americanism and Fordism', politics was subsumed in an uncritical acceptance both of technology and, more important, of new technology-related forms of production. The progressive status of Fordism was taken for granted, with very perfunctory argument. Moreover, this led both of them to take the mechanization of the worker as at least a necessity and even, explicitly in the case of Gramsci, a desideratum.

In Huxley's *Brave New World*, film production is a division of 'Emotional Engineering', a central part of the regulation of leisure. Films have evolved into pan-sensory experiences, 'feelies', which enable the spectator to exper-ience in exact detail all that is felt by the characters in the spectacle – 'every hair on the bearskin rug'. Instead of training the workers for the world of repressive labour, they channel the repressed impulses which might otherwise erupt subversively. They are a force of stability. ' "Stability" said the Controller, "stability. No civilization without social stability. No social stability without individual stability".'[46] The role of the feelies, of emotional engineering, is to ensure that the release of pent-up sexuality in leisure never gets out of control, never becomes impassioned.'Wheels must turn steadily,

but cannot turn untended. There must be men to tend them, men as steady as the wheels upon their axles, sane men, obedient men, steady in contentment.'

Huxley's vision of the feelies reads strangely like a logical extension of the Aristotelian 'theatre of pleasure' which Brecht denounces in the name of epic theatre, his 'theatre of instruction': 'The pleasure grows in proportion to the degree of unreality'[47] – unreality, that is, expressed in a stupendously totalizing illusionism. The sensual pleasure and emotional experience provided in the sphere of 'distraction' compensate for the lack of pleasure and loss of affect suffered in the sphere of labour. A carefully regulated new 'soul' is added to the new Fordized body, a kitsch soul for a machine body. Huxley emphasized that the central feature of the feelie is the kiss. Cinema supplies vicarious eroticism, divorced from pain or tragedy, stability guaranteed by the 'happy end'. Throughout the book, this model of 'distraction' and spectacle is counterposed to Shakespeare's tragedies and to sacred ceremonies: the Hopi snake-dance and the *penitentes* of Acoma.[48] Huxley's alternative was not the epic drama of Brecht and Benjamin but a theatre of implacable cruelty and ritual.

4. The Mass Ornament: Girls and Crisis

A third model of mass culture was put forward by Siegfried Kracauer in his extraordinary essay, 'The Mass Ornament'.[49] Kracauer's central image of art in the age of the engineer was that of the Tiller Girls, a dance troupe that represented for 1920s Berlin the acme of a form of popular entertainment replicated throughout the world, in live shows and on film. Kracauer believed that the Tiller Girls were American, whereas in reality they were an English troupe of lasses from Lancashire, products of the Manchester rather than the Detroit era of manufacturing capitalism.[50] None the less, he saw them as a reflection of Fordism and American mass production:

> Everyone goes through the necessary motions at the conveyor belt. . . . It is conceived according to rational principles which the Taylor system takes to its logical conclusion. The hands in the factory correspond to the legs of the Tiller Girls. . . . The mass ornament is the aesthetic reflex of the rationality aspired to by the prevailing economic system.

In 1931, after the Great Crash, Kracauer looked back on the Tiller Girls in another essay, 'Girls and Crisis':[51]

In that postwar era, in which prosperity appeared limitless and which could scarcely conceive of unemployment, the Girls were artificially manufactured in the USA and exported to Europe by the dozen. Not only were they American products; at the same time they demonstrated the greatness of American production. . . . When they formed an undulating snake, they radiantly illustrated the virtues of the conveyor belt; when they tapped their feet in fast tempo, it sounded like *business, business*; when they kicked their legs with mathematical precision, they joyously affirmed the progress of rationalization; and when they kept repeating the same movements without ever interrupting their routine, one envisioned an uninterrupted chain of autos gliding from the factories into the world.

The mass ornament mirrored the production process of Fordism: a series of formal operations carried out on meaningless parts ('Arms, thighs and other segments are the smallest components of the composition'). These operations produced abstract patterns using the same movements as machines: lines, rotations, repetitions. The Tiller Girls were like Neurath's Isotypes, marshalled in identical lines (as also, Kracauer pointed out, were the spectators in their rows of seats). Kracauer argued that, in the mass ornament, the female body and its component parts were de-eroticized; the body became a pure signifier 'which no longer has erotic meaning'. The apparently human (and sexual) elements were transformed into 'mere building blocks, nothing more'. For Kracauer this dehumanization appeared as a return to abstract nature, as a form of objectification, but it would surely be more accurate to see it as a process of abstract symbolization.

The Tiller Girls reduced the erotic to a set of formal operations, just as logic reduced the rational to a set of formal operations. Indeed the operations and procedure of logic have been not simply formalized but also mechanized. The first steps to this were taken during the early 1930s and it is striking how the early projects for reasoning machines followed the model of the Fordist assembly line. Alan Turing's original concept of a computer developed through imagining a standardized worker (or 'computer') placed before an endlessly moving line (or tape).[52] The procedures performed by the 'computer' were 'to be split up into "simple operations" which are so elementary that it is not easy to imagine them further divided', and which were themselves reduced to a minimum necessary number. 'We may now construct a machine to do the work of this computer', that is, segmented tasks on a moving line. Post, in his parallel speculation, was even more explicit. In his model, a 'worker' would be operating on an endless line of 'boxes' moving in

front of him. This 'worker' was limited to five simple operations, necessary for computation. Thus the computer, the reasoning machine dreamed of by Leibniz, was finally realized on the Fordist model of the assembly line, processing not material commodities but abstract units of information.

Kracauer suggested a way of going beyond the antagonism between Benjamin and Huxley, the endorsement or repudiation of 'distraction' as a functional element within the Fordist system. Kracauer, like Benjamin, rejected the option of going back to traditional forms of art. The way forward 'leads directly through the mass ornament, not away from it', that is, through instrumental reason, not back to irrationality. But he thought that Tiller-esque 'distraction', though a necessary step in the right direction, could provide only a partial answer. Its value lay precisely in the 'emptiness and externality' that were also its limits. The mass ornament exemplified a one-sided, purely formal rationality, like that of the Vienna Circle. It was not a 'full' reason, 'concerned with bringing truth into the world'.[53] Kracauer opposed any attempt to simply add an extrinsic content or 'truth' to the abstract form of the mass ornament. This could only spiritualize or mytholo-gize it in a reactionary way (as Leni Riefenstahl was to do in *Triumph of the Will*). The problem was how to develop a new content, a truth-bearing content, from within formal reason, intrinsically. His utopian dream was of a Fordist rationality that would not be dehumanizing.

The question that we must ask is, perhaps, even more difficult than Kracauer imagined. On the one hand, within the sphere of reason, formal processes of computation, algorithms for the manipulation of symbols, and so on, are separated and cut off from cognitive states, from intentions, wishes, values and desires, from the world. And, on the other hand, both the assemblyline worker and the Tiller Girl are subjected to a segmentation and formalization of the body itself. The problem is that of reintegrating reason not only with truth, but also with the body. The Tiller Girls offered the spectacle of (female) bodies in movement, duplicating the alienated form of the Fordist labour process, its instrumental rationality. What form of bodily movement would correspond to a process of production that displayed a different, transformed rationality – and, of course, a transformed gender division and sexuality?

At the very end of his life, disillusioned by the Hitler–Stalin pact, Benjamin began to rethink many of the basic assumptions of the 1930s. In his

'Theses on the Philosophy of History',[54] his last writing before his death, he looked back sadly:

> Nothing has corrupted the German working class so much as the notion that it was moving with the current. It regarded technological developments as the fall of the stream with which it thought it was moving. From there it was but a step to the illusion that the factory work which was supposed to tend towards technological progress constituted a political achievement. The old Protestant work ethic was resurrected among German workers in a secularized form.

Benjamin went on to contrast this with the formalized utopian conceptions of Fourier, the dream of a new kind of relationship between humanity, technology and nature. This, we might speculate, would require a new reason, not the instrumental reason of utility and the machine as tool but an ornamental reason in which the 'magic force' of the Tiller Girls (no longer 'Girls') was directed to a new form of mass art with the same formal rigour, but with a resituated hedonism and a transformed eroticism. This perhaps would be the 'distraction' typical of a modern Utopia.

By the time when Benjamin was writing 'The Work of Art in the Age of Mechanical Reproduction', Fordism was already entering a new phase. Continued increases in production made it necessary to increase consumption. This development brought with it advertising, packaging, variety marketing, annual changes in model. In the motor industry itself the change was initiated by General Motors, which, under the leadership of Alfred Sloan, introduced styling into automobile design, changing the superstructure, add-ons, and 'look' of their cars every year. Customers were encouraged to trade in their old model in part-exchange for a new one chosen from a range of new models with new looks, launched each year in a blaze of publicity. Fordism gave way to Sloanism.[55] It was no longer possible just to manufacture one basic car, as Ford had done with the Model T. The market (basically the American farm market) was exhausted and new markets had to be developed. Thus marketing began to dominate the production process itself.

The concept of the chorus line, meanwhile, had migrated to the United States. As in Germany, it was first introduced into America by the Tiller Girls themselves, and they long remained pre-eminent, appearing on Broadway shows and for Ziegfeld in the Follies. Eventually, however, American troupes began to take their place and make the form into one that was indeed typically American. The best known of these troupes was the Rockettes, who have

survived right up to the present day, performing at Radio City Music Hall in New York. The Rockettes originated in Kansas City, but when they went on tour they were noticed by the showbiz entrepreneur Samuel Rothafel, known as Roxy, who hired them to appear (as the Roxyettes) on a permanent basis at his showcase New York movie palace (which was also named the Roxy). In early 1933, when the Rockefeller Center was built, Roxy transferred to the new Radio City Music Hall, which was part of the Rockefeller Center development, and brought the Roxyettes with him, enlarging the line to 64 'girls', each between 5 feet 4 inches and 5 feet 7 inches in height. In due course, they were renamed again, in homage to the Rockefellers, as Rockettes.[56]

The Rockefeller Center was the swan song of the twenties skyscraper boom in New York. The Chrysler Building and the Empire State Building had actually been started before the Great Crash, but the Rockefeller Center was launched shortly afterwards, almost as a gesture of defiance on the part of the Rockefeller family. No further developments on anything approaching the same scale and scope were contemplated until after the Second World War, when the era of modernist glass boxes began and continued through the post-war boom. Originally, the Rockefeller Center was to have housed a new building for the Metropolitan Opera House, sanctum of 'old money', but the Great Crash put paid to this high-minded scheme and John D. Rockefeller Jr, whose project it became, turned instead to the new capital of the giant General Electric company and its associate, Radio Corporation of America, who became the centre's major tenants. RCA brought with it the NBC radio studios (and its embryonic television studios) as well as RKO Pictures, which RCA had acquired through its Photophone recording patents during the transformation from silent to sound film. RKO, in turn, placed two cinemas in the development, with Radio City Music Hall as its new flagship.

Thus, the academic beaux-arts form of opera was replaced by the new technological arts of radio, television and sound film, as the putative key to the Rockefeller Center's commercial success. In recognition of this shift, the architects envisaged a modern rather than a beaux-arts complex of buildings. The functionality of the architecture was to be stressed. The central tower of the building was designed to reflect the banks of state-of-the-art high-speed elevators that were its technical core. Thus, the plan of each floor, and the elevation of the building, narrowing towards the top, were determined by the fact that a smaller number of elevator shafts was required for the non-stop

elevators that serviced the uppermost floors. Their more slender outline reflected the fact that only a few of the elevators needed to go non-stop all the way to the top of the building. The Rockefeller Center had originally been intended as an *agora*, a spacious and grandiose central focus for a chaotic, congested New York, as proposed by the City Beautiful movement. Under the commercial pressures caused by the Great Crash, however, its architects were constrained into a series of compromises, toning down their original conception in order to maximize potential income from the site. The *agora* became a real estate development.

The architects concerned were actually a committee put together by Rockefeller and his contractors, in which the dominant figure was Raymond Hood.[57] Hood was best known in New York for his showy commercial architecture, in which he used polychrome stone and metal to add glitz to modernistic buildings that would serve as advertisements for their owners. The McGraw-Hill building, for instance, has the company's name in huge letters at its summit, and Hood also designed the 'iconic' buildings that punned on the shape of commodities they were concerned with: his General Electric refrigerator showrooms were designed in the actual shape of the refrigerators and his Daily News building, an early 'box' with black and white stripes, was immediately likened to a stack of newspapers ready for delivery. At the Rockefeller Center, however, Hood relied on the enormous size of the project, covering several city blocks, to attract attention in itself. Moreover, he was handicapped by the conservatism of John D. Rockefeller Jr, who regretted the disappearance of the opera house and the fine neoclassical façades he had once envisaged.

Eventually, Rockefeller was persuaded to allow the frustrated architects to approach a shortlist of Picasso, Matisse and Diego Rivera to paint a mural for the grand lobby of the RCA building, and when Picasso and Matisse turned the offer down, he reluctantly agreed to Rivera on the grounds that the great Mexican muralist would provide publicity and prestige. In fact, Rivera provided all too much publicity, and scandal rather than prestige. He filled his mural with red flags and marching masses and, as the last straw, included a portrait of Lenin.[58] In the midst of an uproar of anti-communist tirades from the reactionary press and angry defences of artistic freedom from the progressive intelligentsia, Rockefeller and his contractors cancelled Rivera's contract and whitewashed his enormous mural. The lobby returned to its original gloom, adorned now by virtually colourless sepia murals by Brangwyn and

Sert, rather like an opulent funeral parlour, an effect as gloomy as Rivera had warned when (in breach of agreement) he first introduced the bold red of his communist banners. The whole burden of showmanship now devolved into the design on the interiors of Roxy's Radio City Music Hall.

Roxy proved up to the task and the Radio City Music Hall remains the only attraction of this otherwise sombre and pretentious project. Roxy believed fervently in excess. His theatrical career was built on enhancing silent films with musical and theatrical accompaniments and interludes. He put the orchestra on the stage with the film, surrounded by fountains, played coloured lights on the screen, added sound effects and stopped the film during slow passages to add more excitement with a song, a dance or a declamation. As he grew successful, the décor of his cinemas also grew more and more flamboyant as he sought to turn projection of a silent film into an experience more like a Wagnerian opera, a kind of kitsch *Gesamtkunstwerk*, incorporating rather than competing with the threatening new medium of film. The Roxy was an incredible concoction in the lavishly ornamented *plateresque* (or 'Portuguese rococo') style, a monument to antique gorgeousness and mind-boggling extravagance. On the opening night, the show began with a spotlit monk, in medieval garb, who devoutly declaimed, 'Ye portals bright, high and majestic, open to our gaze the path to Wonderland, and show us the realm where fantasy reigns, where romance, where adventure flourish.'[59]

The concerned architects of the Rockefeller Center took Roxy on a European tour to show him the marvels of modernism in Berlin and Moscow: Poelzig's Grosses Schauspielhaus and the constructivist stage. Roxy recognized a new field of opportunity for astonishing the public (after all, there was scant hope of outdoing the Roxy in the historicist mode!) and agreed to let the most modernist of the Rockefeller Center architects, Wallace Harrison, take care of the plans for Radio City Music Hall, while hiring Donald Deskey to control the interior design. Taking into account Roxy's desire to merge the auditorium with the stage and to avoid overhanging balconies, which Roxy felt detracted from the unified communal experience (the 'group contact' and 'mass emotion') of the audience, Harrison designed a single, gigantic egg-like space, with the proscenium arch replaced by a kind of electrical rainbow, which could be played by a 'colour-orchestrator'. The hall would hold more than 6,000 spectators and was so vast that performers on stage appeared like Lilliputians; composite photographs, blowing them up in size, had to be used for the publicity.

Deskey was a vagabond painter who had turned to design, inspired by the Paris Déco Exposition of 1925.[60] He won fame through his windows for Saks Fifth Avenue, his promotion of the steel and wicker tubular chair, and his use of novel and contemporary materials such as corrugated and galvanized iron, stainless steel, cork, bakelite, linoleum, aluminium, vitrolite and transite, an asbestos compound. For Radio City Music Hall, he hired the leading modern artists of the day, Stuart Davis and Georgia O'Keefe, to paint murals for the Men's Smoking Room and the Ladies' Powder Room respectively. Davis's mural, *Men Without Women*, was a triumph, but O'Keefe's was never completed. Tragically, she suffered a breakdown, caused by the stress of working to deadline in a new medium, a stress exacerbated because her companion and mentor, Alfred Stieglitz, was openly and truculently opposed to the project and made every effort to sabotage her.[61]

For the Radio City Music Hall itself, Roxy envisaged a super-showbiz extravaganza, dropping films altogether and expanding the rest of his programme, bringing together custard-pie vaudeville, grand opera, the Wallenda family of aerialists, Louis Armstrong, expressionist ballet, Martha Graham (following a horse act), Eleanor Powell and, of course, the Rockettes. Joseph Losey, who was assistant stage manager on the opening night, has recalled the fiasco:

> The night before the opening, at four o'clock in the morning, we still had not had one complete rehearsal. The gala opening was attended by the Rockefellers in the royal box, and everyone else was there. At two o'clock there was nobody left but the Rockefellers! At three o'clock they had *all* gone home! The show went on till about three thirty. It hadn't been rehearsed, it hadn't been cut, nothing. It was a disaster – absolute disaster.[62]

Within two months Roxy was fired, within a year RKO was bankrupt, within another year the Rockefellers, as creditor landlords, were running the Music Hall themselves and then, by the end of the decade, they were running RKO itself. The Rockefeller Center proved to mark the end of an era in more ways than one. Its downfall began with the craven destruction of Rivera's mural and ended with capitulation to the newspaper proprietor William Randolph Hearst over RKO's *Citizen Kane*, which the Rockefellers were too cowardly to open at the Music Hall, their own flagship cinema. The Rockettes were all that remained, rather like the Beefeaters at the Tower of London or the Swiss

Guards at the Vatican, fossilized and fetishized remnants of a long-gone culture.

Roxy died, Deskey's fame dwindled, Davis and O'Keefe went on to see a new generation of painters eclipse their reputations, although both have since been rediscovered. Only Wallace Harrison continued to thrive under the Rockefeller aegis, becoming the American linkman for the New York triumph of Le Corbusier in the epoch after the Second World War.[63] The International Style in modern architecture became the one school of twenties modernism able to reassert itself after the Depression and the Second World War. Corporate capitalism adopted architectural functionalism as a style of minimal external expression and impersonal anonymity. But whereas instrumental reason banished ornament from the corporate headquarters, it encouraged it in the consumer market. Commodities themselves became increasingly non- or even anti-functional in appearance. Harley Earl, head of the Styling Department at General Motors, annually lowered, lengthened and smoothed out the curves on cars, in a biomorphic naturalization of the angular geometry of the Model T.[64] Eventually streamlining gave way to aerodynamic fantasy and the automobile began to become positively *plateresque*. Similarly the late deco of Busby Berkeley gave way to the smooth fluency of Astaire and Rogers before running riot, after the Second World War, in the musical extravaganzas and dream ballets that Vincente Minnelli and Gene Kelly devised for MGM.

5. The Post-Fordist Spectacle

The Keynesian demand-push transformation of Fordism reached its golden age in the consumer society of the long post-1945 boom. Once again Americanism became identified with the image of the automobile – but now the ornate dream car, the pink Cadillac with tail fins and scallops, the car celebrated by Chuck Berry in his classic rock'n'roll lyrics. This was the car attacked by Vance Packard in *The Waste Makers* precisely for being dysfunctional, a monstrous, gas-guzzling, badly engineered fantasy contraption.[65] Packard excoriated 'pink dinosaurism' and called for a return to historic values: 'Or better still the motorcar makers might try copying some of the features of the Model A Ford, perhaps the most rugged motorcar ever built.' The Model A, with its 'straightforward frame' was 'still getting daily use in North America three decades after it was built'.

Packard's attacks signalled the beginning of the end for Fordism. From being the symbol of instrumental reason in industry, the automobile had become a byword for waste and ornamentation. The economy and culture of the West entered a period of crisis, the decline of Fordism, as consumerism reached the limits possible within the old system. A long transitional period during the 1960s and 1970s finally led to the introduction of a new post-Fordist economy. The first signs of this were already visible in the 1950s, with the beginnings of automation. At that time, automation was seen primarily as a way of rationalizing still further the existing Fordist structures of industry. In reality, we can now see that it prefigured much more sweeping changes in the economy. The rationality of the computer and of robotics turned out to be significantly different from the rationality of the Highland Park assembly line.

Post-Fordism brought three main developments.[66] First, the rise of whole new industries was made possible by advances in electronics and information technology. Second, there was the use of this new technology in the manufacture and design of old products, the upgrading of old industries. Third, there was a systemic shift from the object as commodity to information as a commodity. These changes were initially associated with the shift from smokestack to sunbelt industry, from the manufacturing to the service sector, and with an international shift in the economic relations between centre and periphery: the emergence of a more polycentric world economy accompanied by the appearance of new core economies and a new periphery within the major Western countries themselves, a marginalization of entire zones and sectors. One result of this was the demotion of the automobile industry, the relegation of Detroit to the periphery of American industry.

The communications industry, on the other hand, moved to the centre. Benjamin, writing in the 1930s, was celebrating what was still primarily a nineteenth-century technology. The Lumière brothers, like their American counterpart Edison, or like Henry Ford himself, were typical inventor-entrepreneurs of the period. While it is true that the infant electronics industry had already made its contribution to the coming of sound in the cinema, this was overlooked by Benjamin, who was a protagonist of the silent cinema. Like many avant-garde theorists, he distrusted sound film. Today, we are living in a transformed world in which the cinema itself is fast becoming archaic: an age not so much of 'mechanical reproduction' as of 'electronic intertextuality'. The electronic revolution that began with sound recording

accelerated with magnetic tape and spread into the technology of images with video and television. Now we are moving into an epoch of digitalized image storage and high-definition electronic media.

Most important of all, the invention of the computer, beyond Benjamin's imagination, has transformed the entire field of image production. We are now in the first phase of the period of video–computer integration. In the 1920s Dziga Vertov described the camera as a mechanical eye; now it is the mechanical eye of an electronic brain. Indeed, the camera itself has been transformed. It is now simply one option within a whole range of sensors and information-recording devices, some visual, some non-visual. Images can be produced by means of X-rays, night-vision, thermal, magnetic, electronic spin, and a host of other kinds of sensors. The camera (film or video) is simply the one that still most closely approximates 'natural vision'. Sensors are no longer hand-held or mounted on tripods, with humans attached to them, looking down viewfinders. Their motion and action can be remote-conrolled. They can circle the earth in satellites or transmit from within the human body.

New theories of the image and the media began to appear in the late 1950s and early 1960s, culminating in the work of Marshall McLuhan.[67] Indeed, McLuhan put himself forward explicitly as the theorist of the end of Fordism, a process that – like Gramsci – he saw as the culmination of a logic implicit in typography and the invention of the printing press. Fordism, McLuhan proposed, was the logical end of the Gutenberg era: 'the breaking-up of every kind of experience into uniform units in order to produce faster action and change of form'. Fundamentally McLuhan, like Huxley or Céline, was an opponent of Fordism who saw in the advent of the new electronic technology of the media the possibility of superseding it and reconstructing, on a new basis, the old pre-Fordist (indeed, pre-Gutenberg) 'community' in the form of the 'global village'.

The extraordinary achievement of McLuhan was to break out of the terms of the polemics for and against technology (Benjamin versus Huxley or Heidegger) by fusing romantic reaction with futurist technolatry. With McLuhan you get aspects of both Benjamin and Heidegger. Like Benjamin he privileges the tactile over the visual and dreams of the creation, through technology, of a radically new kind of human being. But like Heidegger he sees the new human being in a quasi-mystical way as a return to origins (back beyond mass production, beyond printing, even further, beyond the alphabet), to a world

without separation, a world of perpetual now-ness. Whatever the incoherence and, indeed, idiocy of many of McLuhan's prophecies and pronouncements, his underlying vision still exerts its fascination.

McLuhan was a visionary writing when the first impact of vast changes was being felt, projecting his own fantasies and hopes onto the new technologies he could partially foresee. We now have a much clearer idea of where those media technologies are leading. Old distinctions are beginning to blur and lose their meaning as the technologies of image production and reproduction begin to merge. The computer with its capacity for manipulation and simulation becomes part of an integrated system with both the old and new recording technologies. We can sum up the main characteristics of the new systems as follows:

1. Access to a database of stored images in the electronic memory. This opens up the possibility of recycling the contents of a vast image bank, an archive from which images can be taken and recontextualized at will. The image bank is more immediate and directly accessible than the 'real world'; it is intra-systemic, whereas the 'real world' is extra-systemic.

2. Immediate manipulation – matting, combination, distortion, alteration, etc – of available images. Images from different sources can be combined together. With motion-control cameras linked by computer, moving imagery from the 'real world' can be combined with other imagery, also from the 'real world' or from the archive, so that there are no discrepancies in speed, point-of-view in combined movement, perspective, or lighting.

3. Generation of images by the computer. The computer can be used to produce animated imagery. Once images are produced they can be stored, retrieved, rotated, textured, etcetera. The computer can also generate text, and consequently opens up new possibilities for the combination of text with images. Computer-generated imagery can itself be combined with other images.

4. Simulation of the 'real world' by the computer. Thus, in Helmut Costard's film *Real Time*, we see computer programmers who produce a visual display of a landscape out of nothing but non-visual, numerical data, which the computer interprets and translates to produce a three-dimensional landscape, through which the viewer can move at will. Today, pioneers of 'virtual reality' are already at work creating a new realm of cyberspace, through which not only can viewers move, but also within which they can react tactilely,

picking up and moving simulated objects. Yet even the most advanced simulations, such as landscape images in flight simulators, are still relatively sparse and schematic. The next areas to be developed include the use of fractal geometry to produce irregular and chaotic forms (also recursive, so that they can be zoomed into without loss of detail), such as we find in nature; improvements in texturing to give greater variation in the surface quality and look of objects; physiognomic analysis to permit the simulation of expressive human facial movements and other types of gesture.

5. Combinations of all the above. Thus imaging can combine the characteristics of the documentary, the studio film, special effects, the animated film and the compilation film. The beginnings of this hybrid imaging can already be seen in many music videos. But this is only a beginning. For instance, we can imagine films in which Charlie Chaplin meets Marilyn Monroe, once their images have been digitalized and the problems of texturing and physiognomic analysis are solved (and copyright problems). Chaplin and Monroe can be taken out of the archive to star in new films with new stories and settings.

6. Further areas of development include holographs and other types of 3-D imagery; interactivity and other types of spectator–image interface; multi-screen systems; new types of transmission and reception, such as optical fibre. These will change not only the nature of imagery but also its patterns of use, as new types and situations of display are introduced. Computer-video imagery could become as ubiquitous as print and photographic imagery are now.

To a lesser or greater degree, the new systems of imagery will be heterogeneous palimpsests. They will combine a number of different types of image (as well as other kinds of sign) and they will refer not only (or not even primarily) to the 'real world' (the extra-textual), but also to the existing archive of images and texts from which they quote (the inter-textual). This does not mean that we will all live in a 'global village' or a ubiquitous 'simulacrum' controlled by a totalizing master code. In effect, these versions of the future (McLuhan, Baudrillard) are contrary projections of a paranoid loss of faith in human reason, a revolt against modernity conceived of as the elevation of instrumental reason to an absolute. McLuhan's optimistic version sees the new technology as heralding the end of Western analytical reason (homogeneous, standardized, linear) and the dawn of a new age, a return to lost pre-Gutenberg values. In contrast, Baudrillard's pessimistic version sees

the new technology as an extension of analytical reason, through which digitalization becomes the final culmination of a process of alienation.

The problem of finding an appropriate aesthetic for the new media is aggravated by the philosophical abyss that has opened up between a logicist rationalism and an anti-logical metaphysics (or 'post-metaphysics'). As we have seen, this split reflects conflicting attitudes to Fordism and the rationality of modern technology and industry. On the whole, aesthetics has been set firmly against Fordism and logicism, in the Romantic tradition, with the outstanding exception of writers such as Benjamin or Brecht, who hoped for a meeting of art and science, mediated by the industrialization of art on 'rational' grounds. Yet the concept of reason at issue here has been a very limited one. In effect, the great advances in logic made possible by Boole's *Mathematical Analysis of Logic* in 1847 transformed not just logic, but the whole of philosophy, cutting aesthetics definitively adrift.[68]

The long-term effect of Boole's work, followed by that of Frege, Russell, and so on, has been to reject art as the sphere of fiction, metaphor, vagueness, nonsense, wordplay, etcetera, all of which fall outside the scope of logical semantics. Conversely, anti-logicist philosophers such as Heidegger proceeded to privilege art and aestheticize philosophy, at the expense of clarity and precision of meaning, running the danger of setting art against analytical reason.[69] The way forward, therefore, must depend on a critique of logicism that is not itself anti-logicist, and a critique of aesthetics that is not itself anti-art. Logic and aesthetics both have their place in the realm of reason.

The first requirement is the development of a heterogeneous theory of meaning, open rather than closed, involving different types of sign, and bringing semantics together with hermeneutics, reference with metaphor. The second is a specific (formal) theory of intertextual meaning, the way in which re-contextualization changes meaning, the double, hybrid coding involved in quoting, plagiarizing, grafting and so on, the back and forth of meaning between texts. Both these projects entail a reconsideration of the logical form of meaning. In the last resort, both logic and aesthetics are concerned with form. The computer is itself, of course, the end product of the triumphal march of mathematical logic. It would be an ironic resolution to the divide between science and art if the formalism of machine code was used to generate new artistic forms that themselves made possible the transformation of reason, thus finally closing the gap between logic and aesthetics.

Notes

1. The first jazz band to reach Europe was the Original Dixieland Jazz Band, which toured in 1918. For a fascinating account of the impact jazz made in the Soviet Union see Frederick Starr, *Red and Hot* (Oxford: Oxford University Press, 1983). As for England, Clive Bell protests against the jazz cult in his 'Plus de jazz', in *Since Cézanne* (New York: Harcourt Brace, 1922). On *Amerikanismus*, see John Willett, *The New Sobriety* (London: Thames & Hudson, 1978).

2. Schlemmer is cited in Willett, *The New Sobriety*.

3. Pirandello is cited in Antonio Gramsci, 'Americanism and Fordism', *Prison Notebooks* (London: Lawrence & Wishart, 1971).

4. Mario Verdone and Barthélemy Amengual, *Le Feks* (Paris: SERDOC, 1970).

5. The best short account of Taylor's work and influence is still in Siegfried Giedion, *Mechanization Takes Command* (Oxford: Oxford University Press, 1948). Giedion reproduces examples of chronophotography by Taylor's disciple Frank B. Gilbreth, which can be compared with those used by Gastev, shown in René Fülöpp-Miller, *The Mind and Face of Bolshevism* (London: G.P. Putnam's Sons, 1927). For Taylor, see also the portrait in John Dos Passos, *The Big Money* (New York: Harcourt Brace, 1936), and for Gastev, see Christina Lodder, *Russian Constructivism* (New Haven, Conn.: Yale University Press, 1983).

6. See Sergei Komarov's astonishing film *Mary Pickford's Kiss* (USSR: 1927).

7. Frederick Taylor, *Principles of Scientific Management* (New York: Harper, 1911). See also Michael O'Malley, *Keeping Watch, A History of American Time* (Penguin: New York, 1990).

8. For Fordism, see Henry Ford, *My Life and Work* (London: Heinemann, 1923) and Giedion. The concept of Fordism as an economic system of production is developed in Emma Rothschild, *Paradise Lost: the decline of the auto-industrial age* (New York: Random House, 1973), Michel Aglietta, *A Theory of Capitalist Regulation* (London: Verso, 1979), and Alain Lipietz, *Mirages and Miracles* (London: Verso, 1987).

9. Matthew Josephson, 'Made in America', *Broom*, no. 2 (June 1922). Cited in Dickram Tashjian, *Skyscraper Primitives* (Middletown: Wesleyan University, 1975).

10. Gramsci, 'Americanism and Fordism'. The preface to the English edition of *Prison Notebooks* contains a detailed bibliographic account of the notebooks by the editors, Quintin Hoare and Geoffrey Nowell Smith.

11. Chaplin describes the origin of *Modern Times* (USA: 1936) in *My Autobiography* (London: Bodley Head, 1964): 'Then I remembered an interview I had with a bright young reporter on the New York *World*. Hearing that I was visiting Detroit, he had told me of the factory-belt system there – a harrowing story of big industry luring healthy young men off the farms who, after four or five years of the belt system, became nervous wrecks.'

12. Louis-Ferdinand Céline, *Journey to the End of the Night* (1932) (London: Chatto & Windus, 1934).

13. Rudolf Carnap, 'The Elimination of Metaphysics Through Logical Analysis of Language', in A. J. Ayer (ed.) *Logical Positivism* (Glencoe: Free Press, 1959). This essay was largely directed against Heidegger's inaugural address at Freiburg University, published in 1930 under the title 'What is Metaphysics?' See Martin Heidegger, *Basic Writings* (New York: Harper & Row, 1977).

14. R. S. Cohen, 'Dialectical Materialism and Carnap's Logical Empiricism', in Paul Arthur Schilpp (ed.), *The Philosophy of Rudolf Carnap* (LaSalle: Open Court, 1963).

15. Rudolf Carnap, 'P. F. Strawson on Linguistic Naturalism', in *Logical Positivism*.

16. See Otto Neurath, *International Picture Language* (1936) (Reading: Reading University, Department of Typography & Graphic Communication, 1980) and Michael Twyman (ed.), *Graphic Communication through ISOTYPE* (Reading: Reading University, Department of Typography & Graphic Communication, 1975). Neurath's text is written in Basic English. I am indebted to Victor Burgin for these references.

17. See Gerd Arntz, *De tijd onder het mes* (Nijmegen: SUN, 1988).

18. See Neurath; and Christopher Green, 'Léger and L'Esprit nouveau', *Léger and Purist Paris*, Tate Gallery

catalogue (London: Boston, 1970). Green points out that the Egyptian rooms at the Louvre were reopened at the pertinent time for them to have influenced Léger.

19. Walter Benjamin, *Moscow Diary* (Cambridge Mass.: Harvard University Press, 1986). Benjamin sought a way between the Scylla of Carnap and the Charybdis of Heidegger.

20. Aldous Huxley, *Brave New World* (London: Chatto & Windus, 1932). Theodor Adorno wrote an important critique of Huxley's book, 'Aldous Huxley and Utopia', in *Prisms* (London: Spearman, 1967).

21. Among the sources for Huxley's vision of the Savage were D. H. Lawrence's letters, which Huxley was editing, and William Seabrook's accounts of his travels. When Seabrook was a neighbour of Huxley in Sanary, Huxley noted that 'the rumour has gone round the village that he beats his ladyfriend' (letter to the Vicomte de Noailles, November 1932, in Grover Smith (ed.), *Letters of Aldous Huxley* (London: Chatto & Windus, 1969)). For further details of Seabrook and sado-masochism, see Vèvè A. Clark et al., *The Legend of Maya Deren* (New York: Anthology Film Archives, 1984), and Man Ray, *Self Portrait* (New York, Deutsch, 1963).

22. Karel Capek, *R.U.R.* (London: Doubleday Page, 1923). On robots, see Jasia Reichardt, *Robots* (London: Thames & Hudson, 1978); also John Cohen, *Human Robots in Myth and Science* (London: Allen & Unwin, 1976), and his later *The Lineaments of Mind* (Oxford: W.H. Freeman, 1980).

23. Capek.

24. Ford.

25. Cited in Edmonde Charles-Roux, *Chanel and her World* (London: Weidenfeld & Nicolson, 1981).

26. See Reichardt; and Cohen, *Human Robots*.

27. Mary Shelley, *Frankenstein* (1818) (Oxford: Oxford University Press, 1969); E.T.A. Hoffmann, 'The Sandman' (1816), in *Tales of Hoffmann* (Harmondsworth: Penguin, 1982); Villiers de L'Isle Adam, *L'Eve future* (1886) (Paris: Fasquelle, 1921). Hadaly is the robot in *L'Eve future*.

28. See Frank Whitford, *Oskar Kokoschka, A Life* (New York: Atheneum, 1986), Peter Webb, *Hans Bellmer* (London: 1985), and Hans Bellmer, *Photographe* (Paris: Centre Georges Pompidou, 1983).

29. Raymond Bellour, 'Ideal Hadaly', *Camera Obscura*, no. 15 (fall 1986). Annette Michelson, 'On the Eve of the Future: the reasonable facsimile and philosophical toy', in *October*, no. 29 (1984), reprinted in A. Michelson, R. Krauss, D. Crimp and J. Copjec (eds), *October: The first decade 1976–1986* (Cambridge Mass.: MIT, 1987).

30. Fritz Lang, *Metropolis* (1926) (London: Lorrimer, 1973). See also Fritz Lang, *Metropolis: images d'un tournage* (Paris: 1985).

31. Andreas Huyssen, *After the Great Divide* (Bloomington: Indiana University Press, 1986).

32. Roger Dadoun, 'Metropolis: mother city – "Mittler" – Hitler', in *Camera Obscura*, no. 15 (fall 1986). Sigmund Freud, 'The "Uncanny" ' (1919), in *The Standard Edition of the Complete Psychological Works of Sigmund Freud*, vol. 27 (London: Hogarth Press, 1955).

33. Patricia Mellenkamp, 'Oedipus and the Robot in Metropolis', *Enclitic*, vol. V, no. 1 (spring 1981).

34. Rudolf Carnap, 'The Elimination of Metaphysics'.

35. El Lissitsky, 'The Electrical-mechanical Spectacle' (1923) *Form*, no. 3 (Cambridge: 1966). See also 'Americanism in European Architecture' (1925) in Sophie Lissitsky-Kuppers, *El Lissitsky* (London: Thames & Hudson, 1968).

36. Walter Benjamin, 'The Work of Art in the Age of Mechanical Reproduction' (1936), in *Illuminations* (New York: Schocken, 1968). See also Susan Buck-Morss, *The Origin of Negative Dialectics* (Cambridge, Mass.: MIT, 1977) and *The Dialectics of Seeing* (Cambridge, Mass.: MIT, 1989).

37. Walter Benjamin, 'Surrealism' (1929), in *One Way Street* (London: Verso, 1979).

38. Walter Benjamin, 'The Author as Producer' (1934), in *Reflections* (New York: Harcourt Brace Jovanovich, 1978). See also Louis Aragon, *Paris paysan* (1925) (London: Cape, 1971).

39. Bertolt Brecht, Afterword to *Mahagonny* in John Willett (ed.), *Brecht on Theatre* (New York: Hill & Wang, 1964). Brecht's liking for logical positivism did not please Benjamin. For how they avoided a quarrel on this subject, see Benjamin, 'Conversations with Brecht', in *Reflections*.

40. Walter Benjamin, 'On Some Motifs in Baudelaire' (1939), in *Illuminations*.

41. Benjamin, 'Work of Art'.

42. According to Céline, the doctor at Highland Park 'confided to us that what they really wanted was chimpanzees'. See Louis-Ferdinand Céline, 'La Médecine chez Ford', *Oeuvres Complètes*, vol. 1 (Paris: 1962).

43. Ilya Ehrenburg, *The Life of the Automobile* (1929) (New York: Urizen, 1976).

44. Benjamin, 'On Some Motifs in Baudelaire', in *Illuminations*.

45. Bertolt Brecht, Notes on *The Threepenny Opera*, in Willett.

46. Huxley's negative attitude towards 'stability' parallels Gramsci's positive attitude to 'equilibrium'.

47. Brecht, Afterword to *Mahagonny*, in Willett.

48. For Huxley's own observation of American Indian ceremonies, see Sybille Bedford, *Aldous Huxley* (London: Chatto & Windus, 1973).

49. Siegfried Kracauer, 'The Mass Ornament' (1927), *New German Critique*, no. 5 (spring 1975).

50. See Derek and Julia Parker, *The Natural History of the Chorus Girl* (Newton Abbott: David & Charles, 1975).

51. Siegfried Kracauer, 'Girls und Krise', *Frankfurter Zeitung*, no. 27 (May 1931). See also Patrice Petro, 'Modernity and Mass Culture in Weimar', *New German Critique*, no. 40 (winter 1987), and Sabine Hake, 'Girls and Crisis: the other side of diversion', in the same issue, which also contains Miriam Hansen, 'Benjamin, Cinema and Experience'. These three articles are indispensable contributions to these debates.

52. See Andrew Hodges, *Alan Turing, The Enigma of Intelligence* (New York: Simon & Schuster, 1983).

53. Kracauer, 'The Mass Ornament'.

54. Walter Benjamin, 'Theses on the Philosophy of History', in *Illuminations*.

55. See Rothschild.

56. For a detailed account of the Rockefeller Center and the Rockettes, see Alan Balfour, *Rockefeller Center* (New York: McGraw Hill, 1978) and Carol Herselle Krinsky, *Rockefeller Center* (New York: Oxford University Press, 1978). For an especially provocative critique of the Rockefeller Center, including the role played by the Rockettes, see Rem Koolhaas, *Delirious New York* (New York: Oxford University Press, 1978). Robert Stern, Gregory Gilmartin and Thomas Mellins, *New York 1930* (New York: Rizzoli, 1987) is also essential reading. Edwin Denby's essay 'The Rockettes and Rhythm', in Denby, *Dance Writings* (New York: Knopf, 1986) gives a leading dance critic's point of view.

57. On Hood, see Walter H. Kilham, *Raymond Hood, Architect* (New York: Architectural Book Publishing, 1973), which is particularly detailed on Radio City, and Robert Stern, *Raymond M. Hood* (New York: Rizzoli, 1982).

58. See especially, Irene Herner de Larrea, *Diego Rivera, paraiso perdido en Rockefeller Center* (Mexico City: Edicupes, 1986) and Lucienne Bloch, 'On Location with Diego Rivera', *Art in America*, February 1986.

59. For the Roxy, see Stern, Gilmartin and Mellins.

60. For information on Deskey, see [Gilbert Seldes], 'The Long Road to Roxy', *New Yorker*, 5 February 1933, and David Hanks, *Donald Deskey* (New York: Dutton, 1987).

61. On Davis, see especially Lowery Stokes Sims, *Stuart Davis, American Painter* (New York: Metropolitan Museum of Modern Art, 1992) and, on O'Keefe and her travails, Laurie Lisle, *Portrait of an Artist: a biography of Georgia O'Keefe* (Albuquerque: University of New Mexico Press, 1986). Lisle stresses Stieglitz's role in O'Keefe's breakdown, while others put more weight on her deadline problems, which became tighter not through any fault of her own, but because the plaster kept peeling off the walls.

62. Michel Ciment, *Conversations with Joseph Losey* (London: Methuen, 1985).

63. Harrison chaired the committee to which Le Corbusier submitted his design for the United Nations Building and then adapted the design. This was built on Rockefeller-donated land. An *agora* for the world or a memorial to Roxy?

64. See Stephen Bayley, *Harley Earl and the Dream Machine* (London: Weidenfeld & Nicolson, 1983).

65. Vance Packard, *The Waste Makers* (New York: D. McKay, 1960). See also Stephen Bayley, *Sex, Drink and Fast Cars* (London: Faber, 1986).

66. See Aglietta; and Lipietz.

67. Marshall McLuhan, *The Gutenberg Galaxy* (London: Routledge & Kegan Paul, 1962) and *Understanding Media* (New York: McGraw Hill, 1964). See also Jonathan Miller, *McLuhan* (London: Fontana, 1971), for an incisive and informed critique of McLuhan.

68. George Boole, *The Mathematical Analysis of Logic* (1847) (New York: Barnes and Noble, 1948). Boole was the first to produce a workable calculus of logic on the model of algebra. He is thus the founder of modern symbolic logic. See Stephen K. Land, *From Signs to Propositions* (London: Longman, 1974).

69. For Heidegger's comment on 'the electronic brain' as the irresistible outcome of logic, see Martin Heidegger, *What Is Called Thinking* (1954) (New York: Harper & Row: 1968).

THE TRIUMPH OF AMERICAN PAINTING: 'A ROTTEN REBEL FROM RUSSIA'

1. Solitude is at the Heart of all Creation

The triumphs of American painting after the Second World War were predicated on the greatness of Jackson Pollock. Once Pollock was recognized, the way was cleared for the consolidation of the New York School, whether around the idea of 'action painting' or, alternatively, 'abstract expressionism'. Yet Pollock had very little in common with the 'colour field' painters who made up the main body of the abstract expressionists. On the contrary, it is much more enlightening to see Pollock as an artist whose work ran parallel to that of Francis Bacon in England and Jean Dubuffet in France, other artists whose paintings, in Clement Greenberg's phrase, were 'not afraid to look ugly'.[1] Both Bacon and Dubuffet can be seen as exceptionally powerful but idiosyncratic painters who were formed in the darker recesses of the surrealist penumbra. None of them were Surrealists in the strict sense of the word, but each of them was crucially influenced by surrealist theories and practices: the importance of images drawn from the unconscious, the value of chance procedures and 'psychic automatism', a distrust for over-polished technique (which could extend to an admiration for the art of the naif, the child or the madman), a pronounced taste for horror and disintegration, an apocalyptic cast of mind.

Bacon shared with Pollock a fascination with metamorphosis, the ways in which one image could transmute into another, a fascination with the cancellation and obliteration of images during the process of painting. Pollock traced a dense web of spattering and cascading paint in a series of multiple 'passes' over the canvas, each one changing and, as Pollock put it, 'veiling' what had gone before. Bacon used a very big brush, overloaded with paint, and tried to suppress his 'conscious will' as he worked, painting and over-painting, then sponging and smearing images out with a rag when they

looked too facile or realistic, in order to see what new 'appearances' would emerge from the magma. Like Pollock, Bacon saw painting as being 'mediumistic'.[2] He sought to paint in a state of trance – whether through being drunk or preoccupied or angry at his own work – to create images that, through accidental effects, through 'non-rational marks', would 'come across directly onto the nervous system' rather than 'tell you the story in a long diatribe through the brain'. Both Bacon and Pollock were directly influenced by surrealism, by André Breton's celebration of the creative role played in art by accident and by the unconscious. Pollock was invited to participate in Breton's First Papers of Surrealism show in New York, but declined. Bacon, then unknown, submitted work to the London exhibition of surrealism in 1936 but it was rejected, after a studio visit by Roland Penrose.[3] As far as I know, Pollock was completely unaware of Bacon's painting. Bacon, of course, knew Pollock's work, after his international success, although he criticized it on the grounds that Pollock did not return to the image in the end, using chance procedures, trance and the unconscious to produce indecipherable marks and trails, rather than following through to the discovery of new, unpremeditated images, created by the paint itself.

Bacon lived in Paris during the thirties, where he acquired copies of Georges Bataille's journal *Documents*.[4] As Dawn Ades points out, Bacon dwelt on the same imagery as Bataille, the slaughterhouse and the screaming mouth, images of disturbing monstrosity. Bacon's recasting of surrealism was similar to Bataille's. It was materialist, honouring the mole grubbing in the earth, rather than the eagle soaring above, which Bataille associated with Breton's visionary romanticism. It prized the *informe*, the shapelessness which characterizes excrement and putrefaction. Not only the rational self but, in Martin Jay's phrase, 'the integral form' of the human body, paragon of Renaissance art, was laid open to 'anti-idealizing distortion'.[5] Bacon was also a friend of the dissident surrealist ethnographer and writer, Michel Leiris, whose portrait he painted. Leiris became a colleague of Bataille and contributor to *Documents*. Leiris's article on Picasso, illustrated by reproductions of Picasso's most surrealistic paintings was followed immediately by Bataille's own article on 'Freaks', accompanied by engravings of Siamese twins. Leiris called his writings *biffures*, or 'scratchings-out', and this idea too has an affinity with Bacon's own cancellation of the image in an effort to conjure the paint into reshaping itself as something unpremeditated and other.[6] Bacon,

like Pollock, never used a preliminary sketch, but melded sketching and painting into one continuous process.

Dubuffet was never a surrealist, but his fascination with *art brut* (or 'outsider art') echoed the surrealist preoccupation with the art and writing of the insane and the untrained. Dubuffet collected outsider art and aimed to transpose its rawness and brutality into his own painting, through his use of graffiti and children's drawings. As Greenberg noted, there was something *lumpen* about his work, an assault on hierarchy from beneath.[7] Dubuffet stressed that the search for a personal means of expression was in no way dependent on culture, skill or instruction. Totally untrained and academically unskilled artists could produce work that was exceptional in its force, fanaticism and idiosyncracy. Dubuffet himself had been to art school, as had Pollock (although Bacon had not) and, when he returned to painting after working as a wine merchant, Dubuffet saw his academic training as a negative rather than a positive benefit, as when Pollock spoke of his years under the sway of his own teacher, Thomas Benton, as 'something against which to react very strongly, later on'.[8] Similarly, like Bacon and Pollock, Dubuffet saw his paintings as emerging from their materials and their textures. He left 'mistakes' in his work and treasured clumsy effects that 'spoiled' the picture. He believed in the effects of 'profuse serendipity', of trying to stay 'on the borderline of the foulest and most wretched daubing and of the little miracle'.[9]

Pollock was keenly aware of Dubuffet's work. Although they never met, there were personal ties between Dubuffet and Pollock, mediated through their mutual friend Alfonso Ossorio, a Filipino artist from a rich family who collected their work and became a close friend of both.[10] It was Pollock himself who first suggested to Ossorio that he should contact Dubuffet on a visit to Paris in 1949. Ossorio, in turn, spoke about Pollock's work with Dubuffet, just as he had discussed Dubuffet's with Pollock. Pollock admired the Dubuffet paintings that Ossorio owned and in 1951 he saw Dubuffet's latest New York show and wrote to Ossorio that he 'was really excited'. Each knew and respected the work of the other, although when Ossorio brought Dubuffet to meet Pollock, Pollock decided it was better to disappear for the evening.[11] Pollock was surely influenced by Dubuffet's fascination with surface textures (walls, the ground, table tops) and non-painterly materials, mixing sand, gravel, tar, varnish, coal dust, pebbles and broken glass with enamel paint. Works using these techniques were exhibited in Paris in May,

1946, under the name, Mirobolus, Macadam & Co, and a selection was shown in New York in early 1947, where it was favourably reviewed by Greenberg, who noted the similarity of these paintings in some respects to Pollock's work. Pollock himself began to add found materials to paint, the results of his beachcombing, as in *The Wooden Horse* (1948), which includes a wooden horse's head, and *Number 29* (1950) which includes pebbles, string, shells and wire mesh. Like Dubuffet, Pollock was fascinated by the 'counter-current' and 'polarization' between materials, with their own 'body', and images, which through painting were given an alien body, with either a destructive or a revelatory effect.[12]

In November 1949, Pollock stayed in Ossorio's New York apartment, which was hung with Dubuffets and Ossorio's own work, densely packed paintings in wax, ink and watercolour, often classed as surrealist, but tending towards the grotesque and *art brut*. The French critic Michel Ragon categorizes Ossorio's work as 'visceral surrealism'.[13] Ossorio had already bought *Number 5* (1948) and later bought a number of other Pollock paintings, including one of the most famous, *Lavender Mist* (1950), the only one sold in his 1950 show. Ossorio wrote the catalogue essay for Pollock's 1951 'black and white pourings' show, and organized his first exhibition in Paris for him, through friends of Dubuffet. From 1952 on, Ossorio housed the famous collection of *art brut* assembled by Dubuffet, Breton and others. He was now Pollock's neighbour in Long Island and Pollock must have seen the work frequently on his visits to Ossorio's home. This was the collection shown in Paris in 1949 under the title, Art in the Raw Preferred to Cultural Arts. There were over a thousand pieces, including mediumistic drawings, paintings by the insane, shell masks, drawings of kitchen refuse, every kind of strange carving, automatic drawing and mystic nightmare, created by shoemakers, postmen, hairdressers, etcetera. Ossorio began to turn his house into a museum–shrine of bizarre found objects, which reminded visitors of the Watts Towers or the Palais Idéal of the postman Cheval. Ossorio saw the affinities between the art of the 'outsider' and that of increasingly established artists such as Dubuffet, Pollock and himself, working in the field of chance, compulsive dream and assemblage.

Pollock was himself a strange hybrid of professional and outsider. Deeply disturbed, driven by raging drives and obsessions, alcoholic, abusive to women, violent to the point of endangering life, confused about his own sexuality, determined to be an artist while unable to draw with any facility or

expertise, verbally inarticulate and a lifelong rebel, Pollock had some affinity with those untrained or demented outsider artists who cover every inch of the drawing surface with intricate doodles and endless curlicues. Greenberg later noted similarities between Pollock's work and that of the naive artist Janet Sobel. [14] As David Maclagan has pointed out, the doodle (Pollock's own word to describe his work) is connected with 'many of the crucial features of modernism – psychoanalysis, abstraction and Art Brut, to name but a few.' [15] He traces this nexus in the relationship between the 'meta-doodles' of high art, outsider art and art therapy. The 'meta-doodle' gives a public dimension to a form that is essentially private, an expression of the solitude that, Maclagan observes, 'is at the heart of all creation'. It intensifies the paradoxical relationships 'between solitude and communication, automatism and non-intentionality and the inarticulate and the figurative'. It is not too difficult to see Pollock's work within this nexus, with its debt to the surrealists and Klee, its therapeutic dimension and its echoes of the deranged artists featured in Prinzhorn's famous collection Artistry of the Mentally Ill, the starting point for Dubuffet's own interest in the art of the insane.

Pollock, on the other hand, was also a trained painter, who had enjoyed a particularly heterogeneous and vivid set of experiences as a student or disciple, a devil's brew that had either to make or to break him. Pollock came from Los Angeles, where he studied art, and most of his life he remained close not only to his elder brothers, who also struggled to become artists, but also to a group from his generation of school friends: Philip Guston (then Goldstein), Harold Lehman, Reuben Kadish and Manuel Tolegian. In New York, where Pollock continued his studies, he aligned himself with the thirties' mural-painting movement, both through his teachers, Thomas Hart Benton, Job Goodman and David Alfaro Siqueiros, and through his own admiration for Mexican mural painting in general, especially the work of José Clemente Orozco. Eventually, he broke out from the influence of the Mexicans and of his teachers, through the impact of surrealism. The Chilean surrealist Roberto Matta Echaurren served as yet another mentor, but one whose influence released rather than constrained Pollock. When he found himself as a painter, it was after years of humiliation and, throughout the Depression thirties, gruelling poverty and recurrent crises of confidence. If there was an American analogue to the career of Pollock, it was that of Louise Nevelson, who similarly struggled for years without recognition and underwent, as a woman artist, even more hurtful humiliation. [16] If he was dismissed as a drunken

bum, she was considered a party girl. She too wanted at first to be a mural painter, under Rivera's influence. Her breakthrough circus sculptures of the forties, provoked by her own interest in outsider art, were insulted at the time, and it was not until the fifties that she was finally accepted. She was the only other American artist admired by Dubuffet, a compliment she too was happy to return.

2. 'A Rotten Rebel from Russia'

At the time of the Great Crash, Jackson Pollock was seventeen years old. Born in 1912, he was considerably younger than most of the abstract expressionists with whom he was later grouped, even though he was the first to be nationally and internationally acclaimed, the first to 'break the ice', as de Kooning was to put it.[17] For his generation, the Great Crash and the subsequent Depression dominated their early adult years. Pollock came from a troubled and nomadic family, one of the many which left the heartland state of Iowa because of the collapse of the agricultural economy and headed west to California.[18] His father, Roy, was a lifelong socialist, a supporter of Eugene Debs and the Wobblies, who celebrated the victory of the Russian Revolution. Roy Pollock eked out a precarious living in a series of transient jobs. He was happiest working as an independent smallholder in Arizona, growing alfalfa and keeping dairy cows on a twenty-acre plot, but was forced out of this occupation too by his business inadequacies and the shift from alfalfa to cotton in the local economy. Soon afterwards the marriage split apart, and in 1924 his wife Stella took the five boys (Jackson was the youngest) and set up home on the outskirts of Los Angeles. Roy drifted from job to job but continued to send money to support the family. Jackson's eldest brother, Charles, ten years older than him, was already enrolled at the Otis Art Institute in Los Angeles, from where he sent copies of *The Dial* back to his family, containing, for instance, the first publication of *The Waste Land* and reproductions of work by Picasso, Matisse and Brancusi. In 1926 he left for New York to pursue his career as an artist.

In Los Angeles, Pollock became a student at Manual Arts High School, but his education was stormy and troubled. In 1929, he was twice expelled (for leading a school uprising and for coming to blows with the football coach) and twice readmitted. During his time out of school he went to Communist Party meetings and to sit at the feet of Krishnamurti, the theosophist sage, in his

community at Ojai, in the nearby mountains. As he noted, 'The whole outfit [at school] think I am a rotten rebel from Russia. I will have to go about very quietly for a long period until I win a good reputation.'[19] But Pollock never went about quietly. Throughout his life he got involved in various kinds of radical and disruptive activity and endless fist-fights and brawls, as well as retaining an interest in the occult. After a brief stint at Otis Art School, he left Los Angeles to join his elder brothers in New York, where both Charles and Frank were studying painting under Thomas Hart Benton. The impetus came principally from the obviously gifted eldest son, Charles, who provided the model of a career as an artist for his siblings, first Frank, then Sande, then Jackson. Similarly, all the Pollock brothers became involved in labour politics, one of them in the Communist Party. Right to the end, Pollock's immediate family could not grasp how it happened that Jackson, and not Charles, became the great painter.

Charles's choice of Benton as a teacher followed logically from his background and his political interests. (Charles later became an artist for the Auto Workers' journal in Detroit during their heroic period of militancy towards the end of the thirties, the period of sitdown strikes and pitched battles which forced the anti-union automobile bosses, even Ford, into capitulation). Benton came from the Midwest and he was the closest thing the United States had produced to a muralist in the Mexican tradition. At the end of the First World War, Diego Rivera, then in Paris, had broken with cubism and returned to Mexico; there he, Orozco and Siqueiros, *los tres grandes*, had launched the movement of mural painting that became known as the Mexican Renaissance. Stylistically, the Mexican painters combined European, pre-Columbian and Mexican vernacular influences to express the spirit of national resurgence and the revolutionary aspirations of the new regime. They returned in an antiquarian spirit to the early Italian tradition of fresco painting, which they associated with the newly discovered Mayan frescoes at Chichen-Itza and the street murals painted, like inn signs, on the walls of *pulqueria* bars. At the same time they fused these influences with European modernism to create an accessible contemporary style. All three were on the left politically and both Rivera and Siqueiros helped to found the Mexican Communist Party.[20]

When he left Los Angeles for New York in September 1930, Pollock already knew that Benton was working on a series of murals which he had been commissioned to paint, along with Orozco, at the independent New School

for Social Research. This was an adult education centre, founded after the First World War by a group of progressives and radicals, such as Thorstein Veblen, John Dewey and the historians Charles and Mary Beard. The impetus came from the firing of professors at Columbia University who had been accused of subversion and disloyalty during the First World War. The New School for Social Research was intended to provide an independent haven and forum for radical and nonconformist ideas. The college had made plans to transfer to a pioneering new building in the modern style, the first in the city, designed by the architect and stage designer Joseph Urban, and completed at the end of 1930. Alvin Johnson, the director of the college, asked each painter to 'paint a subject he regarded as of such importance that no history book written a hundred years from now could fail to devote a chapter to it'.[21] Benton chose the theme *America Today*, and planned an epic depiction of the development of productive forces throughout the United States in ten panels. He took nine months to paint them and they were formally finished in January 1931. Benton was a former Marxist and Communist voter who, at this time, was still a socialist. Whatever his relation to orthodox Marxism, *America Today* was painted within a militantly collectivist–productivist framework, both in its ideology and in its iconography.

Immediately after completing the New School murals, which remain his major work, Benton did the illustrations for a book by his close friend Leo Huberman, a socialist history of the United States called *We, the People*.[22] Huberman went on to become an editor of the Marxist *Monthly Review*, along with Paul Baran and Paul Sweezy, and was a leading figure on the Marxist left throughout the sixties. In the New School murals, which presumably reflect Huberman's thinking, the United States is divided into regions, each with a different historical trajectory and a specific socio-economic structure: Deep South, Midwest and Changing West on one wall and, opposite, different facets of the North – City Building, Steel and Coal. Huberman's book similarly divided the United States into the South, the North, the Frontier and the Far West, each with its own pattern of property relations, sectors of production and forms of labour. Benton's murals celebrate the productive energy of labour combined with technology, but also depict the misery and hard conditions of work for dirt farmers or miners. Significantly, Benton's native Midwest is depicted most optimistically, as closer to nature, its workers more confident; the final panels devoted to New York show a demoralized city absorbed in leisure and fun (burlesque shows, boxing

matches, Coney Island, movies, speakeasies, the Salvation Army, crowded subways) rather than productive labour. Soon after their collaboration, Huberman broke with Benton after a political disagreement and never spoke to him again. Benton's slide to the right was underway, aggravated by his pugnacious boosting of the Midwest as the real America and his increasing, near-pathological distaste for the corrupted city.

In September 1930, while Benton was still working on these murals, Jackson Pollock arrived from Los Angeles along with his brothers Frank and Charles, who were returning to New York after a visit home. All four brothers were personally close to Benton, not only taking his classes at the Art Students League but also mixing with him socially out of class hours. Benton found Charles a job teaching art at the progressive City and Country School, where Jackson worked as a janitor, and Charles's wife Elizabeth is portrayed in the last panel of the New School mural, where she can be seen in a cinema watching a movie. Jackson also posed for the mural, but as a model rather than a portrait subject, posing as a hillbilly musician playing the harmonica. (Benton was a great country music enthusiast and formed a group, The Harmonica Rascals, featuring himself, as well as Charles and Jackson, who played the mouth harp.) Soon Jackson was virtually adopted by the Bentons, who found ways to support him financially and treated him like a family member. When Benton finally left New York for Kansas City in 1935, Pollock broke down and embarked on a frenzy of heavy drinking. His old Los Angeles friend and fellow Harmonica Rascal, Manuel Tolegian, wrote to Benton that, 'when you and Rita left New York, he took to heavy drinking, even spoke to me of suicide a number of times'.[23]

Pollock's interest in mural painting was already well established before he came to New York. California was the first beachhead in the United States for *los tres grandes*, who wanted to carry their revival of the art of mural painting in Mexico north of the border, and enthusiasm for mural painting was consequently strong in Los Angeles from an early point. Pollock had read the special number of *Creative Art* on the Mexican muralists in 1929 (recommended to him by Charles), and had been out to Pomona College to watch Orozco at work on his *Prometheus* in the spring of 1930. In New York he would keep a reproduction of *Prometheus* pinned to his studio wall. Later he went to watch both the other great Mexican muralists at work: Siqueiros in Los Angeles in 1932 and Rivera at the Rockefeller Center in New York in 1933. In 1936, Siqueiros came to New York for a prolonged stay and Pollock joined

his Experimental Workshop, where with Reuben Kadish, Harold Lehman and Pollock's brother, Sande, he worked on fresco projects. Sande had already worked with Siqueiros on a mural in Los Angeles in 1932, along with Philip Guston and Reuben Kadish, Jackson's old schoolfriends. Guston and Kadish themselves went down to Mexico to paint a mural in Morelia in 1934, and Guston in time became one of the most successful Federal Art Project muralists in the United States.

3. Art for the Millions

Whereas in Mexico the mural movement reflected the revolution, in the United States it was precipitated by the Great Crash, which destroyed the expanding art market of the twenties and drove artists into the ranks of the unemployed. The Great Crash and the subsequent Depression destroyed beliefs that American technology was immune from the contradictions of capitalism. Indeed, liberal capitalism on the American model was soon challenged globally both by the alternative Stalinist model of centralized five-year plans and by the rise of Nazism in Germany, with its promise of a dynamic corporative-statist regime. In the United States itself, the discrediting of Hoover and the election of Roosevelt in 1932 led to the epoch of the New Deal and a series of inconclusive experiments with central planning, corporate consolidation and eventually Keynesian welfarism.[24] Not until the Second World War, more than thirteen years after the Great Crash, did the American economy recover its dynamism. The thirties led to an increased politicization of artists and, at the same time, an increased polarization between realist and modernist artists. Political differences became interlocked with struggles to obtain public commissions and to influence or resist official art policies, as the Roosevelt government became increasingly involved in art patronage.

The battle over realism versus modernism was complicated by its confusion with a parallel and itself much more intricate battle over the concept of the 'American scene'. Only three months after Roosevelt came to power, in May 1933, he was approached by George Biddle, an old schoolfriend (Groton and Harvard), with the suggestion that the government should employ muralists to adorn its public buildings.[25] Though a patrician with top-level political connections, Biddle was also an artist, who had studied in Paris. However, his main inspiration came from the muralists of the Mexican Renaissance, and he

envisaged an 'American Renaissance' along the same lines. Biddle was encouraged by the president's response and formed a group of artists, including Benton, to draw up guidelines for the project. However, Biddle was more interested in painting than in administration and control of the new programme eventually passed to Edward Bruce, a lawyer, banker and Washington lobbyist, who had himself given up a successful career to become an artist and muralist, before being invited back into government service at the Treasury. Bruce had clear ideas about the aesthetic guidelines under which the programme should run. Artists enjoying government patronage should be chosen on criteria of quality rather than need and, as far as concerned style and subject matter, they should paint the 'American scene' in a contemporary realist style. Thus the project would rule out not only beaux-arts neo-classicism, allegorical and mythological figures, etcetera, but also international modernism and abstraction.

But Bruce was only able to get funding initially from the Civil Works Administration, which saw its role as one of creating work for artists as a form of relief, rather than as enlightened patronage leading to an American Renaissance. As a result, a series of crossed wires led to conflicts between administrators appointed by Bruce and unemployed artists eager for income and employment, as well as protests from modernists who were excluded. Eventually the situation was resolved when the Works Progress Administration, which replaced the CWA, set up its own programme, explicitly a relief programme, with no exclusionary artistic policy. Bruce retained his own programme, called the Section, directly under the Treasury, with the old 'American scene' requirement. The first commissioned work, for the Post Office and Justice buildings in Washington, went to a group of artists that included not only Biddle but a number of allied painters, including Benton. Eventually, however, Benton withdrew, because he did not like the idea of government supervision of his work. Indeed, there was a chronic problem of censorship. Bruce had already forced the removal of a hammer-and-sickle image from the Coit Tower murals in San Francisco, and later incidents involved the censoring of a Rockwell Kent Post Office mural for its support of Puerto Rican and Native American political rights and a struggle over a 'modern' mural in New London, Ohio, which somehow slipped through the net. Philip Guston, though still working within the Mexican tradition, was asked to make his figures more realistic in a mural for the Social Security Building in Washington.

Conflict developed along two main fault lines. Essentially, rival realist parties, which became identified politically with Midwestern regionalism (on the right) and socialist realism (on the left), were struggling for the vanguard role in a populist art movement bringing 'art to the millions' through the government-sponsored form of mural painting and turning its back on the ivory tower of twenties modernism. The two opposed camps fought it out politically, attacking their adversaries with the rhetoric of anti-fascism or anti-communism, each representing themselves as true democrats. On the other hand, the modernists defended their position too, against both groups of realists. Their most prominent spokesman, Stuart Davis, fought hard to retain for modernism the vanguard role it had enjoyed in the previous decade, when the artistic revolution against the academy was seen as paralleling the political revolution against the *ancien régime*.[26] Davis, in arguing defiantly for modernism as the appropriate form for a socially progressive art, drew especially on Fernand Léger's concept of a 'new realism'. Léger argued that modernism was more rather than less realistic than traditional art, because it expressed the new complexity of perceptual experience that typified a dynamic and multifaceted urban mass society. Abstraction, Davis added, was necessary for art that was to come to grips with new social phenomena, rather than retreating with the populists into illustration and the contingency of immediate appearances.

Léger had set out his agenda programmatically in the lecture he gave in 1935 at the Museum of Modern Art in New York, during a visit he made to America with Le Corbusier.[27] In this text he argued for an art based on montage and close-ups of commonplace objects, following the precedent of avant-garde film (his own *Ballet Mécanique*, René Clair's *Entr'Acte*). Paintings would be composed according to the laws of colour and geometric form, freed from an illustrative relationship to the world and perceived as each 'a reality in itself'. Such an art would be neither purely representational nor purely abstract. Any object might serve – a pile of rope as well as a human face – but its value lay not in its reference to the world, but in its role in the composition of the painting. Davis published Léger's talk in *Art Front*, of which he was then editor. Léger described the 'new realism' he advocated as beginning with his own painting *The City* (1919) which was currently being exhibited in New York for the first time. As depicted there, life in the modern city did not present unified wholes but, as in a film, series of juxtapositions of isolated objects, seen in random or rhythmic sequence, which the painter had to bring

together, according to the logic of post-cubist space and colour, into a new configuration.

Unlike Benton, who celebrated, in his New School murals, the process of production, the power of American capitalism, by representing it in action – heroic figures working in symbiosis with powerful machines – Davis painted the products themselves: cigarette packs, salt-shakers, eggbeaters, radio valves. Benton was much closer to Rivera, whose 1932 Detroit murals are dominated by the giant presses and serpentine belts of the River Rouge Ford plant.[28] Similarly, at the centre of his Rockefeller Center mural of 1933, destroyed by the Rockefeller family's contractors, stood the overwhelming image of a technocrat at the controls of enormous dynamos whose reach stretches out far into the cosmos and deep into the microscopic realms of atom and cell. In Rivera's murals, the natural fecundity of the earth and its resources are symbolized by figures of women, the human effort of science and labour by figures of men. Benton's murals, similarly, are dominated by male workers, farmers and frontiersmen. Among women it was only the wife and mother who really counted for Benton. 'Surely she is about as close to life as anyone gets. She creates it. And she too deals with things – not with symbols.'[29] On the other hand, 'the college girl, or better, I might say, society girl, has the most vapid face of all. The working girl's face is more interesting, even though it belongs to a girl who does nothing more exciting than answering the telephone.'

After the New School murals and his subsequent break with Leo Huberman, Benton cut his ties with the New York left, although he continued to support Roosevelt and the New Deal, combining this with an unpleasant 'nativism', forming new alliances with racists and isolationists. In his Whitney Museum murals of 1932 he caricatured and calumniated 'the intellectual ballyhoo' of Greenwich Village radicals with cartoon-like images and inscriptions that were not simply abusive, but racist and homophobic. Benton's depiction of blacks in this mural was particularly offensive. It was at this point that Davis began to attack Benton publicly, inaugurating an artistic and political feud that continued for decades. Davis was not alone in condemning Benton over this: Benton also lost a large number of his students, including all the blacks. Benton actively discouraged gays and women among his students, and in due course he came to see himself as the victim of some kind of leftist–homosexual conspiracy, against which he hit back blindly. He began to identify New York as a source of corruption, a place where symbols

counted for more than things, and to turn his mind towards regionalism as the right course for art. In 1934 *Time* magazine put Benton on its cover and carried a long essay lauding regionalism and denouncing modernism. The next week Davis launched the first of many apoplectic counterattacks on Benton, accusing him of drifting dangerously towards fascism. The next year, Benton finally abandoned the city for his native state of Missouri, just as the year before, in Germany, Heidegger had rejected Berlin for a hut in the Black Forest, closer to the soil, to real work, and to the authentic Germany.[30]

Throughout this period, Pollock remained close to Benton both personally and artistically. Moreover, when Pollock came finally to reject Benton's influence, he did not turn to Davis's style of modernism, with its areas of flat colour and geometric shapes. Instead, he helped to create an entirely new kind of abstract art, breaking with the 'classical' modernist system of cubism and De Stijl. After Benton, Pollock studied briefly with Job Goodman, himself a former Benton student, with who he also worked on a Federal Art Project mural, and then transferred to Siqueiros's workshop, which was organized as a revolutionary syndicate and worked on commissions for the Communist Party, producing floats for the May Day parade and other such events. Although Pollock was no more than an assistant to Siqueiros, as he had been to both Benton and Goodman, this was an important period for him retro-actively, because Siqueiros, who created a weird personal combination of Mexican muralism with baroque modernism, introduced Pollock to industrial paints, working with a paint spray and industrial panels instead of canvas, like an automobile worker, and even experimenting with random poured shapes and spatters. Harold Lehman, an old schoolfriend of Pollock back at Manual Arts in Los Angeles, was also in the workshop and noted that Siqueiros had two main aims: 'The Workshop should (1) be a laboratory for experimentation in modern art techniques; (2) create art for the people.'[31] This meant 'experiment with regard to tools, materials, aesthetic or artistic approach' and work in a range of media from the poster to the mural.

Throughout this period Pollock was militant in the Artists' Union (of which Stuart Davis was the president) which had been formed to protect artists' jobs, wages and artistic freedom, as well as to protest against fascism abroad and, incipiently, at home. The union mainly represented artists working in the Federal Art Project, painting in a variety of different styles. A friend of Benton from Kansas City, Dan James, remembered looking Pollock up in New York on Benton's advice:

Tom Benton had started Jackson painting. But there came a time – it was just about the time I was in New York, in '36 and '37 – when Jackson was breaking out of this chrysalis. He was torturing the Benton shapes beyond, much beyond, anything that Benton did to them. It was a time when Jackson was terribly unsure of himself. He was destroying one lithographic stone after another. He was working on the Arts Projects. He was involved in all the Artists Union strikes at the time. Between strikes he would get drunk and go out and fight cops. He was a very strong powerful guy, and he could usually beat one cop, but there would always be two. So poor old Jackson would be in and out of jail a good deal, beaten up. He hated his own work.[32]

Pollock's painting was still based on Benton's vision of the 'American scene'. Like Benton he produced work based on sketches he had made on cross-country trips, to Los Angeles and back. He was supported however, not by private commissions, as Benton was, but by the Federal Art Project, which finally brought him out of economic dependence on Benton, though hardly out of poverty.

Siqueiros had originally come to New York as part of the Mexican delegation to the American Artists' Congress, which launched the Popular Front cultural policy in New York, bringing communists together with other anti-fascist artists, whether realist or modernist.[33] He was accompanied by Orozco, who had a commission to paint a mural cycle, *Epic of American Civilization*, at Dartmouth College in New Hampshire, which Jackson later drove up to see with a group of friends, including his brother Sande and Philip Guston. Pollock was deeply impressed by Orozco's new work, as he had been years earlier by the Pomona mural. Siqueiros supported himself, and his workshop, by means of the patronage of George Gershwin, but after a year, in spring 1937, he left for Spain to fight on the Republican side in the Civil War. Pollock was left without a mentor or a work structure and began to succumb to chronic alcoholic bouts. He failed to complete the work expected from him by the Federal Art Project and had to be covered for by a sympathetic supervisor. At Christmas that year he went out on a Greyhound bus to Kansas City to stay with Benton, but the trip was a personal disaster. On his return to New York he entered an even worse cycle of drinking, brawling and self-degradation, which finally ended with him being dumped off the street at Bellevue Hospital, after which, in June 1938, his brother Sande committed him to a mental asylum.

In later years, Clement Greenberg, the critic who launched Pollock on his

triumphal career as an abstract expressionist, saw the explanation for the turn to abstraction in a general revulsion against socialist realism after the Moscow show trials and mass purges of the late thirties and the Hitler–Stalin Pact of 1940. 'Though that is not all, by far, that there was to politics in those years: some day it will have to be told how "anti-Stalinism", which started out more or less as "Trotskyism", turned into art for art's sake, and thereby cleared the way, heroically, for what was to come.'[34] This version of events may explain Greenberg's trajectory, but it does not convincingly account for Pollock's, although, of course, the two were to converge. Pollock was not notably anti-Stalinist. In late 1940, he was fired from the Works Progress Administration as a Communist sympathizer (though he was reinstated later) and after that he was still defending Siqueiros to his future wife, Lee Krasner. Krasner was a Trotskyist sympathizer and an abstractionist, who disliked Siqueiros for both political and artistic reasons: Siqueiros, after all, had recently led an assassination attempt on Trotsky himself, in a criminal act of flamboyant Stalinism. The influences on Pollock were quite different and, at first sight, directly opposed to all Greenberg stood for. In the mental asylum Pollock encountered psychoanalysis and his art began to change. Above all, the experience opened him, however reluctantly, to the influence of surrealism. It was this that unlocked Pollock's thwarted talent.

4. 'Beauty shall be CONVULSIVE'

The first analyst Pollock encountered at the hospital was a Freudian, for whom as part of his therapy he made copper plaques and bowls decorated with allegorical male figures. At the end of September he was released, but continued to pay outpatient visits to his analyst. But Pollock had a second breakdown in January. This time he was referred to a Jungian analyst to whom he began to bring Orozcoesque drawings and paintings for interpretation. He also began to use Jungian symbolism in his ongoing work. The analyst, in an unintended way, seems to have struck the vein of occultism that had been hidden in Pollock since his teenage Krishnamurti days, expressed now, however, in terms of the unconscious rather than esoteric religion. During this same period, from January 1939, Picasso's great mural *Guernica* was brought to New York for exhibition in a desperate attempt to rally support for the doomed Republican cause in Spain and for Republican refugees and exiles. Pollock returned over and over again to study *Guernica* and especially the

accompanying suite of sketches, which showed the development of the painting through a series of metamorphoses. *Guernica* combined political commitment and mural art with Picasso's own private mythology, based on the archetypal imagery of the bullfight and the myth of the minotaur. Together with his play *Desire Caught by the Tail*, it was the culmination of Picasso's own encounter with surrealism in the thirties.

Surrealism was the principal branch of the avant-garde in the visual arts to thrive during the thirties, precisely because it was not linked to a productivist ideology.[35] Indeed, the surrealists were deeply opposed to the instrumental rationality of industrial society and specifically of Fordism. They saw the Great Crash not simply as evidence of the failure of capitalism, but as casting doubt on the more general phenomenon of Fordism and instrumental rationality. During the thirties, surrealism evolved from a movement of poets into a movement of artists. Foremost, of course, was Salvador Dali, who rejuvenated surrealist painting with his 'paranoiac-critical' method derived from the work of the young analyst Jacques Lacan. Although he was the most famous, Dali was only one of a number of artists who rallied to surrealism in the thirties. The Surrealist Exhibition of 1938 in Paris featured work by seventy artists from fourteen countries. America, however, the heartland of Fordism and instrumental reason, was not high on the surrealist agenda. On the contrary, Breton regarded Mexico as the surrealist country *par excellence*. The surrealist map of the world, produced in 1929, simply omitted the continental United States, which vanished into the void between Mexico, Alaska and Labrador. Breton saw much more hope in Latin and Francophone America, in Martinique, where he admired and encouraged the work of the poet Aimé Césaire, and in Haiti, where in 1945 his public lecture in a Port-au-Prince cinema galvanized the radical intelligentsia and, after the banning of a special surrealist number of *La Ruche* and the jailing of its editors, led to student riots, a general strike and the overthrow of the hated Lescot dictatorship.[36] A revolutionary in his politics, Breton believed that 'beauty shall be CONVULSIVE or it shall not be at all'.

Pollock's path towards surrealism was unusual. First came his interest in psychoanalysis, both Freudian and Jungian, set in a personal and therapeutic context. Second came a renewed concern with so-called primitive art, encouraged by the authority of John Graham, an émigré artist and art theorist from Russia. Graham had left Russia as a counter-revolutionary exile, who fought in a Circassian regiment of the white Savage Division, but he had since

turned to Marxism. He was also a devotee of occultism, who had recently been converted to Jungian ideas, as well as an avid collector of pre-Columbian art. Pollock initially came in contact with Graham when he read an article of Graham's, 'Primitive Art and Picasso', in 1937 and wrote an admiring letter to him.[37] Eventually this led to his entry into Graham's circle of protégés. Pollock gradually shifted away from his old milieu of ex-Benton students and friends from Los Angeles towards what turned out to be a much more central position in the New York art world. At the same time, he began to take an interest in contemporary surrealist painters who were exhibiting in New York, such as Ernst, Tanguy, Miró and Matta. Above all, he started looking at Native American art with new intensity. Pollock already owned several volumes of the Smithsonian Institute's classic *Annual Report of the Bureau of American Ethnology*, which he bought secondhand and kept under his bed,[38] and he was a frequent visitor to the Museum of Natural History, especially the Northwest Coast Collection of Kwakiutl and Haida art. He had a longstanding interest in Navajo sandpainting, which was further encouraged by his Jungian analyst, himself an enthusiast for Native American art. The role of the shaman as therapeutic artist clearly became linked in his mind to the therapeutic sounding of the unconscious through art encouraged by his psychoanalysts.

Around the same time, Pollock became close to the surrealist painter William Baziotes, with whom he visited surrealist art shows. Baziotes had discovered the French symbolist poets in Pittsburgh where, according to a friend, Baudelaire's *My Heart Laid Bare* became his bible.[39] In 1938, soon after arriving in New York, he met Matta and the English surrealist Gordon Onslow-Ford at a loft party. Baziotes became the central figure in a small group of American painters (himself, Peter Busa, Gérome Kamrowski, Pollock) who actively pursued an interest in surrealist art at the beginning of the forties, even experimenting together with 'automatic painting'. Baziotes, Kamrowski and Pollock collaborated on a collective painting that used *coulage* directly from the can and flipping and spattering paint from the palette knife. They then tried to interpret it for found images. Busa recalls how Pollock linked this extension of the longtime surrealist technique of automatic writing to the psychoanalytic concept of free association.[40] Pollock also maintained that it was related to Siqueiros's ideas about chance and found images, although Baziotes disputed this with him. In Pollock's mind, free association was also connected to the idea of 'metamorphosis', which he took

from Picasso and then from Northwest Coast art. Baziotes too frequented the Natural History Museum, and based work on pre-Columbian art, although his interest was more in the strange forms of extinct saurians and curious aquatic creatures (the paper nautilus, the giant squid, sea anemones, pond life, etcetera).

Finally, Pollock's direct entry into surrealist circles came in 1942 when he was recruited into a group organized by the Chilean surrealist Roberto Matta Echaurren. Matta had been accepted into the surrealist group in 1938 but very soon afterwards he left Paris for New York to avoid the coming war. However, after Breton's own arrival in New York two years later, Matta decided to try and set up his own American-based surrealist *groupuscule* in emulation, and perhaps revival, of his mentor. He approached Baziotes for a list of names of artists who might be interested and Baziotes suggested himself, Busa, Kamrowski and Pollock. They were all formally approached by Robert Motherwell, whom Matta had met independently and with whom he had visited Mexico, and in 1942 the group began to meet regularly in order to experiment together with automatic painting at Matta's studio. For Pollock this was, in some ways, a repetition of his experience with Siqueiros, but on a more equal and genuinely collaborative basis and now within a psychoanalytic rather than a political context. He also started attending a salon at Matta's home, where the group and their wives or girlfriends would play surrealist games,[41] as Breton did at his salon, and compose collective poems using the Exquisite Corpse technique, writing lines in turn on a folded-over sheet of paper, without knowing what others had written before, and then unfolding the sheet to reveal the finished poem.

The arrival of the European surrealists in exile transformed the American art world. Although Pollock, unlike Baziotes, Kamrowski and Motherwell, declined to participate in their first exhibition in October, 1942, he soon entered the circle of surrealists based around the collector and impresario Peggy Guggenheim, who had also arrived from Europe and was then living with Max Ernst. Guggenheim's Art of This Century gallery became the centre for surrealist art and it was there that Pollock enjoyed his first exhibition success and, soon afterwards, in 1943, his first one-man show. Pollock was sponsored principally by Guggenheim's assistant, Howard Putzel, a protégé of Onslow Ford, and Putzel's recommendation was laconically endorsed by Marcel Duchamp ('*Pas mal!*'). Pollock's paintings at this time combined images drawn from childhood memories and unconscious fantasies with

ambient stenographic doodles and notations, reminiscent of automatic writing. Pollock continued to maintain contact with surrealist experiment through his attendance at S.W. Hayter's workshop, where he tried to transpose automatic drawing to the etching plate, but was thwarted by the resistance of the copper to the tools. Gradually, the element of automatic writing in his paintings grew until it completely 'veiled' the images and eventually merged into image-making, when Pollock would draw in the air, letting paint drip and spatter into indecipherable coils and whorls.

Pollock never described himself as a surrealist, and tended to minimize the influence surrealism had exerted at the crucial conjuncture in his career as he finally threw off the yoke of Benton and found his way towards a new mode of abstraction. Of the group around Matta, he was probably the most chary of formal identification with the movement. Baziotes was widely identified with surrealism and Kamrowski continued to regard himself as a surrealist for the rest of his career, Indeed, he was the one artist from the group whom Breton singled out for praise, for the 'panoramographs' he created in 1943, graphic assemblages of found imagery, printed texts and idiosyncratic drawings.[42] Busa moved on to the Indian Space or Semeiology movement of artists, who sought to combine Northwest Coast Indian art with European modernism, melding the flat, cursive symbolic forms described by Boas in his epochal study *Primitive Art*, with a vocabulary of pictographic glyphs derived from Picasso and Miró.[43] Pollock, on the other hand, combined influences from Native American art with the central current of surrealist automatism, in a context conditioned by his psychoanalytic experiences, and by his earlier participation in Siqueiros's experiments with new ways of applying paint. In fact, rather than abstract expressionism, his work would be more accurately described as 'American automatism'.

5. 'Towards a Newer Laocoon'

It was when Jackson Pollock started to exhibit at Peggy Guggenheim's surrealist-oriented Art of This Century gallery that Greenberg first noticed his work. Greenberg's great achievement was that he recognized that of all the New York painters of his generation, Pollock was the only one who could effectively be cast as the founder of a new art movement of more than local significance. This was true even though Pollock did not fit at all conveniently with the model that Greenberg already had in mind. For one thing,

Greenberg abhorred surrealism. He had explicitly attacked the movement in his ground-breaking essay, 'Towards a Newer Laocoon', published in *Partisan Review* in July–August 1940, which was more or less his manifesto. There he charted out an ideal trajectory for painting and asserted that 'orthodox surrealism' had 'turned back to a confusion of literature with painting as extreme as any of the past' instead of advancing towards a self-reflexive 'abstract purism'. Greenberg freely adapted Lessing's *Laocoon* to argue that the ontological distinction between literature and painting was not, as Lessing had proposed, between a time-based and a space-based representational art, but between two arts, neither of which was intrinsically representational and both of which, in their modern form, rejected representation as extrinsic to their aesthetic essence.[44]

Painting must emancipate itself totally from literature, Greenberg insisted, a process begun in the nineteenth century but not yet completed. Even poetry should discover its own essence, free from literary representation of the world. This essence, in the case of poetry, was the creation of emotions by the evocative and associational power of words. Words should be freed from the semantic constraint of exact denotation, and used to approach the 'brink of meaning', while never falling over it into specificity of reference. Painting, on the other hand, was an art of pure optical sensation, whose effects were produced entirely by the disposition of line and colour on a flat surface, avoiding the least hint of figuration, in a way analogous to the purely acoustic sensations produced by music. Painting should not illustrate music, but should adopt its method, one of unrelenting formal research into the ontological grounding of its own material (acoustic sensation), purged of any extrinsic, outward-looking reference or allusion. This purist programme for painting, Greenberg argued, had entered a new phase with cubism and had been pursued after that by post-cubist artists such as Arp and Miró and, above all, by the abstractionists whose achievement culminated in the work of Mondrian.

Greenberg's dismissal of surrealism as inherently reactionary, because of its extrinsic, literary subject matter, led to a disparaging riposte from Breton's protégé, Nicolas Calas, in the October number of the new magazine *View*, and subsequently further attacks and counterattacks in *Partisan Review* from Greenberg and from *View*'s associate editor, Parker Tyler.[45] *View* had been founded partly to provide an alternative to the high seriousness of *Partisan Review*, drawing instead on the tradition of French magazines like Breton's

Minotaure and aiming 'to combine luxury with the avant-garde'. As one of its key contributors, Paul Bowles, observed, 'ideologically *View*'s policy adhered fairly strictly to the tenets of the Surrealist Manifesto',[46] although it extended its range to cover magic realism and neo-romanticism. *View* published a special 'Surrealist Number' (and another specifically on 'Belgian surrealism') as well as issues devoted to individual artists and to such themes as 'Vertigo', 'Narcissus', 'Americana Fantastica' and 'Tropical Americana'. It carried writing and visual art from both professionals and non-professionals, by world-famous poets and artists as well as by a child or a convicted murderer who sent poems from jail. Many of its poets and writers, including Paul Bowles (in his short story, 'The Scorpion', for instance) and the editor, Charles Henri Ford, had experimented with automatic writing, and they were evidently open to the idea of automatic painting as well.

Among the artists whose work *View* published was Pollock, who was also represented in Breton's own New York art journal, *VVV*. For Greenberg, at that time, this was a discouraging factor. However, although he remained unalterably opposed to the use of unconscious or fantastic imagery as subject matter for painting, he began to rethink his position on automatism as a method. Even so it was not until 1944 that Greenberg tackled the issues raised by surrealism head on, instead of sniping away with disparaging *obiter dicta* in the form of asides. The occasion was an article spread over two weeks in *The Nation* (12 and 19 August), where Greenberg regularly reviewed art exhibitions. The same article was reprinted the following January in the British magazine *Horizon*, so it received an international readership.[47] Greenberg had already noted the promise of Pollock's first show for Peggy Guggenheim's gallery in November 1943; he had seen and been deeply impressed by Pollock's *Mural* commissioned by Peggy Guggenheim and completed in January 1944. In May, Greenberg reviewed a group show at the gallery and hailed Baziotes's work for making him 'more curious about his particular future than about that of any other painter present' (including Motherwell and Pollock, who were both mentioned). In November 1944, he had high praise for Baziotes's one-man show, linking him with Pollock, and encouraging words for Motherwell too. He affirmed that on these three primarily ('and only comparatively few others') 'the future of American painting depends'. Greenberg had clearly decided that he had to come to terms with Matta's group.[48]

The significant new development in Greenberg's essay 'Surrealist Painting'

was his reassessment of automatist procedures in painting. He continued to reject the main current in surrealist art as 'literary' and 'antiquarian', likening the movement to that of the Pre-Raphaelites in the nineteenth century, with Breton, by implication, playing the role of William Morris, laudable in many ways, positive for literature, but negative for painting. Greenberg divided surrealists who used automatism into those for whom it was a primary factor and those for whom it was only secondary, a way towards the discovery of new images. For the first group, chance associations were used as pretexts for the artist's purely 'painterly' imagination. 'Here the reliance upon the unconscious and the accidental serves to lift inhibitions which prevent the artist from surrendering, as he needs to, to his medium.' 'Complete automatism', Greenberg noted, would tend 'in the direction of the abstract'. In effect, Greenberg's argument was that the production of 'identifiable images', academic and illusionist in their essence, was similar to the regulation of the unconscious in language by 'meter or rhyme or logic'. Flying in the face of Freud's view that the unconscious, as demonstrated in dreams, was a reservoir of images, drawn from repressed memories, Greenberg argued that, for painters, unconscious doodling would produce, at most, shapes and colours with a 'schematic' (that is, flat and abstracted), rather than a 'realistic' resemblance to 'actual phenomena'. At the limit, such doodles could be completely abstract.

In this essay, Greenberg at no point mentioned any contemporary American artist. His main targets were Dali, Ernst, Tanguy, Magritte and others, who simply painted a new realm of subject matter in an old naturalistic style. On the other hand, he had some favourable words to say about Picasso and Klee, who had been welcomed by the surrealists, and about Miró, Arp and Masson, the three surrealists who came closest to abstraction. Nor did he mention Matta, whose work he seems to have particularly disliked, comparing it more than once to comic strips and denouncing its 'biomorphic' and 'sculptural' qualities which 'gave the elements of abstract painting the look of organic substances'. Matta, perhaps, was too close to Breton himself, who had drawn on Matta's work as illustration of one of his own crazier ideas, 'les grands transparents', mythic and radically alien creatures which Breton imagined coexisting with humans without being perceived, due to their perfect camouflage.[49] Greenberg wrote to Baziotes the week after the final part of his article had come out in *The Nation*, asking him for his reactions to it. 'I'm waiting for lightning to descend, or hoping rather that it will

descend, for it may not at all. The Surrealists have probably got too tired.'[50] He was right. There was no response. In retrospect, it is clear that Greenberg had missed his opportunity. His article would have had much more effect if he had invoked the names of Baziotes, Motherwell and Pollock directly rather than Picasso, Miró and Arp, established European artists from a previous era. To do this, however, would have been to acknowledge their surrealist provenance openly, a point that Greenberg was never prepared to concede.

6. 'It Needed Mental Cases to Show the Way'

Despite his aversion to surrealism, I believe that Greenberg was attracted to Pollock in particular because of his own interest, as a critic and a collector, in amateur art, primitive art (that is, painting by untrained artists) and outsider art, although, naturally enough, he never acknowledged this explicitly. In fact, Greenberg reviewed exhibitions of (and books about) work by non-professional American artists almost as extensively and much more favourably than he did those of professionals. The reason for this is laid out with great clarity in his April 1942 review of an exhibition '150 Years of American Primitives', in which he observed that the show seemed 'to support my contention that the best American art has been, and perhaps still is, primitive or naive. These pictures have a first-hand quality, an immediacy, which cultured American painting lacks. This quality alone is not enough for great art, but there is no great art without it.' He was particularly fond of work by the self-taught Joseph Pickett (who ran a shooting gallery in a carnival and who Greenberg considered was 'not surpassed by the greatest of the academic American painters'), Arnold Friedman (who worked as a post-office clerk and painted in his spare time, becoming 'one of the best painters this country has ever produced'), and Louis Eilshemius (whom he described as 'deranged' and also 'one of the best artists we have ever produced').[51]

Indeed, as well as believing that the absence of any academic tradition or background was an advantage for American artists, Greenberg agreed that 'those who maintain that modern art was started by mental cases would seem to be right'.[52] The Douanier Rousseau ('psychotic'), Cézanne ('a little barmy') and, of course, Van Gogh were his prime examples. Greenberg argued that their psychotic tendencies gave them the necessary impetus, and fanaticism, to break with 'the practical reality of the bourgeois world' and undertake the task of changing the whole concept of representation. Picasso and Matisse

took the final, irrevocable step, but 'it needed mental cases to show them the way, to cut through to the ultimate truth of life as it is lived at present'. This astonishingly bold vision of the origin of modernism surely relates to Greenberg's later fascination with the work of both Dubuffet and Pollock. Dubuffet, of course, was openly evangelical about *art brut*, the painting of children and the deranged, as well as about urban graffiti. As Greenberg put it, he gave 'an aesthetic role' to 'the *lumpen* art of the urban lower classes', just as 'Marx discovered and gave the proletariat a political role'.[53] But, as Greenberg also pointed out, Dubuffet, though self-taught and originally non-professional, was none the less an extremely sophisticated painter who was appropriating outsider imagery for his own purposes. Pollock, in contrast, one might say, was a trained professional, but certainly uncultivated and 'a little barmy', if not indeed psychotic, fit to be placed alongside Rousseau, Cézanne and Van Gogh.

The article that decisively launched Pollock's reputation, and made possible the subsequent ascent of the New York School, was published in *Horizon* in October 1947. It was titled 'The Present Prospects of American Painting and Sculpture' and singled out Pollock as 'the most powerful painter in contemporary America and the only one who promises to be a major one'. This claim, made to a European audience, was noted and taken up in America by *Life* magazine, which decided to run a feature article on Pollock.[54] Whilst, shortly before, it had done the same for Dubuffet and trashed him, it treated Pollock with respect and cautious enthusiasm. It gave him an image and made him a success. In his *Horizon* article Greenberg used an uncharacteristically vivid vocabulary to describe Pollock's art: 'morbid and extreme', 'radically American' in its 'violence, exasperation and stridency', dwelling 'entirely in the lonely jungle of immediate sensations, impulses and notions', marked by 'paranoia and resentment', 'spasmodic', 'Dionysian'. Historicist as always, Greenberg looked forward to an Apollonian art of the future, an art of balance and 'intense detachment', which would be 'in accord with the most advanced view of the world obtaining at the time' (presumably a coded reference to a future version of Marxism) rather than an art, such as Pollock's, 'in which passion [must] fill in the gaps left by the faulty or omitted application of theory' (presumably, again, current Marxist theory).

In the meantime, Pollock was the best hope for a resurgence of modernism, set this time in America. He was being cast for the same role as 'the more or less deranged' triad of Cézanne, Van Gogh and Rousseau, opening the way for

the cool and hard-headed generation that was still to come. Pollock was able 'to cut through to the ultimate truth of life as it is lived at present', as they had been able to half a century or more before. Like them, he was driven by demons over which he had little control. But, for Greenberg, though perhaps contingently necessary to Pollock's success, this was incidental to his essential achievement. What really mattered was his contribution to the advancement of abstract art, his development of a new 'all-over' type of abstract painting, which went beyond the geometry of the old tradition that culminated in Mondrian's *Broadway Boogie Woogie* and *Victory Boogie Woogie*, yet still emphasized the flatness of the picture surface. Like Mondrian's, Pollock's painting could be presented as art without extrinsic subject matter, art about art, concerned simply with optical sensation and the materiality of paint. The personal turbulence that Pollock brought with him would pass and give way to a new art of order, harmony and rationality. As Greenberg put it, 'All profoundly original art looks ugly at first.'[55] Thus Greenberg maintained his purism by putting the 'ugly' side of Pollock into parenthesis, while insisting that he belonged within the correct modernist tradition, unblemished by such accidental influences as Benton, the Mexicans, surrealism 'and whatnot'.[56]

Greenberg's strategy can be seen at its most audacious in his treatment of Pollock's breakthrough painting, the large mural commissioned by Peggy Guggenheim. In 1943 Pollock was asked to produce a painting, eight feet by twenty feet in size, for the foyer of the duplex apartment she shared with Kenneth MacPherson. In July, he tore out an interior wall in his studio to make room for this work and banished his brother Sande to a temporary workspace. Originally, the mural was intended to be the centrepiece for Jackson's first one-man show at the Art of This Century gallery in November, but he missed the deadline and Peggy Guggenheim then asked him to finish it in time for a large party that was being given in her apartment in January. The day before the deadline Pollock was still staring at a blank canvas. Some time that evening, he at last began to paint and was finished by nine the next morning, in time to get the mural transported and erected, with some difficulty, in Peggy Guggenheim's foyer before the party began. He later explained what had happened separately to Peter Busa and to Reuben Kadish.[57] Apparently he had a vision of a stampede, based on childhood memories of seeing horses running wild on a trip to the Grand Canyon. He painted hordes of animals charging across the canvas, then, in a continued frenzy, obliterated them all again with swirling lines, finally filling in the

spaces between with broad, spattering brushstrokes. Whilst the painting retained the momentum and rhythmic dynamism of the original conception, the subject matter was completely lost to view. The sensation of energy, panic and wildness was preserved in a sublimated form.

Whichever way you consider it, this was not the work of an artist primarily preoccupied by the formal problems of his art. The formal innovativeness of *Mural* was the result of Pollock's unreflective and trancelike conjuring up of images based on childhood memories (or screen memories) and his subsequent secondary suppression (conscious censorship) of these intensely cathected images with 'automatic' scrawlings-through and overpainting. Thus the 'all-over' composition and the 'flatness' of the work come from the act of obliteration, which is total and calligraphic, an extension of two-dimensional doodling. It is significant that this work was a mural, a form Pollock had long dreamed of working in as he sat posing for Benton or performing menial tasks for Siqueiros. And the hidden subject matter – the American West – has clear echoes of Benton's regionalist preoccupations, whilst the cinematic intensity of the work recalls Siqueiros's theories on the dynamism of space, which originated from his conversations with S.M. Eisenstein in Mexico. It should also be noted that Pollock reversed both Siqueiros's and surrealist practice, in that he used accidental effects to obliterate rather than to suggest images (though these images were themselves drawn from the unconscious).

Pollock remained attached to the project of mural painting. His paintings became monumental in scale and he responded enthusiastically to repeated suggestions by architect and patron friends such as Peter Blake, Alfonso Ossorio and Tony Smith that he paint murals for buildings they would design or help to commission. These included a range of imaginary sites, including private homes, a chapel and a 'museum without walls', meaning that mural paintings would themselves serve as the interior walls. This project was to be designed by Mies van der Rohe but, like the others, it came to nothing. In Pollock's 1947 application for a Guggenheim Fellowship, which followed Peggy Guggenheim's departure for Paris and the closing of her gallery, he wrote thus:

> I intend to paint large movable pictures that will function between the easel and mural. . . . I believe the easel picture to be a dying form, and the tendency of modern feeling is towards the wall picture or mural. I believe the time is not yet ripe for a *full* transition from easel to mural. The pictures I contemplate

painting would constitute a halfway state, and an attempt to point out the direction of the future, without arriving there completely'.[58]

Actually, the 'time was not ripe' simply because none of the projects proposed to Pollock ever came to fruition. Pollock himself, however, had seized on the idea of combining his old wish to paint largescale mural paintings with a subject matter that was intensely private rather than public, and that he could 'veil', to use his term, through the method of automatism.

Shortly afterwards Greenberg noted that 'there is a persistent urge, as persistent as it is largely unconscious, to go beyond the cabinet picture, which is destined to occupy only a spot on the wall, to a kind of picture that, without actually becoming identified with the wall like a mural, would *spread* over it and acknowledge its physical reality'.[59] The 'all-over' picture, then, was seen by Greenberg precisely as such a 'halfway state', suspended between easel and mural painting, neither clearly delimited upon the wall nor fully identified with it. The 'quest for the irreducible and primary elements of the art of painting' which Mondrian had led was encountering the alternative, even antagonistic tradition of mural painting. For Greenberg, a crucial step had been taken beyond the entire cubist tradition of which Mondrian had been the end point, a step which he himself could never have taken, though Greenberg felt that his last paintings, *Broadway Boogie Woogie* and *Victory Boogie Woogie*, showed that Mondrian knew there was a need to go further. Greenberg announced the impending death of easel painting and the appearance of a new type of mural painting, 'a living modern form', in contrast to 'the archaeological reconstruction of Puvis de Chavannes, Rivera, and the WPA projects'.[60] Mural painting, though a public form, would be free from both subject matter and ideological programmes of any kind, except those restricted to the aesthetic realm itself, the programme of art for art's sake.

7. As Trotskyism Turned into Art for Art's Sake

Greenberg's aesthetic position can be seen as a displacement of his political position: a radical, independent Trotskyism, which led him to oppose support for the Allies in the Second World War and to prefer Luxemburg's ideas on party democracy to those of Lenin and Trotsky.[61] His dislike of subject matter in art reflects, first, a radical extension of the modernist rejection of academic realism to include every kind of representation; second, the vanguardist idea

of a band of revolutionaries, united by purity of principle, transposed from the political reality of the hopelessly divided Trotskyist movement to an idealized avant-garde of abstract artists; third, and perhaps most significant, a deep distrust of the cultural preferences of 'the masses', whom Greenberg saw as easy prey for commercialized kitsch just as, in the Soviet Union and Nazi Germany, they had proved unable to resist political demagogy. The Russian Revolution, Greenberg believed, had been 'premature'. His political perspective became one in which an isolated and tragic group of politically cultured militants must strive to keep a revised Marxist theory alive and developing, while they waited for capitalism to reach the level of abundance necessary for socialism to succeed. Not until then could the masses hope to attain the cultural level that was a condition for the democratic exercise of popular power.

Greenberg had a similar outlook for the arts, except that there he seems to have been more optimistic. He felt more confident that the dead end represented by Mondrian could be surpassed than he was about that represented by Trotsky. When Trotskyism failed to develop, as he saw it, and seemed fated to an 'Alexandrian' decadence, he became more and more disenchanted politically with the left. Eventually he reached a point where, despite his commitment to personal liberty and his distrust of state power, he was unwilling to agree that it was now a priority to take a public stand against McCarthyism. As Trotskyism turned into art for art's sake, it thereby cleared the way, ingloriously, for the activities of the American Committee for Cultural Freedom. The model for this classical Cold War organization was the short-lived Committee for Cultural Freedom founded in 1939 by the rightward-moving Marxist philosopher Sidney Hook. At that time, the committee was fiercely opposed by the editors of *Partisan Review*, including Greenberg, who supported the rival League for Cultural Freedom and Socialism. This had been created by a group of Trotskyist activists and intellectuals in the aftermath of the famous meeting in Mexico between Trotsky, Breton and Rivera and the publication, in *Partisan Review* of Autumn 1938 of their joint manifesto, 'Towards A Free Revolutionary Art'. Both organizations soon fell apart, but the committee was relaunched by Hook and others after the proSoviet Waldorf World Peace Conference, held in New York in 1949. This time it was joined by the *Partisan Review* group, who no longer saw a need for 'Cultural Freedom' to be coupled with 'Socialism'.

In March 1952, the novelist James Farrell (also an ex-Trotskyist, but a

contributor to *View* rather than *Partisan Review*) proposed in a CFC conference resolution that 'the main job *in this country* [the United States] is fighting McCarthyism'. He argued that European intellectuals would be encouraged in their fight against Stalinism if they saw Americans tackling McCarthyism head on. Greenberg, unlike his old colleagues from the *Partisan Review* group, Dwight Macdonald and Philip Rahv, declined to take a stand and found reasons to object to this position. At the conference, an anti-McCarthy resolution was ruled out of order by the chair, Lionel Trilling, and the matter was dropped. There was no majority for a general condemnation of McCarthy, which it was felt would only detract from the struggle against communism. A generation of ex-Trotskyists, whose political formation was crucially dependent on their reaction to Stalin's show trials and Hitler's Degenerate Art exhibitions, was not unduly perturbed by the spectacle of film-makers being dragooned in front of government tribunals, interrogated about their political beliefs, blacklisted, jailed or (perhaps worse) forced into degrading confessions, which they spent the rest of their lives defending, repressing or regretting. Nor, while Pollock was built up into a monument of American freedom, and endorsed as such by the State Department, did they pay much heed to the purges taking place in the movie industry and the flight to Europe, directly or indirectly caused by McCarthyism, of artists such as Brecht, Chaplin, Huston, Losey and Welles.[62]

The reasons for this silence lay, I believe, not only in their political drift to the right, but also in their dislike for the popular arts and their inability to take them seriously. Wedded to a purist version of high modernism, intellectuals such as Greenberg had already consigned Hollywood cinema to oblivion, along with magazine illustrations, ads, comics, Tin Pan Alley and tap-dancing. So what did it matter if Gene Kelly joined Sidney Bechet in France?[63] The fact that Jackson Pollock would plainly have been liable to McCarthyist persecution if the spotlight had ever turned intensely onto painting seems to have been completely discounted. Not only Pollock, of course: a whole generation of painters had been involved in the Popular Front and the Artists' Union, just as a generation of scriptwriters, actors and stage directors had been involved in parallel organizations. Of course, it was paradoxical that one set of artists should be promoted into the official spotlight, as exemplars of American liberty, just as their former comrades were being cast into outer darkness. One set, however, was seen to represent high culture and the other low. The important thing for Greenberg was to

preserve high culture within an elite until the United States, then the world's most dynamic capitalist power, entering the second consumerist stage of Fordism, had reached the breakthrough point at which such a culture could become generalized through the whole of society. In the interim, Greenberg remained hostile not only to Stalinist culture, but also to the new middlebrow values at home which, he felt, simply promoted 'an ingratiating pseudo-advanced kind of painting', more threatening than the straightforward kitsch he had warned about a decade before.[64]

For Greenberg, kitsch became the enemy, the artistic accomplice of totalitarianism, just as it was in another sense for Adorno. Whereas Greenberg saw kitsch as fundamentally Stalinist, Adorno saw it as fundamentally Nazi.[65] In each analysis, the particularity of democratic, capitalist societies was occluded. And each analysis, too, led to the endorsement of abstraction, ultra-modernism and art for art's sake. Schoenberg was Adorno's Mondrian. But whereas Adorno continued to write as a fierce and sardonic social critic, Greenberg gradually allowed social criticism to lapse. Modernism simply displaced Marxism. Modern art, Greenberg argued, was a form of pastoralism, a retreat from the discouraging reality of actually existing society into a self-contained aesthetic realm, innocent of any political or ideological entanglement. Ironically, William Empson had described proletarian realism as a form of pastoralism, a romanticized vision not of Arcadian shepherds, but of class-conscious workers.[66] For Greenberg, however, pastoralism involved a complete retreat from involvement in society and a total commitment to art as such and only as such. The banishment of subject matter in art was a necessary precondition for this policy of heroic isolation because, in Greenberg's view, all subject matter – all reference to the world, whether the real world of nature and history or the unconscious world of fantasy and dream – was inevitably tainted with ideology and threatened to engage artists politically and thus instrumentalize their art.

Among the future abstract expressionists, many openly opposed Greenberg's views. In 1940, for example, Mark Rothko and Adolph Gottlieb, along with the Trotskyists, left the Popular-Front-based American Artists' Congress in protest against the Hitler–Stalin Pact and the Soviet invasion of Finland, and set up the rival Federation of Modern Painters and Sculptors. When the work they exhibited at the federation's third annual show in 1943 was attacked by the *New York Times* critic, they collaborated with Barnett Newman (himself an anarchist) on writing a joint manifesto as a riposte,

which was published on the front page of the *New York Times*. There they denounced 'American scene' painting and asserted their commitment to 'flat forms' and 'the picture plane', but they also invoked the 'world of the imagination' and affirmed that 'there is no good painting about nothing. We assert that the subject is crucial and only that subject matter is valid which is tragic and timeless. This is why we profess spiritual kinship with primitives and archaic art'. This group became known as the Myth-makers.[67] In 1947 Newman helped to organize an exhibition of Northwest Coast art, titled The Ideographic Picture, with work from the Museum of Natural History and from Max Ernst's collection, asserting in the catalogue that the Kwakiutl had influenced a new generation of American painters 'who are not abstract painters, although working in what is known as the abstract style' and claiming their work not as 'the esoteric exercise of a snobbish elite' but 'the normal, well-understood tradition' of their people.[68]

The next year, in the late autumn of 1948, Clyfford Still, another key abstract expressionist, approached Mark Rothko with the idea of starting an art school, which they agreed should be called Subjects of the Artist. As Motherwell noted, the name of the school 'was meant to emphasize that our painting was not abstract, that it was full of subject matter'.[69] Still, always a loner, withdrew and went to California, but Rothko persisted with the help of Motherwell, who brought in Baziotes and David Hare, another protégé of the surrealists. Motherwell slanted the school towards 'psychic automatism' and other surrealist ideas. The first three public meetings, in January and February 1949, offered screenings of early fantasy films (by Georges Méliès and others) from Joseph Cornell's collection, a lecture by John Cage on 'Indian Sand Painting' (as noted earlier, also an interest of Pollock's)[70] and a talk by Richard Huelsenbeck on 'Dada Days'. In 1949 Rothko persuaded Barnett Newman to join the faculty as well. Thus the 'Subjects of the Artist' school brought the Myth-makers together with Baziotes and Motherwell from the Matta American Surrealist group, in defence of subject matter and in opposition to purist abstraction.

Yet for Greenberg art became, in contrast, a kind of monastic discipline. Artists must devote themselves to an other-wordly pursuit, rejecting not only the crude temptation of kitsch but also the more subtle temptation of subject matter. Greenberg had argued that, in previous epochs, subject matter had been simply a pretext for art, which was dropped, for the sake of aesthetic economy, when the doctrine of 'art for art's sake' was formulated. Yet the

affirmation of art for art's sake does not necessarily deny that art has any
subject outside itself. The absolute reflexivity Greenberg demanded came at a
cost. It led to a denial of any involvement of art with discursive thought and
the figurative imagination, a denial that was in fact completely fictive and, in
a sense, fraudulent. Abstract art itself was rooted in ideas about the world and
even images of it. Mondrian, for instance, came to abstraction by way of
theosophy, and his painting reflected a kind of mystical hermeticism. Others
sought to discover a Neo-Platonic geometry in nature, reduced from the
messiness of contingent detail to the clarity of essential form. Greenberg
himself was not an idealist but, judging from his own writings, a positivist:
hence his conclusion that 'optical sensation' was the basic material of art. This
did not mean that Greenberg was a 'sensualist'. In argument with Herbert
Read, who believed that art should appeal primarily to the senses, he made it
clear that the senses should be subordinated to reason.[71] Indeed, part of his
hostility to surrealism sprang from his belief that it was based on an
irrationalist view of the world. But Greenberg's own rationalism itself
presupposed an ideological position, the reflection of which Greenberg then
looked for in the art of others.

8. *The Seven Lively Arts*

The history of modernism is caught between two poles of attraction: on the
one hand, a visionary utopianism, built around an ideal of mass production,
rational organization and machine technology harnessed to an aestheticized
sense of civic purpose; on the other hand, a fascination with the urban
vernacular, with the entertainments, environments and lifestyles that grew up
in the unplanned and chaotic milieu of the modern city. These conflicting
drives often coexisted in the same artist: thus, we can see Fernand Léger
swerving between the urban vernacular influence of Blaise Cendrars and the
futuristic purism of Le Corbusier, between the proletarian dance hall where
young workers spontaneously invented the stunning new 'whirlwind dance'
and the Radiant City where healthy sports took place in the orderly framework
of a totalizing vision.[72] The conflict of attitudes was one that crosscut
differences in political philosophy. The urban crowd could be construed as the
organized masses, the hysterical mob or the consumerist public; the idea of
planning, founded in practical terms on the model of wartime mobilization,
could be seen as serving left, right or centre. Thus Léger ended up in the

Communist Party, Le Corbusier working for Vichy.[73] Similarly, the idea of a future just and free society, based on material abundance sufficient for all, could lead to a utopian activism, as with Herbert Marcuse, or to a complicit quietism, as it did with Greenberg.

Léger, like Greenberg, who believed that the great majority of people could not 'develop esthetic awareness – until they are free from want and insecurity', consistently argued for the importance of increased leisure as the basis for popular creativity and taste. But Léger saw the signs of this advanced popular taste already existing around him in the urban vernacular forms created and enjoyed by ordinary people.[74] Not only did he look for creativity in the way in which ordinary people used their free time, inventing new dances, transforming language through slang or, like his hero and friend the Douanier Rousseau, painting according to their own vision, but he also loved jazz, movies, the circus and, indeed, the chorus line. Like many artists of the twenties, he was a devotee of what Gilbert Seldes, writing in Paris about New York, described in his book of 1924 as 'the 7 lively arts'.[75] Managing editor of the avant-garde journal *The Dial* and partisan of Picasso and Stravinsky, Seldes also celebrated Mack Sennett and the Keystone Cops, jazz, Ziegfeld, journalism, the Four Marx Brothers, comic strips, clowns, Vernon and Irene Castle, the anonymous dancers of the java and the maxixe, Tin Pan Alley, Pearl White, Cole Porter and a host of other popular and performing artists. Above all, he singled out Charlie Chaplin and George Herriman, creator of Krazy Kat, as the two great geniuses of American art. (The first, it should be noted, was a Cockney orphan from the Elephant and Castle, and the second was black, a New Orleans creole who, like so many jazz musicians, fled his native city.) Léger too had celebrated Chaplin in his own film *Ballet mécanique* and in a number of surrounding artworks, Picasso was an ardent devourer of American comic strips and Stravinsky, like the composers of 'Les Six', had borrowed from popular music, especially black music.

In *The 7 Lively Arts*, Seldes titled his chapter on jazz 'Toujours Jazz' as a pointed rebuttal to Clive Bell's chapter heading 'Plus de Jazz' in his book *Since Cézanne*.[76] Clive Bell was a modernist neither in the 'machine aesthetic' nor the 'urban spectacle' sense, but was in many ways, with his doctrine of 'significant form', a precursor of Greenberg. He saw twentieth-century art developing along lines laid down primarily by Cézanne, whose fundamental interest, Bell supposed, was in the formal qualities of his art. Subject matter, Bell thought, may be 'conditioned by an artist's opinions and his attitude to

life' but 'such things are irrelevant to his work's final significance. Strange as it may seem, the essential quality in a work of art is purely artistic. It has nothing to do with the moral, religious or political views of its creator.' Although Bell himself pulled back from endorsing abstract art, this was plainly a possible corollary of his argument. Jazz, for Bell, was contemporary but impudent and immature – like America – whereas real art – European art – was the product of long centuries of aesthetic and intellectual maturation. The battle was not simply between an insurgent modernism and a neoclassical call for order, but between upstart America and wise old Europe. But now, after the Great War, Europe was shattered and impoverished. How could America possibly rise to the challenge, if the best it could produce was jazz? Plainly Americans must learn from Europe, learn discrimination and the need for the highest standards, and, of course, seriousness.

Yet Seldes's book was written in Paris. It was actually European artists, refugees from the war like Gleizes, with his paintings of Brooklyn Bridge, or Picabia, with his machine drawings, who had first brought modernism and thus Americanism to New York. It was after the Armory Show that American artists like Charles Demuth and Stuart Davis began to reassess their concept of art and to develop a specifically American programme for modernism, based on the urban vernacular around them. It was in Paris that the American editors of *Broom* learned to look at America and New York in the way that Cendrars or Léger looked at Paris, as the site of a modern, metropolitan spectacle. Paradoxically, American modernism first began as an assimilation of European Americanism. In the end even Mondrian, the purist of the pure, came to New York as a war refugee and revealed his Americanism in his startling last paintings, perhaps the most vivid 'American scene' paintings ever made in their invocation of the Manhattan grid, the V for Victory and, of course, boogie-woogie. Stuart Davis recounted with irony an occasion on which he played rare jazz records from his collection for Mondrian and how Mondrian 'pronounced certain examples of boogie-woogie to be "Pure" or "The True Jazz"; as for the rest it was worthy, provided an inferior status be granted'. (According to Mondrian, it should be noted, neoplasticism was to cubism as boogie-woogie was to jazz.[77])

A new generation grew up in New York which saw art as the means of celebrating, rather than redeeming, the specifically American city in which it lived and worked. Pioneers like Stieglitz had struggled to build the basis of an American modernism, but his followers went much further than their

mentor. An American national art, they felt, could not be neoclassical, or even post-impressionist like that of France. On the contrary, it must begin with its own materials, its own contemporary life and popular actualities – jazz, skyscrapers, movies, billboards – and build on those. Dancing-palaces, which Bell belittled, were precisely the right places at which to begin. Thus was born the specifically New York movement that Wanda Corn has dubbed that of 'the new vulgarians'.[78] Its adherents brought back European American-ism from Paris and set about creating a brand-new American art, rooted in the urban vernacular. Charles Demuth's *I Saw the Figure 5 in Gold*, painted in 1928, is based on a poem by William Carlos Williams describing the sensation of seeing a huge number 5 on a red firetruck rumbling down a city street at night, gong clanging and siren howling. At the same time, the painting is a 'portrait poster' of Williams, one of a series made by Demuth with friends as subjects. Demuth adopted the aesthetic of the poster, the advertizing art form of the street, to represent a contemporary street scene, to which he added poster-style lettering: the word 'BILL', a pun on billboards and William Carlos Williams, and the middle name 'CARLOS' in lights like a Broadway theatre sign.

The most complex, assiduous and long-lasting of this group of artists was Stuart Davis. Davis began as an American realist of the Ashcan School, but became fascinated by European avant-gardism as a result of the notorious Armory Show held in New York in 1913. Davis was then twenty and had already started to paint street scenes with signage, vaudeville theatres, saloons, jazz bars and dance halls. Gradually he assimilated the lessons of cubism and Matisse and made his crucial breakthrough after the First World War, in 1921. This was the year in which he decorated the walls of a soda fountain and candy store in Newark, New Jersey: Gar Sparks's Nut Shop, whose proprietor was both a friend and a fellow-artist. Davis covered the walls with 'letters of every colour, letters of every shape and size [reading 'BAnaNA rOyaL', 'HOuSE sOda', etc], looking at first like a pied form in a lunatic's print shop'.[79] Davis was familiar with Apollinaire's 'calligrammes' and the use of found lettering in cubist collages. One of his closest friends, Robert Brown, was an 'image-poet' and, after the Second World War, Davis seems to have followed lettrism with interest.[80] Indeed, his postwar paintings, full of commercial logos and cursive signatures, can be seen as running in parallel with the use of signs and glyphs by the Indian Space painters or, indeed, the stenographic notation adopted by Pollock.

Davis visited Newark often, not only to enjoy the Nut Shop, but also to listen to black music. He reminisced later about the days when he was

> particularly hep to the jive, for that period, and began listening to the negro piano players in Newark dives. . . . The pianists were unpaid, playing for love of art alone. In one place the piano was covered on top and sides with barbed wire to discourage lounging or leaning on it and give the performer more scope while at work. But the big point with us was that in all of these places you could hear the blues, or tin pan alley tune turned into real music.

Jazz was a lifelong enthusiasm for Davis and one of his goals as a painter was to capture the quality of the music he loved. At the Armory Show he felt 'the same kind of excitement I got from the numerical precisions of the negro piano players in the negro saloons, and I resolved that I would quite definitely have to become a "modern" artist'. More than twenty years later, he wrote:

> . . . some of the things which have made me want to paint, outside of other paintings, are: American wood and iron work of the past; Civil War and skyscraper architecture; the brilliant colors on gasoline stations; chain-store fronts and taxi-cabs; the music of Bach; synthetic chemistry; the poetry of Rimbaud; fast travel by train, auto, and aeroplane which brought new and multiple perspectives; electric signs; the landscape and boats of Gloucester, Mass.; 5 & 10 cent store kitchen utensils; movies and radio; Earl Hines hot piano and negro jazz music in general, etc. In one way or another the quality of these things plays a role in determining the character of my paintings. Not in the sense of describing them in graphic images, but by predetermining an analogous dynamics in the design, which becomes a new part of the American Environment.[81]

Jazz was important to avant-garde white artists in America for a number of reasons. First, it was a striking element of the 'American scene', especially the topical, urban scene, from which artists could borrow and which they could represent visually, perhaps through aiming to invent some equivalent in terms of colour or pattern. Second, white artists could look to jazz as an art form that provided them with a model of a 'usable American past' which they could counterpose to the all-too-available 'usable European past'. In the search for the authentically American, black music could be mobilized against 'European' music and viewed as a potential source for a new, alternative aesthetic, which could somehow be used as a can-opener to break with the obviously European norms of acceptable white art. Evidently, this often involved exaggerating and distorting the nature of the real African substrate

of jazz, which had survived right through slavery, and minimizing its European-derived aspects, often through appealing to the 'primitive' and 'wild' stereotypes of African-ness. Third, though probably this was not uppermost in the minds of either performers or listeners at the time, jazz did not simply provide subject matter for artists or even an influence or a model, but itself instituted a reorganization of the whole field of art between 'high' and 'low'.

9. 'It Don't Mean a Thing if it Ain't Got That Swing'

Jazz brought together phenomena that had previously been kept apart (or at least considered unconnected: folk art; urban vernacular art; popular entertainment; mass commercial art; and, last but not least, a marginalized form of 'art for art's sake' (or 'jazz music for jazz musicians'). At each level, jazz retained traces of the other levels and also absorbed a range of different outside influences. Moreover, the 'function' of jazz, to use Adorno's term, varied from level to level. Jazz could be found in the street, in the barrelhouse, in church, in the dance hall, in the nightclub, on the theatre stage, in the sound film, in the recording studio, on the radio, at rent parties, at the Aeolian Hall, at funerals and in the back room after hours. Its function clearly varied from situation to situation and the same musicians and bands could be found playing across a range of situations, though adapting or varying their music to suit different audiences. Jazz was thus quite different from any other type of music. Jazz was not tied to recording or to broadcasting. Rather, it provided an early and dynamic example of the way in which modern art forms might be expected to develop, not as fixed entities with well-defined borders, but as practices that underwent complex mutations and crossovers as they pursued trajectories through very different situations and aesthetic levels. Jazz was able to penetrate the realm of high art while retaining its connections with vernacular culture and developing its own avant-garde. Plainly, this was made possible by the historic origins of jazz when slavery was overthrown. For example, in the specific situation of New Orleans, formerly free creole ('mixed race') musicians, often highly trained musically, were thrown together with newly urbanized former slaves as white society reorganized itself to exclude anyone with the least touch of black descent – a much stricter *apartheid* than had prevailed before the Civil War, when creoles could even be slave-owners.[82]

Not only did this crossover between two hitherto distinct sections of what was now lumped together indiscriminately as the 'black' population take place in a large city, but the end of slavery also meant that black musicians of many different types could now professionalize themselves. This involved changes in the character of jazz and also the spread of jazz outside the black community and its eventual recognition as a national music. First, black musicians conquered vaudeville, introducing the cakewalk and tap, driving out the racist minstrel and coon shows that had flourished there. Next, they brought jazz to dance halls and Tin Pan Alley, where ragtime and jazz triumphed as the music of choice for the dance crazes that swept America from the turn of the century onwards (the Turkey Trot, Fox-Trot, Charleston, etcetera), reflecting enormous changes in American urban lifestyle and leisure activity, especially among youth and women. Finally, in the 1930s, building on the accomplishments of earlier black arrangers such as Don Redman, musicians such as Duke Ellington, along with white bands, made significant inroads into radio. Jazz, already established in clubs and on records, now reached a nationwide mass domestic audience in the newly evolved form of swing. In 1932 Davis painted the words 'It don't mean a thing if it ain't got that swing' down the side of his *American Painting*. Duke Ellington, whose words Davis was citing, later played at a mini-concert held at the opening of Davis's 1943 one-man show, an occasion that also allowed Piet Mondrian to enjoy some fine boogie-woogie piano.[83]

Jazz became associated with modernity, with the whole dynamic of the period in which the United States industrialized and then, from the beginning of the Fordist epoch on, began to overtake Europe. It was the epoch in which the skyscrapers were built and in which the United States established its dominance within the mass media (Hollywood) and industrialized consumer culture. In the 1920s and 1930s, jazz became an integral part of America's Great Leap Forward, even though the black community in general was left behind. Black painters also took jazz as their point of reference. Aaron Douglas, the outstanding visual artist of the Harlem Renaissance, whose mural *Aspects of Negro Life* in the 135th Street (now Countee Cullen) Library remains an outstanding monument of the Federal Art Project, used images of musicians as the main motif of his painting and clearly tried to find a pictorial equivalent to jazz in his stylized silhouettes and undulating bands of colour intersected by concentric circles and narrow cones of light. The iconography of the mural moves from the drums in Africa, through the banjo on the slave

plantation, to the trumpeter during Reconstruction and then, finally, to the saxophonist surveying an urban landscape of smokestacks and skyscrapers.[84]

A decade earlier, Douglas had done the cover and the illustrations for *Fire!!*, the avant-garde journal that Langston Hughes first suggested one evening in Douglas's apartment, whose contributors celebrated and drew from black vernacular culture, including jazz and the blues. Langston Hughes's article in *The Nation* in 1924 (the year Louis Armstrong came to New York as lead soloist for Fletcher Henderson) served as a manifesto for the group that gathered around *Fire!!* There Hughes called out:

> Let the blare of Negro jazz bands and the bellowing voice of Bessie Smith singing Blues . . . and Jean Toomer holding the heart of Georgia in his hands, and Aaron Douglas drawing strange black fantasies cause the smug Negro middle class to turn from their white, respectable, ordinary books and papers to catch a glimmer of their own beauty.[85]

Aaron Douglas surmised that music, rather than the plastic arts, had been in the forefront of black culture because of the iconoclastic nature of the Protestant religion that was imposed on Afro-Americans during slavery. Jazz, on the other hand, 'had dominated the form and direction of modern popular music' and jazz dance (from the Cake Walk, through Balling the Jack and the Lindy Hop to the Shim, Sham, Shimmie and Trucking) had 'not only kept the dance alive, but in a spontaneous, revolutionary, creative state'. Douglas noted that 'the Negro artist, unlike the white artist, has never known the big house' and consequently, was bound to suffer from the lack of a popular, visual culture.[86]

Modern painting in Europe, in contrast, began at the top, as one of the beaux-arts. The period of expansion of modernism, in the 1910s and especially the 1920s, saw a determined move into the field of the popular and performing arts: posters and advertising art, stage design, industrial and costume design and even, through the constructivists, the Bauhaus and Esprit Nouveau, an alliance and attempted integration with architecture. Although painting tried to incorporate elements of photography, it never succeeded in entering the mass media. Léger, Moholy-Nagy and Dali were almost alone in making films and none of them succeeded in penetrating the industry. In the 1930s this movement collapsed completely under the impact of the Great Crash, political repression and the corporate consolidation of the mass media. Indeed, a counter-tendency of purism soon emerged, seeking to restrict painting on two fronts, first by bringing it back firmly into the fine art

tradition and, second, where it had moved into design and applied arts, by attacking the 'pseudo-modern' and the 'modernistic'. In architecture, for example, buildings such as the Chrysler Building were denounced as spurious, even though they broke completely with the academic beaux-arts style. The Chrysler Building's architect, William Van Alen, had returned from Paris 'without a box of architectural books' and announced, 'No old stuff for me! No bestial copyings of arches, and colyums [sic] and cornishes [sic]! Me, I'm new! *Avanti*!'[87] None the less the building was denounced as a 'stunt design', characterized by 'meaningless voluptuousness'. Van Alen was immortalized as 'the Ziegfeld of architecture'. Indeed, this was also a tactic that Adorno applied to jazz, attacking it as pseudo-modern, as 'eccentric' and 'purposeless' in its deceptive 'sex appeal'.[88]

This tendency culminated in Greenberg's doctrine of modernism. On the one hand, Greenberg had taken a leaf from Benton and demanded an end to the hegemony of Paris, the lingering effete influence of Europe. But on the other hand, rather than falling back on isolationism and heartland populism, he had out-trumped Paris by backing a new and more dynamic version of abstract art. American painting, he argued, finally went beyond the limits imposed by the cubist aesthetic, beyond the *terminus ad quem* represented by Mondrian, now dead and buried in Brooklyn. High culture was in safe hands, where bohemia, a cultivated intelligentsia and an enlightened leisure class met in New York. Art would henceforth evolve within its own autonomous social space, its own ivory skyscraper. Outside, in the 'American scene', kitsch would reign supreme. Yet, in the end, Greenberg's efforts to combat kitsch in the name of a purified avant-garde were doomed to failure. The repression of subject matter and figuration was too harsh to survive. The monstrous spectacle of pop art sprang up to replace abstract expressionism and colour field painting, in a massive return of the repressed.

Pop went back to the basics that had been lost during the Greenberg years. It attempted once again to find a way to reinscribe the 'American scene' into the main tradition of modernism, to remake a link with the generation of Duchamp, Léger and indeed Davis. These may seem old issues now, yet I doubt that they have yet been fully worked out. Critics of Davis, with Pollock in mind, often describe him as having gone down a dead end. But perhaps it was Pollock rather than Davis who went down the dead end, threatening to deliver American painting, in its moment of triumph, into the very academicism and 'Alexandrianism' that Greenberg dreaded and which, when it came,

took the form of the abstract purism he himself promoted. Pop art, at the very least, rescued it from that sad fate. After Pollock, painting desperately needed to re-establish contact with the vernacular, even while retaining its long allegiance to formalism. Victor Shklovsky described the process of filiation in art history as like that of a 'Knight's Move'.[89] Perhaps this is how we can best see the relationship between Davis and Pollock. If we take the key issue to be that of the occult relationship between painting and writing, which surfaces early on in the history of modernism, in Lautrec's posters and in cubist collages, and continues up to the present, then we can see Pollock as displacing the logos, advertising graphics and signatures that fascinated Davis, enlarging them to fill the whole canvas and reducing them to calligraphic scrawls and *biffures*. In pop art, legible words reappear, now in the form of cartoon bubbles or newspaper headlines.

In the same way, Davis's homage to jazz reappears unexpectedly when critics make an analogy between Pollock's automatism and the improvisations of Charlie Parker or Thelonious Monk. Of course, there are basic differences between the two. Jazz improvisation consists of virtuoso embroidery around a given theme or rhythm, breaking it up, complicating it, pushing it to its limits. Pollock's automatism starts out with a void and then fills it with its own web of forms. But both have a mediumistic aspect, both threaten to dissolve into abstraction and chaos, both are forms of signifying, of searching for new, highly personal modes of utterance. As a psychiatrist friend of Pollock observed:

> I know people speak of his dancing in his paintings, but to me it's more like talking. I think there was a process – the old, primitive process – of the need to utter. Jackson took in a lot of experience, relations with people and with ideas; he'd seen therapists and all, and since he was a philosopher he had to ask 'What does it mean?' I think he had trouble saying it – a lot of people might understand him better if he had been a writer – and I think as a philosopher the best he could do was an approximation. There's an utterance there, but it's a lot like trying to understand brain-damaged people or those with an autistic or dyslexic factor, or psychotics, or somebody in an altered state of consciousness. Jackson the philosopher liked to talk, but he had trouble expressing what he saw and in that sense he was inarticulate.[90]

Much the same could be said of Monk. Both reached the point where, one starting from high, the other from low art, they each approached a kind of autistic rococo, creating meta-doodles of extraordinary virtuosity.[91]

The basic point here is the danger of purism, which is best seen simply as a closing off and cancellation of options and possibilities. Purist aesthetics attempt to channel art towards a single, overriding, conscious goal. To that end, accidental and unconscious influences, distracting compulsions and strange affinities are eradicated or denied. In the end, purism leads toward stasis, even when it is conceived of as an endless Sisyphean task. Pollock was followed by a period dominated by bland, vacuous, grandiloquent canvases, which, whatever their metaphysical pretensions, ended up as decorative adjuncts to corporate lobbies, monuments to fashion and to charm.[92] Worst of all, he was crowned the king of American painting in a triumphalist wave of nationalism and political manipulation of art. The 'ideologically innocent' art desired by Greenberg was inverted into an art of imperial propaganda. It was a strange and tragic fate for a great artist, who spent nights on the street in a drunken stupor, fought with the cops on demonstrations, haunted the Museum of Natural History in reverence contemplation of the art of Native Americans, scoured the beach for detritus to fling down onto his paint-encrusted canvas, loved the work of El Greco and Goya, played Exquisite Corpse in a surrealist salon, was thrown off the Federal Art Project as a Red, and wrestled all his life with childhood memories and philosophical conundrums that remained convulsive to the last, resistant to containment, regulation and good order.

Notes

1. Clement Greenberg, reviewing Jackson Pollock's second one-man show at the Art of This Century Gallery in *The Nation*, 7 April 1945, reprinted in Clement Greenberg, *The Collected Essays and Criticism*, vol. 2, *Arrogant Purpose, 1945–1949* (Chicago: University of Chicago Press, 1986).
2. For Bacon's observations on his own work, see David Sylvester, *The Brutality of Fact: interviews with Francis Bacon* (London: Thames & Hudson, 1985).
3. Dawn Ades and Andrew Forge, *Francis Bacon* (New York: Harry N. Abrams, 1985).
4. *Documents* (Paris), vols. 1 & 2, 1929, 1930.
5. Martin Jay, 'The Disenchantment of the Eye: surrealism and the crisis of ocularcentrism', in *Visual Anthropology Review*, vol. 7, no. 1 (spring 1991). See also, in the same issue, James Clifford, '*Documents*: a decomposition'.
6. Michel Leiris, *Biffures* (Paris: Gallimard, 1948). The autobiographical texts in this book, which plunge back into childhood memory and explore the 'spider's web' of language and its mysterious power, were written between 1940 and 1947.
7. Clement Greenberg, in 'Jean Dubuffet and "Art Brut" ', *Partisan Review*, March 1949, reprinted in Greenberg, *Collected Essays*.
8. Jackson Pollock, 'A Questionnaire', *Arts and Architecture*, no. 61, February 1944.
9. Jean Dubuffet, cited in Michel Ragon, *Dubuffet* (New York: Grove Press, 'Evergreen Gallery Book 1', 1959).

10. B.H. Friedman, *Alfonso Ossorio* (New York: Harry N. Abrams, n.d.).

11. Ossorio's recollection, cited in Jeffrey Potter, *An Oral Biography of Jackson Pollock* (Wainscott, NY: Pushcart Press, 1985). Ossorio comments that 'Jackson decided that life would be simpler if he and Dubuffet didn't meet.' He also notes that, although 'they looked at each other's work with extreme attention and understanding', Pollock thought that 'Dubuffet didn't go far enough' and Dubuffet thought that 'Jackson was too easy'.

12. For Dubuffet, see also Georges Limbour, *Tableau Bon Levain à vous de cuire la pate* (Paris: René Drouin, 1953).

13. Ragon.

14. Greenberg, 'Arrogant purpose', where he twice makes the comparison between Sobel and Pollock. Sobel, like Pollock, was counted as a surrealist in Sidney Janis, *Abstract and Surrealist Art in America* (New York: Reynal & Hitchcock, 1944).

15. David Maclagan, 'Solitude and Communication: beyond the doodle', *Raw Vision*, no. 3 (summer 1990).

16. For Nevelson's career, see Laurie Lisle, *Louise Nevelson: a passionate life* (New York: Simon & Schuster, 1990). Nevelson personally persuaded Alfred Barr to exhibit a decorated shoeshine stand, made by the self-taught bootblack Joe Milone, in the Museum of Modern Art lobby at Christmas 1942, an incident that led to Barr's dismissal. She began 'to see almost anything on the street as art', in a spirit she felt derived from her sense of social injustice. The other exceptional woman artist shamefully ignored at this time was Louise Bourgeois, who came to New York from Paris, where she had been strongly affected by Breton and surrealist ideas.

17. De Kooning is cited in Irving Sandler, *Abstract Expressionism* (London: Pall Mall Press, 1970).

18. For Pollock's life, as well as Jeffrey Potter, see also especially Steven Naifeh and Gregory White Smith, *Jackson Pollock: an American saga* (New York: Harper, 1991) and B.H. Friedman, *Jackson Pollock: energy made visible* (New York: McGraw Hill, 1972). Potter was a friend and neighbour of Pollock in Easthampton. Friedman was an early collector of Pollock's work. Both these authors have a vivid and informed personal viewpoint. Naifeh and White Smith won the Pulitzer Prize for their monumental and minutely researched biography, which, for me, is marred by their patronizing tone towards many of the characters in their fluent narrative. Even Pollock himself is treated with an edge of contempt, concealed behind the veil of adulation.

19. Naifeh and White Smith.

20. The standard introduction to the Mexican Renaissance is Jean Charlot, *The Mexican Mural Renaissance* (Newhaven: Yale University Press, 1963). For the expeditions of the Mexican muralists north of the border, see Laurence P. Hurlburt, *The Mexican Muralists in the United States* (Albuquerque: University of New Mexico Press, 1989). This is an outstandingly sympathetic, acute and well-researched treatment.

21. On the New School murals, see Emily Braun, *Thomas Hart Benton: the 'America Today' murals* (Williamstown: Williams College Museum of Art, 1985). On Benton's career in general, see Henry Adams, *Thomas Hart Benton: an American original* (New York: Knopf, 1989), which is thorough and detailed, though strictly limited to a fine arts approach, and, worse, falls over itself trying to put the best possible interpretation on Benton's outbursts and 'originality'. Erika Doss, *Benton, Pollock and the Politics of Modernism* (Chicago: University of Chicago Press, 1991) is much more wide-ranging and provocative. It takes pains to place Benton and Pollock in their cultural context, but over-eggs its pudding, highlighting every possible aspect of continuity. On the origins and role of the New School for Social Research, see Russell Jacoby, *The Last Intellectuals* (New York: Noonday, 1987) and, on the architecture, Robert A.M. Stern, Gregory Gilmartin and Thomas Mellins, *New York 1930* (New York: Rizzoli, 1987).

22. Leo Huberman, *We, The People!* (New York, Harper, 1932).

23. Henry Adams.

24. On the New Deal see, perhaps, Paul P. Conkin, *FDR and the Origins of the Welfare State* (New York: Thomas Y. Crowell, 1967). I have not been able to find a satisfactory overview of the New Deal.

25. For a personal account, see George Biddle, *An American Artist's Story* (Boston: Little Brown, 1939) and, for a more general treatment, Richard D. McKinzie, *The New Deal for Artists* (Princeton: Princeton University Press, 1973) and Belisario R. Contreras, *Tradition and Innovation in New Deal Art* (Lewisburg: Bucknell University Press, 1983). For the problems of censorship, see also Karal Ann Marling, *Wall-to-Wall America* (Minneapolis: University of Minnesota Press, 1982) and for muralists in New York City, Greta Berman, *The Lost Years* (New York: Garland, 1978), which is a volume in their series of reprints of 'Outstanding Dissertations in the Fine Arts'.

26. On Stuart Davis, see especially Lowery Stokes Sims, *Stuart Davis: American painter* (New York: Metropolitan Museum of Art, 1992). Cécile Whiting, *Antifascism and American Art* (Newhaven: Yale University Press, 1989) is useful on Davis's political activities as an artist.

27. Reprinted in Fernand Léger, *Functions of Painting* (New York: Viking, 1963).

28. On Rivera's United States murals, see Hurlburt.

29. Henry Adams.

30. See Michael E. Zimmerman, *Heidegger's Confrontation with Modernity* (Bloomington: University of Indiana, 1990). When Davis and others accused Benton of drifting dangerously towards fascism, it is clear why they thought this convincing at the time, while both the trajectory of the New Deal and of Benton were still unclear. However, in retrospect, we can see that Benton was something more like a nativist and chauvinist social democrat than an anti-democratic proto-fascist. He supported Roosevelt throughout. His social-democratic ideas, however, were strongly coloured by the Midwestern agrarian populism that underpinned much regionalist ideology, whose other adherents often displayed an isolationist indifference to the dangers of fascism abroad.

31. Hurlburt.

32. Henry Adams.

33. See Matthew Baigell and Julia Williams, *Artists Against War and Fascism* (New Brunswick: Rutgers University Press, 1986). In his address to the congress, Siqueiros stressed a movement away from mural painting set within official buildings towards 'graphic art' accessible to people in the street.

34. Clement Greenberg, *Art and Culture* (Boston: Beacon Press, 1961).

35. The standard introductory work on the history of surrealism remains Maurice Nadeau, *The History of Surrealism* (London: Jonathan Cape, 1968). This, however, was first written in France during the Nazi occupation and was never subsequently updated. Recent books that raise vital issues for our assessment of surrealism are Whitney Chadwick, *Women Artists and the Surrealist Movement* (Boston: Little, Brown, 1985) and Susan Rubin Suleiman, *Subversive Intent* (Cambridge, Mass.: Harvard University Press, 1990).

36. See René Depestre, *Bonjour et adieu à la négritude* (Paris: Seghers, 1980) for an account by a Haitian who was present at the lecture and went on to be a leading poet and theorist of *négritude*.

37. John Graham, 'Primitive Art and Picasso', *Magazine of Art*, April 1937. Jung, it may be relevant to note, believed that elements of the Amerindian unconscious were inherited in some occult way by Euro-Americans.

38. According to his brother Charles, he bought these in used bookstores on Fourth Avenue, between 1930 and 1935, but according to others he stole them from the City and Country School library. See Friedman.

39. On Baziotes, see Barbara Cavaliere, 'An Introduction to the Method of William Baziotes', *Arts Magazine*, no. 51 (April 1977).

40. See especially Jeffrey Wechsler, *Surrealism and American Art* (New Brunswick: Rutgers University Art Gallery, 1977). This work is invaluable for a clear understanding of the options open to American artists.

41. For surrealist games, see Mel Gooding (ed.), *Surrealist Games* (London: Redstone Press, 1991), compiled and presented by Alastair Brotchie. This is the best available introduction to the emancipatory methods of surrealism and crams an amazing amount of research into a very small space.

42. André Breton, *Surrealism and Painting* (New York: Harper & Row, 1947). A panoramograph by

Kamrowsky was published in Breton's magazine *VVV*, March 1943. The most prominent American surrealist was Dorothea Tanning.

43. See Sandra Kraskin and Barbara Hollister (eds.), *The Indian Space Painters* (New York: Baruch College, 1991), the catalogue of a pioneering exhibition at the Sidney Mishkin Gallery, and Ann Eden Gibson, *Issues in Abstract Expressionism: the artist-run periodicals* (Ann Arbor: UMI Research Press, 1990), which focuses on the journal *Iconograph*, which was associated with the group. The achievements of Robert Barrell, Gertrude Barrer and Peter Busa, and indeed many other artists associated with the Indian Space movement, have been shamefully overlooked. Gertrude Barrer's exceptionally interesting work developed in the direction of abstract expressionism and was noted by Greenberg, but of course she was a woman and this counted against her. There is an underlying connection between the American fascination with Kwakiutl art and that of the surrealists. Breton, Ernst and the anthropologist Claude Lévi-Strauss, who was close to the surrealists at that time, were all collectors of Northwest Coast art while they were in New York, and in 1943 Lévi-Strauss wrote for the *Gazette des Beaux-Arts* an article, 'The Art of the Northwest Coast at the American Museum of Natural History', which was a forerunner of his classic *The Way of the Masks* (Seattle: University of Washington, 1975).

44. Gotthold Ephraim Lessing, *Laocoon* (London: Dent, 1930). For an excellent commentary on *Laocoon*, see David E. Wellbery, *Lessing's Laocoon* (Cambridge: Cambridge University Press, 1984). Goethe's 'Observations on the Laocoon', which reflect his critical reading of Lessing, are available in English in Gert Schiff (ed.), *German Essays on Art History* (New York: Continuum, 1988).

45. Nicolas Calas, 'View Listens', *View*, no. 2 (October 1940); Clement Greenberg, 'The Renaissance of the Little Mag', *Partisan Review*, January–February 1941; Parker Tyler, 'Letter', *Partisan Review*, May–June 1941.

46. Cited by Catrina Neiman in her Introduction to Charles Henri Ford (ed.), *View: parade of the avant-garde* (New York: Thinder's Mouth Press, 1991). This is a compilation of articles and illustrations from *View*, 1940–47, with a full contents index.

47. Clement Greenberg, 'Surrealist Painting', *The Nation*, 12 and 19 August 1944, reprinted in *Horizon*, January 1945.

48. Greenberg reviewed Pollock's first Art of This Century show in *The Nation*, 13 November 1943, the salon show at the same gallery in the issue of 27 May 1944, and Baziotes's and Motherwell's shows in a joint review, 11 November 1944.

49. For Matta, see Nancy Miller, *Matta, the First Decade* (Waltham: Brandeis University, 1982) and for Breton's suggestions, André Breton, 'Prolegomena to a Third Surrealist Manifesto or Not' (1942), reprinted in André Breton, *Manifestos of Surrealism* (Ann Arbor: University of Michigan Press, 1969).

50. Clement Greenberg, letter to Baziotes.

51. Clement Greenberg, 'Review of the Exhibition *150 Years of American Primitives*', *The Nation*, 11 April 1942. On Pickett, see 'Primitive Painting', 10 October 1942; on Friedman, first reviewed 15 April 1944, see 'An Obituary of Arnold Friedman', 1 February 1947; on Eilshemius, see the exhibition review of 18 December 1943. Pickett is mentioned in three reviews by Greenberg, Friedman in eight, Eilshemius in five. By way of comparison, the abstract expressionists Newman and Still were mentioned in one, Reinhardt in two, Rothko and De Kooning in three, Baziotes in four, Gottlieb in nine, Motherwell in ten, Gorky in twelve, Pollock in many more. Incidentally, Louise Nevelson was a friend and major collector of Eilshemius.

52. Clement Greenberg, 'Henri Rousseau and Modern Art', *The Nation*, 27 July 1946.

53. Clement Greenberg, 'Jean Dubuffet and Art Brut', *Partisan Review*, March 1949.

54. 'Jackson Pollock: is he the greatest living painter in the United States?', *Life*, 8 August 1949.

55. Clement Greenberg, in his review of Pollock's second Art of This Century show, *The Nation*, 21 April 1945. In his review of Pollock's third show, Greenberg continued in the same vein, noting that 'in the course of time this ugliness will become a new standard of beauty' (*The Nation*, 13 April 1946). Then, in a review of Arshile Gorky's work on 4 May, he compared Gorky adversely with Pollock, adding that if Gorky acquired 'integral arrogance' then he might possibly 'begin to paint pictures so original that they will look ugly at first'.

56. Review of Pollock's first show, *The Nation*, 13 November 1943. Actually, Benton and surrealism were what Greenberg meant by 'and whatnot'.

57. Naifeh and White Smith.

58. Cited in B.H. Friedman, *Jackson Pollock*.

59. Clement Greenberg, 'The Situation at the Moment', *Partisan Review*, January 1948.

60. Clement Greenberg, 'Obituary of Mondrian', *The Nation*, 4 March 1944.

61. For Greenberg's political positions see the *Collected Essays and Criticism*, and Alan M. Wald, *The New York Intellectuals* (Chapel Hill: University of North Carolina, 1987). This is an outstanding work, a thorough and politically informed account of the steady rightward drift of revolutionary Marxist intellectuals such as Greenberg. Terry A. Cooney, *The Rise of the New York Intellectuals* (Madison: University of Wisconsin, 1986) is also particularly valuable.

62. For these events, see Wald; Serge Guilbaut, *How New York Stole the Idea of Modern Art: abstract expressionism, freedom and the Cold War*, (Chicago: University of Chicago Press, 1983); Jacoby; and from the copious literature on McCarthyism, Victor Navasky, *Naming Names* (New York: Viking, 1980).

63. John Cogley, in *Report on Blacklisting*, vol. 1, *Movies*, notes that Kelly was 'so harassed that he went off to Europe' at the end of 1951. While he was away both *An American in Paris* and *Singin' in the Rain* were listed in the *American Legion Magazine* as films made by communists or 'collaborators'. Kelly returned to Hollywood in July 1953 when a deal was cut with Roy Brewer, head of the film technicians union IATSE, a notorious broker of clearances. Kelly's wife, Betsy Blair, did not get off the blacklist till she was cast in *Marty* in 1955. See also Peter Wollen, *Singin' in the Rain* (London: BFI, 1992).

64. As early as 1939 Greenberg had noted that: 'Kitsch is deceptive: it has many different levels, and some of them are high enough to be dangerous to the naive seeker of true light.'

65. See Theodor Adorno, 'Perennial Fashion-Jazz', in *Prisms* (London: Neville Spearman, 1967).

66. William Empson, *Some Versions of Pastoral* (London: Chatto & Windus, 1935).

67. See Guilbaut. Rothko favoured ancient Greek myth, particularly the tragic saga of the Oresteia, while Gottlieb and Newman were enthusiasts for pre-Columbian and Native American art. Rothko's approach to mythology involved, in his own words, 'a pantheism in which man, bird, beast and tree – the known as well as the knowable – merge into a single tragic idea'. Polcari, in *Arts*, no. 54, September 1979, suggests persuasively that Rothko's famous horizontal bands of colour derive from the coloured bands in the charts of geological strata, illustrating the fossil record and the development of human culture, which he presumably saw at the Museum of Natural History. Gottlieb, throughout the forties, painted a series of 'pictographs': 'I disinterred some relics from the secret crypt of Melpomene [the Muse of tragedy] to unite them through the pictograph, which has its own internal logic.'

68. Barnett Newman, *Northwest Coast Indian Painting* (New York: Betty Parsons Gallery, 1946).

69. Barbara Cavaliere and Robert C. Hobbs, 'Against A Newer Laocoon', *Arts Magazine*, no. 51, April 1977.

70. Naifeh and White Smith.

71. Clement Greenberg, 'Ideal Climate for Art', *New York Times Book Review*, 4 May 1947.

72. For the 'whirlwind dance' see Fernand Léger, 'Popular Dancing', in *Léger and Purist Paris* (London: Tate Gallery, 1970).

73. On Léger's politics see Sarah Wilson, 'Fernand Léger, Art and Politics 1935–1955', in Nicholas Serota (ed.), *Fernand Léger* (London: Prestel-Verlag, 1987) and for Le Corbusier's politics, see Robert Fishman, 'From the Radiant City to Vichy: Le Corbusier's plans and politics, 1928–1942', in Russell Walden (ed.), *The Open Hand, Essays on Le Corbusier* (Cambridge, Mass.: MIT, 1977).

74. See, for instance, 'Art and the People', in Fernand Léger, *Functions of Painting* (New York: Viking, 1973), where he talks about slang, Rousseau, children's drawings, choosing a necktie, and jazz, as well as noting that 'more leisure time must be created for the workers. Contemporary society is very harsh, and the workers do not have the indispensable freedom to see, to reflect, to choose.'

75. Gilbert Seldes, *The 7 Lively Arts* (New York: Harper, 1924).

76. Clive Bell, *Since Cézanne* (London: Chatto and Windus, 1922).

77. Stuart Davis, 'Memo on Mondrian', in Diane Kelder (ed.), *Stuart Davis* (New York: Praeger, 1971).

78. Wanda Corn, *In American Grain* (Poughkeepsie: Vassar College, 1991).

79. Unsigned, 'Even in Grinnich There's Nothing as Odd as Emblazoned Walls of "Nut Shop" Here', *Newark Evening News*, 16 May 1921, cited in Lowery Stoke Sims, *Stuart Davis: American painter* (New York: Metropolitan Museum of Art, 1991).

80. See Lewis Kachur, 'Stuart Davis's Word-pictures', in Sims.

81. Quotations from Stuart Davis, 'Autobiography', 1945, and 'The Cube Root', *Art News*, vol. XLI, no. 1, February 1943, cited in Kelder.

82. See Leroy Ostransky, *Jazz City: the impact of our cities on the development of jazz* (Englewood Cliffs: Prentice-Hall, 1978) for a brave attempt to trace the complex development of jazz in its institutional context.

83. The jazz at Davis's one man-show, held at the Downtown Gallery in 1943, was organized by John Hammond and William Steig, the *New Yorker* cartoonist. Among those who played were W.C. Handy, Red Norvo, George Wettling, Duke Ellington and Pete Johnson. Hammond was a close friend of Joseph Losey, who took a collection of jazz records assembled by Hammond to the Soviet Union in 1935.

84. See Charles Miers (ed.), *Harlem Renaissance Art of Black America* (New York: Harry N. Abrams, 1987).

85. See Arnold Rampersand, *The Life of Langston Hughes*, vol. 1 (Oxford: Oxford University Press, 1986).

86. See Aaron Douglas, 'The Negro in American Culture', Douglas's address to the First American Artists' Congress, 1936, reprinted in Matthew Baigell and Julia Williams (eds.), *Artists Against War and Fascism* (New Brunswick: Rutgers University, 1986). Marshall Stearns, in his classic *The Story of Jazz* (Oxford: Oxford University Press, 3rd edn, 1958) points out that New Orleans, the cradle of jazz, was distinctively Catholic and Caribbean in its history and culture, in contrast to the Protestant regime of the slavery South in general.

87. Cited in Robert A.M. Stern, Gregory Gilmartin and Thomas Mellins, *New York 1930* (New York: Rizzoli, 1987).

88. Theodor Adorno, 'On Jazz', in *Discourse*, vol. 12, no. 1 (fall–winter 1989–90). It is important to remember that Adorno's text was written and published in Europe in 1936, which gave him a very restricted and distorted view of his subject. The great French critic Hugues Panassié was limited in the same way when he published *Le Jazz Hot* in Paris in 1934. Panassié, however, had the grace to apologize in 1942, in his *The Real Jazz*, where he noted, 'I had the bad luck, in a sense, to become acquainted with jazz first through white musicians. . . . I did not realize until some years after the publication of my first book that, from the point of view of jazz, most white musicians were inferior to most black musicians.' Adorno never retracted his condescending view of black musicians.

89. V. Šklovskij, *La Mossa del Cavallo* (Bari: De Donato, 1967), translated from Sklovskij, *Chod Konja* (Berlin: Helicon, 1923).

90. B.H. Friedman, *Jackson Pollock*.

91. The best source on Thelonious Monk is a film rather than a book: *Thelonious Monk: Straight No Chaser*, dir. Charlotte Zwerin, prod. Clint Eastwood, for Monk Film Project/Malpaso Productions, 1988.

92. Pollock's old friend Philip Guston went through a period of painting truly dreadful 'abstract expressionist' canvases. it was not until the 1960s that he recovered to paint his amazing late paintings, which drew on comic strip imagery and his own earlier work.

CHAPTER FOUR

THE SITUATIONIST INTERNATIONAL: ON THE PASSAGE OF A FEW PEOPLE THROUGH A RATHER BRIEF PERIOD OF TIME

1. Bitter Victory

De Sade liberated from the Bastille in 1789, Baudelaire on the barricades in 1848, Courbet tearing down the Vendôme Column in 1870: French political history is distinguished by a series of glorious and legendary moments which serve to celebrate the convergence of popular revolution with art in revolt. In this century, avant-garde artistic movements took up the banner of revolution consciously and enduringly. The political career of André Breton and the Surrealists began with their manifestoes against the Moroccan war (the Riff War) in 1925 and persisted through to the Manifesto of the 121, which Breton signed in 1960, shortly before his death, denouncing the Algerian war and justifying resistance. In May 1968 the same emblematic role was enacted once again by the militants of the Situationist International (SI).

The SI was founded in 1957, at Cosio d'Arroscia in northern Italy, principally out of the union of two prior avant-garde groups, the Movement for an Imaginist Bauhaus (MIBI, consisting of Asger Jorn, Pinot-Gallizio, and others) and the Lettrist International (LI, led by Guy Debord).[1] The Movement for an Imaginist Bauhaus itself originated from splits in the COBRA group of artists, which Jorn had helped found after the Second World War, and the SI was soon joined by another key COBRA artist, Constant.[2] The ancestry of both COBRA and lettrism can be traced back to the international Surrealist movement, whose break-up after the war led to a proliferation of new splinter groups and an accompanying surge of new experimentation and position-taking. The SI brought together again many of the threads whose dispersal had signalled the decay and eventual decomposition of surrealism. In many ways, its project was that of relaunching surrealism on a new foundation, stripped of some of its elements (emphasis on

the unconscious, quasi-mystical and occultist thinking, cult of irrationalism) and enhanced by others, within the framework of cultural revolution.

In its first phase (1957–62) the SI developed a number of ideas that had originated in the Lettrist International, of which the most significant were those of *urbanisme unitaire* ('unitary urbanism', or integrated city-creation), psycho-geography, play as free and creative activity, *dérive* (drift) and *détourne-ment* ('diversion', or semantic shift).[3] The SI expounded its position in its journal *Internationale situationniste*, brought out books and embarked on a number of artistic activities. Artists were to break down the divisions between individual art forms, to create *situations*, constructed encounters and creatively lived moments in specific urban settings, instances of a critically transformed everyday life. They were to produce settings for situations and experimental models of possible modes of transformation of the city, as well as to agitate and polemicize against the sterility and oppression of the actual environment and ruling economic and political system.[4]

During this period a number of prominent painters and artists from many European countries joined the group and became involved in the activities and publications of the SI. With members from Algeria, Belgium, England, France, Germany, Holland, Italy and Sweden, the SI became a genuinely international movement, held together organizationally by annual confer-ences (1957 – Cosio d'Arroscia, Italy; 1958 – Paris, France; 1959 – Munich, Germany; 1960 – London, England; 1961 – Goteborg, Sweden; 1962 – Anvers, Belgium) and by the journal, which was published once or twice a year in Paris, with an editorial committee that changed over time and represented the different national sections.[5]

From the point of view of art, 1959 was an especially productive (or should one say, dialectically destructive) year. Three artists held major exhibitions of their work. Asger Jorn showed his *Modifications* (*peintures detournées*, or altered paintings) at the Rive Gauche gallery in Paris. These were over-paintings by Jorn on secondhand canvases by unknown painters, which he bought in flea markets or the like, transforming them by this double inscription.[6] The same year Pinot-Gallizio held a show of his *Caverna dell'antimateria* (Grotto of anti-matter) at the Galerie René Drouin. This was the culmination of his experiments with *pittura industriale* – rolls of canvas up to 145 metres in length, produced mainly by hand, but also with the aid of painting machines and sprayguns using special resins devised by Pinot-Gallizio himself (he had been a chemist before he became a painter, linking the two activities with

Jorn's encouragement).[7] The work was draped all round the gallery and Pinot-Gallizio sold work by the metre by chopping lengths off the roll. His painting of this period was both a 'diverted' parody of automation (which the SI viewed with unremittingly hostile concern) and a prototype of vast rolls of 'urbanist' painting which could engulf whole cities. Later in 1959 Constant exhibited a number of his *ilôts-maquettes* (model precincts) at the Stedelijk Museum in Amsterdam. These were part of his ongoing New Babylon project inspired by unitary urbanism: the design of an experimental utopian city with changing zones for free play, whose nomadic inhabitants could collectively choose their own climate, sensory environment, organization of space and so on.[8]

During this period, however, a series of internal disagreements arose inside the organization that finally culminated in a number of expulsions and a split in 1962, when a rival Second Situationist International was set up by Jörgen Nash (Asger Jorn's younger brother) and joined by others from the Dutch, German and Scandinavian sections. In broad terms, this can be characterized as a split between practising artists and political theorists (or 'revolutionaries'). The main issue at stake was the insistence of the theoretical group, based around Debord in Paris, that art could not be recognized as a separate activity, with its own legitimate specificity, but must be dissolved into a unitary revolutionary praxis.[9] After the split the SI was reformed and centralized around a central office in Paris. Up to 1967, the journal continued to appear annually, but only one more conference was held (1966, in Paris).

During the first, art-oriented phase of the SI Debord worked closely with Jorn on collective art books and also made two films, *Sur le passage de quelques personnes à travers une assez courte unité de temps* (1959) and *Critique de la séparation* (1961).[10] Debord's future orientation can already be clearly seen in the second of these films, which makes a distinct break from the assumptions of the first. Debord had been auditing a university class taught by the Marxist philosopher Henri Lefebvre; subsequently he began to collaborate with the revolutionary Socialisme ou barbarie group and issued a joint manifesto in 1960 with its leading theorist, Cornelius Castoriadis. Fairly rapidly, his political and theoretical positions clarified and sharpened to the point when a split was inevitable.

After 1962 Debord assumed an increasingly central role in the SI, surrounded by a new generation of militants who were not professional artists. The earlier artistic goals and projects either fell away or were transposed into an overtly political (and revolutionary) register within a unitary theoretical

system. In 1967 Debord published his magnum opus, *Society of the Spectacle*,[11] a lapidary totalization of situationist theory, which combined the situationist analysis of culture and society within the framework of a theoretical approach and terminology drawn from Georg Lukács's *History and Class Consciousness* (published in France by the *Arguments* group of former Communist Party members who had left the party after 1956)[12] and the political line of council communism, characteristic of Socialisme ou barbarie,[13] but distinctively recast by Debord. In this book, Debord described how capitalist societies East and West (state and market) complemented the increasing fragmentation of everyday life, including labour, with a nightmarish false unity of the 'spectacle', passively consumed by the alienated workers (a term understood in the broadest possible sense of non-capitalists and non-bureaucrats). Not until they became 'conscious' (in the totalizing Lukácsian sense) of their own alienation could and would they rise up to liberate themselves and institute an anti-statist dictatorship of the proletariat in which power was democratically exercised by autonomous workers' councils.

Society of the Spectacle is composed in an aphoristic style, drawing on the philosophical writings of Hegel and the polemical tropes of the young Marx, and it continues to extol *detournément* (and the obligation to plagiarize) but, in general, it is a work of theory without artistic pretensions. This did not mean, however, that the Situationists had retreated from any forms of action but the elaboration of theory. The previous winter a student uprising at the University of Strasbourg, one of a wave sweeping across the world, had been specifically inspired by the SI and based its political activity on situationist theory.[14] The next year, 1968, saw the great revolutionary uprising, first of students, then of workers, which threatened to topple the de Gaulle regime. Here again student groups were influenced by the SI, especially at Nanterre, where the uprising took shape, and the Situationists themselves played an active role in the events, seeking to encourage and promote workers' councils, and a revolutionary line within them, without exercizing positive powers of decision and execution or political control of any kind.[15]

1968 was both the zenith of SI activity and success, and also the beginning of its rapid decline. One more issue of the journal was published, in 1969, and the same year the last conference was held, in Venice. Further splits followed and in 1972 the organization was dissolved. For the situationists 1968 proved a bitter victory. Indeed, ironically, their contribution to the revolutionary uprising was remembered mainly through the diffusion and spontaneous

expression of situationist ideas and slogans, in graffiti and in posters using *détournement* (mainly of comic strips, a graphic technique they had pioneered after 1962) as well as in serried assaults on the routines of everyday life. In short, it was a cultural rather than a political contribution, in the sense that the Situationists had come to demand. Debord's political theory was more or less reduced to the title of his book, generalized as an isolated catch phrase, separated from its theoretical project. Council communism was quickly forgotten by students and workers alike.[16]

Thus the Situationist International was fated to be incorporated into the legendary series of avant-garde artists and groups whose paths had intersected with popular revolutionary movements at emblematic moments. Its dissolution in 1972 brought to an end an epoch that began in Paris with the Futurist Manifesto of 1909: the epoch of the historic avant-gardes with their typical apparatus of international organization and propaganda, manifestos, congresses, quarrels, scandals, indictments, expulsions, polemics, group photographs, little magazines, mysterious episodes, provocations, utopian theories and intense desires to transform art, society, the world and the pattern of everyday life.

This is a truth, but a partial truth. Separated from the mass of the working class, the SI was bound to remain in memory and in effect what it had begun by being, an art movement, just like the Surrealists before it. But at the same time, this verdict neither tells the whole story of the relation between art and politics nor does justice to the theoretical work of the SI and of Debord in particular. If we can see the SI as the summation of the historic avant-gardes, we can equally see it as the summation of Western Marxism – and in neither case does the fact that a period has ended mean that it need no longer be understood or its lessons be learned and valued. May 1968 was both a curtain call and a prologue, a turning point in a drama we are all still blindly living.

2. Western Marxism

Western Marxism developed in two phases. The first followed the 1914–18 war and the Bolshevik Revolution. In 1923 Lukács published his collection of essays *History and Class Consciousness* and Karl Korsch published the first edition of his book *Marxism and Philosophy*.[17] The immediate post-war years had brought a revolutionary ferment in Europe, which was eventually rolled back by the forces of order, leaving the Soviet Union alone and isolated, but in

command of a defeated and demoralized international movement. In time, not only was this movement further threatened and mortally attacked by fascism, but the citadel of the Soviet Union fell into the hands of Stalin. The early writings of Lukács and Korsch are the product of the revolutionary ferment itself, whilst later Western Marxism developed under the shadow of fascism: Antonio Gramsci writing in an Italian prison; Korsch and the Frankfurt School working in an American exile. Only Lukács went east, to make his peace with Stalinism and adapt his theoretical position accordingly.

The second phase of Western Marxism came after the Second World War and the victory over fascism of the Soviet Union (together, of course, with its United States ally). Once again, the growth of resistance movements and the dynamic of victory brought with it a revolutionary ferment, which triumphed in Yugoslavia and Albania, was crushed in Greece and was channelled into parliamentary forms in France and Italy. Immediately after the war Sartre began his long process of interweaving existentialism with Marxism, and Lefebvre published his *Critique of Everyday Life* (1947).[18] A decisive new impetus came when the Soviet Union suppressed the Hungarian Revolution in 1956 and a wave of intellectuals left the western Communist parties. It is from this date especially that we can see the beginnings of the New Left and the intellectual cross-currents that led to 1968.

The shift of the centre of Western Marxism to France from Germany (the product, of course, of the catastrophe of fascism and the absence of an internal resistance movement) naturally led to shifts of emphasis. However, these were not as great as might be imagined, because French thought had already opened itself, before the 1939–1945 war, to the influence of Hegel (and Heidegger) and it was therefore possible to reabsorb Lukács's writings when they were republished in the post-1956 journal *Arguments*.[19] Indeed, there were many obvious affinities both with Sartre's method and with Lefebvre's.

Debord dates his 'independent' life from 1950, when he first threw himself into the artistic and cultural scene of the Left bank, its bars, its cinemas, its bookshops.[20] His thought was marked in turn by Sartre (the concept of 'situation') and Lefebvre (the critique of everyday life), the *Arguments* group and Lukács (the subject–object dialectic and the concept of 'reification'). In the first instance Debord envisaged Lefebvre's everyday life as a series of fortuitous Sartrean situations. Existence, Sartre had argued, is always existence within a particular context, within a given situation, which is not simply lived-in, but also lived-beyond, through the subject's free choice of the

manner of his or her being within that given situation. Debord, following Lefebvre's injunction to transform everyday life, interpreted that as a positive injunction to construct situations – as an artistic and practical activity – rather than accept them as given, to impose a conscious order at least in enclaves of everyday life, an order that would permit fully free activity, forms of *play* set consciously within the context of everyday life, not separated from it in the predetermined sphere of 'leisure'.[21] He wanted to expand the realm of freedom beyond the situated individual to the situating group.

From situation, Debord enlarged his scope to city, and from city to society.[22] This, in turn, involved an enlargement of the subject of transformation from the group (the affinity group of lettrists or situationists with shared goals) to the mass of the proletariat, constructing the totality of social situations in which it lived. It is at this point that Debord was forced to think beyond the sphere of possible action of himself and his immediate associates and engage with mass politics and classical revolutionary theory. This, in turn, radicalized him further and sent him back to Western Marxism to reinterpret it on a new basis. Instead of changing limited ambiances for transient and brief periods, the whole of social space and time was to be transformed and, if it was to be transformed, it must first be theorized. This theory, it followed, must be the theory of the whole of contemporary, even future, society and its contemporary alienation (the key idea for Lefebvre).

Lukács's *History and Class Consciousness* had represented a shift in its author's thought from 'romantic anti-capitalism' to Marxism, made possible first by the assignment of the role of the subject of history to the working class and, second, the combination of Marx's concept of commodity fetishism with the Hegelian concept of 'objectification' to produce a new theory of 'reification' as the contemporary capitalist form of the alienation of human subjectivity. Debord, reading Lukács many decades later, was able in turn to relate Lukács's theory of the reification of labour in the commodity to the appearance of 'consumerism' in the long post-1945 boom of Keynesian capitalism. Just as Lukács was writing during the first period of Fordism, that of standardization and mass production, so Debord was writing in the second, that of variety marketing and mass consumption. Consumer society confronted producers with their products alienated not only in money form, quantitatively, but also in image form, qualitatively, in advertising, publicity, media: instances of the general form of the 'spectacle'.

However, in order to get from his *Report on the Construction of Situations*

(1957) to *Society of the Spectacle* ten years later, Debord had to pass through the portals of the past: the legacy of classical Marxism, discredited by the cruel experience of Stalinism, yet still the sole repository of the concept of proletarian revolution. Scholars have disagreed about the relation of Western to classical Marxism, drawing the dividing line between the two at different places. For Perry Anderson, Western Marxism resulted from the blockage of revolutionary hope in the West, and the consequent substitution of Western for classical Marxism was a formal shift away from economics and history towards philosophy and aesthetics, in a long detour from the classical tradition. For Russell Jacoby, in contrast, Western Marxism is a displacement onto the terrain of philosophy of the political left of the classical tradition, the failed opposition to Leninism, articulated politically in the council communist movement.[23] In this perspective, Western Marxism represented, from the beginning, a historic alternative to classical Marxism as it developed through the work of Lenin and his followers.

Council communism, the literal interpretation of the slogan 'All power to the soviets!', flourished briefly during the post-1917 period of revolutionary upsurge and marked the work of Lukács, Korsch and Gramsci at that time. Lukács and Gramsci soon rallied to the orthodox line, however, stressing the party as the condensed organizer of a diffuse class (the Hegelian 'subject' and Machiavellian 'prince' respectively) while Korsch remained loyal to councilist principles, stressing the self-organization of the workers in their own autonomously formed councils. This debate over party and council, the necessary mediations between state and class, reached its highest peak in this period, but it had already taken shape before the First World War.

The debates in the German party between Herman Gorter and Anton Pannekoek (from Holland), Rosa Luxemburg and Karl Kautsky, and those in the Russian party between Alexander Bogdanov and Lenin prefigured the postwar debates on councils. In fact, Lenin polemicized mainly against both the Dutch councilists and Bogdanov in the immediate post-revolutionary years, and figures such as Lukács and Korsch, with no background in the prewar movement, only felt the polemical backwash of the titanic struggles of their elders.[24]

The immediate background to these clashes lay in the quite unanticipated appearance of soviets in the 1905 Russian revolution and the rise of syndicalism as a competitor to Marxism in western Europe (and, with the rise of the Wobblies, the IWW in the United States too).[25] It is significant also that

both the Dutch and Russian trends were associated with philosophical (as well as political) heterodoxy: Pannekoek and Gorter promoted the monist 'religion of science' of Joseph Dietzgen, and Bogdanov the monist positivism of Ernst Mach. These philosophical deviations reflected the wish to find a role for collective subjectivity in politics that went beyond the limits imposed by 'scientific socialism', bringing them closer to both the syndicalist mystique of the working class as collectivity and the concomitant stress on activism (expressed in extreme and distorted form by Georges Sorel).

After the Bolshevik Revolution, left communists with philosophical inclinations turned away from the modified scientism of Dietzgen and Mach to full-scale Hegelianism, covered by the tribute paid to Hegel by Marx. Lukács and Korsch went far beyond reviving Hegel as a predecessor of Marx (turned into a materialist by being stood on his head) and integrated Hegelian concepts and methods into the heart of Marxism itself: especially those of 'totality' and 'subject'. In this way council communism appeared as a Marxist reformulation of syndicalist ideas, and Western Marxism appeared as a philosophical reformulation of scientific socialism. The link between the two was provided by the transformation of romantic, vitalist and libertarian forms of activism into the more sober Hegelian categories of subjectivity and praxis, now assigned to the self-consciousness of the proletariat as a class. At the same time, the left communists of this period instituted a much more radical break with classical Marxism and suffered a much more serious political defeat than did their predecessors.

Like Western Marxism, council communism was revived in France after the Liberation, by the Socialisme ou barbarie group, which began a correspondence with the aged Pannekoek. Both the leaders of this group were ex-Trotskyists: Claude Lefort had joined the Fourth International after studying philosophy with Sartre's colleague Maurice Merleau-Ponty, and Cornelius Castoriadis was a Greek militant and economist who left the Communist Party for Trotskyism during the German occupation of Greece, which he fled after the Greek Civil War. Lefort and Castoriadis left the Trotskyists to set up their own journal, *Socialisme ou barbarie*, in 1949. The Trotskyist Fourth International was the single organizational form of classical Marxism to survive the debacle of Stalinism, but after Trotsky's assassination it split into a number of fragments, divided over the analysis of the Soviet Union. Loyalists followed Trotsky in dubbing it a 'degenerated workers' state', while others judged it 'state capitalist'. A third path was taken by Socialisme ou barbarie,

which characterized the Soviet Union as a bureaucracy and came to see a convergence East and West towards competing bureaucratic state systems.

In 1958 the Socialisme ou barbarie group split over questions of self-organization, and Lefort left it. Castoriadis remained the leading figure till its dissolution in 1966 (although there was another split in 1964 when Castoriadis abandoned Marxism).[26] Debord's contact with the group was primarily through Castoriadis who, it should be stressed, was not a philosopher but an economist, whose misgivings over orthodox Marxist theory began with the law of value. When revolution is uniformly against a bureaucratic class, East and West, there is in any case no pressing need for Marx's *Capital*. Debord, however, did not follow Castoriadis entirely out of Marxism, though he often blurs the distinction between bureaucracy and capitalism, if only because the Lukácsian side of his system would collapse back into its Weberian origins and antithesis if the Marxist concept of capital was entirely removed.[27]

Debord was able to take Lukács's ringing endorsement of the revolutionary workers' councils and transpose his critique of the Mensheviks to fit the Western Communist parties and the trade unions they controlled. ('Moreover, the function of the trade unions consists more in atomizing and depoliticizing the movement, in falsifying its relationship with the totality, while the Menshevik parties have more the role of fixing reification in the consciousness of the working class, both ideologically and organizationally.'[28]) Debord had only to read 'Communist' for 'Menshevik' to fit a contemporary political analysis into the historic Lukácsian framework. But, for Debord, as for Socialisme ou barbarie, the fact that the Communist Party was bureaucratic in form and ideology, a fore of order rather than revolution, meant not that an alternative party should be built, but that the very idea of party should be rejected. Instead of a party, necessarily bureaucratic and separated from the working class, the revolution should be carried out directly by the workers themselves, organized in self-managing councils.

At the same time, the concept of revolution itself changed from the Leninist model. Instead of seeking state power, the councils should move directly to abolishing the state. The revolution meant the immediate realization of the realm of freedom, the abolition of all forms of reification and alienation in their totality, and their replacement by forms of untrammelled subjectivity. Thus the syndicalist spectre rose up again to haunt social democracy, fortified by the philosophical armoury of Western Marxism and carried, in accordance with Debord's temperament, to its extreme conclusion.

Lukács had always assumed the existence of 'mediations' within the totality, forms of unity within difference, but Debord's maximalist vision sought to abolish all separation, to unite subject and object, practice and theory, structure and superstructure, politics and administration, in a single unmediated totality.

3. The Critique of Everyday Life

The impetus behind this maximalism came from the idea of the transformation of everyday life. This in turn derived from Lefebvre's idea of total (that is, unalienated) man. Lefebvre was the first French Marxist to revive the 'humanist' ideas of the young Marx and (though he never questioned the privileged role of economics in Marxist theory) he began to argue that Marxism had been wrongly restricted to the domain of the economic and the political, when its analysis should be extended to cover every aspect of life, wherever alienation existed: in private life, in leisure time, as well as at work. Marxism needed a topical sociology, it should be involved in cultural studies, it should not be afraid of the trivial. In the last analysis, Marxism meant not only the transformation of economic and political structures, but 'the transformation of life right down to its detail, right down to its everydayness'. Economics and politics were only means to the realization of an unalienated, total humanity.[29]

Lefebvre began his intellectual career in the 1920s in close association with André Breton and the Surrealists. As a member of the *Philosophies* group he co-signed the manifesto against the Riff War in 1924 and remained involved with the Surrealists at least until his entry into the Communist Party in 1928 (although Breton denounces him by name in the Second Surrealist Manifesto of 1929 as base, insincere and opportunistic: insults which Lefebvre did not forget when he later vilified Breton in the *Critique of Everyday Life*.[30] In retrospect, personal and political quarrels aside, we can see how much Lefebvre owed to Breton: not only the idea of the transformation of everyday life, a fundamental surrealist concept, but even his introduction to Hegel and Marx.[31] 'He showed me a book on his table, Vera's translation of Hegel's *Logic*, a very bad translation, and said something disdainfully of the sort: "You haven't even read this?" A few days later, I began to read Hegel, who led me to Marx.' Breton never swerved from his own attachment to Hegel:

The fact remains that ever since I first encountered Hegel, that is, since I presented him in the face of the sarcasms with which my philosopher professor, around 1912, André Cresson, a positivist, pursued him, I have steeped myself in his views and, for me, his method has reduced all others to beggary. For me, where the Hegelian dialectic is not at work, there is no thought, no hope of truth.[32]

Historians of Western Marxism have tended to discount Breton, seeing him as 'off-beat' (!) or lacking in 'seriousness'.[33] Perhaps it is because, like Debord but unlike most other Western Marxists, he was never a professor. No doubt Breton's interpretation of Hegel, like his interpretation of Freud, of Marx, of love and of art (to name his major preoccupations) was often aberrant, but the fact remains that French (and Western) culture is unthinkable without him. Not only did he develop a theory and practice of art that has had enormous effect (perhaps more than any other in our time) but he also introduced both Freud and Hegel to France, first to non-specialist circles, but then back into the specialized world through those he influenced (Lefebvre, Jacques Lacan, Georges Bataille, Claude Lévi-Strauss) and thence out again into the general culture.[34] Politically too, he was consistent from the mid-1920s on, joining and leaving the Communist Party on principled grounds, bringing support to Trotsky in his last tragic years and lustre to the beleaguered and often tawdry Trotskyist movement.[35]

The 1920s was a period of dynamic avant-gardism, in many ways a displacement of the energy released by the Russian Revolution. Groups like the Surrealists identified with the revolution and mimicked in their own organization many of the characteristics of Leninism: establishing a central journal, issuing manifestos and agitational leaflets, guarding the purity of the group and expelling deviationists. (Characteristics which carried through, in full measure, to the Situationists). But many features of the Surrealist movement and, specifically of Breton's thought, distinguish it from other avant-garde groups and theorists of the time. Indeed, it might even be possible to think of surrealism as a form of 'Western avant-gardism', as opposed to the scientistic 'Soviet avant-gardism' that flourished not only in the Soviet Union (futurism, constructivism, *Lef*) but also in central Europe. Especially in Germany, there was a struggle between a Bauhaus- and constructivist-oriented modernism (often explicitly Soviet-oriented too) and a radical romantic movement, expressionism, which had affinities with surrealism,

but lacked both its originality and its theoretical foundation. Constructivism too had its reformist wing, closely tied to German social democracy.

The Soviet avant-garde, like the surrealists, wanted to revolutionize art in a sense that went beyond a simple change of form and content, and to alter its entire social role. But whereas Breton wanted to take art and poetry into everyday life, the aim in the Soviet Union was to take art into production. In both cases the bourgeois forms of art were to be discarded or suppressed, but the Soviet artists and theorists stressed the affinities of art with science and technology, tried to take art into modern industry, and argued that artists should become workers or 'experts'. Beauty, dream, creativity were idle bourgeois notions. Art should find a productive function in the new Soviet society and, in its exercise, it would cease even to be art. 'Death to art, long live production!'[36] Thus the latent scientism of classical Marxism, in its Soviet form, and the productivism of post-revolutionary Soviet ideology were imported into the world-view of the militant artist. But Breton's 'Western avant-gardism' went in the opposite direction, abhorring modern industry, anti-functionalist, deeply suspicious of one-sided materialism and positivism, dedicated to releasing the values of romantic and decadent poets from the confines of 'literature': aestheticizing life, rather than productivizing art.

Like Lukács, Breton brought about an irruption of romanticism into Marxism, and, again like Lukács, this both drew from a previous literary background and reflected a convert's enthusiasm for the drama of revolution. But there were three significant differences between Breton and Lukács.[37] First, Breton was himself a poet, rather than a critic, and for this reason the problem of 'practice' was located for him personally within the sphere of art, and theory had a direct bearing on his own activity as a poet. Second, as a result of his training as a medical psychiatrist, he turned to Freud, and integrated elements of psychoanalytic theory into his thought, before he made any formal approach to Marxism. In some ways, Freud played the same kind of role for Breton as forebears such as Georg Simmel or Max Weber did for Lukács, but Breton's interest in Freud took him into the domain of psychology, whereas for Lukács the prior engagement was with sociology. Thus when Breton read Marx or Lenin, it was in relation to the mind, rather than society, as with Lukács. Third, Breton, despite his Hegelianism, insisted always on retaining the specificity and autonomy of artistic revolution, intellectually and organizationally.

Breton spelled out his position very clearly from the beginning. Thus in the

Second Surrealist Manifesto he sets himself the question, 'Do you believe that literary and artistic output is a purely individual phenomenon? Don't you think that it can or must be the reflection of the main currents which determine the social and social evolution of humanity?' He rephrased the question in his answer – 'The only question one can rightly raise concerning [literary or artistic output] is that of the sovereignty of thought' – and concluded, quoting Engels, that art, as a mode of thought, is 'sovereign and limitless by its nature, its vocation, potentially and with respect to its ultimate goal in history; but lacking sovereignty and limited in each of its applications and in any of its several states'. Thus art 'can only oscillate between the awareness of its inviolate autonomy and that of its utter dependence'. The logic of Breton's argument presumed that it is the task of the social revolution to get rid of that limiting 'dependence' on economic and social determinations, but meanwhile art should fiercely guard its 'inviolate autonomy'. He went on to dismiss the idea of proletarian art and, writing soon after the Great Crash, concluded, 'Just as Marx's forecasts and predictions have proved to be accurate, I can see nothing which would invalidate a single word of Lautréamont's with respect to events of interest only to the mind.'[38]

When he wrote this, Breton was still a Communist Party member. It was not till 1933 that the break came, despite Breton's public support for Trotsky, his rift with Aragon over the subordination of art to party politics and his increasing exasperation at the cult of labour in the Soviet Union. (Thirion, a communist surrealist wrote, 'I say shit on all those counter-revolutionaries and their miserable idol, WORK!' – a position later taken up by the Situationists.[39] After leaving the party, Breton's line remained constant. In the 1942 'Prolegomena to a Third Surrealist Manifesto or not', he explained that theoretical systems 'can reasonably be considered to be nothing but tools on the carpenter's workbench. This carpenter is you. Unless you have gone stark raving mad, you will not try to make do without all those tools except one, and to stand up for the plane to the point of declaring that the use of hammers is wrong and wicked.' For Breton, Marxist and Freudian theory, like politics and art, were distinct but compatible, each with its own object and its own goals. Breton did not try to develop an integrated, totalizing 'Freudo-Marxism' (like Wilhelm Reich or Herbert Marcuse), but maintained the specificity of each in its own domain, in the psyche and in society. It should be

clear what the implications were when the Situationists later rejected Breton and accepted Lukács.[40]

For Breton, the transformation of everyday life moved on a different time scale from that of the revolution. It could take place, for individuals here and now, however transiently and imperfectly. In Breton's interpretation of Freud, we find that everyday 'reality' can satisfy us all too little. As a result we are forced to act out our desires as fantasies, thus compensating 'for the insufficiencies of our actual existence'. But anyone 'who has any artistic gift', rather than retreating into fantasy or displacing repressed desires into symptoms, can 'under certain favourable conditions' sublimate desires into artistic creation, thus putting the world of desire in positive contact with that of reality, even managing to 'turn these desire-fantasies into reality'. In his book *Communicating Vessels*, Breton describes how his dreams reorganize events of everyday life (the 'day's residues' in Freudian terms) into new patterns, just as everyday life presents him with strange constellations of material familiar from his dreams. The two supposedly distinct realms are in fact 'communicating vessels'.[41] Thus Breton does not argue for dreams over everyday life, or vice versa, but for their reciprocal interpermeation, as goal and as value.

Breton's concept of everyday life reminds us of how Freud in his *Psychopathology of Everyday Life* mapped out the paths by which displaced desire (*Wunsch*) inscribed itself in everyday gestures and actions. Breton wanted to replace this involuntary contact between unconscious desire and reality by a voluntary form of communication, in which, as in poetry, the semantic resources of the unconscious, no longer dismissed, after Freud's work, as meaningless, were channelled by the artist, consciously lifting the bans and interdictions of censorship and repression, but not seeking consciously to control the material thus liberated. For Breton, Hegel provided the philosophical foundation for a rejection of dualism: there was no iron wall between subject and object, mind and matter, pleasure principle and reality principle, dream (everynight life, so to speak) and waking everyday life. We should be equally alert to the potential of reality in our dreams and fantasies and to the potential of desire in our mundane reality. As Breton succinctly put it, the point was both to change the world and to interpret it.

In many ways, Breton was actually less hostile to the scientific approach that was Lukács, less engrained in his romanticism. For Lukács, science ruled the realm of human knowledge of nature, whereas human history itself was the province of dialectical philosophy, of a coming to consciousness of the

objective world which was simultaneously a coming to self-consciousness. Breton, on the other hand, was quite happy to accept the scientific status of historical materialism, with its objective laws and propositions about reality, provided equal status was given to poetry, with its allegiance to the unconscious, to the pleasure principle. Thus Breton was completely unconcerned by any concept of 'consciousness', class or otherwise. For him, there was the possibility of science – the concern of somebody else, since he lacked the totalizing spirit – and there was poetry, the field of unconscious desire, with which he was intensely concerned, while recognizing the claims of science and orthodox Marxism in almost all his public pronouncements. It is no wonder that Breton's Hegelianism (based, we should remind ourselves, on the *Logic*) was so inimical and seemed so scandalously inept to the mainstream of Marxists and existentialists, who read Hegel's philosophy, in contrast, through the *Phenomenology*, through a totalizing theory of history.[42]

4. 'Take your Desires for Reality!'

Debord's rejection of surrealism focused mainly on the blind alleys and wrong turnings down which Breton's faith in the unconscious and belief in 'objective chance' (a phrase, incidentally, borrowed from Engels) came to lead him in his later years. Increasingly, Breton began to dabble distractedly in occultism, spiritualism and parapsychology, which he saw a liminal areas between dream and reality, to become a magus rather than a poet. Debord's refusal to accept Breton's 'super-naturalism' led him to refuse any role to the unconscious and to be extremely sceptical about Freud in general. (In *Society of the Spectacle* he toys with the idea of a 'social unconscious' and concludes, 'where the economic *id* was, there *ego* [*le je*] must come about.'[43]) Thus, in the 1950s, Debord joined the Lettrist rather than the Surrealism movement and then, when it proved too restricted to 'experimental art', he split from it, with a few friends, to form the splinter Revolutionary Lettrists. Lettrism sought to go beyond the schism between abstract and figurative art (which marked West and East, as well as different trends within surrealist painting) by reintroducing the word into the sphere of the visual ('*metagraphie*'), creating a kind of interzone between dadaist word collage and concrete poetry. Lettrists, under the leadership of Isidore Isou, also used a pseudo-technical vocabulary of arcane neologisms and sought to combine technical innovation with neo-dadaist scandal.[44]

Despite opting for Lettrism rather than Surrealism, Debord was still able to collaborate with the independent Belgian Surrealists around the journal *Les Lèvres nues*, in the late fifties, and he continued to recognize the legacy he had inherited from surrealism, albeit in mutilated form, while also striving to supersede it, to go beyond the 'realization' of art to its 'suppression', that is, its integration into the totality through its own self-negation. What this meant in effect was both the inversion of surrealism (rather than freeing unconscious desire from the repression of the ego, Debord wanted to free the ego, the conscious self, from the determinism of the unconscious) and the displacement of the surrealist notion of poetic freedom, as the uncompromising release of repressed desire, into the practical and political register of council communism. This displacement also involved, of course, a semantic shift in the meaning of the word 'desire' (from unconscious to conscious) which enabled the SI to endorse the surrealist slogan, 'Take your desires for reality!', adopted by the Enragés at Nanterre (rather than the suspect 'Power to the imagination', launched by the 22 March group).[45] For Debord, the poetic revolution must be the political revolution and vice versa, unconditionally and in full self-consciousness.

But the Lettrist International around Debord was not the only channel by which surrealist, and Marxist, thought reached the Situationist International. The artists from the COBRA movement brought with them their own revision of surrealism and their own political positions and theories. Asger Jorn, in particular, was not only a prolific artist and dedicated organizer but also a compulsive writer and theorist. The first phase of the SI was marked as much by Jorn as by Debord and though Jorn resigned from the group in 1961, his influence was lasting. He was never criticized or denounced by Debord, either through the period of the schism (when Jorn collaborated with both parties, under different false names) or during the highly politicized period before and after 1968. Debord paid a moving posthumous tribute to his old comrade (Jorn died in 1973) in his introductory essay to *Le Jardin d'Albisola* (1974), a book of photographs of the ceramic garden Jorn had built in Albisola, northern Italy, in the late fifties, around the time of their first contact.[46]

COBRA (the name originates from the initial letters of *Co*penhagen, *Br*ussels, *A*msterdam) was formed by a group of artists from Denmark, Holland and Belgium (including Jorn and Constant) in November 1948.[47] In broad terms, COBRA grew from the disenchantment with surrealism of

artists whose political ideas were formed during the Resistance. After Breton returned to Paris, he took a militantly anti-Communist line politically and sought to reimpose his own views and tastes on surrealist groups that had flourished independently during his exile. These artists were unwilling to break with Communist comrades with whom they had worked in the struggle against the German occupation and wanted to see surrealism move forward onto new, experimental ground, rather than to revive pre-war trends, especially towards abstraction in painting and 'super-naturalism' in ideology.

After the Liberation, groups of French and Belgian communists split from Breton to form the Revolutionary Surrealist (RS) movement, but then splintered further among themselves over the problem of how to respond to Communist Party attacks. The Communist Party attacked even pro-communist surrealism (which led the French wing of the RS to argue, against the Belgian wing, that they should dissolve their group) as well as all forms of abstract art (the French in the RS were in favour, the Belgians against). Meanwhile, Christian Dotremont, a poet and leader of the Belgian fraction, had made contact with Jorn, Constant and their friends. They too had been formed by the Resistance and were active in small avant-garde groups. At the end of the Second World War, Jorn returned to Paris (where he had studied with Léger, working as his assistant on a mural in the late thirties, and then worked with Le Corbusier). There he met members of the French Surrealist movement who later joined the Revolutionary Surrealists and also Constant, with whom he struck up a close friendship. He even went on a pilgrimage to visit André Breton, who dubbed him 'Swedenborgian', but reportedly 'got lost in the labyrinth of theories delivered sometimes rather abruptly in Jorn's gravelly French'. There had already been a definite surrealist influence on Danish painting, but of a diluted, eclectic and stylized kind. Despite his initial sympathy and interest, Jorn felt the need to find a new direction.[48]

Later the same year (December, 1946) Jorn went north to Lapland to spend time in retreat, reading and writing, developing the outlines of a heterodox Marxist theory of art. Before the war, Jorn had been deeply influenced by the Danish syndicalist Christian Christensen, and he continued to honour Christensen, paying homage to him in the pages of the *Internationale situationniste* many decades later. Christensen was a kind of milder Danish equivalent of the early council communists. Jorn himself had left syndicalism for communism during the Resistance, but he always retained the libertarian principles he had learned from Christensen, as well as a faith in direct action and collective

work. The theoretical project Jorn set himself was massive and arduous. Essentially he wanted to recast elements from surrealism (magic, child art, 'primitive' art, automatism) and combine these with strong strands of Scandinavian romanticism and libertarian activism within a materialist and Marxist framework.[49]

He began by defining materialism in relation to nature. Materialist art would express the natural being of humans as well as their social being. It would be on the side of instinctive vitality and would involve physical gesture. European art was vitiated by its classical heritage, its metaphysical overvaluation of reason and the ideal. The 'materialist attitude to life' must involve the expression of natural rhythms and passions rather than seeking to subordinate activity to a sovereign reason or engage in the unnatural and slavish copying of nature. Materialist art, therefore, was Dionysiac rather than Apollonian; it was on the side of festival and play: 'spontaneity, life, fertility and movement'. Jorn consistently attacked classicism (and its surrogates realism and functionalism) and favoured instead the 'Oriental' and the 'Nordic', which he associated with ornament and magical symbolism respectively. (It is interesting that Breton, in the First Manifesto of Surrealism also celebrates the Oriental and the Nordic as privileged fields for the 'marvellous'.) The Nordic especially fascinated Jorn, as a Dane, and he worked closely with the eminent archeologist Professor Glob and other scholars on studies of prehistoric and ancient Scandinavian society and art.[50] Jorn believed that the intensively local and the extensively cosmopolitan should mutually reinforce each other.

Jorn never really completed his mammoth theoretical task, though he published a vast number of articles and books, besides leaving many unpublished manuscripts. He wrestled continually with the problems of the dialectic, drawing not directly on Hegel but on Engels's *Dialectic of Nature* and *Anti-Dühring*. He tended to reduce the dialectic to the simple combination of opposites into an unity, and then become uncertain how to unsettle this new synthesis, which itself now threatened to develop in a one-sided way. In the end he even invented a new three-term logic of 'trialectics'! There is an aspect to Jorn's theoretical work that is reminiscent of Dietzgen or Bogdanov, an attraction to forms of mystical monism, as he strives to reconcile Kierkegaard or Swedenbord with Engels and the dialectic of nature. Often too he seems caught between the constraints of system-building and his spontaneous

impulses towards provocation and proliferation, which sprang from his personal exuberance and his libertarian background.

Constant, though rather more sparing in his prose, developed a line of thought similar to that of Jorn, but much simpler. For Constant, surrealism had been right in its struggle against constructivism ('objective formalism') but had become too intellectualized. It was necessary to find new ways of expressing the impulse that lay behind surrealism in order to create a popular, libertarian art. In his painting Constant, like Jorn, developed a style that was neither abstract nor realist, but used figurative forms that drew on child art and the motifs of magical symbolism, without effacing the personal trace of physical gestures. For both Constant and Jorn art was always a process of research, rather than the production of finished objects. Both were influenced by libertarian syndicalism: Jorn through Christensen, Constant in the Dutch tradition of Pannekoek and Gorter. They stressed the role of the creative impulse, of art as an expression of an attitude to life, dynamic and disordered like a popular festival, rather than a form of ordered ideational production.

In Brussels, Dotremont was, of course, much closer to surrealism than Jorn or Constant, much more influenced by French culture.[51] The COBRA group in general had an ambivalent relationship with Paris. Dotremont, as the closest, perhaps experienced this love–hate most intensely. In the years immediately after the Second World War he was attracted immediately to Lefebvre's critique of everyday life. Lefebvre seemed to offer the possibility of an alternative to surrealism and existentialism, which was communist without being orthodox. Art should pair itself with the critical spirit to transform the consciousness through 'experiments on everyday life'. At the same time, Dotremont was deeply influenced by the writings of Gaston Bachelard, whose works on poetic reverie and the four elements had been appearing through the early forties. Bachelard stressed the distinction between images of receptive perception and those of the active imagination directed onto the external world, which allowed us to see, for instance, figures and scenes in the flames of the fireplace or the whorls of wood. For COBRA artists, Bachelard pointed to a third path between realism and the delineation of purely internal dreams and fantasies by one section of surrealist painters, while also avoiding the trend towards abstraction of the rest of the surrealists. Jorn too, after he was introduced to Bachelard's work, was deeply impressed. At the museum he instituted at Silkeborg in Denmark, there is a startling and magnificently imaginative portrait of Bachelard, one of the few he ever painted.

5. Caught in the Crossfire

COBRA thus brought together elements from surrealism, a commitment to revolutionary politics, and an openness to experiment and new ideas, a determination to make art that was materialist, festive and vital. COBRA wanted to displace the three major contenders in the Paris art world: the decomposing School of Paris (which sought to unite a refined cubism with a pallid fauvism), orthodox Bretonian surrealism, and the various forms of abstract and non-figurative art. By the time the movement dissolved in 1951, after only three years of existence, it had both succeeded triumphantly and failed miserably. It triumphed historically, in the long term, but failed in its immediate aims, in that it proved impossible at that time either to set up alternative art centres to Paris elsewhere in Europe, or to conquer the Paris art world from the outside. Although many of the COBRA artists stayed in loose touch, the group broke up organizationally and geographically. Jorn and Constant both ended up in the situationist movement (which underwent the same problems in choosing between Paris and the COBRA capitals). In the end, COBRA was haltingly recognized at its full value, but not until Paris was finally displaced as an art centre, first by New York, then by a redistribution of influence within Europe (and eventually between Europe and New York).[52]

The immediate reasons for the break-up of the group were both organizational and personal, both political and material. The Danish group pursued a life of its own (like ostriches, Dotremont complained, in contrast to the French, who were often more like giraffes, with their heads held high in the air); the Dutch and the Belgians began to drift to Paris, and Paris, in turn, began to absorb elements of COBRA back into the mainstream; personal difficulties (Jorn went off with Constant's wife) threatened to divide close friends. The COBRA artists were often literally starving. Jorn described in a letter to Dotremont how he and his family were forced to 'sleep on the floor so that we don't have to buy a bed' in a studio without gas or electricity. Both Jorn and Dotremont suffered from tuberculosis, a disease promoted and aggravated by poverty, and at the time of COBRA's dissolution they were both hospitalized in the same clinic in Denmark.

But political problems played a part too. At first, the COBRA artists were militant within the Communist Party (Dotremont) or sympathetic to it, even if inactive (Constant, Jorn). But the brief heyday of the Liberation was soon

halted by the tightening grip of Stalinism and the ominous beginnings of the Cold War. When COBRA was formed and held its first exhibition, in March 1949, it had friendly relations with the Communist parties. COBRA was able to maintain contact with the parallel ex-surrealist Bloc group in Czechoslovakia, even after the 1948 seizure of power by the Communists in Prague. But, through 1949, with the persistence of the Berlin blockade, the formation of NATO, the declaration of the Federal Republic of Germany and the ever-increasing pressure against Tito from the Soviet Union, Revolutionary Surrealist and COBRA artists began to feel themselves squeezed, caught in an untenable position. Later that year Dotremont tried unavailingly to stake out a claim for artistic autonomy at the Communist-controlled Salle Pleyel Peace Congress in Paris (the equivalent of the New York Waldorf Congress) and in November matters came to head at the time of the COBRA exhibition in Amsterdam, held at the Stedelijk Museum. The wave of purges and show trials had already begun in Eastern Europe and Dotremont's second attempt, at an experimental poetry reading, to clarify his political position led to barracking, forcible ejections and fist-fights. 'When the words Soviet and Russian were mentioned, that brought the house down. . . . There was an undescribable uproar, anti-Soviet jeers and anti-French insults flying.' Or as he put it in his reading: 'La merde, la merde, toujours recommencée.'[53] COBRA found itself caught in the crossfire between communists and anti-communists.

Dotremont, Constant and Jorn reacted to their dilemma in different ways. Dotremont eventually became disenchanted with politics altogether and began to take the first steps towards depoliticizing the movement. Constant and Jorn disagreed. In a world in which 'politics are (not without our complicity) placed between us and the Universe like barbed wire', it was all the more important to struggle to maintain a genuine and direct relationship between art and politics, to reject all stultifying labels and ideological prejudices: 'Experimentation in these conditions has a historical role to play: to thwart prejudice, to unclog the senses, to unbutton the uniforms of fear.'[54] However, Constant and Jorn interpreted that historical role differently. Constant began to move out of painting altogether, collaborating with the Dutch architect Aldo van Eyck, and then, after the dissolution of COBRA, moving to London and devoting himself to research into experimental urbanism and city planning. Constant sought an art that would be public and collective in a way that easel painting could never be, a transposition into

contemporary terms of the idea of the communal, festive use of social space. Jorn persisted in painting, after his recovery from tuberculosis, but was eager to find a way of reviving the COBRA project in a purer, more advanced form: a hope realized with the foundation of the SI after his meeting with Debord (who was something like a second Dotremont for Jorn, less problematic in some ways but, as it turned out, in others more).

Looking back at the COBRA movement, it is possible now to see many points of similarity between COBRA attitudes and those of Jackson Pollock or Willem de Kooning (who often looks like a displaced mutant of Dutch COBRA). Pollock, like Jorn, exemplified the spontaneous, the vital, the ornamental (in Jorn's sense of the 'arabesque'). His background too was in political mural art, which he rejected for a new approach, indebted to surrealism but departing from it.[55] Like Jorn he was influenced by indigenous ritual art: Indian sand painting and totemic figures, rather than Viking runes and ancient petroglyphs. Pollock's *Blue Poles* can be measured with Jorn's great *Stalingrad*, now in Silkeborg. If Jorn always resisted the pull of abstraction, it was largely because of his political commitment, the quest for an art that would be neither bourgeois, Stalinist (socialist realist) nor surrealist. Art, for Jorn, should always retain both the 'social' and the 'realist' poles, or else it would be undialectical, one-sided, metaphysical. Jorn's experience of the Resistance and the vicissitudes of the Cold War in Europe prevented the headlong slide into abstraction of his American counterparts (which was ideologically counterposed to Soviet socialist realism in Cold War terms).

After leaving a Swiss sanatorium in 1954, Jorn began to visit Italy for his health, and because it was a relatively cheap place to live. Indefatigable as ever, he founded the Movement for an Imaginist Bauhaus while still in the clinic, and soon he was able to combine some of the old COBRA artists with new Italian friends, drawn first from the Nuclear Painting movement, led by Enrico Baj, and then (after 1955) the group gathered around Pinot-Gallizio in Alba. This new venture of Jorn's began after he was approached by the Swiss artist Max Bill, who had been given the job of setting up the new Hochschüle für Gestaltung in Ulm, which was planned as a 'new Bauhaus'. At first, Jorn was enthusiastic about the project but he soon found himself in violent disagreement with Bill, who was linked to the Concrete Art movement of geometrical abstractionists and wanted the new Bauhaus to provide training in a technological approach to art, an updated re-run of the old productivist model. Soon Jorn was writing to Baj that 'a Swiss architect, Max Bill, has been

given the job of restructuring the Bauhaus where Klee and Kandinsky taught. He wants to reproduce an academy without painting, without any research in the field of the image, fictions, signs and symbols, simply technical instruction.'[56] As the references to Klee and Kandinsky suggest, this was in many respects a repeat of the controversies that had divided the old Bauhaus when László Moholy-Nagy was appointed and productivism triumphed.

Jorn was in favour of an ideal Bauhaus that would bring together artists in a collective project, in the spirit of William Morris or the Belgian socialist Van der Velde, who had inspired Gropius. But he was resolutely opposed to functionalism and what he regarded as a moralistic rationalism that threatened to exclude spontaneity, irregularity and ornament in the name of order, symmetry and puritanism. The polemic against the technological thinking of Bill brought Jorn to formulate a theoretical and polemical counterattack, on the grounds of general aesthetics and urbanism. At the 1954 Triennale of Industrial Design in Milan, Jorn engaged in public debate with Bill on the theme 'Industrial Design in Society'. Jorn argued that the Bauhaus and Le Corbusier had been revolutionary in their day, but they had been wrong in subordinating aesthetics to technology and function, which had inevitably led towards standardization, automation, and a more regulated society.[57] Thus Jorn began to venture into areas which brought him closer again to Constant as well as to the Lettrist International, whose members were simultaneously developing their own theories of unitary urbanism, psycho-geography and *dérive*.

In 1955 Jorn met Pinot-Gallizio, who had been a partisan in the Italian Resistance during the war, and was now an independent left councillor in his home town of Alba. Pinot-Gallizio shared Jorn's interests in popular culture and archeology. Together they set up an Experimental Laboratory as a prototype Imaginist Bauhaus, libertarian in its structure (without teachers or pupils, but only co-workers). The Imaginist Bauhaus aimed to unite all the arts and was committed to an anti-productivist aesthetic. In this context, Pinot-Gallizio began to develop his new experimental paints and painting techniques, drawing on his background as a chemist, and Jorn began to devote himself to collaborative works in ceramics and tapestry, seeking a contemporary style for traditional crafts and expanding his painting with new materials and forms. The next year, Pinot-Gallizio and Jorn organized a conference in Alba, grandly entitled the First World Congress of Free Artists, which was attended by both Constant and Gil Wolman, representative of the

Lettrist International (though Debord himself did not attend). Wolman addressed the congress, proposing common action between the Imaginist Bauhaus and the Lettrist International, citing Jorn, Constant and the Belgian surrealist Marien approvingly in his speech, as well as expounding the idea of unitary urbanism. The stage was now set for the foundation of the Situationist International.

Besides a common approach to urbanism, there were other issues that linked Jorn, Pinot-Gallizio and Constant with the Lettrist International: a revolutionary political position independent of both Stalinism and Trotskyism (and their artistic correlates, socialist realism and orthodox surrealism), a dedicated seriousness about the theory and goals of art combined with an unswerving avant-gardism, and a common interest in the transformation of everyday life, in festivity, in play and in waste or excess (as defined by the norms of a purposive rationalism). The journal of the Lettrist International was called *Potlatch* after the great feasts of the Northwest Coast Indians of Canada and Alaska, the Kwakiutl and the Haida, in which the entire wealth of a chief was given away or even 'wastefully' destroyed.[58] Described by Franz Boas (and his native informant George Hunt) and then theorized by Marcel Mauss in his classic *The Gift*, the idea of potlatch had fascinated both Georges Bataille, who made it a central theme in his own writing, and Claude Lefort, of Socialisme ou barbarie, who reviewed Mauss's book in Sartre's journal *Temps modernes*, when it was reissued after the Second World War. Potlatch was taken to exemplify the opposite of an exchange or market economy: in a potlatch economy, objects were treated purely as gifts rather than as commodities in the setting of a popular feast. Generosity and waste rather than egotism and utility determined their disposal.

The theme of festivity is linked, for Jorn, with that of play. In his 1948 'Magic and the Fine Arts', Jorn made the following observation:

> . . . if play is continued among adults in accordance with their natural life-force, i.e., in retaining its creative spontaneity, then it is the *content* of ritual, its humanity and life, which remains the primary factor, and the form changes uninterruptedly, therefore, with this living content. But if play lacks its vital purpose, then ceremony fossilizes into an empty form which has no other purpose than its own formalism, the *observance of forms*.

Festivity is thus ritual vitalized by play. In the same way, the formal motif of art must be vitalized by the creative figure, the play of calligraphy. This

concept of play linked Jorn closely to Constant, who was deeply influenced by his compatriot Johan Huizinga's pioneering book, *Homo Ludens*, published in Holland just before the Second World War.[59] Huizinga argued that man should be seen not simply as *homo faber* (man as maker) or *homo sapiens* (man as thinker) but also as *homo ludens* (man as player). He traced the role of play both in popular festivities and in art: in the rhythms of music and dance, as well as in the use of masks, totems and 'the magical mazes of ornamental motifs'. Huizinga's thought converged in France with that of Bataille's colleague Roger Caillois, who also made the link to festival and thence to leisure: 'Vacation is the successor of the festival. Of course, this is still a time of expenditure and free activity, when regular work is interrupted, but it is a phase of relaxation and not of paroxysm.'[60] For Caillois, the problem was how to restore true 'play' to the realm of leisure, which had been reduced to mere relaxation. Play too had a crucial place in both Breton's thought and, to a lesser extent, Sartre's. In the background lay Schiller's epoch-making celebration of play in his *On the Aesthetic Education of Man*.

6. Children of Paradise

In 1957 the Situationist International was proclaimed at Cosio d'Arroscia and the collaboration between Jorn and Debord was sealed by the publication of a jointly composed book (a successor both to the COBRA concept of 'writing with two hands' and lettrist practice of *metagraphie*). This work, *Fin de Copenhague* (followed two years later, in 1959, by a second, *Mémoires*) was both a *détournement* of found images and words and a piece of impromptu, spontaneous, collective work in the festive spirit.[61] The common ground between the different currents in the Situationist International was reinforced and enriched by theoretical publication in their new journal and by joint artistic projects. These established both an enlarged aesthetic scope and a clarified political direction, to which all the parties could contribute. The next task was to make a dramatic intervention in the art world and this was achieved in 1959, when both Jorn and Pinot-Gallizio held exhibitions in Paris, in the same month, May, while Constant had an exhibition at the Stedelijk Museum in Amsterdam later that year.

Jorn's show of *modifications*, 'found' paintings which he overpainted and altered, was intended to introduce his new work in a startlingly original manner, positioning it not only within the situationist context of *détournement*,

but also as blazing a new path between Jackson Pollock and kitsch (the two antinomic poles proposed by Clement Greenberg, who valued them as 'good' and 'evil' respectively) in a gesture that would transcend the duality of the two. In his catalogue notes, Jorn stressed that an artwork was always simultaneously an object and an intersubjective communication, a sign.[62] The danger for art was that of falling back into being simply an object, an end in itself. On the one hand, Pollock produced paintings that were objectified traces of an 'act in itself', through which he sought to realize his own self in matter for his own enjoyment, rather than as the realization of an intersubjective link. The action of painting failed to be effective as an act of communication. On the other hand, the anonymous kitsch paintings that Jorn bought in the market were merely objects in themselves with no trace of subjective origin at all, simply free-floating in time and space. By overpainting them in his own hand, Jorn sought to restore a subjectivity to them, to reintegrate them into a circuit of communication, a dialectic of subject and object.

Jorn characterized Pollock as an 'Oriental' painter (on the side of abstract ornament) and the kitsch works as 'classical' (on the side of representation, both idealizing and naturalistic). In the past, Jorn had himself taken the side of the 'Oriental' against the 'classical'. Thus he commented on the *Laocoön*, 'Laocoön's fate – the fate of the upper class'. He identified the snakes (representing the serpentine, Oriental line) with the natural, the materialist, and the revolutionary classes. Conversely, the figure of Laocoön (the classical form) represented the ideal, associated with repression and sublimation. However, in the case of his own *modifications*, Jorn characterized his project as 'Nordic' rather than one-sidedly 'Oriental', thus going beyond the 'Oriental'/'classical' antinomy. Here the 'Nordic', separated out and set over and against the 'Oriental', implied the use of 'symbolic' motifs rather than abstract ornament. The *modifications* were magical actions which revitalized dead objects through subjective inscription, transforming them into living signs (spontaneously subjective expressions which also had a common, collective meaning). The kitsch paintings were not simply *détournées* but were also sacrificial objects in the festive ceremony of a fertility rite. Objectified beings were broken open, vandalized and mutilated, in order to release into life the 'becoming' latent within them.

At the same time, Jorn saw the *modifications* as a celebration of kitsch.[63] It was precisely because kitsch was popular art that a living kernel could still be found in it. In his very first contribution to the Danish art magazine *Helhesten*,

published during the Second World War, Jorn had written in praise of kitsch in his essay entitled 'Intimate Banalities' (1941). Jorn wanted to get beyond the distinction between 'high' and 'low' art. While his sympathies were always on the side of the 'low' in its struggle against the 'high', Jorn also wanted to unite the two dialectically in his art and hence supersede the split between the two, which deformed all human subjectivity. In this article he praised both the collective rage for toy celluloid flutes that swept a small Danish town (trivial, yet festive) and the work of a tattoo artist (an ornamental supplement to the human body, both mutilation and creation, like that of the *modifications* themselves to the body of art). Further, in combining 'high' art with 'low', Jorn also wanted to deconstruct the antinomy of 'deep' and 'shallow'. In his essay, 'Magic and the Fine Arts', he had long previously remarked that

> . . . today we are unable to create general artistic symbols as the expression of more than a single individual reality. Modern artists have made desperate attempts to do this. The basic problem is that a general concept must be created by the people themselves as a communal reality, and today we do not have the kind of fellowship among the people which would allow that. If the artist has plumbed the depths, like Klee, he has lost his contact with the people, and if he has found a popular means of expression, like Mayakovsky, he has, in a tragic way, betrayed the deeper side of himself, because a people's culture which combines the surface issues with the deeper things does not exist.

Thus, for Jorn, the deconstruction of antinomies could only be fully realized through social change but, in the meantime, artistic gestures like those of the *modifications* could symbolically enact their possibility and thus help form the missing fellowship, by providing a ceremonial model for it.

Finally, for Jorn, revitalization was also revaluation. The act of modification restored value as well as meaning. Here, Jorn returned implicitly to the Marxist theory of value, which he was to develop in a personal way. (In a way reminiscent of Bataille's postulate of a 'general economy' which incorporated a domain of excess excluded from the 'restricted' economy of exchange and utility), Jorn reformulated the Marxist formula C–M–C (commodity > money > commodity) into the expanded N–U–C–M–C–U–N (nature > use > commodity > money . . .) as the formula for a socialist economy, in which the economic cycle was contained in the natural cycle, transforming 'economic utility' into 'natural use'.[64] Jorn always insisted that Marxism was not simply the theory of exploitation as the general form of the extraction of a

surplus, because a surplus was necessary for socialist society, if it was to go beyond functionalism and utility to excess and luxurious enjoyment, new social forms of creative, ornamental play. Socialism was ultimately based on natural rights, and the realm of freedom was based on the reintegration of history into nature. Jorn thus foreshadowed contemporary attempts to reconcile socialism with ecology, the 'Red' with the 'Green'. Seen in this light, the transformation of paintings as commodities (objects bought in the market) into sites of spontaneous, natural creativity entailed the revaluation of exchange value into natural use value. This too was a ceremonial prefiguration of the transformation of the market into a truly communal society, based on natural use rather than commodity exchange.

Pinot-Gallizio and Constant followed parallel, but different, paths. Rather than seeking, like Jorn, to reinscribe unalienated creativity into easel painting, though in an original, dialectical form, they each began to push forward beyond the limits of easel painting. For Pinot-Gallizio, the actually existing economy of standardization and quantity, of unending sameness, must be superseded by a civilization of 'standard-luxury', marked by unending diversity. Machines would be playful, in the service of *homo ludens* rather than simply *homo faber*. Free time, rather than being filled with banality and brainwashing, could be occupied in creating brightly painted *autostrade* (freeways in the true sense of the word), massive architectural and urbanistic constructions, fantastic palaces of synesthesia, the products of 'industrial poetry', sites of 'magical–creative–collective' festivity. Pinot-Gallizio's exhibition in Paris was designed as the prototype cell of such a civilization. The gallery was draped all over, walls, ceiling and floor, with paintings produced by Pinot-Gallizio's pioneering new techniques of 'industrial poetry'. The exhibition was to use mirrors and lights to create the effect of a labyrinth, filled with violent colours, perfumes and music, producing a drama that would transform visitors into actors. Pinot-Gallizio's aim, encouraged by Debord, was to create in one ambiance a premonitory fragment of his totalizing vision of a future aestheticized society and socialized art.[65]

Constant's utopian *New Babylon* project was similar to Pinot-Gallizio's in its conceptual basis, but very different in its style. In his essay 'The Great Game to come' ('Le Grand Jeu à venir', published in 1959) Constant called for a playful rather than functional urbanism, a projection into the imaginary future of the discoveries made by the lettrist method of *dérive*: drifting, unpremeditated journeys through actually existing cities in order to exper-

ience rapid, aimless and unpredictable changes of environment ('ambiance') and the consequent changes in the psychological state of the urban wanderer.[66] Constant had been inspired by Pinot-Gallizio, who had become the political representative of the gypsies who visited Alba, to build a model for a nomadic encampment. From this he developed to building architectural models of a visionary city (New Babylon) designed for nomadic inhabitants. He also produced a number of series of blueprints, plans and elevations, moving out of painting altogether. Sceptical of the prospect of immediate political change, Constant set about planning the urban framework for a possible post-revolutionary society of the future. New Babylon was devised on the assumption of a technologically advanced society in which, through the development of automation, alienated labour had been totally abolished and humanity could devote itself entirely to play. It would be the ceaselessly changing, endlessly dramatic habitat of *homo ludens*, a vast chain of megastructures each of which could be internally reorganized at will, through new technologies of environmental control, to satisfy the desires of its transient users and creators.[67]

Thus the Situationist International launched itself into the art world, in Paris and Amsterdam, with exceptional ambition and bravura. Not only were the works formally path-breaking, pushing up to and beyond the limits of painting, but their stakes, their theoretical engagement went far beyond the contemporary discourse of art and aesthetics in its implications. It would be easy to look at Jorn's *modifications*, for instance, as premonitions of postmodern 'hybridity', but this would be to miss their theoretical and political resolve, their emergence out of and subordination to Jorn's general revolutionary project. There had not been such a fruitful interchange between art, theory and politics since the 1920s. Yet, despite this, the situationist intervention in the art world hardly lasted a year. In the summer of 1960 Pinot-Gallizio was expelled from the movement (he died in 1964) and Constant resigned, both as a result of disagreements and denunciations stemming from contacts they and/or their associates had made in the art world, outside the restrictive framework of the SI itself. In April of the next year, 1961, Jorn too resigned, in the upheaval that led to the schism of 1962, when Jorgen Nash and the German Spur group of artists (who had joined in 1959) were ousted and set up the dissident Second Situationist International of their own. This schismatic movement, and its own new creation, the Situationist Bauhaus, have lasted

up to the present, maintaining the project of a situationist art, with vivid flares of provocation and festivity.[68]

The rejection by Debord and his supporters of any separation between artistic and political activity, which precipitated the schism, led in effect not to a new unity within situationist practice but to a total elimination of art, except in secondary propagandist and agitational forms. The SI simply reappropriated the orthodox Marxist and Leninist triad of theory, propaganda, agitation, which structured Lenin's classic *What is to be Done?*, while making at the same time every effort to avoid the Leninist model of leadership that naturally went with it. Theory displaced art as the vanguard activity and politics (for those who wished to retain absolutely clean hands) was postponed till the day when it would be placed on the agenda by the spontaneous revolt of those who executed rather than gave orders. *Mirabile dictu*, the day duly came, in May 1968, to the surprise of the Situationists as much as anyone else, even though the 1968 uprising was ignited, to a significant extent, by the impact of the SI's preceding years of 'theoretical practice'. The problem remained that the revolutionary subjectivity that now irrupted into the objectified 'second nature' of the society of the spectacle came from nowhere and vanished again whence it came. In terms of situationist theory it represented a paroxystic expansion and subsequent collapse of consciousness, detached from the historical process which still faced the subject, before, during and after the events, as an essentially undifferentiated negative totality.[69]

In a strange way, the two legendary theoretical mentors of 1968, Guy Debord and Louis Althusser, form mirror images of each other, complementary halves of the ruptured unity of Western Marxism. Thus Debord saw a decline in Marx's theory after *The Communist Manifesto* and the defeats of 1848, while Althusser, conversely, rejected everything before 1845. (They could both agree to accept the *Manifesto*, but otherwise there was near-total breakdown!) For Debord, everything after 1848 was sullied by an incipient economism and mechanism; for Althusser everything before 1845 was ruined by idealism and subjectivism. For Debord, the revolution would be the result of the subjectivity of the proletariat, 'the class of consciousness'. 'Consciousness' had no place in Althusser's system, nor even subjectivity: he postulated an historical 'process without a subject'. When, after the defeat of 1968, both systems disintegrated, leftists abandoned the grand boulevards of totality for a

myriad *dérives* and peregrinations in the winding lanes and labyrinthine backstreets. Too many got lost.

The publication in France of Lukács's *History and Class Consciousness* (1960) and Lévi-Strauss's *The Savage Mind* (1962) provided the basis for two fundamentally opposed totalizing myths: that of a rationalist pseudo-objectivity and that of an imaginary pseudi-subjectivity respectively, which could only be combated on the terrain of Marxism by two antagonistic crusades, one precisely for a true revolutionary subjectivity (Debord) and the other for a true revolutionary objectivity (Althusser). Debord and Althusser each saw the other's work as fatally vitiated by the idealism and rationalism respectively which each upheld or abhorred.[70] One was, so to speak, abstractly romantic, the other abstractly classical. The unfulfilled dialectical project that remains (one that Jorn would have relished) is evidently that of rearticulating the two halves, each a one-sided development to an extreme of one aspect of the truth. Yet that one-sidedness is itself the necessary outcome of the pursuit of totality, with its concomitant critique of separation and its refusal of specificity and autonomy. Ironically, Lukács's own analysis of the 'society of manipulation' in *Conversations with Lukács*, published in 1967, the same year as Debord's *Society of the Spectacle*, takes up many of the same themes as Debord's book, yet without the philosophical maximalism of Debord's own Lukácsianism.[71] Finally, we need to remember, too, André Breton's metaphor of the workbench with its many tools, and Breton's insistence that compatibility is sufficient grounds for solidarity, without the need to erase difference and attempt to totalize the protean forms of desire.

In 1978 Debord returned to his first love, the cinema, to make a new film, *In Girum Imus Nocte et Consumimur Igni* ('We circle in the night and are consumed by the fire' – in palindromic Latin!). Like his previous work, this was a collage of found footage, but with a soundtrack that is simultaneously an autobiographical, a theoretical and a political reflection. He remembers Ivan Chtcheglov (the first formulator of 'unitary urbanism') and pays tribute to his dead comrades Jorn and Pinot-Gallizio. He recapitulates the story of Lacenaire in *Les Enfants du Paradis* ('Children of Paradise'), long the object of his identification, like Dr Omar and Prince Valiant.[72] He does not regret that an avant-garde was sacrificed in the shock of a charge. 'Je trouve qu'elle etait faite pour cela.' Avant-gardes have their day and then, 'after them operations are undertaken in a much vaster theatre'.[73] The Situationist International left a legacy of great value. The wasteful luxury of utopian projects, however

doomed, is no bad thing. We need not persist in seeking a unique condition for revolution, but neither need we forget the desire for liberation. We move from place to place and from time to time. This is true of art as well as politics.

Notes

1. For the history of the SI, see Mirella Bandini, *L'estetico il politico: Da Cobra all'Internazionale situazionista, 1948–1957* (Rome: Officina Edizioni, 1977), which also reprints a number of crucial documents, and Jean-Jacques Raspaud and Jean-Pierre Voyer, *L'Internationale situationniste: Chronologie/Bibliographie/Protagonistes (Avec un index de noms insultés)* (Paris: Editions Champ Libre, 1972), which, as the title indicates, includes much useful information. The full run of the SI journal is collected in *Internationale situationniste, 1958–69* (Paris: Editions Champ Libre, 1975), and the 'official' history of the movement is by Jean-François Marios, *Histoire de l'Internationale situationniste* (Paris: Editions Gérard Lebovici, 1989). In English, see Ken Knabb (ed. and trans.), *Situationist International Anthology* (Berkeley: Bureau of Public Secrets, 1981).

2. For COBRA, see Jean-Clarence Lambert, *Cobra*, translated by Roberta Bailey (New York: Abbeville Press, 1983), and *Cobra, 1948–1951* (Paris: Association française d'action artistique, 1982), the catalogue of the exhibition held at the Musée d'art moderne de la ville de Paris (9 December 1982–20 February 1983). For the prehistory of the SI, see Gérard Berreby (ed.), *Documents relatifs à la fondation de l'internationale situationniste* (Paris: Editions Allia, 1985). For lettrism, see the self-presentation in Isidore Isou, *De l'impressionisme au lettrisme* (Paris: Filipacchi, 1974). See also Greil Marcus, *Lipstick Traces: a secret history of the twentieth century* (Cambridge, Mass.: Harvard University Press, 1989) for an erudite and devoted account of lettrism and its aftermath in the SI.

3. See Berreby, and the journal of the SI, especially the first issue, for definitions.

4. See Guy Debord, 'Rapport sur la construction des situations et les conditions de l'organisation et de l'action de la tendance situationniste internationale', in Berreby, pp. 607–19.

5. For group photographs, see the SI journal.

6. The standard works on Jorn are the three volumes by Guy Atkins (with Troels Andersen), *Jorn in Scandinavia, 1930–1953* (New York: George Wittenborn, 1968), *Asger Jorn: The Crucial Years, 1954–1964* (New York: Wittenborn Art Books, 1977), and *Asger Jorn: The Final Years, 1965–1973* (London: Lund Humphries, 1980). See also Troels Andersen, *Asger Jorn* (Silkeborg: Silkeborge Kunstmuseum, 1974) and, for the *modifications*, see Asger Jorn's essay 'Peinture détourné', in the exhibition catalogue *Vingt peintures modifiées par Asger Jorn*, (Paris: Galerie Rive Gauche, 1959); for a translation, see 'Detourned Painting' in the section of situationist documents in *On The Passage of a few people through a rather brief moment in time: The Situationist International 1957–1972* (Cambridge, Mass.: MIT, 1989).

7. For Pinot-Gallizio's *Cavern of Anti-Matter*, see Bandini.

8. For material on Constant, see Bandini; and Constant [Nieuwenhuys], *New Babylon* (Den Haag: Gemeente Museum, 1974).

9. For the history of the 'Nashist' Second Situationist International after the split, see Carl Magnus, Jörgen Nash, Heimrad Prem, Hardy Strid and Jens Jørgen Thorsen, *Situationister i Konsten* (Sweden: Bauhaus situationniste, 1966), and the defence in Stewart Home, *The Assault on Culture* (London: Aporia Press and Unpopular Books, 1988).

10. For Debord's films, see Guy Debord, *Contre le cinéma* (Aarhus, Denmark: L'Institut scandinave de vandalisme comparé/Bibliothèque d'Alexandrie, 1964) and *Oeuvres cinématographiques complètes, 1952–1978* (Paris: Editions Champ Libre, 1978), which both contain full versions of the scripts of films made up to the date of publication. Sadly, the films themselves have been withdrawn by their maker. For an account of the place of Debord's films in the history of French experimental cinema, see Dominique Noguez, *Eloge sur cinéma expérimental: Définitions, jalons, perspectives* (Paris: Musée national

d'art moderne, Centre Georges Pompidou, 1979). See also Tom Levin's essay, 'Dismantling the Spectacle: The Cinema of Guy Debord', in *On the passage of a few people through a rather brief moment in time*.

11. Guy Debord, *La Société du spectacle* (Paris: Buchet-Chastel, 1967). An unauthorized American translation was made by Freddy Perlman, *Society of the Spectacle* (Detroit: Black & Red, 1970).

12. Georg Lukács's *Geschichte und Klassenbewusstsein* first appeared in Berlin in 1923. Sections were translated into French in *Arguments*, nos 3, 5, and 11, and a full French translation, *Histoire et conscience de classe*, was published in Paris in 1960. An English translation was not to appear for many years; see *History and Class Consciousness*, translated by Rodney Livingstone (Cambridge, Mass.: MIT Press, 1971).

13. The journal *Socialisme ou barbarie* first appeared in Paris in 1949 and ran for forty numbers until it ceased publication in 1965. For a brief account of the group, see Dick Howard, *The Marxian Legacy* (London: Macmillan, 1977) – bearing in mind the implications of the word *legacy* – and, more important, the republication of Cornelius Castoriadis's writings for the journal in his two-volume *Cornelius Castoriadis: political and social writings*, edited and translated by David Ames Curtis (Minneapolis: University of Minnesota Press, 1988). The history of the group is also retold from the point of view of a participant (with much hindsight) by Jean-François Lyotard in his *Peregrinations: law, form, event* (New York: Columbia University Press, 1988).

14. See Mustapha Khayati, *De la misère en milieu étudiant* (Strasbourg: Union nationale des étudiants de France, Fédérative générale des étudiants de Strasbourg, 1966). This key text was widely and rapidly translated into many languages in pamphlet form and served as the main means by which situationist ideas were introduced into the student movements. For an English translation, see Christopher Gray, *Ten Days That Shook the University: the Situationists at Strasbourg* (London: Situationist International, 1967).

15. See especially the last issue of the SI journal, *Internationale situationniste* 12 (September 1969). For a rival viewpoint, refer to Edgar Morin and Claude Lefort (eds), *Mai 1968: La brèche* (Paris: Fayard, 1968), with contributions from the founders of Socialisme ou barbarie. For an English account sympathetic to the situationist milieu, see Angelo Quattrocchi and Tom Nairn, *The Beginning of the End: France, May 1968* (London: Panther, 1969), and for a retrospective history with a number of comments on the impact of situationist ideas, see Ronald Fraser et al., *1968: A Student Generation in Revolt* (New York: Pantheon Books, 1988).

16. For Debord's own account of the aftermath of 1968, see *La Véritable Scission dans l'Internationale* (Paris: Editions Champ Libre, 1972), with its withering dismissal of the 'pro-situ' wannabees of the period. For a concerned critique of the 'simulationist' art boom of the eighties and its debt to the dry husks of situationist thought, see Edward Ball, 'The Beautiful Language of My Century', *Arts*, no. 63 (January 1989), pp. 65–72. (Due to editorial error, this issue of *Arts* was mistakenly printed as *Arts*, no. 65, no. 5 (January 1988) and may be catalogued as such.) The most significant attempt to make use of situationist graphic techniques within a militant political framework, reviving the tradition of agit and poster art, has been in the work of Jamie Reid, especially during the *Suburban Press* and Sex Pistols periods. For Jamie Reid, see *Up They Rise: the incomplete works of Jamie Reid* (London: Faber & Faber, 1987) with texts by Jamie Reid and Jon Savage.

17. Karl Korsch's *Marxismus und Philosophie* was first published in Leipzig in 1923, with the first English translation (with an introduction by Fred Halliday) published in London in 1970; for the American edition, see *Marxism and Philosophy*, translated by Fred Halliday (New York: Monthly Review Press, 1971). Korsch, like Lukács, was translated into French by the *Arguments* group.

18. Henri Lefebvre, *Critique de la vie quotidienne* (Paris: Editions Grasset, 1947). A second edition was published by L'Arche in 1958 with an extensive new introduction. In the interim Lefebvre had been compelled to make a self-criticism by the French Communist Party, which he left after the Budapest uprising of 1956. The English translation is *Critique of Everyday Life* (London: Verso, 1991).

19. For the *Arguments* group, see Mark Poster, *Existential Marxism in Postwar France: from Sartre to Althusser*

(Princeton, NJ: Princeton University Press, 1975). After leaving the Communist Party, Lefebvre became an editor of *Arguments*. In due course, the group was unsparingly denounced by the SI.

20. For the Left Bank culture of the period, see Ed van der Elsken, *Love on the Left Bank* (London: André Deutsch, 1957) and Guillaume Hanoteau, *L'Âge d'or de Saint-Germain-des-Prés* (Paris: Denoël, 1965), which provides an appealing photographic and anecdotal record. For a somewhat more scholarly account, see Paul Webster and Nicholas Powell, *Saint-Germain-des-Prés* (London: Constable, 1984).

21. Note also that for Debord the construction of situations was to be a collective activity.

22. Debord was able to totalize the partial critiques of 'consumerism' that were typical of the period within a Marxist framework that also took account of the increased power and scope of the media.

23. See Perry Anderson, *Considerations on Western Marxism* (London: New Left Books, 1976) and Russell Jacoby, *Dialectic of Defeat: contours of Western Marxism* (New York: Cambridge University Press, 1981). These two critical histories, taken together, provide an excellent 'stereoscopic' view of Western Marxism. Martin Jay's *Marxism and Totality: the adventures of a concept from Lukács to Habermas* (Berkeley: University of California Press, 1984) provides an extremely thorough and illuminating overview, but for a reader interested in the SI, which Jay relegates to the status of footnotes to Lefebvre, it must be supplemented by, for instance, Richard Gombin's *The Origins of Modern Leftism*, translated by Michael K. Perl (Harmondsworth: Penguin, 1975) and *The Radical Tradition: a study in modern revolutionary thought* (London: Methuen, 1978), which unashamedly puts politics in command of philosophy.

24. For Bogdanov, see Robert C. Williams, *The Other Bolsheviks: Lenin and his critics, 1904–1914* (Bloomington: University of Indiana Press, 1986), which is also useful on Pannekoek, Gorter, and Roland-Holst; also important is Sheila Fitzpatrick, *The Commissariat of Enlightenment: Soviet organization of education and the arts under Lunacharsky, October 1917–1921* (Cambridge: Cambridge University Press, 1970). See also Gombin, *The Radical Tradition*. Jacoby, in *Dialectic of Defeat*, cites Korsch's observation that the post-1917 disputes in which he and Lukács were involved were 'only a weak echo of the political and tactical disputes that the two sides [by which Korsch meant Lenin, on the one side, and Pannekoek and Gorter, on the other] had conducted so fiercely some years before.'

25. I have not been able to find a good history of syndicalism, although Phil H. Goodstein, *The Theory of the General Strike from the French Revolution to Poland* (Boulder, Colo.: East European Monographs, 1984) is full of interesting material. A number of books deal obliquely with the subject and there are several national case studies.

26. See Lyotard, *Peregrinations* and Dick Howard's interview with Castoriadis in *Telos*, no. 23 (spring 1975).

27. The major issue in the split between Castoriadis and Debord seems to have been Debord's insistence on the abolition of labour. See *Internationale situationniste*, no. 4 (June 1960) and no. 6 (August 1961).

28. See Lukács, *Histoire et conscience de classe*. My translation is from the French edition (which Debord used), translated by Kostas Axelos and Jacqueline Bois (Paris: Editions de Minuit, 1960).

29. For an account of Lefebvre's political and philosophical career, see Jay.

30. See André Breton, *Manifestoes of Surrealism*, translated by Richard Seaver and Helen R. Lane (Ann Arbor: Michigan University Press, 1969) and Henri Lefebvre's introduction to the second edition of *Critique de la vie quotidienne*, 2 vols (Paris: L'Arche, 1958). The habit of vitriolic denunciation of ex-comrades was inherited by the SI and mars a great many pages of their writings. The reader often feels relieved that these writers never enjoyed real public power or influence.

31. See Jay.

32. See Elisabeth Roudinesco, *Histoire de la psychanalyse en France: La bataille de cent ans*, vol. 2, *1925–1985* (Paris: Seuil, 1986). This staggeringly informative work is indispensable for an understanding of French culture far beyond the bounds of psychoanalysis.

33. Both Mark Poster and Martin Jay fail to understand the importance of surrealism. Neither Perry Anderson nor Russell Jacoby pays any attention to Breton and most of the standard discussions of Marxist aesthetics, let alone politics, prefer to steer rapidly away.

34. Within the Western Marxist tradition, Walter Benjamin was also greatly indebted to surrealism.

35. The standard history of surrealism remains Maurice Nadeau, *The History of Surrealism*, trans. Richard

Howard (New York: Macmillan, 1965), which has been recently reprinted by Harvard University Press (1989). Helena Lewis, *The Politics of Surrealism* (New York: Paragon House, 1988) provides a detailed chronicle of surrealist political activity.

36. From Rodchenko's memoirs, quoted in Vahan D. Barooshian, *Brik and Mayakovsky* (The Hague: Mouton, 1978). I have written about Soviet productivism elsewhere; see my *Readings and Writings: semiotic counter-strategies* (London: Verso Editions and New Left Books, 1982).

37. For the background to Lukács's Marxism, see Jay; Michael Löwy, *Georg Lukács: from romanticism to Bolshevism*, translated by Patrick Camiller (London: New Left Books, 1979); and Gareth Stedman Jones, 'The Marxism of the Early Lukács: an evaluation', *New Left Review*, no. 70 (November–December 1971), reprinted in New Left Review, ed., *Western Marxism: a critical reader* (London: New Left Books, 1977). For Breton and Freud, see Roudinesco.

38. See Breton, *Manifestoes of Surrealism*.

39. See André Thirion, *Revolutionaries without Revolution*, trans. Joachim Neugroschel (New York: Macmillan, 1975).

40. Debord's early interest in psycho-geography reflects the influence of a traditional scientistic psychology. See, for instance, P.-H. Chombart de Lauwe, *Paris et l'agglomération parisienne*, 2 vols (Paris: Presses universitaires de France, 1952), which, despite its dedication to Marcel Mauss, relies on conventional statistical and empirical methods. It is also full of marvellous maps (which can also be seen plagiarized in the pages of the SI journal).

41. André Breton, *Les Vases Communicants* (1933) (Paris: Gallimard, 1970).

42. Breton's Hegel was eventually superseded by Kojève's – even among those who had undergone Breton's influence.

43. A *détournement* of Lacan.

44. The Lettrists returned to dadaism and 'modernized' dadaist techniques in the name of artistic research, while maintaining the dadaist penchant for scandal.

45. See the last issue of the SI journal, *Internationale situationniste*, no. 12 (September 1969). For the Situationists and Enragés at Nanterre, see also René Viénet, *Enragés et situationnistes dans le mouvement des occupations* (Paris: Gallimard, 1968). This book contains many examples of situationist comic strips, posters, and graffiti.

46. See *Le Jardin d'Albisola*, text by Ezio Gribaudo, Alberico Sala, and Guy Debord (Turin: Edizioni d'arte Fratelli Pozzo, 1974); for a translation of Debord's text, 'On Wild Architecture', see the section of situationist documents, 'A Selection of Situationist Writing: imaginary maps of the real world' in *On the passage . . .* Jorn wrote the introductory essay for Debord's *Contre le cinéma*, in which he compares Debord to Godwin.

47. See Lambert, *Cobra*, Jens Jorgen Thorsen, *Modernisme* (Copenhagen: Thaning & Appel, 1965). Torsen was a leading figure in the Second Situationist International.

48. Not for the first time. Earlier he had worked with Le Corbusier.

49. See Graham Birtwistle, *Living Art: Asger Jorn's comprehensive theory of art between Helhesten and Cobra (1946–1949)* (Utrecht: Reflex, 1986). This extremely important book gives a comprehensive account of Jorn's thought and writings during the formative pre-COBRA years and offers a number of insights on how these developed later. It draws extensively on both published and unpublished manuscripts. For a full bibliography of Jorn, see Per Hoffman Hansen, *A Bibliography of Asger Jorn's Writings* (Silkeborg: Silkeborg Kunstmuseum, 1988).

50. P.V. Glob's *The Bog People: Iron Age man preserved*, translated by Rupert Bruce-Mitford (Ithaca, NY: Cornell University Press, 1969) is a work of great charm and distinction, which provides an English language introduction to Glob's writings. He contributed to many journals with which Jorn was associated.

51. For Dotremont, see the works on COBRA cited in note 2 above, and José Vovelle, *Le Surréalisme en Belgique* (Brussels: A. de Rache, 1972). Belgian surrealism developed independently from French surrealism and was divided between various groups, relatively depoliticized (like those

around Magritte) and heavily politicized (as was Dotremont).

52. Serge Guilbaut, *How New York Stole the Idea of Modern Art: abstract expressionism, freedom, and the Cold War*, trans. Arthus Goldhammer (Chicago: University of Chicago Press, 1983) was the first pioneering study of the interlock between the art market, art movements, and global political power. Another such study is badly needed to bring the story up to the present.

53. See Lambert, *Cobra*.

54. Ibid.

55. Jorn had studied with Léger, as Pollock had with Benton and Siqueiros.

56. Bandini.

57. Ibid.

58. See *Potlatch, 1954–1957* (Paris: Editions Gérard Lebovici, 1985), a reprint of the journal of the Lettrist International.

59. *Homo Ludens* was published in Haarlem in 1938, then translated into German and published in Switzerland in 1944. The German translation was then retranslated into English and synthesized with Huizinga's own incomplete English language version (made shortly before his death in 1945), and this new English version was published in London in 1949. A French translation was published in Paris in 1951. For the most recent American edition, with an introduction by George Steiner, see Johan Huizinga, *Homo Ludens: a study of the play element in culture* (New York: Harper & Row, 1970).

60. Denis Hollier (ed.), *The College of Sociology, 1937–39* (Minneapolis: University of Minnesota Press, 1988). See also Roger Caillois, *Man, Play, and Games* (Glencoe, Ill.: Free Press, 1961).

61. *Fin de Copenhague* was republished in Paris by Editions Allia in 1985; it is also reprinted in Berreby, pp. 553–92. For *Mémoires*, see Marcus, *Lipstick Traces* and his article, 'Guy Debord's *Mémoires*: a situationist primer', in *On the passage . . .*

62. See Jorn, 'Peinture détourné' and Bandini.

63. For another sympathetic view of kitsch from within the Marxist tradition, see Ernst Bloch, *The Utopian Function of Art and Literature: selected essays*, translated by Jack Zipes and Frank Mecklenberg (Cambridge, Mass.: MIT Press, 1988).

64. See Asger Jorn, *Critique de la politique economique* (Paris: Internationale situationniste, n.d. [1960]), summarized in Gombin, *The Radical Tradition*.

65. Bandini. Among later artists, both Merz and Pistoletto were influenced by Pinot-Gallizio early in their careers and pay tribute to him in Mirella Bandini's monography.

66. Ibid. For a bibliography of Constant, see Lambert, *Cobra*.

67. For Constant's influence, see Reyner Banham, *Megastructure: urban futures of the recent past* (London: Thames & Hudson, 1976), which cites the Beaubourg museum in Paris as a spin-off.

68. In 1961, Jorn, Nash, and Strid founded the Bauhaus situationniste in Sweden. In February 1962, the Spur group was expelled from the SI, followed by the Nash group in March. These expelled groups then formed the kernel of the Second Situationist International, founded later the same year. The Bauhaus situationniste still thrives, continuing to produce publications, sponsor events, and agitate for a situationist path in art, under the guidance of Nash and Strid. The Second SI has been a more notional body but has never been dissolved.

 Nash, of course, is the doyen of Danish poets and his unflagging energy has kept the standard of artistic rebellion flying, not only through these organizations, but also through the journal *Drakabygget* and his involvement with the Co-Ritus group (with Thorsen and others) and the Little Mermaid scandal. See Carl Magnus and Jörgen Nash et al., cited in 9 above. In his forward to the book, Patric O'Brian [Asger Jorn] writes as follows: 'The anti-art of the late 1950s and early sixties stated that visual art was a useless medium for creativity and thinking. It was the radiation of art into pure existence, into social life, into urbanism, into action and into thinking which was regarded as the important thing. The start of situationism, the foundation of the first Internationale Situationniste in 1957, was a reflection of this thinking. The motto 'Réaliser la philosophie' [*sic*] was a starting point for situationist anti-art. But it caused also violent discussions in the First Situationist International. Opposing this point of view, Strid, Nash and Thorsen, among others, in 1962 founded the second

Internationale Situationniste. These five Situationists, Strid, Prem, Thorsen, Magnus, Nash, are all aiming to place art in new social connections. They are fully aware of the possibilities of artistic radiation. Far from creating any feeling of anti-art in their minds, this point of view gives visual arts a far more central position in their experiments.'

Also associated with the Second SI was Jacqueline de Jong, who produced the *Situationist Times*. She was one of the few women closely associated with the Situationists, who, like other avant-garde groups, marginalized, undervalued, and overlooked women both in their circle and in society at large. Indeed, the SI journal blatantly reproduces images of women as 'spectacle'.

69. Although the SI itself dissolved soon after 1968, the fallout spread far. American groups flourished in Detroit, New York, and Berkeley, where Ken Knabb's anthology (see note 1 above) and Isaac Cronin and Terrel Seltzer's videotape *Call It Sleep* helped popularize situationist ideas in the radical community. In Britain, situationist graphics were popularized within art colleges affected by the 1968 occupations and thence infiltrates the popular music scene. Jamie Reid's triumphantly subversive Sex Pistols polyptych ensures that the punk debt to the situationists will not be forgotten. See also Marcus, *Lipstick Traces*.

70. See Perry Anderson, *In the Tracks of Historical Materialism* (Chicago: University of Chicago Press, 1984), for a lucid account of the trajectory of Althusser and Althusserianism.

71. See Georg Lukács (with Heinz Holz, Leo Kofler, and Wolfgang Aberdroth), *Conversations with Lukács*, edited by Theo Pinkus (Cambridge, Mass.: MIT Press, 1975). For comparison, see Guy Debord's deLukácsized *Commentaires sur la société du spectacle* (Paris: Editions Gérard Lebovici, 1988), which is closer to the late Lukács.

72. Dr Omar is the Doctor of Nothing played with such languorous disdain by Victor Mature in von Sternberg's *Shanghai Gesture*. Prince Valiant is the comic strip hero, evidence of a chivalresque bent on the part of Guy Debord; somewhat unexpected but consonant with his conception of a fraternal avant-gardism, militant and pure, devoted to the quest for the Grail of council communism.

73. Debord, *Oeuvres cinématographiques*. Debord's work in the cinema concludes with this film, the last image of which bears the subtitle, 'A reprendre depuis le début' ('To be recommenced from the start').

NOTES FROM THE UNDERGROUND: ANDY WARHOL

Fordist mass production inevitably demanded mass marketing and mass consumption as its corollary.[1] Thus the long American boom after the Second World War saw the development of a massive merchandizing machine, in the advertising, packaging and media industries. This Great Leap Forward of marketing and publicity was predicated, of course, on a Great Leap Forward in the production of images: in the streets, in the press, on television. The seismic change in the form of mass culture, as it both proliferated and was subordinated to the drive of mass production and consumption, was finally reflected in the narrower and traditionally 'purer' spheres of the arts and high culture, now unable to delay or resist confrontation with the new visual (and, indeed, verbal) environment or the economic weight and pressure of the new communications industries. In this sense, the arrival of pop art in the early sixties was just one element in a much more general cultural shift: Warhol and Lichtenstein should be seen alongside cultural critics such as McLuhan (or Eco or Barthes), writers like Burroughs, obsessed by advertising, the image bank, the word virus and the 'Reality Studios', and of course, film-makers like Godard. Artists had to come to terms with the new images, whether through irony, celebration, aesthetic enhancement, or *détournement*. But if Warhol stands out among them as anything more than a harbinger of this new parasitism of art on the media, it is because his work has a more complex meaning. Like his great contemporary, Joseph Beuys,[2] Warhol (another master of disguise) was able to shift the optical and semiotic field of art towards a new, and potentially troubling, theatricality. This in turn left an important political, as well as aesthetic, legacy: in the case of Beuys to be found in the Green Party, and in the case of Warhol in the gay liberation movement. Warhol's key achievement, within the field of pop, was to bring together the apparent contraries of 'minimalism' and 'camp' in a paradoxical and perverse new combination.

The minimalist current into which Warhol tapped began (or re-began) with John Cage (after Gertrude Stein, after Satie).[3] Cage, in a revolt against the authoritarian systematicity of his teacher, Schoenberg, invented a form of music that rejected the traditional ideology of composition, with its pillars of harmony, structure, order and control. This, in turn, led him to abandon the whole idea of the artist as organizational source and master of the work. Instead Cage developed a philosophy (inspired by Buddhism and a certain pantheism) which equalized all the parts of a work and stressed duration, repetition and random elements. Art, according to Cage, should be brought back into relationship with everyday life. It should use found objects (or found sounds) and respect the uneven rhythms of day-by-day existence, even its banality, dead periods and ordinariness. At the limit, Cage was fascinated by silence, which posited duration with a special intensity while negating the traditional appeal of music as melody and even the unthought-through concept of audibility – because, in a certain sense, silence was the most audible register of all. Silence, too, foregrounded the incidental and the not-meant-to-be-listened-to, refocusing our perception of the acoustic environment, removing the aural 'frame' which marked 'music' off from 'everyday life'. Like the artists of COBRA in Europe, Cage placed 'everyday life' in relationship to 'play', to non-purposive, free activity.[4] Thus everyday life would be aestheticized as art was recontextualized as part of, rather than separated from or exterior to daily life. But for Cage, unlike the COBRA artists with their surrealist background, this was primarily a spiritual rather than a political project.

Cage's ideas and practices gradually spread out of the music world into the related dance world (especially through his collaboration with Merce Cunningham) and eventually into the art world through Black Mountain College (to Rauschenberg and thence to Johns) and through the Fluxus group (to De Maria, Morris and others). It was through this radiation of Cage's aesthetic that minimalism came to Warhol, although Cage himself notes analogies between his own love for Satie's 'furniture music' and Warhol's manufacture of Brillo and other boxes which could be (and actually were) used as furniture, being treated as coffee tables.[5] Rauschenberg and Johns were initially Warhol's role models in the art world. Like him, they designed window displays for Bonwit Teller but, unlike him, they were recognized in the gallery world for their fine art.[6] Like him, too, they were gay artists who came from art-starved provincial backgrounds, who had fled to New York to

nurture their will-to-art. They offered an alternative avenue to those who, like Warhol, could hardly identify with the straight, macho posturing of the Cedar Tavern and the claims of abstract expressionism to seriousness and mastery. Rauschenberg knew Cage from 1951 (when he collaborated with him on an 'automation' piece in which Cage drove his Model A Ford along an inked section of roadway and then across twenty pasted-together sheets of paper) and grew close to him in 1952 when they both spent the summer at Black Mountain.[7] Rauschenberg meanwhile had been working on all-white and all-black paintings, analogous to Cage's work in their early minimalism, but the important collaboration which took place there was at the now-legendary Event, a precursor of the multimedia performances and happenings of the sixties. Rauschenberg operated the gramophone for Cage, and films and slides were projected onto his white paintings, beneath which Cunningham danced, poems were read and Cage's music was played.

The Black Mountain Event was the first of a series of artistic collaborations between Merce Cunningham and Rauschenberg which persisted till the mid-sixties. Rauschenberg worked on other dance performances too, designing sets and/or costumes, and in the early sixties he became closely involved in the work of the Judson Dance Theater, founded by dancers from Cunningham's company and deeply influenced by Cage. They were joined by other dancers who performed at the Judson Church, a space and refuge made available to artists in many fields and from different backgrounds, a catalyst for the arts, avant-garde, bohemian and 'underground', whose activities had a deep and lasting impact on Warhol. It was because of Rauschenberg's involvement, Warhol said, that he first went to the Judson Church.[8] It was there that he encountered the theatricalization of minimalism, and it was there too that he saw that same theatricalization reach into the realm of glitter, extravaganza and camp.[9]

'Camp' of course, emerged as an art-historical category with Susan Sontag's brilliant 'Notes on "Camp"', first published in *Partisan Review* in 1964.[10] This was the year in which Warhol had his Flowers show and made his first sound films in the Factory which Billy Linich had decorated all over with silver foil a few months previously. Reading Sontag's essay today is like reading through a litany of Warhol's tastes, allusions and affinities. It is all there: the Tiffany lamps, the *Enquirer* headlines, the Bellini operas, the Firbank novels, the old comics, the bad movies, the idolization of Garbo, post-rock'n'roll pop music, 'corny flamboyant femaleness', dresses made of

millions of feathers . . . And, on a more theoretical level, there is the redemption of banality, the transcendence of 'the nausea of the replica', the volatile intermixing of sheer frivolity with passionate commitment, the taste for excess and extravagance, 'dandyism in the age of mass culture'. Camp, of course, involves a rejection of the whole late-modernist aesthetic, that citadel of high seriousness and good taste as elaborated by Greenberg, who saw himself as defending the gates against the barbarians of kitsch massed without.[11] In this sense, camp taste, with its hyperbolic aestheticization, its playful connoisseurship of kitsch, was fated to play a decisive part in the demise of modernism. At the same time, it was pushing insistently towards performance, towards the theatricalization of everyday life.

Warhol's own version of camp is visible everywhere in his commercial art work, where, however, the inclination to excess is prudently held in check.[12] There are limits: limits that often seem calculated in their containment. Gold leaf remains decorative, foot fetishism remains whimsical, boys and cherubs remain charmingly precious. It was not till the Factory days that camp was let off the leash of good taste, no longer limited by a self-conscious censorship (to be evaded in 'private' scrap books, like the 'Foot Book' and the 'Cock Book') but channelled within a rigorous and austere aesthetic. It was minimalism that enabled Warhol to release an orgy of camp. And it was at the Judson Church that this encounter of minimalism and camp crystallized for Warhol, to be transposed later into a new register. There the discipline of minimalist dance met the flagrant masquerade of femininity.

Warhol was already aware of the minimalist direction in which the art world was moving. He had acquired a set of small paintings by Frank Stella (through De Antonio, who was Stella's agent, as well as Rauschenberg's and Johns's, and who played a crucial role in encouraging Warhol himself to paint and exhibit) and must also have known the Stella black painting that De Antonio owned.[13] He was also a dedicated gallery-goer. Moreover, he prided himself, when he was a commercial artist, on his facility, his ability to draw fast with only one line, and he had also always been interested in print media, in techniques of replication, such as the blotting technique he made his own and the stamps he carved out of erasers. His longstanding interest (encouraged by commercial considerations) in doing as much work as possible as fast as possible was bound to push him towards a minimalist reduction. But he was also interested in content and in performance. Here the example of dance was crucial.

The exemplary minimalist dancer and choreographer at the Judson Church was Yvonne Rainer.[14] Her first work, 'Three Satie Spoons', at the Cunningham Studio in 1961, was a repetitive structure, based on Cage's work, and performed to music by Satie. The next year, Warhol was at Judson to watch her 'Ordinary Dance' and there in 1963 he saw 'Terrain' (lit by Rauschenberg), which included a series of partly rule-governed activities (walking, jostling, passing, standing still), of choreographed walks, runs, falls, somersaults, ballet and cheesecake postures, games (with a ball, wrestling) and a love duet in which 'she delivered hackneyed expressions ("I love you", "I don't love you", "I've never loved you") in a flat monotone which one critic likened to the recitation of a grocery order'. In 1966 Yvonne Rainer wrote a retrospective manifesto for the dance work of the period, drawing parallels between sculptural and dance minimalism ('A Quasi Survey of Some "Minimalist" Tendencies . . .'), in which she likened the 'energy equality and "found" movement' of dance to the 'factory fabrication' of sculpture (or 'objects'); 'equality of parts, repetition,' to 'modules'; 'repetition or discrete events' to 'uninterrupted surface'; 'neutral performance' and 'tasklike activity' to 'nonreferential forms' and 'literalness', etcetera.[15] Though she was presumably thinking of other artists than Warhol, the parallelism would still hold good, both for Warhol's gallery work (including the 'sculptural' Brillo boxes), except for 'non-referential forms', and for his film work, except that Warhol's predilection for exhibitionistic 'routines' replaced 'neutral performance', at least in the later films. (Early work like *Sleep*, *Eat*, or indeed *Empire*, was often neutral). There is a sense, perhaps, in which we can think of Warhol's relationship to Rauschenberg as analogous to Rainer's relationship to Cunningham.

Before she became involved with the founding and programme of the Judson Dance Theater, Rainer had worked with the James Waring company of dancers, an experience she later recollected:

> Jimmy had an amazing gift which – because I was put off by the mixture of camp and balleticism in his work – I didn't appreciate until much later. His company was always full of misfits – they were too short or too fat or too uncoordinated or too mannered or too inexperienced by any other standards. He had this gift of choosing people who 'couldn't do too much' in conventional technical terms but who – under his subtle directorial manipulations – revealed spectacular stage personalities.[16]

Here a completely different parallel with Warhol and his Factory 'company' is

plain, one that also relates Waring and Warhol to the other camp and gay performance groups of the sixties, such as the Playhouse of the Ridiculous or Jack Smith's 'mouldy' extravaganzas.[17] Indeed, Warhol was particularly enthralled by one of Waring's star performers, Freddy Herko, who also danced in a number of pieces and programmes with Yvonne Rainer. Herko shared an apartment with Billy Linich (Billy Name) who moved into the Factory and became Warhol's longest-lasting and most enigmatic associate of the sixties. Warhol made three films with Herko, and was fascinated by his beauty, his 'star quality', his use of glitzy window-display materials, paste jewels, feathers, glass flowers, the whole tawdry fairyland of fake glamour transcended by a spectacular stage presence. For Warhol, looking back on Herko's career after he became a speed freak and, in 1964, 'choreographed his own death and danced out of a window' in a sensational camp suicide, the roots of the tragedy were in Herko's lack of confidence, concentration and discipline.[18] It was a career of unchannelled excess.

Warhol transposed his own interior discipline into the exterior form of the machine and the factory as site of automation and of productivity. But this factory was a minimalist factory that simply recorded rather than transformed its raw materials. The techniques of standardization, repetition and assembly-line throughput were used to assemble not complex finished products but literal replicas of what was already there, more or less unaltered. (Though art critics and connoisseurs have often chosen to stress the tiny percentage of 'personal touch' they are able to trace.[19]) Warhol's Factory was a travesty of a real factory. Warhol had farmed out work to assistants and friends when he was a commercial artist, holding 'colouring parties' when he produced handmade books and experimenting with handmade printing devices.[20] His assistant, Nathan Gluck, did original drawings for Warhol which the latter then corrected, as well as doing the blotting that was part of Warhol's technique. Warhol's mother was entrusted with doing lettering. Warhol's practice at the Factory was simply to update these habits and procedures as new, relatively inexpensive technology became available to him: the silkscreen, the Polaroid, the tape recorder, the film camera. All these devices simplified and speeded up the work and removed Warhol himself from arduous involvement. It was much easier that way (as indeed, it was for Ford).

But Warhol's rationalization of the work process was half serious, half theatrical. In an article on Fordism, published recently, Robin Murray describes the impact of Ford's methods and ideas in the Soviet Union:

Soviet-type planning is the apogee of Fordism. Soviet industrialization was centred on giant plants, the majority of them based on Western mass-production technology. So deep is the idea of scale burnt into Soviet economics that there is a hairdresser's in Moscow with 120 barbers' chairs. The focus of Soviet production is on volume and because of its lack of consumer discipline, it has caricatured certain features of Western mass production, notably a hoarding of stocks, and inadequate quality control.[21]

These 'caricature' elements of Soviet mass production are precisely the ones Warhol prized: volume ('Thirty Mona Lisas are better than one'), hoarding and (deliberately) inadequate quality control, leaving errors of alignment uncorrected, etc.[22]

It is easy to imagine the delight Warhol would surely have felt at seeing the 120 barbers' chairs: Warhol often reiterated the ideology of Fordism (Americanism, or 'common-ism' as he once called it) in the form which Robin Murray describes: 'In the welfare state, the idea of the standard product was given a democratic interpretation as the universal service to meet basic needs'.[23] Warhol frequently commented on the way in which post-1945 Fordism produced a form of basic social levelling (without, of course, redistributing wealth), through standardizing consumption (Campbell's Soup, Coke, and so on).[24] But, of course, Warhol's own standardization was precisely on the barber's shop scale.

Warhol's attitude to the mass consumption commodities whose packaging he replicated is often described as 'ironic'. But I think it might be better understood in terms of theatre, of performance or masquerade. Rather than producing images of commodities, he was repackaging packaging as a commodity in itself. In this process it was the element of display that fascinated Warhol, the transfer to a new space (the art gallery) of images whose display was already familiar in different spaces (the supermarket, the daily newspaper, the fan magazine). It was precisely the proliferation of 'spectacle', of the 'to-be-looked-at', the saturation of everyday life by a new scopic regime, that Warhol chose to replicate in a further gesture of theatricality. Warhol was not particularly concerned by the problem potentially posed in terms of loss of originality or authenticity. He was already used to working on assignment in the commercial art world, where he was told what kind of image to produce and then produced it as fast as possible in a given format. He was already used to copying and tracing from photographs (in fact, his first recorded drawing was a childhood copy of Hedy Lamarr in a Maybellene ad[25] and was a frequent

visitor to the Picture Collection of the New York Public Library where 'he would often come and check out hundreds of pictures'.[26] To produce work for gallery spaces he acquired an 'iconographic programmer' (Henry Geldzahler) and restructured his system of production. The innovation of Warhol's gesture was that of displaying display.

In this circuit of display, Warhol's particular position was to be with, to be alongside the recording apparatus. Indeed, he seemed both to identify with the apparatus and to perceive it as an extension of himself, a prosthesis, or, as he came to call his tape recorder, a 'wife'.[27] At the same time the apparatus 'mechanized' its controller, turning Warhol himself into a phantasmatic machine, in line with his desire: 'The reason I'm painting this way is because I want to be a machine. Whatever I do, and do machine-like, is because, it is what I want to do.'[28] Only if the apparatus was too complex or tiresome to operate would Warhol let go of it: like the 35mm still camera he gave to Billy Name because there were too many controls to work (Billy Name used it to document the scene at the Factory). Similarly Warhol hired Gerard Malanga to do the silkscreens because it was too much effort to do it all himself. To Geldzahler these pieces of apparatus were 'baffles' which Warhol needed to function in the interpersonal world. He could only have a conversation over the telephone, and if it was being recorded. He took his tape recorder to dinner parties and took Polaroids of the other guests. He wanted everybody who came to the Factory to be filmed in one of an endless series of 'screen tests'. It is as if by submerging himself into machine-like-ness, Warhol could enter, in phantasy, a world of pure seriality and standardization, in which, at one and the same time, the 'otherness' of the image of the 'other' was effaced and the identity of the self was obliterated through the agency of an impersonal machine-like 'Other'. Thus imaginary difference was erased and the identity of the subject was reduced to the purely symbolic dimension of the name, functioning like a logo, 'Andy Warhol', like 'Coca-Cola' or 'Walt Disney'.[29]

This idyllic vision of the Andymat stands in obvious tension with the camp world of caricature and masquerade. Yet the baffle was itself a form of mask: a shield or screen which promised immunity from the exchange of intersubjective looks, while permitting a whole economy of voyeurism and exhibitionism in the form of recorded spectacle. Here the excess and extravagance of masquerade and display were neutralized by the apparatus, framed, registered

and re-projected on the exterior blank of screen or wall, under the supervision of the passive yet sovereign master of ceremonies.

At the same time, recording was also a form of storage, Warhol recorded everything endlessly. He ended up becoming a compulsive hoarder of every detail of his daily life. Not only did he have fourteen hundred hours of taped telephone conversation with Brigid Berlin alone, but he saved records and samples of everything that passed through his hands, packing it all up in boxes each month and sending it to storage as 'time capsules'. This mania extended far beyond the bounds of an artistic strategy. It became constitutive of Warhol's being-within-the-world, so to speak. Once again this accumulative drive was channelled into a serial form, that of the regular scheduled 'time capsules': 'What you should do is get a box for a month, and drop everything in it and at the end of the month lock it up. Then date it and send it over to Jersey.' This indeed is what Warhol did: accumulate 'clutter' and then empty it out of his immediate space into his 'closet' in New Jersey in an orderly fashion, accumulating an endless series of identical sealed and labelled boxes.[30]

In 1970 Andy Warhol was invited to curate an exhibition selected personally from the storage vaults of the Museum of Art at the Rhode Island School of Design in Providence. In his preface to the catalogue (*Raid The Icebox*) the museum director remarked that

> . . . there were exasperating moments when we felt that Andy Warhol was exhibiting 'storage' rather than works of art, that a series of labels could mean as much to him as the paintings to which they refer. And perhaps they do, for in his vision, all things become part of the whole and we know that what is being exhibited is Andy Warhol.[31]

It is as if the label 'Andy Warhol' would signify, not a person, in the sense of a human subject, but storage: boxes, reels, spools, Polaroids, all labelled 'Andy Warhol'. It would be an immense museum of junk (or rather, since it could all be metamorphosed into commodity form, a department store or gigantic thrift shop).[32] At the root of this attitude we find once again many affinities with Cage's aesthetic: the refusal of hierarchy or consequence or narrative (hierarchy and consequence of events over time). Everything is equally worth recording and storing and hence all that is needed to record and store it is an automatic process, the simplest possible algorithm. The recording/storing apparatus should not make evaluative distinctions, and to avoid 'clutter' (the

single aesthetic imperative) it should adopt a serial procedure of segmentation and ordering, based on arbitrary data (the length of a reel of film) or decisions (for his second exhibition in Los Angeles, in 1964, Warhol sent a roll of silkscreened Elvises, with a request to 'cut them any way you think it should be cut. I leave it to you. The only thing I really want is that they should be hung edge to edge densely – around the gallery. So long as you can manage that, do the best you can.')[33]

Raid The Icebox records another poignant moment:

> Back in his office, Robbins [the museum director] informed the curator of the costume collection that Warhol wanted to borrow the entire shoe collection. 'Well, you don't want it all', she told Warhol in a somewhat disciplinarian tone, 'because there's some duplication.' Warhol raised his eyebrows and blinked. In fact he wanted all the shoes, all the hatboxes (without taking the hats out), all the American Indian baskets and ceramics, all the parasols and umbrellas, all the Windsor chairs, and so on. 'All of them – just like that.'

This same attitude inspired Warhol's approach to film-making. He would shoot a single reel of film for each episode or each movie. He would shoot only one take. Then he would show the movie (the take) either as a work in itself or, like *Kiss*, as a serial – a different *Kiss* opened every screening at the Film-Makers Co-op for a period of time. Or, as with the longer works, such as *Chelsea Girls*, a series of ten-minute takes would be joined up and shown end to end. There was no editing. Nothing was selected within each take and, since there were no second takes, there was no selection between takes.[34] Here Warhol's approach is completely the opposite to that of William Burroughs, who also tape-recorded and photographed everything incessantly, but precisely in order to edit it, to cut the word lines and reorganize the images in complex photo-collages. Burroughs's paranoid fear of being taken over by alien words and images is the exact converse of Warhol's 'reverse-paranoid' desire to be taken over. Both recorded compulsively in order to sabotage (Burroughs) and to facilitate (Warhol) the workings of the semiotic machine.

Warhol's reluctance to edit was a constant in all his activities. Unedited tape transcripts became the basis for his novel *a* and, later, for his magazine *Interview*. With Cage this refusal of selectivity had both an aesthetic and a spiritual, quasi-religious foundation, but with Warhol we can sense another dimension, a more social and psychological fear of rejection, which could express itself in the attempt to reintegrate the rejected. Talking about Freddy Herko and the Factory 'company', the San Remo crowd of faggots and

amphetamine freaks, Warhol recollected, 'the people I loved were the ones like Freddy, the leftovers of show business, turned down at auditions all over town. . . . You had to love these people more because they loved themselves less.'[35] Warhol surrounded himself with 'leftovers' and set about turning them into 'stars': these were not just ordinary people, as in the Hollywood myth, but rejects, people 'turned down at auditions all over town'.

In *Raid the Icebox*, Daniel Robbins remarks that Warhol 'picked an entire row of Windsor chairs but, from an antique connoisseur's point-of-view the chairs he chose were of secondary interest. In fact, they had been kept, according to a venerable entry, for use in spare parts!' Robbins continues, commenting, 'What violence the idea of spare parts does to our fanatical notion of uniqueness and the state of an object's preservation. Our present curator will not allow a piece to be exhibited at Pendleton House if it is "married" – that is, if all parts are not original to it'. Of course, Robbins is right: Warhol's aesthetic does challenge ideas of uniqueness and authenticity. But it is also important to note that the chairs in question 'were of secondary interest'. In fact, they were the leftovers – the understudies, the rejects. Elsewhere, Warhol said:

> I always like to work on leftovers, doing the leftover things. Things that were discarded, that everybody knew were no good. . . . When I see an old Esther Williams movie and a hundred girls are jumping off their swings, I think of what the auditions must have been like and about all the takes where maybe one girl didn't have the nerve to jump when she was supposed to, and I think about her left over on the swing. So that the scene was a leftover on the editing-room floor – an out-take – and the girl was probably a leftover at that point – she was probably fired – so the whole scene is much funnier than the real scene where everything went right, and the girl who didn't jump is the star of the out-take.[36]

There cannot be much doubt that the girl on the swing in the fantasy scenario is Andy, the childhood reject and misfit, beaten up at school, kept in bed with nervous disorders, 'the girl who didn't have the nerve'.[37] The fear is mingled with the anxiety of not being like everybody else, like the ninety-nine other girls on their swings. So, on the one hand, we have the deep desire to be exactly like everybody else 'I don't want it to be essentially the same. I want it to be exactly the same.'[38] And, on the other hand, there is the identification with the rejected. It was 'the stars of the out-take' that Warhol loved, who were meaningful to him. The others, the ninety-nine, had no emotional

charge for him. 'I want it to be exactly the same. Because the more you look at the same exact thing, the more the meaning goes away, and the better and emptier you feel.' Warhol's fascination with images was bound up with his dissatisfaction with his own image, his unattractiveness. He had hair that fell out, blotchy odd-looking skin, a bulbous nose that reminded people of W.C. Fields (his family called him 'Andy, the Red-Nosed Warhola'). He had a nose job and kept out of the sun and acquired a wig. 'I really look awful, and I never bother to primp up or try to be appealing because I just don't want anyone to get involved with me'.[39]

Tina Fredericks, his first picture editor (at *Glamour*) comments, 'Like the harem guards at ancient courts, he had the power that comes from being totally unthreatening and endearing'.[40] The power, that is, which emanates from an imaginary castration. In his novel, *a*, Warhol is called 'Drella', that is, a mixture of Cinderella and Dracula.[41] The magical transformation from out-take to stardom was achieved for Warhol through voyeurism, as a kind of ocular vampirism. The look recorded, appropriated and re-projected as spectacle the magical transformation of other leftovers into stars. At the same time, it conferred a magical aura on Warhol himself. He acquired not beauty or attractiveness but glamour and fame.

For Warhol, the kind of love that counted was that of the fan for the star – a love that linked private fantasy with public image, a love at a distance, mediated through merchandizing, maintained by the obsessive hoarding of fetishes – the process described so well in Edgar Morin's book *The Stars*, which Warhol acquired, I assume, when it was published by Grove Press in New York in 1960.[42] And as Warhol acquired confidence and assurance, as he began to savour his own success and fame, he turned more and more to 'the stars of the out-take', a process only ended when he was shot by one of the out-takes in 1968.

In 1965, in Paris, Warhol announced his intention of giving up painting. He had started making films the previous year and, on his return to New York, he would soon become involved with the Velvet Underground and the world of music. The Soviet artists who moved out of painting in the 1920s did so in order to enter the field of commercial and industrial art: advertising, design and even their own functionalist version of fashion. This, of course, was the world Warhol was coming from. His trajectory was towards performance. In retrospect, it is possible to see telltale signs of the impending move in the art works themselves. There is a move from the generic products as subject

matter (Campbell's Soup, Coca-Cola) to the stars (Marilyn, Liz, Jackie) and then to the increasingly 'frivolous' flowers and cows (subjects from Dutch genre painting helpfully suggested by Geldzahler). At the same time, the gallery space was being threatricalized: the wrap-around Elvis paintings, the Brillo boxes littered all over the gallery floor, the cow wallpaper with the inflatable silver balloons (perhaps the turning point was 1963, when Warhol first wore a silver-sprayed wig). Warhol was deeply impressed by the scene at his opening in Philadelphia in 1965, when a crowd of fans screamed at Warhol, Edie Sedgwick and his entourage:

> It was incredible to think of it happening at an art opening. . . . But then, we weren't just at the art exhibit – we were the art exhibit, we were the art incarnate and the sixties were really about people, not about what they did; 'the singer/not the song', etc. Nobody had even cared that the paintings were all off the walls [removed because they were in danger of getting crushed by the crowd]. I was really glad I was making movies instead.[43]

In one sense, of course, films were just another form of wallpaper: wallpaper that slowly began to move out of stasis and silence into movement and sound, even eventually into colour. But in another sense they ratified Warhol's need for theatricality; they made possible his plunge into the world of camp, the underground, the bohemian avant-garde.[44] Warhol traces his interest in film back to the days when he would go to 'bad' movies on Forty Second Street with De Antonio, and this camp inflection of his taste was strongly reinforced by the films he saw at the Co-op screenings organized by Jonas Mekas, especially films from the gay scene, like those by Jack Smith. All this led him on to even 'worse' films like Arthur Lubin's cut-price stagey desert melodramas. The aesthetic was one he shared with Jack Smith and the other film-makers devoted to what Carel Rowe calls 'moldy art' and the 'Baudelairean cinema'.[45] Smith himself talked about 'pasty art'. Ronald Tavel, the founder of the Theatre of the Ridiculous and later Warhol's scriptwriter, described Smith's project for a new film, *Normal Love*:

> *Normal Love* is meant to define and reach the heights of 'pasty art'. What that is can sooner be gotten from studying the film than speaking of it. But briefly, 'pasty art' refers to what it suggests – bad art. But bad in a very special sense. It is bad and 'moldy' and 'pasty' because it involves all that is pitiful and miserable and lost and degraded about people. It encompasses their wretched, deceitful, inherited dreams, the abominable fantasy prisons that follow their twisted

childhoods and their doomed, unrequitable groping into a dismal future. The art is pasty because this is not only the subject matter but, properly, its form and method and surface.[46]

Warhol's most successful pop art simply recycled an obsession with stars and glamour and celebrity, an obsession that never left him and eventually propelled him into celebrity himself. But for Jack Smith, and no doubt for Warhol too, buried behind his own mirror-glass façade, there was a recognition that Hollywood glamour was a fantasy surface, even, in Baudelaire's phrase, 'a phosphorescence of rotten-ness'. As another underground filmmaker, Ken Jacobs, put it: 'Pop Art was a thing we hated. . . . it lacked terror.' The '"Human Wreckage" aesthetic' he shared with Smith was built on garbage and hopelessness. Hollywood was 'a seedy garbage heap' and the 'low-budget personalities' they loved were condemned to waste and suffering. There was nothing left but 'a hilarious and horrifying willingness to "revel in the dumps", to create some sort of "garbage culture" '.[47] But Warhol's key decision was to combine the minimalist aesthetic he brought with him, and which was naively present in many 'bad' cheaply made films, with an equally minimalist refusal to direct. His instructions to his scriptwriter, Ronald Tavel (whom Warhol approached when he acquired the Auricon sound camera) were that he wanted 'situation' and 'incident' rather than 'plot' or 'narrative'. At first, he wanted Tavel to invent situations and provoke responses from off-screen. In fact, much of the soundtrack came from off-screen comments. Later, he realized that with a cast of confessional exhibitionists, he could dispense with the idea of a writer entirely. Given a forum, they would talk.

Moreover, Warhol made it clear that his non-interventionism meant that there would be no censorship. Warhol benefited from the freedoms that had been won by others, who had to face legal actions: Allen Ginsberg, William Burroughs, Jack Smith (and Jonas Mekas), Kenneth Anger. The liberties Warhol enjoyed meant that not editing meant not censoring. This was an outcome of the minimalist aesthetic which accommodated Warhol's own voyeurism and love of sexual gossip, and made it possible to combine minimalism with a scabrous sense of the histrionic and the breaking of taboo. Warhol believed so strongly in a certain kind of literalism that he was worried when filming Sleep that he was missing moments because of having to change the reel in the camera. (Later when he was recording interviews for his book Pop-ism, he would come with two tape recorders and start them at different

times, so nothing could escape). To make up for the missing moments, Warhol slowed down the projection speed of the film, so that it would be the length he felt it should have been, without the gaps. It is exactly this literalism, this insistence on missing nothing, on suppressing nothing, that made the connection between minimalism and outrageous camp performance.[48]

Finally, Warhol moved into the music world, with the Exploding Plastic Inevitable, a mixed-media performance environment, with movies, light-show, expressive dancing and the Velvet Underground.[49] Warhol recognized in the Velvets a group that already shared the same aesthetic, minimalist and outrageous. John Cale had been a student of Cornelius Cardew in England, where he had already absorbed Cage's ideas. In New York, he was close to another minimalist composer, LaMonte Young, and played in John Cage's 1963 eighteen-hour performance of Satie's 'Vexations', a series of 840 repetitions. (This was a performance which Warhol attended.)[50] At the same time, Lou Reed brought a star presence, as bard of drug-taking and paranoia. Warhol both expanded the theatricality of the Velvets by turning every performance into a mixed-media event (shades of Black Mountain) and also sought to minimalize the performance.[51] 'One of the ideas he came up with, which was very beautiful, was that we should rehearse on stage, because the best music always took place in rehearsals.'[52] Similarly he had irritated Tavel by preventing any rehearsal for films, so that the take was in effect the rehearsal.

Warhol was many things. He was the revenge of graphics on fine art. He was the revenge of the 'swish' on the 'macho'.[53] He was the revenge of camp on high seriousness and of the underground on the overground. Perhaps, one might even say he was the revenge of the Ballets Russes on the Great Masculine Renunciation.[54] His legacy has passed to different hands in a number of different directions. The most obvious has been assimilated into mainstream postmodernism and simulationism. But the potential of the other dimension – the underground, the camp, the Velvets – is still available. It left its trace on punk and on the emergence of militantly gay art. In the last analysis, it may be, to borrow Walter Benjamin's categories, that he will be remembered not as the artist of the 'copy' but, more subversely, as the artist of 'distraction', whose Chelsea Girls rampage through the perverse aesthetic realms of the underground imagination.[55]

Notes

1. For discussion of the historic impact of Fordism on culture more generally see chapter 2.
2. For Joseph Beuys, see Joseph Beuys, *Ideas and Actions* (New York: Hirsch & Adler, 1988) and *Skulpturen und Objecte* (Berlin: Martin-Gropius-Bau, 1988).
3. For John Cage and his influence on Rauschenberg and others, see Calvin Tompkins, *The Bride and the Bachelors* (New York: Schirmer, 1981). See also Michael Nyman, *Experimental Music: Cage and beyond* (Harmondsworth: Penguin, 1976).
4. For COBRA, see chapter 4.
5. See John Cage's comments in the 'Madame Duchamp' section of *Andy Warhol*, a transcript of David Bailey's ATV documentary (London: Bailey Litchfield/Matthews Miller Dunbar, 1972).
6. For Rauschenberg in general, and the work he did with Johns for Bonwit Teller in particular, see Calvin Tomkins, *Off the Wall* (Garden City: Doubleday, 1980).
7. For Black Mountain, see Martin Duberman, *Black Mountain: an experiment in community* (New York: Dutton, 1972).
8. For Warhol and Rauschenberg see Emile De Antonio's comments in Patrick S. Smith, *Warhol: conversations about the artist* (Ann Arbor: UMI Research Press, 1988).
9. For Judson Church and New York bohemia in general, see Ronald Sukenick, *Down and In: life in the underground* (New York: Macmillan, 1988); Barbara Haskell, *Blam! The Explosion of Pop, Minimalism and Performance 1958–1964* (New York: Whitney Museum, 1984); and Sally Banes, *Terpsichore in Sneakers* (Middletown: Wesleyan, 1976) and *Democracy's Body: Judson Dance Theater, 1962–1964* (Ann Arbor: UMI Research Press, 1983).
10. 'Notes on "Camp"', in Susan Sontag, *Against Interpretation* (New York: Farrar, Strauss & Giroux, 1966), first published in 1964. For a modernist response, see Matei Calinescu, *Faces of Modernity: avant-garde, decadence, kitsch* (Bloomington: Indiana University Press, 1977).
11. See Walter Hopp's comment in Jean Stein and George Plimpton (eds), *Edie* (New York: Knopf, 1982): 'No chic, no chi-chi, no frills, no nothin'!' For Warhol's own comments, see Andy Warhol and Pat Hackett, *POPism: the Warhol 1960s* (New York: Harcourt Brace Jovanovich, 1980): 'It was exactly the kind of atmosphere I'd pay to get out of. . . . I tried to imagine myself in a bar striding over to, say, Roy Lichtenstein and asking him to "step outside" because I'd heard he'd insulted my soup cans. I mean, how corny '
12. For Warhol's commercial art, see Smith; Jesse Kornbluth, *Pre-pop Warhol* (New York: Random House, 1988); and Donna M. DeSalvo (ed.), *'Success Is A Job In New York'* (New York: Grey Art Gallery, 1989).
13. For De Antonio's impact on Warhol, see Emilio De Antonio, *Painters Painting* (New York: Abbeville, 1984), and Warhol and Hackett; Stein and Plimpton; and Smith. These three works remain the basic source material for Warhol's life.
14. See Yvonne Rainer, *Work 1961–1973* (Halifax: Nova Scotia College of Art and Design, 1974).
15. 'A Quasi Survey of some "Minimalist" Tendencies . . .' in Rainer, and reprinted in Gregory Battcock (ed.), *Minimal Art: a critical anthology* (New York: Dutton, 1968).
16. Rainer.
17. See Stefan Brecht, *Queer Theatre* (Frankfurt am Main: Suhrkamp, 1979), and 1960s numbers of *Film Culture*.
18. Warhol and Hackett.
19. See Richard Morphet's essay in R. Morphet (ed.), *Warhol* (London: Tate Gallery, 1971). In contrast, see Malanga's comments in Smith: 'This one he may have purposely decided to leave that corner blank. But, as far as this part here is concerned, we didn't know what was going to happen.'
20. According to Malanga: 'Andy even had his mother's penmanship – the script – made into Letrasets so that he would have instant lettering.'
21. Robin Murray, 'Life after Henry Ford', *Marxism Today*, October 1988.
22. Nathan Gluck remembers an early example of lack of quality control, in Kynaston McShine (ed.),

Andy Warhol: a retrospective (New York: Museum of Modern Art, 1989): 'If the drawing needed a caption, Mrs Warhola would painstakingly copy it out letter-by-letter, but sometimes she mistook one letter or another and would write *Marlyn Monore* for *Marilyn Monroe*, for example. Andy loved these errors.' See Benjamin Buchloh's essay in the same volume for other examples.

23. Murray.

24. Nathan Gluck remembers, in Smith: 'You know, at one time, when the movement first got started, he wanted to call his stuff "Commonist Painting".'

25. Isabel Eberstadt, in Stein and Plimpton.

26. See Alfred Carlton Walters, in Smith. For his fine art, Warhol used an old file of UPI photos he had acquired.

27. See Andy Warhol, *The Philosophy of Andy Warhol* (New York: Harcourt Brace Jovanovich, 1977).

28. G.R. Swanson, 'What is Pop Art?', *Artnews*, no. 62, November 1963.

29. Or more still of a *béance*: 'I always thought I'd like my own tombstone to be blank. No epitaph, no name. Well, actually, I'd like to say "figment".' In Andy Warhol, *America* (New York: Harper & Row, 1985). Compare Billy Linich: 'People would ask me what my name was and semifacetiously I would say my name is Name.'

30. Brigid Berlin, 'Factory Days', *Interview*, February 1989. See also Pat Hacket (ed.), *The Andy Warhol Diaries* (London: Simon & Schuster, 1989).

31. Andy Warhol, *Raid the Icebox* (Providence: Rhode Island School of Design, 1969).

32. For Warhol as a collector, see the five volumes of Sotheby's catalogue, *The Andy Warhol Collection* (New York: 1988). In his preface (printed in each volume) Fred Hughes observes that: 'Andy was an omnivorous observer and recorder of everything, and his collecting habits were, in some way, an extension of this.' He goes on to describe the difficulty he had in persuading Warhol to 'deaccession' some of his collection in order 'to upgrade it'. 'I have no doubt, however, that the disposal of even the smallest items would have been a long, hard struggle as Andy considered himself to be a natural bargain hunter, feeling that everything he bought should have increased in value thousands of times. He had strange anxieties that made him extravagant at times and really quite stingy [i.e. minimalist] at others.'

33. Cited by Irvin Blum in Smith.

34. This minimalist approach would be serialist when it was easier to put together prefabricated or pre-measured units, such as photo-booth portraits or reels of film, or when the production process could be mechanized, as with the silkscreens. See John Coplans, *Serial Imagery* (Pasadena: Pasadena Art Museum, 1968) for an early (and pretentious) attempt to deal with Warhol's serialism. Coplans's work has been superseded by Rosalind Krauss, *Grids: format and image in twentieth century art* (New York: Pace Gallery, 1978).

35. Warhol and Hackett.

36. Warhol, *Philosophy*.

37. In Smith. Fritzie Wood remembers Warhol asking, 'Do you think I dare go up to such-and-such theatre where he or she is playing, and ask if I could sketch. Would I dare? Would I dare?'

38. Warhol and Hackett.

39. Warhol, *Philosophy*.

40. In Kornbluth.

41. Andy Warhol, *a* (New York: Grove, 1968).

42. Edgar Morin, *The Stars* (New York: Grove, 1960). The frontispiece of this book consists of a repeated serial image of an advertising poster featuring Marlon Brando. Warhol collected both fan magazines and books about stars. His own involvement with star-making may have been modelled, I suspect, on David Bailey's success in creating stars. One of these, Jane Holzer, enthused: 'Bailey is fantastic . . . Bailey created four girls that summer [1963]. He created Jean Shrimpton, he created me, he created Angela Howard and Susan Murray. There's no photographer in America like that. Avedon hasn't done that for a girl, Penn hasn't, and Bailey created four girls in one summer.' (See 'The Girl of the Year' in Tom Wolfe, *The Kandy-Kolored Tangerine Flake Streamline Baby* (London: Cape, 1966). Warhol met

Bailey at a dinner party given by Jane Holzer, who became his own first superstar the next year, 1964, after her success modelling for Bailey. The word 'superstar', incidentally, occurs in Morin's *The Stars*, referring to Marilyn Monroe.

43. Warhol and Hackett.

44. Stephen Koch's *Stargazer* (New York: Praeger, 1973), remains the best book on Warhol's films. See also Jonas Mekas, *Movie Journal* (New York: Macmillan, 1973) for both comment and context. For Warhol's 'pre-film' interest in film, see also Charles Lisanby's account in Smith. He remembers how Warhol 'thought that the "Kodak" and all the dots and everything at the beginning or at the end of the leader . . . was as important as anything else [in his home movies]'.

45. For 'Baudelairean cinema', see Carel Rowe, *The Baudelairean Cinema* (Ann Arbor: UMI Research Press, 1982). This is a detailed and fascinating study of the underground cinema of the sixties, especially the work of Kenneth Anger, Ken Jacobs, Ron Rice, Jack Smith and Andy Warhol.

46. Cited in Rowe.

47. Cited in ibid.

48. There is a sense in which Warhol's fine-art phase was bracketed by the much more obviously gay affiliation of both his earlier work (personal and commercial) and by his subsequent film work. (Although there is a trace of camp and belle in Campbells!) On the gay sensibility in the earlier work, see Trevor Fairbrother's essay, 'Tomorrow's Man', in DeSalvo.

49. See Victor Bockris and Gerard Malanga, *Up-Tight: the Velvet Underground story* (London: Omnibus, 1983) for information on Warhol and the music scene. See also, for the Exploding Plastic Inevitable, Marshall McLuhan and Quentin Fiore, *The Medium is The Massage* (New York: Bantam, 1967).

50. See the accounts by George Plimpton and John Cage in Stein and Plimpton.

51. There is an obvious line of descent from the Velvets both to glam rock (one of Bowie's early songs is called 'Andy Warhol') and to punk.

52. Bockris and Malanga.

53. Cited in Warhol and Hackett. Warhol remembers asking De Antonio about why he was not accepted by artists of the previous generation. De replied: 'Okay, Andy, if you really want to hear it straight, I'll lay it out for you. You're too swish and that upsets them.'

54. See chapter 1. In this interpretation Warhol plays the part of a street Diaghilev.

55. Where, perhaps, they might just encounter William Burroughs's Wild Boys.

MORBID SYMPTOMS:
KOMAR & MELAMID

'The crisis consists precisely in the fact that the old is dying and the new cannot be born; in this interregnum a great variety of morbid symptoms appear.'[1] Gramsci's famous dictum, written in his prison notebook in 1931, today seems to describe two apparently quite different situations: the Soviet Union plunged into its long succession crisis, after the death of Stalin, now entering an unpredictable and chaotic new phase, and (in the West) the succession crisis of a dying modernism, whose 'great variety of morbid symptoms' have been given the provisional name of 'postmodernism'. The two are intimately linked, however, in the trajectory of Komar & Melamid, two Soviet artists formed in the post-Stalin epoch who arrived in New York just in time to find themselves potential postmodernists. In fact, their artistic careers are now more or less evenly divided in extent between the Soviet Union and the United States: they date their first collaborative work from 1965, when they were both students at the Stroganov Institute of Art and Design in Moscow; they left the Soviet Union twelve years later, in 1977, and (after a year in Israel) arrived in New York in 1978, just fourteen years ago.[2]

In the Soviet Union, modernism was brutally expunged by Stalin. However, it would be misleading the see the Soviet avant-garde of the 1920s as simply an extension of the Western avant-gardes of the same period. As I have argued elsewhere,[3] modernism must itself be seen in the context of cultural 'Americanism' (or its underlying substrate, Fordism). The emblematic imagery of the assembly line, the powerhouse, the chronometer and the robot all reflect this fascination. But the fantastic prospect of Americanism was naturally more pronounced the further a nation was, practically and historically, from its real possibility, the more recent its own industrialization. In England, home of the first industrial revolution, the avant-garde hardly existed. In France, alongside Le Corbusier and Léger, we find an anti-Fordist avant-garde led by Breton; in Germany, the expressionists were ousted from

their dominance prior to the First World War by the impact of the Fordist Bauhaus. In the Soviet Union, the avant-garde was the most militant of all, dominated by the imagery of construction, production, engineering, the machine and the factory, to the extent, in many cases, of abandoning art altogether for industrial design or publicity. This was the avant-garde of Mayakovsky, Tatlin, Vertov, Rodchenko and others, which Stalin so ruthlessly suppressed.

The irony, of course, was that Stalin was himself committed to his own brand of Fordism, as a model for the industrialization of the Soviet Union and his project of 'catching up with the West'. Indeed, he revered Henry Ford, invited his engineers, his management specialists and his architects to the Soviet Union, and commissioned them to build no less than 521 factories, beginning with a tractor plant in Stalingrad in 1930. This mammoth task of Fordization, led by Albert Kahn and his brother Moritz, lasted just over two years, concluding triumphantly in 1933 with the completion of the giant works at Cheliabinsk.[4] But Stalin was not interested in Americanizing art. Though he could make use of phrases defining artists as 'engineers of the human soul', he wanted a realist form of art, fully integrated with the ideological apparatus of the Communist Party. The trinity of 'Party, Ideology and People' was proclaimed, simply transposing the Tsarist model of 'Autocracy, Orthodoxy and Nation', just as the academic institutions, styles and shibboleths of absolutism were also revived.[5]

Thus, by a strange paradox, Stalin's project was to combine a Fordist industrial revolution in the base with a neo-tsarist cultural counter-revolution in the superstructure, freezing Soviet culture in the nineteenth century while trying to force Soviet industry into the twenty-first. This dual imperative of accelerating towards the future while reversing towards the past naturally caused havoc with the Soviet sense of history. Moreover, by a strange byproduct of this time-warp, modernism in its Soviet form (constructivism, futurism, etcetera) began to recede into the distant past until, by the end of the Stalinist period of super-industrialization, it had become little more than a memory, almost a phantasm. But because Stalinist industry was simply self-reproducing, building machines to build machines and factories to build factories, and also increasingly inefficient compared to its Western model, it failed completely to improve the quality of life of its labour force (or even, to any great extent, of its managing elite).[6] Consequently the Fordist and

futurist vision of the twenties avant-garde also appeared as mythic and even deluded, a kind of messianic utopianism.

After Stalin's death, there was a gallant attempt by some survivors to reconnect with the twenties. Ilya Ehrenburg, for instance, organized a Picasso exhibition and published his pointed and polemical memoirs. But this attempt to pick up the threads and begin again *da capo* could not dissolve the effect of the decades of intervening history, the experience of Stalisnism and the cultural impoverishment and dislocation it had caused. The years of the Thaw were marked by a cautious and prudent 'pluralization' of styles and approaches still under the rubric of 'socialist realism'. The field of permitted subject matter was 'bravely' expanded: 'One has only to recall what a stir [Plastov's] painting "Spring At The Bathhouse (The Old Village)" (1954) caused. The new pharisees were shocked by the nude motif.'[7] On the other hand, 'unofficial' artists began to experiment with expressionist, cubist and abstract styles, cautiously hopeful about reform as they began to surface publicly in the 1960s, even imagining the possibility of some future convergence with official art. These somewhat superficial hopes were crushed by the Soviet invasion of Czechoslovakia in 1968.

Komar & Melamid, along with Erik Bulatov and Ilya Kabakov, belong to the next artistic generation. More pessimistic about reform, the problem which faced them was how to relocate themselves within a non-convergent Soviet history, how best to extricate themselves from the false dilemma of a choice between official art and a dehistoricized neo-modernism. It was plain by then, after the post-1968 crackdown, that the prolonged succession crisis was much deeper than the reformist generation of the Thaw had imagined. It was necessary to move beyond Yevtushenko and Neizvestny, to confront the stabilized crisis in more radical terms, to re-engage with everyday life, which was equally remote both from the rhetoric of official art and from a neo-modernism irreparably robbed of its original utopian energy.

'We are children of sots-realism [Socialist Realism] and grandchildren of the avant-garde.'[8] Thus Komar & Melamid later encapsulated their heritage. They wanted to confront socialist realism, the art in which they had been trained and which still surrounded them, not as a mere style but as an all-embracing ideological presence, not merely high art but the pervasive public representation of the Soviet state itself, using, as their inheritance from the avant-garde, not the style of constructivism or suprematism, but the stance of rejection and refusal, of 'alienation'. Necessarily, this double acceptance and

rejection of socialist realism led them towards an art of contradiction, juxtaposition and irony. The same paradoxical juxtaposition exists in different ways in the art of Bulatov and Kabakov: the project of using a false language against itself, in seeking to expose its gaps and elisions, in probing its limits, making it transparent. To a Western eye, this often seems like parody, but if so, it is parody of a serious kind, 'making a virtue of necessity', as a Soviet friend of mine observed.

Though sots art was named after pop art (and sots realism) by Komar & Melamid in Moscow in 1972,[9] its significance is very different. Pop art in the West emerged from an encounter with consumerism, a recognition that the barrier erected between high and low art could no longer be maintained. The successful Fordist economies of the West were predicated not simply on mass production, but on mass consumption also, and artists increasingly lived in a visual environment dominated by the commodity and by commercial art. Soviet Fordism, or pseudo-Fordism (itself a gigantic parody) totally failed to develop a system of mass consumption. Instead, it delivered ideology, which filled the Soviet visual environment: political slogans, not advertising slogans; ideological emblems, not trademarks or logos; posters and banners, not billboards and ads; a cult of the party, not of the commodity. These two visual (and textual) systems are analogous only in a surface sense. In the Soviet Union there was no fundamental difference between high and low art: each was part of the same totalizing system. In contrast, pop art signalled the beginning of just such an integrated system, based on the generalized circulation of commodities and removing the barriers between commercial and fine art, whereas sots art was an attempt to subvert an already established system from within.

In fact, it was precisely the failure to deliver consumer goods that led to the crisis of the Soviet state. As Platonov put it in his novel *Kotlovan* (The Pit), as summarized by Komar & Melamid:

> The revolution was over and people decided to build a tall building in a field, a socialist palace, where happy people would live. They began to dig a pit for the foundation, for the future, but as the work progressed, more and more people wanted to live in this house and take part in the work. The builders understood each day that the building would have to be bigger and, consequently, the pit should be even bigger and deeper since the bigger the building the larger its foundation should be. Thus, day after day, they did not rise upwards with the floors, but dug down deeper, into the earth.[10]

The ideology of socialist realism continued to glorify the work and paint a picture of the future palace, but gradually the workers – and, of course, the overseers – came to realize that it was a fiction, that their leaders had no idea how to reach the future for which they were working and suffering.

The theme, or rather the climate, of post-utopianism pervades Soviet art today – the art, that is, of the post-1968 generation. The underlying mood of Komar & Melamid's work has always been elegiac. Their painting is full of ruins, of nostalgia, of memory, of a search for a usuable past. It is a painting suffused by a sense of entropy. From the start, the Russian intelligentsia was oriented towards the future, construed unproblematically as the elimination of the past. As Chaadaev, the founding figure of the Russian intelligentsia wrote:

> The past is no longer within our power, but the future depends on us. . . . I have a profound conviction the we have a vocation to solve a great many of the problems of social order, to bring about the fulfilment of a great many of the ideas which have taken their rise in societies of the past, and to give an answer to questions of great importance with which mankind is concerned.[11]

Awareness of Russia's 'backwardness' found its compensation in an intense commitment to an idealized future.

Chaadaev's vision of Russia's role was given substance by the advent of socialist ideas in Russia. Socialism became the favoured version of a Western-ized future for the Russian intelligentsia, numbers of whom, of course, eventually made the transition from populist socialism ('narodism') to Marx-ism. In fact, Marxism, just like modernism, became an ideology of 'catching up with the West', a tendency exacerbated after the failure of revolution in the West itself had left Russia isolated and alone. Lenin and the Bolsheviks had argued that a German revolution would validate their decision to 'force' history in backward Russia. Eventually, in the face of economic difficulties, Stalin would decide the force history even further and faster, desperately trying to close the gap between Russia and the West. As the Russian historian Gerschenkron has argued, the more belated the industrialization, the more virulent the ideology accompanying and facilitating it: Manchester liberalism in England, Saint-Simonian socialism in France, Listian nationalism in Germany, Marxism in Russia – a Marxism which, as Gerschenkron notes, cut itself adrift from Marx, ending up with the consolidation of Stalinism as 'the

highly hybrid ideological concoction that went under the misnomer of Marxism'.[12]

The Stalin regime showed no concern for the traditional democratic, egalitarian and proletarian values of socialism. It was a coercive top-down system, characterized by enormous pay differentials and ruthless exploitation of the peasantry and the working class. It destroyed the Bolshevik Party and tried to obliterate every vestige of an autonomous intelligentsia. As Gerschenkron points out, it was like a nightmarish parody of the regime of Peter the Great, the Westernizing tsar who instituted serfdom and consolidated absolutism in Russia. Thus it managed to combine a Westernizing zeal with a traditional Russian despotism. By many post-Stalinist Russian intellectuals, one dimension of this concoction has been singled out for attack and the contrasting one praised as its antidote. Thus, a resurgent nationalism and slavophilia has denounced Stalinism (and Leninism) as a poisoned fruit of the West, while a helter-skelter market liberalism calls for immediate, total Westernization and an end to 'Asiatic' statolatry and stagnation. The dislocation of any sense of a coherent history (aggravated by Stalinism's own claim itself to be the science of history!) has given tragedy a desperate gloss of comedy.

In 1973, Komar & Melamid painted a large group portrait, *Meeting Between Solzhenitsyn and Böll at Rostropovich's Country House*. Komar comments:

> You see, we have included in this painting everything that liberals in Moscow love, all you need for a good bourgeois life — a bowl of grapes, nice crystal glasses, a lemon with the peel hanging over the edge of the table. Like Dutch still-life painting of the seventeenth century. Most important we have done everything in a different style — Cezanne's style, Cubism, Futurism. We painted Böll's left leg in the style of Russian icons.[13]

There is also a socialist realist heavy red curtain with a tassel and, over Solzhenitsyn's head, the sly suggestion of a pre-Petrine halo of gold mosaic. The painting presents an omnibus version of the paradoxically confused ideology of the Russian intelligentsia: the Stalinist remnant overhanging them, the fantasy of the plethora of the West, the echoes of a glorious national and sacred religious past. It combines two strategies that run throughout Komar & Melamid's career: the mixture of discordant styles and the mismatching of style to subject matter.

Two years after this group portrait, in 1975, they painted a new series

called *Scenes from the Future*, in which architectural masterpieces of American modernism are depicted in ruins, using styles of the eighteenth and nineteenth century. Thus, Wright's Guggenheim Museum, a tree growing up from the courtyard over the broken outer wall, is painted as a lonely ruin in a pastiche of Hubert Robert, an artist collected by Catherine the Great. With nostalgic irony the West, in all its modernity, is inscribed into the pre-Romantic, eighteenth-century vision of antiquity favoured during the heydey of Russian absolutism. In a similar gesture conflating modernity with antiquity, they painted damaged and time-worn versions of a Warhol soup can painting and a Lichtenstein comic strip painting, as though they were now stained and aged enough to be included in a Soviet museum as ancient artefacts. Thus American pop art itself was Russified by being seen retrospectively, in the remote past, rather than projected into an imaginary Westernized future.[14]

A little later in the same year, Komar & Melamid painted a multi-panel *History of the USSR*, fifty-eight feet long (one for each year since October). For this work, they used a modernist abstract style, in which each choice of colour, form and brushwork reflected the events and political climate of the appropiate period. Abstraction was thus harnessed to history painting and to allegory. This attempt to reclaim abstract painting by historicizing it was not simply another play with styles. On the contrary, it was part of a re-engagement with history painting, which demanded the development not of a single 'correct' style but of an experimental range of styles, each permitting a different mode of historical interpretation. The obsessive repainting of history to preserve it and to destroy it necessarily led Komar & Melamid to eclecticism, and hence to pastiche, to an 'Alexandrian' art of stromata and the cento.[15] But this protean nature of their work in Russia predates their encounter with the turn of the West towards postmodernism. It reflects a very different background and a very different purpose. As Komar & Melamid shifted between abstract history painting, sots art and even the invention and fabrication of work by imaginary painters of the Russian past, this was not a symptom of the end of modernism, but a sign of their engagement with the massive task of creating a new art from the rubble left behind by Stalinism.

When they arrived in New York, they remained Russian painters, although their new environment forced them to revise their imaginary expectations of the West and consequently their understanding of its art. Emigration has been a frequent fate for Russian artists in this century:

consider Kandinsky, Chagall, Larionov, Goncharova, Sonia Terk Delaunay, the Ballets Russes, Stravinsky, etcetera, etcetera. Indeed, without this emigration, Western art itself would hardly have been the same. It was the Russian artists of La Ruche and the Rotonde who provided the foot soldiers for the avant-garde, while Diaghilev became its most flamboyant impresario.[16] But, once again, we cannot expect to find a continuity between these two emigrations, pre-and post-Stalinist. In the interim the distinct histories of Russia and the West veered sharply apart and the two could not easily be bridged. The seventies emigration occurred in circumstances very different from those of the twenties.

The problem that New York posed for Komar & Melamid was how to escape the omnivorous maw of postmodernism. Their experience of the Manhattan art world sharpened their distrust of modernism, which had become the official art of the United States. But – as I interpret it – the divorce of modernism from its role as an avant-garde, which was a precondition for its triumph, also led to its rapid dissolution. From the sixties on, it no longer functioned as a heroic quest, in the way in which Greenberg had programmed and promoted it. Instead, it disintegrated into a competing plethora of neo-styles and mini improvements feeding off the heroic past. After the turbulence of the 1968 period, when there was a limited secession of artists from the dealer–museum system, there was a rapid institutionalization of the new phase of modernism, under the rubric of 'postmodernism'.[17] This development had some positive aspects – the new pluralism permitted a revival of figurative painting, for instance – but its impetus still remained intrinsically formalist and reflexive. Postmodernism was to be defined as 'art about art', not in the modernist sense of ontological self-examination and research, the testing and probing of the foundations of painting, but in the new sense of citation, translation, 'deconstruction' and neoclassicism.

The strategies Komar & Melamid brought with them could easily be assimilated into the conceptual field of postmodernism. Their use of pastiche and parody, their doctrine of 'anarchic eclecticism', their diaristic polyptychs could all be glossed as signs of the new postmodern variant, albeit one with an exotic 'Russian' feeling for kitsch. Strangely enough, the most serious of artists, in the Russian tradition of the intelligentsia, began to seem less than serious seen through the remorselessly frivolous spectacles of the Manhattan art world! For Komar & Melamid, socialist realism might be kitsch but it was kitsch that carried the wight of fifty years of Russian history, and its

reworking can hardly be dismissed superficially as comedy.[18] New York's absorption in the 'flux of temporal values', as Perry Anderson put it, in the insatiable search for the new, 'defined simply as what comes later',[19] ran completely counter to the fundamentally historical nature of their project.

In 1988, Komar & Melamid finally made a decisive move away from the 'nostalgic socialist realism' and transplanted sots art that had dominated the first decade of their stay in New York. They began to work in Bayonne, New Jersey, on a project based at the Bergen Point Brass Foundry, a small factory dating from the 1890s. Bayonne is an industrial town, the terminus for the Standard Oil (now Exxon) pipeline. The first refinery was built in 1875 and Bayonne is still dominated by massive tank farms, oil and chemical installations, and tanker berths. As the 1939 Works Progress Administration guide put it, 'pollution from gasoline products, at first generally dumped into the bay, spoiled swimming and fishing'.[20] Last year, despite clean-up measures, there was a massive oil spill in the channel that separates Bayonne from Staten Island. The WPA thumbnail history of the town principally records spectacular fires and desperate strikes 'that left a heavy toll of dead and wounded among the employees'. The town is tightly packed on a narrow peninsula with water on three sides. It is filled with saloons, churches, garden shrines and discount stores ('Rock Bottom', 'Price Tag'). Culturally conservative and isolated from New York it still retains the feeling of 'a workingman's city, and its localized industries are attuned to this basic fact; so also are its recreations and its civic life'. In a word, Bayonne epitomizes the rust-belt.

It was precisely these qualities that attracted Komar & Melamid to Bayonne. They compare their exodus to Bayonne to the movement of painters from Paris to Barbizon in the forest of Fontainebleau. Starting in 1847, in conjunction with the first Salon Independant, democratic artists began to move out of Paris, rent rooms around the village of Barbizon and set up studios in barns. Theodore Rousseau ('Le Grand Refusé'), the instigator of the move, was joined by other artists, the best known of whom was J.-F. Millet, who lived there until his death twenty-seven years later. Daumier visited and is remembered holding forth 'in Rabelaisian vein'.[21] The exodus was, of course, in protest against the Salon, the Institute and the Academy, against the corrupt atmosphere of the capital. It is ironic that Komar & Melamid should have first turned their thoughts to New Jersey out of admiration for its garish sunsets, diffracted through the corrupt atmosphere of the industrial,

rather than rural, hinterland, and set out there in search of spiritually clean air.

William Empson began his classic *Some Versions of Pastoral* with a chapter on 'Proletarian Literature', seeing there a yearning for a lost dignity, beauty and pathos.[22] Here, perhaps, is the connection between Bayonne and Barbizon, between the foundryworkers of New Jersey and the peasants celebrated by Millet. This is a complex 'rust-belt pastoralism' which also, of course, contains an element of nostalgia for Russia. In their pen-portrait of Bayonne, Komar & Melamid comment on the sound of vesper bells (doubtless from the church of St Peter and St Paul) and the 'bittersweet aroma' of wormwood, bringing back memories from their Moscow childhood. These are the same elements that appear in their autobiography of the fictional peasant painter Nikolai Buchumov (Buslaevsk, Penza, 1929; Moscow, 1973): 'I only remember the sharp odor of wormwood, its smell mixed up with something sweet and good.'[23] Compare the 'elusive fragrance of wormwood' which now 'rises up to mingle with the bouquet of chemical emissions' (Bayonne, 1989).[24] Plainly this is a version of pastoralism enriched by personal nostalgia but also, perhaps for that very reason, corroded by irony. Yet, at some level, the black foundryworkers of Bayonne echo the muzhik proletarians of Russia, liberated from slavery and serfdom only to enter the heat and glare of the furnace.

There is a curious similarity between Komar & Melamid's description of the Bergen Point Foundry – 'While the slanting rays of the sun slice randomly through the lamp-like building, the workers, clad in protective helmets, gloves and aprons reaching down to the floor, move about the foundry fire as if in some ritual dance, pouring out the liquid sun and fashioning it for human needs: drainage faucets, pipes, sewer valves'[25] – and Empson's evocation of the Spanish workers he watched 'tread out sherry grapes and squeeze out the skins afterwards, which involves dance steps with a complicated rhythm. I said what was obvious, that this was like the Russian ballet, and . . . [they] showed us the other dance step used in a neighbouring district; both ways were pleasant in themselves and the efficient way to get the maximum juice'.[26] Empson's pastoral through English eyes, though, is straight, whereas Komar & Melamid undercut theirs with a final note of irony. Yet, not only irony: it is also an invocation, once again, of decay, effluence, entropy.

It is interesting to compare Komar & Melamid's Bayonne work with Robert Smithson's New Jersey pieces: *The Monuments of Passaic* (1967) and the

Nonsite 'Line of Wreckage', Bayonne, New Jersey (1968).[27] Smithson was born and raised in New Jersey. He saw Passaic, his birthplace, as existing 'without a rational past and without the "big events" of history. Oh, maybe there are a few statues, a legend, and a couple of curios, but no past – just what passes for the future. A Utopia minus a bottom, a place where the machines are idle, and the sun has turned to glass.' It was a place full of 'the memory-traces of an abandoned set of futures'. For *Nonsite 'Line of Wreckage'*, Smithson took pieces of asphalt-coated concrete rubble from a landfill near an old ships' graveyard, where the hulks are still rotting today. This same landfill is now covered with wormwood: 'Ah, wormwood, eternal grass of industrial dumps!'[28] The same year Smithson observed, '. . . the more I think about steel itself, devoid of the technological refinements, the more rust becomes the fundamental property of steel. . . . In the technological mind rust evokes a fear of disuse, inactivity, entropy and ruin. Why steel is valued over rust is a technological value, not an artistic one'.[29] Like Smithson, Komar & Melamid transported industrial debris into the gallery to make a *Bayonne Rock Garden*. In subsequent paintings, for a church in Jersey City, they painted on rusted steel, rather than canvas, leaving sheets of metal out in the rain till they acquired the desired reddish-yellow coating.

Yet, despite all these parallels, there are differences between Smithson and Komar & Melamid. Not only does their work contain human beings – portraits of the foundryworkers, studies of heads and hands – but it is oriented more to the sublime than to the picturesque. Komar & Melamid's vision of Bayonne has a melancholy grandeur; it is bathed in the glow of furnace and sunset. The furnace is the forge of Hephaistos and Vulcan. The art-historical echoes are of *An Iron Forge* by Wright of Derby or of J.M.W. Turner's *The Limekiln at Coalbrookdale*.[30] Smithson, in contrast, saw himself as a revivalist of the picturesque, mediated to him through Olmsted (who is said to have designed the public park in Bayonne), a picturesque that would heal the wounds inflicted on nature, restoring 'the democratic dialectic between the sylvan and the industrial',[31] the terror exorcized.

As you drive through the tank farms of Bayonne, you can see the dialectic of rust and paint: the rust breaking through the paint to form patterns 'like a Clyfford Styll', then being painted over again by the agents of modernity, ever vigilant in their battle against entropy. Ruins are the monuments of human failure. This endless process of degeneration, this struggle of art against time, is a constant preoccupation. Komar & Melamid write: 'Restorers commit

crimes. Artists mixed transparent colors with varnish, then a restorer will remove the varnish and take the color with it. . . . They don't just remove paint. They paint in a new style. Absolutely. They invent an image of the past, a contemporary image'.[32] Indefatigable entropy is found also in the movement of human history, in the attempt of utopianism to abolish the past, to live instantly in the future. Both Western modernism and Russian Stalinism were projects that demanded a denial of the past, a constant movement towards an ideal future. But the past cannot be denied. Like the repressed it always returns, and when it is foreclosed (as Lacan noted) it returns in the form of madness.[33]

It is against this sombre background, that Komar & Melamid's penchant for parody and irony should be seen. It is a device, a way of combating the sense of tragedy. They quote Kierkegaard: 'In irony, the subject is negatively free, free from the shackles which in reality restrain him so firmly.' Irony provides a provisional release from tragedy. At the same time it eats away at rhetoric, hypocrisy and idealization. It corrodes myths, old and new. In his brilliant and path-breaking assay from the late fifties, 'On Socialist Realism', Sinyavsky wrote that 'iron is the laughter of the superfluous man who derides both himself and everything sacred in this world. . . . Irony is the faithful companion of unbelief and doubt; it vanishes as soon as there appears a faith that does not tolerate sacrilege'[34] — whether, it might be added, that faith is in Stalinism, Old Russia or 'free market' Westernization. Irony may provide only a 'negative freedom', yet this peculiarly 'accursed' Russian irony, this 'disorder of the soul', as Blok put it in 1907,[35] is still the only passage out from an epoch of half-measures and half-truths, from a present mortgaged to an imaginary future and a future dragged back by the weight of the past. There are no new miracles or new truths to be spun out of new dreams and new delusions. It is better to start the future over with the wormwood and the rust.

Notes

1. Antonio Gramsci, *Prison Notebooks* (London: Lawrence & Wishart, 1971).
2. For an account of Komar & Melamid's career, see Carter Ratcliff, *Komar & Melamid* (New York: Abbeville Press, 1988). Melvyn B. Nathanson (ed.), *Komar/Melamid, Two Soviet Dissident Artists* (Carbondale: Southern Illinois University, 1979) provides a detailed treatment of their early Soviet work.
3. See chapter 2.
4. See W. Hawkins Ferry, *The Legacy of Albert Kahn* (Detroit: Wayne State University, 1970).
5. John Bowlt, 'The Stalin Style: the first phase of socialist realism', in *Sots Art* (New York: New Museum

of Contemporary Art, 1986). See also John Bowlt, 'Socialist Realism Then and Now', in *Russian Art 1875–1975* (Austin: University of Texas, 1976).

6. On the Soviet economy, see Alexander Gerschenkron, *Economic Backwardness in Historical Perspective* (Cambridge, Mass.: Harvard University, 1966), and *Europe in the Russian Mirror* (Cambridge, Mass.: Harvard University, 1970). For a general survey, see Alec Nove, *An Economic History of the USSR* (Harmondsworth: Penguin, 1969, new edition 1989).

7. Quotation from Vladislav Zimenko, *The Humanism of Art*, (Moscow: Progress Publishers, 1976).

8. Komar & Melamid, *Death Poems* (Amsterdam: Galerie Barbara Farber, 1988).

9. For Komar & Melamid's early work see Melvin B. Nathanson (ed.), *Komar/Melamid* (Carbondale: University of Southern Illinois, 1979), and Margaret Tupitsyn, 'Sots Art: the Russian deconstructive force' in Bowlt, *Sots Art*.

10. Komar & Melamid, *Death Poems*.

11. Chaadaev cited in Nicolas Berdyaev, *The Russian Idea* (New York: Macmillan, 1948).

12. Gerschenkron, *Russian Mirror*.

13. Komar, cited in Carter Radcliff.

14. These two works formed part of a 'trilogy' whose third component was a series of sketches of Red Army soldiers in historic Western tourist spots: Paris, Florence, etcetera.

15. See Komar & Melamid, *Death Poems*: 'The chief work of Clement of Alexandria is "The Stromata" ("Rag Rugs"). The philosophy of the "stromata" is the compilation of brightly-colored patches and scraps coming from something that was once a whole, forming a colorful mosaic depicting something new, that is virtually an esthetic type of thinking. In the culture of later antiquity "centos" were widespread – word mosaics ("rugs") depicting the events of Christian history through verses selected from various works of ancient authors. Christian temples were built using the maximum amount of elements and blocks from ancient temples.' Komar & Melamid's use of patchwork recalls Salman Rushdie's statements in his recent essay, 'In Good Faith', published in *Newsweek*, 12 February 1990: '*The Satanic Verses* . . . rejoices in mongrelisation and fears the absolutism of the Pure. Melange, hotch-potch, a bit of this and a bit of that is how newness enters the world.'

16. See Kenneth E. Silver and Romy Golan (eds,), *The Circle of Montparnasse* (New York: Universe Books, 1985), and Lynn Garafola, *Diaghilev's Ballets Russes* (New York: Oxford University Press, 1989).

17. See Komar & Melamid, *Death Poems*: 'If modernism can be compared to an intellectual adventure, the discovery of new lands, then post-modernism reminds one of tourism.'

18. See Peter Wollen, 'Painting History' in *Komar & Melamid* (Edinburgh: Fruitmarket Gallery, 1985).

19. Perry Anderson, 'Modernity and Revolution', in *New Left Review*, no. 144 (March–April 1984).

20. Federal Writers Project of the Works Progress Administration for the State of New Jersey, *New Jersey* (New York: Hastings House, 1939).

21. See John Sillevis, 'The Barbizon School', in John Sillevis and Hans Kraan (eds.), *The Barbizon School* (The Hague: Haags Gemeentemuseum, 1985) and Jean Bouret, *The Barbizon School and Nineteenth Century French Landscape Painting*, (Greenwich: New York Graphic Society, 1973), which cites Alfred Sensier on Daumier's visit to Barbizon.

22. William Empson, *Some Versions of Pastoral*, (Norfolk: New Directions, n.d.).

23. Carter Ratcliff.

24. Komar & Melamid, 'We ♥ New Jersey' in *Artforum*, April 1989.

25. Komar & Melamid, 'We ♥ New Jersey'.

26. Empson.

27. See Robert Hobbs, *Robert Smithson: sculpture* (Ithaca: Cornell University Press, 1981). Smithson's own writings are collected in Robert Smithson, *The Writings of Robert Smithson* (New York: New York University, 1979). See especially 'The Monuments of Passaic' first published in *Artforum*, December 1967 and 'Frederick Law Olmsted and the Dialectical Landscape', first published in *Artforum*, February 1973. I am grateful to John Welchman for drawing my attention to these texts.

28. Komar & Melamid, 'We ♥ New Jersey',

29. 'A Sedimentation of the Mind: earth projects', in Smithson.

30. See Francis D. Klingender, *Art and the Industrial Revolution* (Chatham: Evelyn, Adams and Mackay, 1947).

31. Smithson, 'Frederick Law Olmsted'.

32. Carter Ratcliff.

33. The French psychoanalyst Jacques Lacan used the term 'foreclosure' in order to pinpoint the difference between neurosis and psychosis. Whereas neurosis derives from repression, from the transfer of symbolic value and meaning from a repressed memory, displacing it into a symptom, psychosis (such as paranoia or schizophrenia) derives from a fundamental failure to symbolize, which leaves a yawning gap in the fabric of language and memory. While it is dangerous to draw analogies between individual and social pathology, it seems plain that Soviet culture suffers from a general disturbance of the collective memory, from agonizing cultural gaps and voids.

34. 'Abram Tertz' [Andrei Sinyavsky], *The Trial Begins* and *On Socialist Realism* (Berkeley: University of California, 1960).

35. Blok's *Irony* (1908) is cited in Sinyavsky.

INTO THE FUTURE: TOURISM, LANGUAGE AND ART

The infrastructure of contemporary tourism was created on foundations built in the imperial nineteenth century by Thomas Cook. But in the decades since the 1960s new developments in the transportation and information industries made possible an unprecedented worldwide expansion: the passenger jet with upgraded airport and hotel facilities, the computerized booking and ticketing system, etcetera. At the same time, the expanded leisure time and disposable income of both the managerial and the working classes in the tourist-exporting countries of Europe and North America produced a new demand for vacation travel. Tourism began to spread in vast waves out from the core countries to the peripheries. Although the new international tourist trade was still much smaller in volume than tourist movement within and between the core countries themselves, it none the less had a major impact on the rest of the world. From the traditional 'pleasure peripheries' of the core countries (French Riviera, Costa Brava, California, Florida), it next began to transform the Mediterranean and Caribbean basins, and areas of East Asia. It made a particular impact on small island economies and societies and on a small group of tourist-oriented countries (Morocco, Tunisia, Kenya, Mexico, Thailand). Eventually it began to penetrate the most remote areas of the globe. The world became 'smaller' and 'denser' than ever before.[1]

The effects of tourism have not been as horrifically catastrophic as those of slavery and colonialism, but they have been perhaps as ubiquitous and often as pervasive. We are moving inexorably into a new epoch of global culture contact, in which the art of the post-colonial world will be shaped not only by its own internal dynamic but also through its interface with immigration and tourism. Art, in particular, has developed a special relationship with tourism as its artisanal base has been reshaped as a department of the souvenir industry. Tourists mainly consume services and non-durables, such as food, drink, drugs, beauty aids, etcetera. But they also take souvenirs home with

them, and in most countries crafts have been created or adapted to meet the new opportunities. In the periphery, this new art market, which is, of course, a hard currency market, is typically stronger than the 'soft' internal art market. Generally speaking, art was restricted to specific ritual or social situations outside the commodity economy and it is the tourist art market that has provided a model for the commercialization of art and thus produced a new institutional, professional and technical infrastructure. Tourism — the movement of consumers — is the inverse of immigration — the movement of producers.[2] Both are mediated by the international flow of capital, as we can see from the similarities between EPZs (Export Processing Zones) and ITZs (Integrated Tourist Zones). Both are intrinsic to the emerging new world system, and both will affect world art.[3]

As we look back over the twentieth century from our present post-colonial vantage point and try to understand the ways in which massive culture contact has shaped the history of art, both in the core and in the periphery, we can see three main phases, which themselves correspond to phases in core–periphery relations: colonialism, anti-colonialism, and post-colonialism (though with some lags and leads). The first of these was marked by the ethnographic plunder of Third World artefacts by anthropologists and museums, and the subsequent appropriation of these artefacts for 'hybridized' use by avant-garde artists as a resource in their overthrow of nineteenth-century academicism. Here, the emblematic moments were Picasso's visits to the Trocadero ethnographic collection in Paris and the painting of the *Demoiselles d'Avignon*.[4] The second of these phases was characterized by the bold attempt of a group of artists from Mexico (*los tres grandes*: Rivera, Siqueiros, Orozco) after the Mexican Revolution to create a pan-American art in which the southern (Hispanic and Indian) periphery would be hegemonic, rather than the Eurocentric north. Ultimately this project faltered and fell. Its emblematic moment was the destruction of Diego Rivera's mural in the Rockefeller Center, New York.[5] This, in turn, led to a revival of the first phase on a new basis. Eventually, after the dismantling of the old colonial empires and the exhaustion and crisis of modernism itself, we entered a third phase, marked by what we might call the global development of 'para-tourist' art, alongside and as an alternative to the postmodernism of the core.[6] Here a crucial moment was the installation of the exhibition Magiciens de la Terre in Paris in 1989 which — whatever the intentions of its organizers — gave us an unprecedented

opportunity to see a range of art from many different cultures and settings across the whole world, including but not limited to the Western art world.[7]

The first phase, cubism and alongside it expressionism, drew from African and Pacific carvings and masks a new formal and compositional system that challenged the norms of Renaissance perspective and proportion, a new morphology and a new syntax, so to speak. On another level, European cultures obsessed with tracing their own origins, in search of national self-validation, were confronted by the collapse of the archaic into the contemporary, in a dizzy telescoping of time. Here the 'primitivism' of early modernism should be seen in relation to the work of Frazer and Freud, the anthropology of the Classical and the archeology of the mind. In time, cubism divided itself into two main currents: surrealism and constructivism. The first of these redefined Western borrowing from the periphery in both explicitly psycho-analytic and in directly political terms. Breton's endorsement of cubism and his fascination with Third World art cannot be separated from his political reading of Freud or his political support for Abd-el-Krim in the Riff War and for many subsequent anti-colonial struggles, up to and including that of the FLN in Algeria. For Breton, the march of instrumental, repressive reason was central to exploitation and oppression both at home and abroad, and the art of the colonized peoples, together with elements of the Gothic and symbolist traditions, offered an alternative model and a site of resistance. Breton's concept of Third World art was often abstract and romantic, but it could feed directly into the art of periphery itself, as it did in Cuba, Haiti and the Arab world, for instance. Surrealism appropriated the art of the colonized in the name of freedom and revolt.[8]

The rival current, that of constructivism, developed cubism into the art of instrumental reason, set firmly in the Western tradition of mathematical rationality and technological progress, an artistic expression of militant Fordism. Yet, even within the ambit of constructivism one non-European element was admitted: American jazz. Constructivism was closely linked to the Americanism that swept through Europe in the twenties, the so-called Jazz Age.[9] Jazz was perceived as both stereotypically primitive and ultra-modern, machine-like. As Le Corbusier put it, with shameless projection, in his essay 'The Spirit of the Machine, and Negroes in the USA': 'The popularity of tap-dancers shows that the old rhythmic instinct of the virgin African forest has learned the lesson of the machine and that in America the rigor of exactitude is a pleasure' – and the jazz orchestra in Harlem 'is the equivalent of

a beautiful turbine' playing a music that echoes 'the pounding of machines in factories'(!).[10] Loos struck a similar note in his eulogy of Josephine Baker. In this racist vision, black America was taken to be a fascinating synthesis of the 'primitive' and the 'futuristic', the body and the machine.

The second phase is in marked contrast to the first. Its triumphal accomplishment was the painting by Diego Rivera of the Ford River Rouge factory, which covers all four walls of the central courtyard of the Detroit Institute of Art, in the heartland of American industrial capital. The great achievement of Rivera, and the artists of the Mexican Renaissance in general, was to change, provisionally, the relationship between metropolis and periphery. Rivera's aim was to create not only a national art for Mexico, within Mexico, but a pan-American art, with hegemonic aspirations over the United States itself. He wanted to set the agenda on both sides of the border. Hence the importance he gave first to his Californian murals, then – more ambitious still – to his commission in Detroit. The roots of the Mexican Renaissance were in the nationalism released by the revolution, but the goals became international: Rivera, Orozco and Siqueiros all went north and made a lasting impact in the USA.

Rivera's strategy in Detroit was to find an artistic form that would transcend a series of antinomies and contrasts: those of modernity with authenticity (a recurrent problem for nationalist culture), of North with South, of proletariat with peasantry, and of avant-gardism in art with local, popular traditions. In a sense, these antinomies overlapped. Rivera associated the United States, the North, with modernity and the industrial working class – and Mexico, the South, with the land, the authenticity and the Indian peasantry. For the two to be combined into a unity, a form of art was needed that would be both advanced and traditional, both international (even universal) and local. He drew his conceptual model of hybridity and the graft from the agricultural experiments of Luther Burbank, whom he visited in California and painted into two of his San Francisco murals.[11]

The central images of this graft in the Detroit murals are those of the gigantic stamping press (for the fenders of the car) and the spindle machines for reaming the valve ports in the V8 engine block. These dominant machine forms are deliberately made to resemble the great statue of the god Coatlicue, from Tenochtitlan and the rows of statue pillars at the Toltec ruin of Tula. Rivera wanted to combine two apparently opposed forms of plastic beauty. As he put it, 'the steel industry itself has tremendous plastic beauty . . . as

beautiful as the early Aztec or Mayan sculptures'.[12] Rivera associated Marxism with the progress of science and technology and Fordist industrial production, and nationalism with the tradition of Indian culture, which had survived from pre-Columbian times, surfacing irrepressibly in new popular forms, breaking through the veneer of Catholicism and European beaux-arts culture that he detested.

It is important to stress Rivera's role because the Mexican Renaissance is the one recent Third World art movement that has had a significant impact on the metropolis. It is worth noting, perhaps, that the influence came mainly through California. It was in California that Rivera got his first North American commissions and where he first met William Valentiner, curator of the Detroit Institute and art expert of the Ford family, through a shared fascination with the tennis star Helen Wills Moody. It was from California that Edward Weston visited Mexico and returned with the precisionist aesthetic that later fed into Charles Sheeler's photographs of the River Rouge plant in Detroit. And it was two Los Angeles art students, Jackson Pollock and Philip Guston, who brought the strongest and most specific Mexican influence into United States art of the thirties and forties. Guston himself made the pilgrimage to Mexico and even painted a mural there. Pollock was steeped in the muralist tradition, revering Orozco, following Rivera's work, studying with Thomas Hart Benton (the nearest American counterpart to the Mexicans) and then, crucially, working with Siqueiros during his exile in New York.[13]

Indeed, I think the Mexican influence on Pollock has been almost cynically understressed: not only on the move out of easel painting, but on Pollock's own cross-cultural interest in Native American art, in combination with his quest for modernity (and the use of industrial paint he took from Siqueiros). The great difference between the two, finally, was in the turn to abstraction, which followed Pollock's encounter with surrealism, itself made possible in the aftermath of the Trotsky–Breton–Rivera meetings and manifesto. Thus Rivera's general project of an American art, absorbing European tradition selectively without being derivative, was finally carried out by Pollock. The crucial cost of this, of course, was its depoliticization. The political dimension of both Mexican muralism and European surrealism was excised to produce a purified North American modernism.

But today, half a century later, we are in the shrinking world of trans-national capital, telecommunications and mass tourism. We live in a different

epoch. Not only is this a post-colonial era, in which most Third World countries have already acquired their own post-colonial history and even their own repression of history, but it is also a postmodern era, in which the artistic modernism initiated by Picasso, and Americanized by Pollock, finally entered into crisis. Plainly, the nature of culture contact, both in general economic and political terms but also in artistic terms, has also changed drastically. This does not mean that it has diminished. In most respects, it has intensified, but the modes of contact have changed, as have both metropolitan and peripheral cultures themselves. Indeed, the great works of the Mexican muralists have themselves become tourist attractions. Post-1945 Mexican artists, from the generation of the Ruptura onwards, have felt compelled to question the idea of an unproblematic *Mexicanidad*, itself now seen as mythic and folkloric in a problematic sense.[14]

Two shifts in the nature of culture contact have clearly affected the arts. The first is the end of the privileged position held by ethnographers. Ethnographers traditionally formed part of the apparatus of colonial rule, alongside traders, administrators and missionaries. Although their discipline gradually broke free from this compromised position (and, indeed, in France the influence of surrealism, from Leiris to Lévi-Strauss, contributed to this), it was none the less ethnographers who largely established the image of Third World art from which metropolitan artists drew. It was ethnographers who stuffed the museums full of artefacts and wrote both popular and scholarly accounts of them. It was from classic ethnography that Western culture acquired the idea of archaic, ceremonial societies, repositories for the phantasmatic construction of otherness and purity. While such societies indeed existed, ethnographers tended to minimize the reality of culture contact (of which, indeed, they themselves were a significant part). This pose is no longer possible.[15]

Second, in the Third World countries themselves, art forms developed that were themselves a response to contact. The most important of these was tourist art. Tourist art, of course, has existed as long as there have been trading contacts, going back centuries. For instance, the Haida people, Northwest Coast Native Americans living in the Queen Charlotte Islands, developed an original form of tourist art, argillite sculpture, within a few decades of the first contacts in the eighteenth century (with Captain Cook), during the period of the fur trade.[16] But the great shift from 'authentic' or 'tribal' art to 'tourist' art as the main focus for contact with the West took

place in the past forty years. In very disparate places all over the world, artists began to produce for an organized craft-centre, hotel and export trade, a trade that was a significant money-earner in many countries. Co-ops, workshops and wholesaling and marketing institutions were set up. Eventually the shift takes place from tourist to para-tourist art, to forms that may draw from tourist art but also go beyond it into new areas of originality and complexity. Often, this shift can even be traced bak to the efforts of a single *animateur*, who may be Western, often an artist who encouraged more ambitious production, both in scale and in quality control. This was the story, for instance, in the settlement of Papunya, in central Australia, after Geoff Bardon arrived there in 1971 and the acrylic movement got underway;[17] or in Port Harrison in Baffin Land, where James Houston, after 1948, encouraged Inuit soapstone sculpture and set up trading arrangements with the Hudson's Bay Company.[18] Similarly, Frank McEwen, in Salisbury, now Harare, encouraged local sculptors and sold their work at the shop of the Rhodesian National Gallery.[19]

The collapse or erosion of the institutions of traditional art created a vacuum which was first filled by the opportunistic structures of tourist art. But some of the artists were then able to use the *animateurs* as resources to expand the ambition, complexity and scope of their work. The makers of this new para-tourist art themselves have to find a new institutional support system, which will be ambiguously enabling and exploiting. The balance between exploitation and enablement will depend on the political and economic dynamics of each specific situation. In many ways, this development of para-tourist art from tourist art can be compared to the development of expanded pidgin or creole languages. In a pioneering article, Paula Ben-Amos compared the basic forms of tourist art to pidgin languages, similarly despised by linguists and scholars, but now at last being revalued.[20] Tourist art, like pidgin, reduces and simplifies, striving for intelligibility to an alien target group of foreigners, and, like pidgin, it uses makeshift means of expression around a central core of universal features. Today we can see pidgins, not as ignorant garbling, but as innovative adaptations, signs of an ability to create structures of communication in the most unpromising situations. This is all the more true of creoles, which in emergency situations develop out of pidgins to form complete new vernacular languages. In other cases, there is a more gradual process of borrowing and merging, as pidgins, old vernaculars and emergent creoles coexist and interact.[21]

We can find a similar kind of complex relationship between urban vernacular, tourist art and para-tourist gallery art. For instance, the three run parallel in the work of the Neo-Figuratist painters of Lusaka in Zambia (many of them exiles from Zaire) described by Jules-Rosette in her book *The Messages of Tourist Art*.[22] These painters formed a self-conscious circle working and meeting together, around the Zairean painter Diouf Kabamba, who had set up a studio in a Lusaka shantytown. Diouf, who had exhibited and travelled in North America and Europe, and taught at the beaux-arts academy in Kinshasa, had left Zaire in 1974, unhappy at artistic and political censorship. In the circle, he taught new techniques (such as the use of the palette knife), provided a philosophy of art, and organized exhibitions in local hotels. In fact, he was both an artist and an *animateur*. Diouf encouraged artistic 'code-switching' among the group. He himself painted gallery art under his own name, and tourist paintings to make money under the name Muntu. The output of the group ranged all the way from urban vernacular through tourist art for foreigners and the local elite (black velvet paintings), through to para-tourist gallery art, and even to shows in Europe. The urban vernacular paintings seem to have fallen into two main genres that could be sold to the African working class: *mami wata* paintings of mermaids, and scenes of modern, industrial monuments such as the Kariba Dam. Similarly, across the border in Zaire, in Shaba province, local artists painted both mermaids and the copper smelter at Kolwezi. These artists also painted their colonial and pre-colonial history in the Colonie Belge and Things Past genres. Tshibumba Kanda-Matulu produced a series of Things Past paintings depicting key events from the life of President Lumumba, for instance. Both in Shaba and in Zambia, the same painters also worked in the more tourist-oriented Things Ancestral genre, switching from one genre and one market to another.[23]

In other contexts, tourist art has produced its own internal breakthroughs. Jules-Rosette describes the emergence of 'art-stars' among the Kamba tourist artists of Kenya, and in Tanzania a whole new genre emerged among the Makonde tourist art carvers. Originally they produced typical 'local colour' motifs, working for European or Asian middlemen and curio dealers. But some time in the 1950s the first Shetani carvings were produced in Dar es Salaam, according to legend, by Samaki, who offered his patron, the curio dealer and *animateur* M. Peera, 'a grotesque figure of a kind never seen before. In contrast to what might have happened in other curio workshops the piece was not rejected. Customers in the art shop seemed to find it attractive and

more carvings of strange spirit objects were created in the shed.' It is from this background of Shetani/Satanic tourist art that John Fundi (born in the Makonde lands in Mozambique, now living in Tanzania) emerged as an 'art-star' in his own right.[24]

Most of the examples I have given come from Africa, but the phenomenon of a syncretistic para-tourist art can be seen in many areas worldwide: in the Arctic, in Haiti, in Bali, or in Australia. Indeed, the site-specific *Yam Dreaming*, which was one of the centrepieces of the Magicians show, and which seemed perhaps to be a traditional work, was in reality another example of para-tourist art, inflected by 'roots revivalism'. The most active participant in this collective work was Paddy Jupurrarla Nelson who comes from Yuendumu. Acrylic painting of Dreamings started there in earnest only in the early 1980s, on the model of Papunya and with the help of Western art advisers. originally, this painting was done by women, who still make up 70 per cent of the Yuendumu artists. When the men saw that the women were able to buy a four-wheel-drive truck with the funds that they had accumulated from painting, they joined in too. Jupurrula Nelson was one of this group, and was also involved in the School Doors project, organized by the local school's new headmaster. Another Westerner took snapshots of the doors to Canberra and as a result the artists were asked to reproduce the paintings on canvas (for a fee of two Toyotas).[25]

Another example of apparently traditional work that in fact has a tourist art background is the well-known mural work of the Ndebele artist Esther Mahlangu (from South Africa), who paints homes with ceremonial designs. Traditional Ndebele house painting was monochromatic, and as with the Aboriginal painting, it was transformed by the introduction of modern acrylic polymers. Gavin Younge, in his *Art of the South African Townships* writes that 'there is clear evidence that official patronage after 1953, when the government promoted tours to a "Ndebele Village", led to a more general acceptance of modern paints'.[26] Moreover, many Ndebele house paintings are much less purist than those featured in the West, and incorporate contemporary motifs such as airplanes, light bulbs or telegraph poles, just as Balinese temple sculptures show motorcycles, armed bandits performing hold-ups and Dutchmen drinking beer. In fact, the South African townships, as illustrated in Younge's book, have a rich urban vernacular tradition, which has thrown up a number of idiosyncratic and innovative artists.

In Bali, a culture with a long and rich traditional heritage, we find the

development of a self-sustaining and economically successful para-tourist art. After the Dutch invasion of Bali in 1906 and the subjugation of the Balinese kingdom of Gianyar, it was only a matter of time before tourists began to arrive and, after the introduction of a steamship line from Surabaya, Bali became an elite tourist destination. In the 1930s artists appeared among the tourists and three of them, Rudolf Bonnet, Walter Spies and Miguel Covarrubias (from Mexico) had a decisive influence on the course of Balinese plastic arts.[27] They encouraged the production of art for tourists, feeling that otherwise, deprived of royal and court sponsorship, crafts would soon die out. As a result, a new generation of Balinese carvers and painters began to work, often in new materials, with new subject matter and with marked personal styles, breaking with the formulaic tradition of the past. A co-op was eventually set up, with exhibitions selected by two European and two Balinese artists, and after the Second World War it was revived in the wholly Balinese form of the Ubud Painters Group. An art museum was opened in Ubud, containing works by early pioneers of the new para-tourist mode, founded by Ida Bagus Nyana. It is of especial interest to note than through Covarrubias there was a Mexican influence on Balinese art, due to his role as an *animateur*.

Even explicitly religious and sacred art is inflected by the vernacular and can be highly syncretistic. Thus voodoo or voodoo-related art, the voodoo continuum, ranges from African examples using polychrome naturalistic sculpture (by Aghagli Kossi, for instance, in Togo, who also does tourist art on commission), through the work of Maestre Didi in Brazil, or the site-specific *vévés* or thrones of Haitian artists, through to works alluding to voodoo from within a Western art tradition. Here we see complex progressions: from updated traditional forms, through the syncretistic modes of diaspora voodoo in America (themselves either revivalist or innovative) to art springing from the rich discourse of voodoo in the core and alluding, like that of the Catalan artist Miralda, to the origin of voodoo objects and apparatus in the West itself as manufactured goods.[28] (These objects, 'objets trouvés' for Miralda, were gathered in the voodoo stores of the second Haitian diaspora, north to the cities of the United States – and thence taken back across the Atlantic to Barcelona, port of origin for Columbus, thus closing a circuit.)

It is important to stress that Third World so-called traditional cultures vary enormously in their nature, ranging from the massive, resilient cultures of many Asian countries, through the syncretistic cultures of Latin America and the creolized post-slavery cultures of the Southern United States, the

Caribbean and Brazil, to the multifarious African cultures which were not exposed to the West till much more recently. In the transformation of traditional to syncretistic cultures, both the nature of the original indigenous culture and also, of course, the nature and history of Western domination and culture contact are crucial factors, producing different responses and results. The relative and absolute weight of tourism (and offshore investment) varies from country to country. The age of cities is also an important factor and, with urbanization, the development of local print media, especially for the emergence of new vernacular forms. Thus, already in the 1920s, Rivera was able to refer to a long tradition of popular caricature and print-making, culminating in the work of Posada. The same tradition is still at work in Mexico in the papier-mâché figures of the Linares family. Not only have they developed the making of folk Judases (*judios*) into personal visions of their own demons (*alebrijos*), but they also continue to draw on the Posada tradition, as in the topical figure groups they made after the catastrophic Mexico City earthquake.[29]

It is instructive, also, to compare the Mexican experience with that of Ireland. Each country had its revolution about the same time (though the Irish revolution was, of course, specifically anti-colonial) and each was a dependent country adjacent to a powerful and intrusive metropolitan neighbour. There were also some major differences: the Irish Renaissance came mainly before and the Mexican Renaissance after the revolution, and the Irish Renaissance was centred on literature and drama, the Mexican on visual art and, to a lesser extent, music. But these differences are themselves of interest. Nationalism has always been attentive to problems of language, and in Ireland writers were divided between a range of strategies.[30] At the extremes were the two options we have already encountered, archaism (in the form of the Gaelic Revival, led by Douglas Hyde and Padraig Pearse) and assimilation – both in an Anglicized form (Wilde or Shaw) and in a 'roots revivalism' form (Yeats). Besides these options we also find writers using popular forms, both peasant dialect (Synge) and urban vernacular speech (O'Casey).[31] Then there was Joyce, who moved from the hybrid styles and registers of *Ulysses* to the cosmopolitan linguistic hybridity of *Finnegans Wake*, an expanded, distorted and polyglottally relexified mixture of literary and 'Irish' English.[32] Finally, we should not forget Beckett, in the next generation of exiles, who chose to write in French and translate his own work into English, as though it were a second language.

We find a similar range of strategies if we look at Jewish culture of the same

period, also developing its own models of resistance and nationalism. Once again there is the polarization between archaism (Hebrew as a literary and ultimately vernacular language) and assimilation (which could take an 'ultra' form, as with Karl Kraus, or be more complex and 'roots revivalist' in attitude, as with Svevo, Babel, or Kafka). Assimilation also was divided between a liberal–national outlook and a Marxist–international outlook, of which Rosa Luxemburg is a fascinating example. Again, there was the option of using the Yiddish vernacular, rescuing it from its despised role as jargon, a kind of 'broken German' or semi-pidgin, and revalidating it as a national literary language. This trend reached its peak at the Yiddish Language Conference, held at Czernowicz in then-Austrian Bukovina in 1908, but foundered on the differences between 'pure' Yiddishists and the more 'political' Bundists and others, who though they supported the idea of a new diaspora culture, saw Yiddish primarily in instrumental terms.[33] Finally, there was the utopian and cosmopolitan solution of Esperanto, developed by Zamenhof as a result of his experience in multilingual and ethnically divided Bialystok. 'The population consisted of four diverse elements: Russians, Poles, Germans and Jews; each spoke a different language and was hostile to the other elements . . . this was always a great torment to my infant mind . . . and I kept telling myself that when I was grown-up I would certainly destroy this evil.'[34] The first Esperanto Congress was held in Boulogne, France, in 1905. (Perhaps it is worth adding that Bloom in *Ulysses*, one year earlier, is already interested in Esperanto.)

Creole languages have also developed their own literature, proof of their creativity and vitality. They are the most striking of the many possible responses to cultural catastrophe. Arising out of the ruins of culture and communication, they draw from both substrate languages (typically, those of the slaves or the plantation workers) and superstrate (the language of the slave trader) to build a new and original creole language. The reduced forms of pidgin or 'foreigner talk', makeshift second languages, are expanded into the new first language, built around a common core of universal features. Of course, it is hazardous to draw an analogy between literature and the visual arts, as Jules-Rosette points out in her critique of Ben Amos's 'pidginization' theory of tourist art. None the less, I think at least a 'weak' analogy can be drawn. Catastrophic contact with Western culture leads at first to the reduced 'tourist art' forms typical of pidgin and then, drawing on both surviving indigenous elements and on the foreign target culture, artists can begin to

expand the formal language and produce new and innovative work. It is clear, too, that the literary strategies I have outlined, developed both by Irish and Jewish writers, correspond in many respects to strategies adopted elsewhere in the visual arts. Creolization, archaism, assimilation and the use and development of the vernacular run in parallel, despite the different semiotic modes involved.

Indeed, there is an unexpected and ironic precedent for programmatic expansion after a period of catastrophic culture shock and subsequent linguistic simplification and borrowing. It has been argued that the English language itself, the language of empire, went through a process akin to creolization. Anglo-Saxon society and its language underwent a massive culture shock after the Norman Conquest, leading to the shift from Anglo-Saxon to Middle English, which is marked by many of the features of a creole language: relexification from the Norman-French target language of the dominant cultural group, and reduction of the syntax and vocabulary of the indigenous language.[35] Thus Anglo-Saxon lost its verb and noun inflections and simplified its syntax. Then in the Renaissance period, the language was re-expanded, through literary innovation and through a programmatic relexification. In fact, this expansion of vocabulary was a subject of debate between different factions: 'roots revivalists' like Spenser, going back to the Anglo-Saxon; assimilationists, the 'inkhorn writers', who wanted to borrow from the culturally more prestigious Romance languages, and supporters of an immanent enrichment of the vernacular itself by compounding and combination.[36] The end result, of course, was Modern English (though significantly this still retains class distinction in the relative use of Romance and Anglo-Saxon words).[37]

Perhaps we can imagine para-tourist art in Third World countries taking a similar trajectory. The Zairois painter Diouf put the problem succinctly:

> You see, the problem for us – the artists – is to situate ourselves in our era, not to want to do as our ancestors have done, not to want to do as the Europeans have done. Here in Africa there was no painting. There were perhaps three colours. You can't speak of modern painting at that time. All the materials come from abroad. Now, despite the fact that we only know that from abroad, we must seek to be *new*.

And about the problem of being new: 'Granted, it's the Europeans who buy our art. But we don't produce for the Europeans. We want our own people to

understand what we produce. But that's a delicate problem.'[38] A strategy of avoiding both archaism and assimilation, of creating an original visual language is dependent not only on the development of para-tourist art, but also on the growth of a new indigenous visual culture: urban rather than rural, composite rather than pure.

But such a culture has already developed throughout large areas of the periphery, where urban vernacular and para-tourist forms begin to merge, bringing increasingly complex and innovative blends of different cultural elements. Consider, for instance, the artistic career of the Nigerian painter and musician Twins Seven Seven. Twins first came into contact with painting at an arts summer school, run by a resident European painter, held in the northern Yoruba town of Oshogbo, in Nigeria. The summer school itself had a fascinating history. In 1969, Wole Soyinka and a group of African writers set up the Mbari club in Ibadan, with a press, a gallery and a stage for plays. The same year, a Yoruba composer, Duro Ladipo, wrote an Easter Cantata for performance in his local church, for which he had previously composed hymns and other incidental music. But the church elders refused to let it be performed because they objected to the composer's use of drums in the piece. This led to a local controversy and a European *animateur* living in Oshogbo, Ulli Beier, arranged a series of performances of the cantata with Ladipo, outside the church, culminating with one in the Mbari club. Ladipo was inspired by the club to build a similar one in Oshogbo, in his father's compound there, converting it for performance and exhibition, and writing his own first play launch it. The new club thrived and eventually a programme of summer schools was set up for the local public.[39]

Twins Seven Seven, who first wandered into the club when he was a dancer for a travelling medicine show, rapidly became successful as a painter (through Westerners who made the pilgrimage to Oshogbo). He also continued to work as a performer, however, and used the money earned from painting to subsidize a new career as a band-leader, playing Afro-beat on the model of Fela Kuti. In the meteoric and diversified career of Twins Seven Seven we can see the emergence of an idiosyncratic art-star from a hybrid matrix of traditional culture, urban vernacular culture and upmarket tourist art. It is not surprising, also, that Twins should gravitate towards the music world, which is the most visible and vibrant arena for this new, hybrid urban culture. All over Africa new musical forms have grown up – soukous in Zaire, highlife in Ghana, rai in Algeria – themselves drawing on the creolized music

of post-slavery America: jazz, rumba, merengue, calypso. In this sense, Twins is the art equivalent of his musician compatriot Fela Kuti, just as the urban vernacular painter Cheri Samba calls to mind his fellow-Zairois the musician Papa Wemba. Just as Cheri Samba uses the creolized Kinshasa lingua franca, Lingala, in the texts written on his paintings, often switching in mid-sentence into French, so Papa Wemba speaks his own hybrid argot, Hindu-bill, a code-switching street language, as he plays his electro version of soukous in his Paris designer clothes.[40]

The Third World is changing rapidly in many different ways. The notion of a 'Third World' was always a portmanteau concept into which many radically different types of society and culture were crammed, and as the relations between the core and the periphery change and a new world system begins to emerge, it will open up yet new fields of difference. Cultures within the peripheries will change at different rates and in different directions. We can be sure, however, that these changes will take place along the triple axes of migration, urbanization and culture contact. The choice between an authentic nationalism and a homogenizing modernity will become more and more outmoded. Questions of cultural identity, both in the core and the peripheries, become more complex as we begin to understand that there is no single model of a hybrid or composite culture, but many different possibilities. One advantage of the linguistic paradigms − creole, vernacular, Esperanto, etcetera − is that they can provide us with a precise sense of the range of options available. Salman Rushdie recently wrote eloquently of his wish to celebrate 'hybridity, impurity, intermingling, the transformation that comes of new and unexpected combinations of human beings, cultures, ideas, politics, movies, songs'.[41] If the vision of a creolized para-tourist art is one possible outcome of such an intermingling, it will take many different forms, inflected by different types and pressures of culture contact, by different patterns of tourism, by different matrices of the vernacular and the migrant. But we are entitled to hope that in the visual arts, as elsewhere, we are entering an epoch in which invention and regeneration will come from the periphery, free from the self-obsession of the increasingly provincial culture of the metropolis.

The redistribution of core and periphery throughout the world will have a decentralizing effect, at least for a transitional period. The industrial metropolis has become increasingly divided between North America, Western Europe and East Asia. The old 'socialist camp' has fragmented. The Third

World has produced its own regional cores and peripheries as uneven development has promoted some areas and demoted others. At the same time, while ruling elites in the Third World become drawn ever more organically into the hegemonic system of word trade and investment, so large sections of the population in the metropolis, often ethnic minorities, are peripheralized and virtually excluded from the system. Within this new format of world capitalism, capital itself becomes increasingly fluid and mobile. The metropolis agglomerates into new competing superstates while the margins shatter under the stress of national and ethnic rivalries. The world is full of multinational companies, global agencies and affluent world travellers at the same time as it sees national diasporas, desperate waves of refugees and unstable patterns of migrant labour. In this context, the crisis of Fordism has not only thrown modernism into crisis, it has globalized the crisis. The pattern of global cultural flows and exchanges is changing rapidly in ways that go beyond a simple process of contamination, on the one hand, and predation, on the other.

Modernism saw itself self-consciously as the culmination of the long history of Western culture. Yet, against the grain, it always contained currents that challenged the norms of Western culture: in Orientalism, in surrealism, in *Mexicanidad* and so on. These currents were systematically assimilated into the Western tradition, with their most dangerous residues dismissed or expelled, under the banner of purism, but they served also to create the elements of a counter-tradition, which implicitly challenged the ruling norms. The time has come now to look back critically over the history of modernism and to pick up those threads which run counter to its orthodoxy. Within the West, debate over the crisis of modernism has been displaced on to a provincial debate about 'postmodernism': a strange, eclectic brew which appears in many different forms. Plainly, this dominant trope of 'postmodernism', which first surfaced at the beginning of the seventies, expresses the confusion caused by the simultaneous and persistent crisis of Fordism in the economy and of high modernism in the arts. Yet the discourse of postmodernism, even more than that of modernism, has been stiflingly Eurocentric.

Indeed, the very term 'postmodern' reveals the extent to which the new trends that first became widely noted in the early seventies were linked to the great twentieth-century movements of modernism, which had finally triumphed only in the period after the Second World War, only a few decades before, and which had arguably reached their finale (or perhaps their curtain

call) in 1968. It was then, after all, that the last upsurge of avant-gardism began to give way to ideas of 'trans-avantgardism' and the last minimalist and conceptualist tremors of the modern turned out to presage the imminent advent of the postmodern, as Beuys gave way to Clemente or Kiefer and Warhol was followed by Sherman and Basquiat. But was everything really so very different? Charles Jencks carefully and correctly distinguished between 'late modernism' and 'postmodernism'. But postmodernism too could be seen, not so much as a complete rejection or replacement of modernism, but rather as a belated surfacing of subordinate aspects of modernism that had always been there. They had simply been written out of the orthodox version. And, to adapt Jencks's own phrase, was not architectural postmodernism mainly 'modernism plus cosmetics'?[42] So many years ago Loos had declared ornament a crime and now the cosmeticians and embroiderers and tattooists were finally having their revenge as they stuck their pastel neon or their Chippendale curlicues or their brutalist storm fencing, according to taste, on to perfectly legible modern buildings. Jencks called this 'double coding', but to what extent had modernism ever really been a single monosemic code?

The modern movement was always a battlefield on which purists endlessly struggled to expel difference, excess, hybridity and polysemy from their brave new world. Even the masters themselves had terrible lapses from their supposed purism. Adolf Loos's design for the *Chicago Tribune* competition, a high point in the history of modernism, consisted of an enormous fluted Doric column on a pedestal. And what about his zebra-striped fantasy concoction for Josephine Baker, to be built around a two-storey swimming pool with glass walls, for guests in the salon to enjoy the spectacle of their hostess swimming underwater?[43] The pioneer of American modernism, Raymond Hood, designed refrigerator sales buildings to look exactly like refrigerators[44] ('ducks' as Robert Venturi notoriously dubbed these mimetic follies, like the Tail o' the Pup hotdog-shaped hotdog stand in Los Angeles or other such roadside attractions). Frank Lloyd Wright built his own kind of 'duck' at Wingspread, just outside Racine, where his Johnson's Wax Building prefigures the weird fairyland of the Marin County Courthouse. And even Le Corbusier used openly symbolic elements in his designs for the new city of Chandigarh. Of course, these could always be dismissed as *jeux d'esprit* or marginalia, eccentric deviations from the straight and narrow path that led to the magisterial concrete and glass blocks and towers these architects really believed in.

This book originally began as an inquiry into postmodernism, but as I thought more about it, it became increasingly clear that it was impossible to understand the concept of postmodernism without first investigating afresh the history of modernism itself. Indeed, as I began to think further about modernism, I began to realize how deeply its development was inflected from the beginning by quarrels and debates which concerned, not issues of aesthetics alone, but social issues and political strategies. The School of Paris developed in a maelstrom of discussion about what properly characterized French culture, just as abstract expressionism emerged within a long history of argument about what an American art should look like. Moreover, these were not simply arguments about heritage, they were also arguments about the role of art, particularly in relation to the development of mass production which made this, in Henry Luce's famous term, 'the American Century'.[45] By now we are used to the idea that nineteenth-century culture developed in relation to the Industrial Revolution, in relation to the rise of manufacturing industry. But the twentieth century had its own industrial revolution – if Manchester was the capital of the nineteenth century, then Detroit was the capital of the twentieth. The revolution inaugurated by Henry Ford in Detroit led to the great American leap forward of the 1920s, followed by a crisis of underconsumption, the Great Crash and the subsequent Depression. After the Second World War, a restructured Fordism now proceeded in tandem with Keynesian policies of full employment, high wage levels and state welfare provision, which provided a stable market for the new expansion in production, a Golden Age for the countries of the developed North.

It was this long period of post-1945 Fordism that eventually went into crisis in the early seventies. In the legend of postmodernism the crisis was emblematically captured by the blowing-up of the Pruitt-Igoe housing complex in St Louis. As Charles Jencks put it:

Happily we can date the death of modern architecture to a precise moment in time. Modern Architecture dies in St Louis, Missouri, on July 15, 1972 at 3.32 p.m. (or thereabouts) when the infamous Pruitt-Igoe scheme, or rather several of its slab blocks were given the final *coup de grâce* by dynamite.[46]

Thus the failed modernism of inner-city decay and welfare was dispatched, to be replaced by the new up-scale postmodernism of enterprise zones and debt-financed corporate towers. Canary Wharf replaced Pruitt-Igoe, as post-Fordism replaced Fordism. With hindsight, we can see that an attentive

consideration of pop art might have led critics to anticipate what was to come. Following right in the wake of the critique of Fordist consumerism by Vance Packard and others, pop art was both a celebration of the American Century and a nostalgic elegy for it. Pop art was fundamentally a celebration of teenage years lived in a Golden Age, at a time when that epoch was showing its first signs of crisis. Indeed Warhol's career, to take the most notorious example, straddles the watershed in a revealing way: pop-ism and underground movies up to 1972, society portraits and cable TV thereafter. With critics too, we can see the shift in the work of Barthes or McLuhan (or their epigone, Baudrillard) from the modernist critique of consumerism represented by *Mythologies* or *The Mechanical Bride*[47] to the postmodern celebration of the consumerist ('writerly') text and the redefinition of the sign as a pure mechanism of credit (a kind of semiotic Eurodollar) or the rapturous vision of a fully media-integrated globe and a disembodied terrestrial nervous system.

At the same time, both Barthes and McLuhan emerged from a modernist environment and, interestingly enough, both found a source of their own thought in Joyce's *Finnegans Wake*, celebrating respectively its textual non-linearity and pluralism (Barthes) and its pluralism and non-linearity (McLuhan). Postmodernism, not surprisingly, developed by bringing together in a new way many of the strands of modernism, just as modernism itself had its precursors in the nineteenth century. The long history of modernism and postmodernism, began, I would argue, with Champfleury and his 1869 volume of popular prints, *Histoire de l'imagerie populaire*. Champfleury had written about popular prints long before, in 1854, and the print of the Wandering Jew on which his friend Courbet based his *The Meeting* (1856) is the same one that Champfleury later used as his frontispiece. Next, of course, came the Japanese prints with their influence on Manet and Degas and Lautrec, then the Russian *lubki*, with their impact in Larionov, Goncharova and Malevich, then Mexican catchpenny prints, which were an inspiration for Orozco, Rivera and Siqueiros.[48] Picasso, of course, followed American newspaper comics and Matisse revered the cheap Japanese woodblocks (*crepons*) he bought from booksellers' stalls by the banks of the Seine.[49] From the beginning, modernism developed out of the circulation of images from low to high and periphery to core and, by doing so, challenged the aesthetic hierarchies of the *anciens régimes*. On this subversive and unstable base an aesthetic of rationalism and functionalism was later superimposed, after the collapse of the *anciens régimes* precipitated by the First World War. Artists and

art theorists rallied to a utopian dream of a new society modelled on the exemplary modernity of new American technology and new Fordist industrial organization. But the circulation of images and discourses was never completely blocked and with the collapse of high modernism, it simply re-emerged.

Since Champfleury, at least, this discursive circulation has been the acknowledged or unacknowledged constant of modern art. It is important to stress that this circulation has always been a two-way process, and yet the two contrary flows have been customarily treated in very different ways. On the one hand, the flow from low to high and from periphery to core has been discussed in terms of appropriation and innovation, while the opposite flow has been seen as vulgarization and its end product has been dismissed as kitsch. In this perspective, the argument against tourist art simply recapitulates the argument against kitsch, seen now in terms of global mass consumption rather than of the effects of mass production within the core. Again the flow from core to periphery and its appropriation by artists on the periphery is nothing new. The rich nineteenth-century tradition of Haida soapstone carving developed directly because of the new market of sailors and travellers, who began to visit the Northwest Coast for trade or for tourism.[50] At the same time, Qajar painting in Iran developed as a complex synthesis of traditional Persian with imported Frankish forms.[51] Spanish baroque was appropriated by indigenous artists in Mexico, and increasingly complex forms emerged (as we can see, for instance, in the work of Frida Kahlo and, more recently, artists on both sides of the Mexican–United States frontier). Indeed this new baroque once again is beginning to redefine Americanness, in a complex composite of differential times and cultures.[52]

As the world economy becomes increasingly globalized and core and periphery are redistributed across old boundaries, this process can only accelerate and become more elaborate. The old barriers between 'Western' art and 'Third World' art (once known, symptomatically, as 'primitive' art) will dissolve even further – in both directions. Thus artists as diverse as Jean-Michel Basquiat or Audrey Flack or Francisco Clemente or Cheri Samba can be seen not in simple terms of identity and difference but as part of a dynamic system of aesthetic circulation. Modernism is being succeeded not by a totalizing Western postmodernism but by a hybrid new aesthetic in which the new corporate forms of communication and display will be constantly confronted by new vernacular forms of invention and expression. Creativity

always comes from beneath, it always finds an unexpected and indirect path forward and it always makes use of what it can scavenge by night.

Notes

1. For the history and economics of tourism, see Francois Vellas, *Économie et politique du tourisme international* (Paris: Economica, 1985) and Pierre Aisner and Christine Pluss, *La Rue vers la soleil* (Paris: L'Harmattan, 1983). Louis Turner and John Ash, *The Golden Hordes* (London: Constable, 1975) introduced the term 'the pleasure periphery' and remains an indispensable source. Dean MacCannell, *The Tourist* (New York: Schocken, 1976, and with a new introduction, 1989) provides a vivid cultural analysis.
2. See Saskia Sassen's outstanding *The Mobility of Labour and Capital* (Cambridge: Cambridge University Press, 1988) for a theoretical and empirical account of labour mobility.
3. For the concept of 'world system', see Immanuel Wallerstein, *The Modern World-System II* (New York: Academic Press, 1979). In her *Before European Hegemony* (New York: Oxford University Press, 1989), Janet Abu-Lughod provides a model of the pre-Eurocentric thirteenth-century world system and speculates that the current epoch is one in which the restructuring of the twentieth-century world system (that of the 'American Century') may lead to rapid and even chaotic shifts in core–periphery relations.
4. See William Rubin (ed.), *Primitivism in Twentieth Century Art* (New York: Museum of Modern Art, 2 vols., 1984), especially Rubin's own essay 'Picasso'. For a critique of Rubin, see James Clifford, *The Predicament of Culture* (Cambridge, Mass.: Harvard University Press, 1988).
5. See chapter 2 and especially Laurence P. Hurlburt, *The Mexican Muralists in the United States* (Albuquerque: University of New Mexico, 1989), which contains an extensive bibliography. Jean Charlot, *The Mexican Mural Renaissance* (New Haven: Yale University, 1963) remains an indispensable introduction. See also Rivera's *Portrait of America* (New York: Covici, Friede, 1934) and Irene Herner de Larrea (ed.), *Diego Rivera: paraiso perdido en Rockefeller Center* (Mexico City: Edicupes, 1986) for detailed documentation of the Rockefeller Center scandal. Jose Clemente Orozco's *The Artist in New York* (Austin: University of Texas, 1974) leaves a moving impression of his attitude to the United States.
6. I am grateful to participants at a seminar at Harvard University for suggesting the term 'para-tourist' to me, after I read an earlier version of this chapter there.
7. See *Magiciens de la Terre* (Paris: Editions du Centre Pompidou, 1989). The exhibition was curated by Jean-Hubert Martin, with Mark Francis, and Aline Luque and Andre Magnin. Work by 100 artists was exhibited, coming from more than forty countries. About half came from Latin America, Africa and Asia, depending on how you count, and there were several indigenous North American and Australian artists. The catalogue contains essays by the curators, as well as others. The exhibition was copiously reviewed.
8. The impact of surrealism in the Caribbean and Latin America is well documented, but little has yet been written in English on the important Arab movement.
9. Christine Lodder, *Russian Constructivism* (New Haven, Conn.: Yale University Press, 1983), should be read in conjunction with S. Frederick Starr, *Red & Hot* (New York: Oxford University Press, 1983).
10. Le Corbusier, *When the Cathedrals Were White* (New York: Reyanal & Hitchcock, 1947).
11. For Rivera in Detroit, see *Diego Rivera: a retrospective* (New York: Detroit Institute of the Arts with W.W. Norton, 1986). This catalogue contains both an essay on the Detroit murals and a full bibliography.
12. Diego Rivera, 'Dynamic Detroit – An Interpretation', *Creative Art*, vol. 12, no. 4 (April 1933). For Rivera's writings, see the edition collected by Xavier Moyssn, *Textos de arte* (Mexico DF: Universidad nacional autonoma de Mexico, 1986).

13. See chapter 3. The true story of Pollock's and Guston's involvement with the Mexican muralists still has to be pieced together from a variety of sources.

14. *Ruptura* (Mexico DF: Museo de Arte Carrillo Gil, 1988).

15. James Clifford, *The Predicament of Culture* (Cambridge, Mass.: Harvard University Press, 1988).

16. Victoria Wyatt, *Shapes of their Thoughts* (New Haven, Conn.: Peabody Museum of Natural History, Yale University Press; and Norman: University of Oklahoma Press, 1984).

17. Peter Sutton (ed.), *Dreamings: the art of Aboriginal Australia* (New York: George Braziller, 1988).

18. See the writings of Nelson Graburn for the history of Inuit carving.

19. Ulli Beier, *Contemporary Art in Africa* (New York: Praeger, 1968). See also Jane Cousins, 'The Making of Zimbabwean Sculpture' in *Third Text*, no. 13 (winter 1991).

20. Paula Ben-Amos, 'Pidgin Languages and Tourist Arts', in *Studies in the Anthropology of Visual Communication*, vol. 4, no. 2 (winter 1977) (Washington DC: The Society for the Anthropology of Visual Communication).

21. Suzanne Romaine, *Pidgin and Creole Languages* (London: Longman, 1988); John Holm, *Pidgin and Creoles* (2 vols.) (Cambridge: Cambridge University Press, 1988); Loreto Todd, *Pidgins and Creoles* (London: Routledge & Kegan Paul, 1974).

22. Benetta Jules-Rosette, *The Messages of Tourist Art* (New York: Plenum, 1984); Nelson Graburn (ed.), *Ethnic and Tourist Arts* (Berkeley: University of California Press, 1985).

23. Guy Brett, *Through Our Own Eyes* (London: GMP, 1986); Ilona Szombati-Fabian and Johannes Fabian, 'Art History and Society: popular painting in Shaba, Zaire', *Studies in the Anthropology of Visual Communication*, vol.3, no.1 (1976).

24. J. Anthony Stout, *Modern Makonde Sculpture* (Nairobi: Kibo Art Gallery Publications, 1966); John Korn, *Modern Makonde Art* (London: Hamlyn, 1974).

25. Warlukurlangu Artists, *Kuruwatti/Yuendumu Doors* (Canberra: Australian Institute of Aboriginal Studies, n.d.).

26. Gavin Younge, *Art of the South African Townships* (New York: Rizzoli, 1988).

27. Fred and Margaret Eiseman, *Woodcarvings of Bali* (Berkeley: Periplus, 1988); Miguel Covarrubias, *Island of Bali* (New York: Knopf, 1965). See also Helena Spanjaard, 'Free Art: academic painters in Indonesia', in Paul Faber, Liane van der Linden and Mien Tulmans (eds.), *Art From Another World* (Gent: Snoeck-Ducaju & Zoon, 1989).

28. There is an extensive literature on voodoo, but most of it tends to stress the archaic rather than the composite nature of the rituals, art and belief system.

29. See *Magiciens de la terre*, and *Mexico, au déla du Seisme* (Paris: ACSS, n.d.).

30. For the role of language and literature in the development of nationalism, see Benedict Anderson, *Imagined Communities* (London: Verso, 1983).

31. See especially David Cairns and Shaun Richards, *Writing Ireland* (Manchester: Manchester University Press, 1988), and Loreto Todd, *The Language of Irish Literature* (New York: St Martins Press, 1988). Seamus Deane, *Celtic Revivals* (London: Faber & Faber, 1988) is also essential reading.

32. Seamus Deane, 'Joyce and Nationalism', in Colin MacCabe (ed.), *James Joyce: new perspectives* (Brighton: Harvester, 1982). For an intelligent, but in my view wrongheaded account of the syntax of *Finnegans Wake*, see also Strother B. Purdy, 'Mind your Genderous: towards a *Wake* grammar', in Fritz Senn (ed.), *New Light on Joyce* (Bloomington: Indiana University Press, 1972). Vivian Mercier takes a very different but equally interesting approach in 'James Joyce and the Macaronic Tradition', in Jack P. Dalton and Clive Hart (eds.), *Twelve and a Tilly* (Evanston: Northwestern University Press, 1965).

33. Emanuel S. Goldsmith, *Modern Yiddish Culture* (New York: Shapolski, 1987).

34. Marjorie Boulton, *Zamenhof: creator of Esperanto* (London: Routledge & Kegan Paul, 1960). See also Peter G. Forster, *The Esperanto Movement* (The Hague: Mouton, 1982).

35. C.-J. N. Bailey and Carl Maroldt, 'The French Lineage of English', in Jürgen M. Maisel (ed.), *Langues en Contact – Pidgins – Creoles – Languages in Contact* (Tübingen: TBL Verlag Gunter Narr, 1977).

36. Richard Foster Jones, *The Triumph of the English Language* (Stanford: Standford University Press,

1953). See also David Simpson, *The Politics of American English* (Oxford: Oxford University Press, 1986).

37. See Braj B. Kachru, *The Alchemy of English* (Oxford: Pergamon, 1986) and Loreto Todd, *Modern Englishes: pidgins and creoles* (Oxford: Basil Blackwell, 1984).

38. Jules-Rosette.

39. Ulli Beier, *Three Yoruba Artists*, Bayreuth African Studies Series, no. 12 (Beyreuth, 1988). Another Nigerian artist who has developed an original composite and vernacular style is Middle Art (whose art is neither high nor low).

40. Chris Stapleton and Chris May, *African All-stars* (London: Paledin, 1989).

41. Salman Rushdie, *In Good Faith* (London: Granta, 1990).

42. Charles Jencks, *The Language of Post-Modern Architecture* (London: Academy Editions, 1977).

43. See Paul Groenendijk, *Adolf Loos, House for Josephine Baker* (Rotterdam: Uitgeverij 101, 1985).

44. See Robert Stern, *Raymond Hood* (New York: Rizzoli, 1982).

45. On Henry Luce and the 'American Century', see Serge Guilbaut, *How New York Stole the Idea of Modern Art* (Chicago: University of Chicago Press, 1983).

46. Jencks. Strangely, despite the celebratory 'Boom, boom, boom', Jencks also notes that, alongside the ruins 'some blacks have been able to form a community in parts of remaining habitable blocks — another symbol, that events and ideology, as well as architecture, determine the success of the environment'. By 'events and ideology' I assume he means 'community action and community creativity'.

47. Roland Barthes, *Mythologies* (Paris: Seuil, 1957) and Marshall McLuhan, *The Mechanical Bride* (London: Routledge & Kegan Paul, 1951).

48. For further reflections on this theme, see my introduction to Julian Rothenstein (ed.), *J. G. Posada, Messenger of Mortality* (London: Redstone Press, 1989).

49. Cited in Jack D. Flam, *Matisse On Art* (New York: E.P. Dutton, 1978).

50. See Peter L. Macnair, Alan Hooker and Kevin Neary (eds.), *The Legacy: Tradition and Innovation in Northwest Coast Indian Art* (Seattle: University of Washington, 1984).

51. See, for instance, B.W. Robinson, *Persian Oil Paintings* (London: Victoria and Albert Museum, 1977).

52. For the revival of baroque, see Serge Gruzinsky, 'From the Baroque to the Neo-Baroque' in Matthew Teitelbaum and Olivier Debroise (eds.), *El Corazon Sangrante/The Bleeding Heart* (Boston: Institute of Contemporary Arts, 1991) and Pedro Cuperman, 'Becoming Baroque', in Marja Bloem and Donna De Salvo (eds.), *Izhar Patkin, Four-Piece Suit* (Amsterdam: Stedlijk Museum, 1990). See also Thomas W. Sokolowski, *Precious, An American Cottage Industry of the Eighties* (New York: Grey Art Gallery, 1985). For corporate neo-baroque, see Judith Barry, *Public Fantasy* (London: ICA, 1991), especially 'Pleasure/ Leisure and the Ideology of the Corporate Convention Space'.

INDEX